TWENTIETH-CENTURY
WATERCOLORS

TWENTIETH-CENTURY WATERCOLORS

CHRISTOPHER FINCH

ABBEVILLE PRESS

PUBLISHERS NEW YORK

FOR CHLOE

EDITOR: Nancy Grubb

ART DIRECTOR: James Wageman

DESIGNER: Stephanie Bart-Horvath

PRODUCTION SUPERVISOR: Hope Koturo

PICTURE RESEARCHER: Lisa Peyton

FRONT COVER: Piet Mondrian. *Red Amaryllis with Blue Background*, c. 1907. See plate 172.
BACK COVER: Pablo Picasso. *The Acrobat Family*, 1905. See plate 106.

FRONTISPIECE: Sam Francis (b. 1923). *Untitled*, c. 1957. Watercolor on paper, 24 x 19½ in. Hirshhorn Museum and Sculpture Garden, Smithsonian Institution, Washington, D.C.; Gift of Joseph H. Hirshhorn, 1966.

First edition

Library of Congress Cataloging-in-Publication Data

Finch, Christopher.
 Twentieth century watercolors.

 Bibliography: p.
 Includes index.
 1. Water-color painting—20th century.
I. Title. II. Title: 20th century watercolors.
ND1798.F5 1988 759.06 88-3398
ISBN 0-89659-811-X

CONTENTS

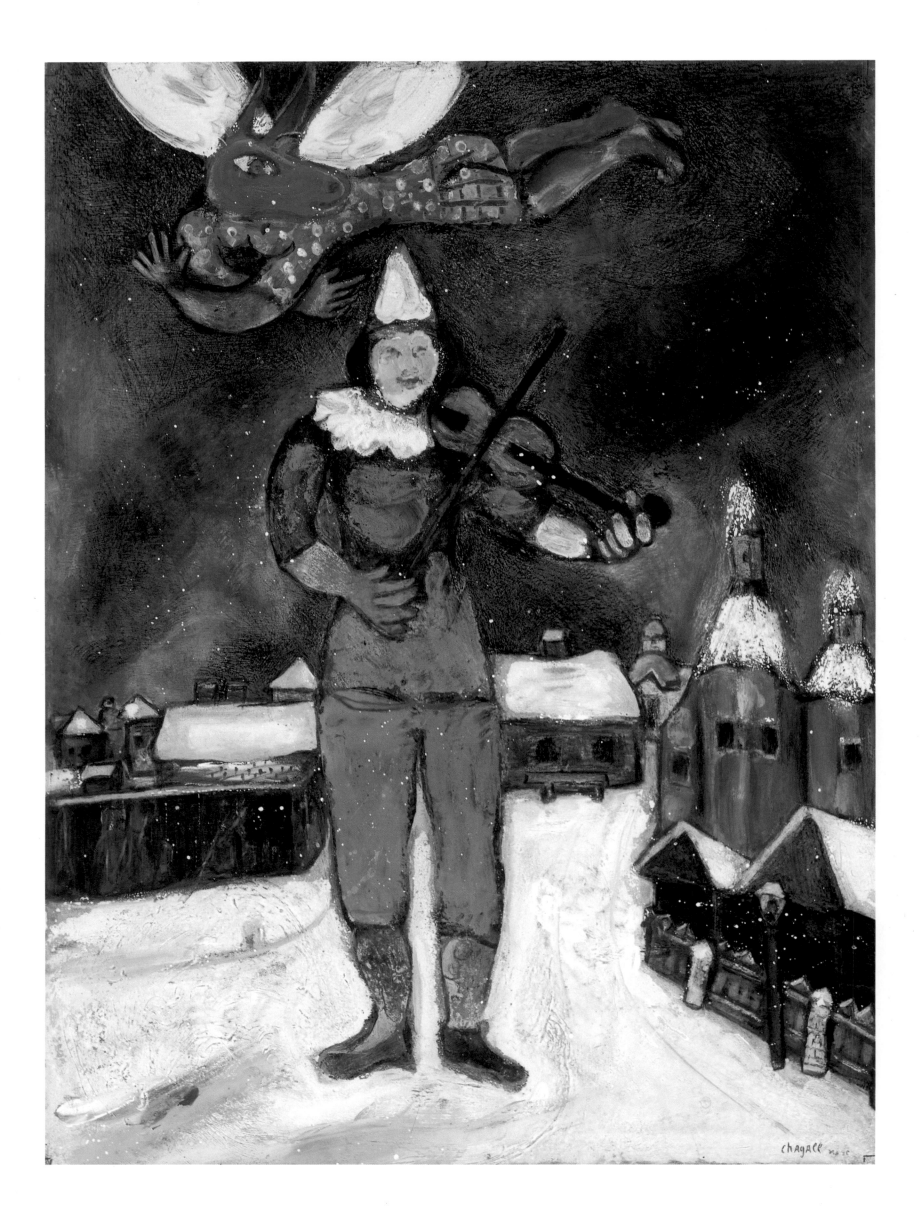

To attempt a history of twentieth-century watercolor is to take on a challenge that is both exciting and a little daunting. It is exciting because it gives the writer an opportunity to review the complete panoply of modern art from an unexpected point of view that makes the familiar seem fresh and new. It is daunting because the evolution of watercolor in this century has been rapid and not easily categorized.

True watercolor—the building of an image from layers of transparent wash—came of age a little before 1800 and evolved predictably throughout the nineteenth century. During the first decade of the twentieth century, however, what had become an established tradition collided with modernism and shattered. That did not mean watercolor was abandoned. Rather, it meant that artists sifted through the shards of this tradition, choosing a fragment here, a fragment there, from which to build a new approach. In their hands watercolor became a wonderfully pliable medium, well suited to experiment in a century that has placed a high premium on experimentation. Indeed, watercolor activity has been especially vigorous during periods of aesthetic ferment.

Few twentieth-century artists have suffered any qualms about abandoning the purity of the medium. They have freely combined it with crayon and collage or heightened it with gouache (sacrilege so far as traditionalists were concerned). Indeed, gouache—opaque water-based body color—has enjoyed considerable popularity in the twentieth century, favored by some of the greatest masters of the modern era. For this reason, my definition of twentieth-century watercolor includes gouache as well as transparent watercolor and watercolor used in combination with other media.

The evolution of watercolor in the twentieth century is tied to the evolution of modern art in general, and most of the masters of modernism have used the medium at one time or another. Some of the most important figures, including Pablo Picasso, employed watercolor extensively throughout their careers. A handful of masters—such as Paul Klee, Wassily Kandinsky, Emil Nolde, and George Grosz—used the medium so extensively that their contributions to the art of the century would be greatly reduced without it. This does not mean, however, that this book should be read as a complete history of modern art as seen in a single medium. Some movements, such as Expressionism, can be rather fully documented using watercolor alone. Surrealism, on the other hand, cannot be treated in this way, despite the fact that the movement did produce interesting work in the medium. I have, therefore, used the conventional history of twentieth-century art as a framework, but within this structure I have permitted myself shifts of emphasis that reflect the significance of watercolor to individual artists or to particular groups. I have also devoted a chapter to one national school—the American

—that made extensive use of watercolor while remaining outside the mainstream.

Twentieth-century artists have employed watercolor in many different ways and have subjected it to types of handling never envisioned by their predecessors. It is a measure of the medium's versatility that it has risen to every challenge. Even in the anything-goes atmosphere of the so-called postmodern era, watercolor continues to hold its own as an important medium, one that is likely to command the interest, and even devotion, of serious artists for many years to come.

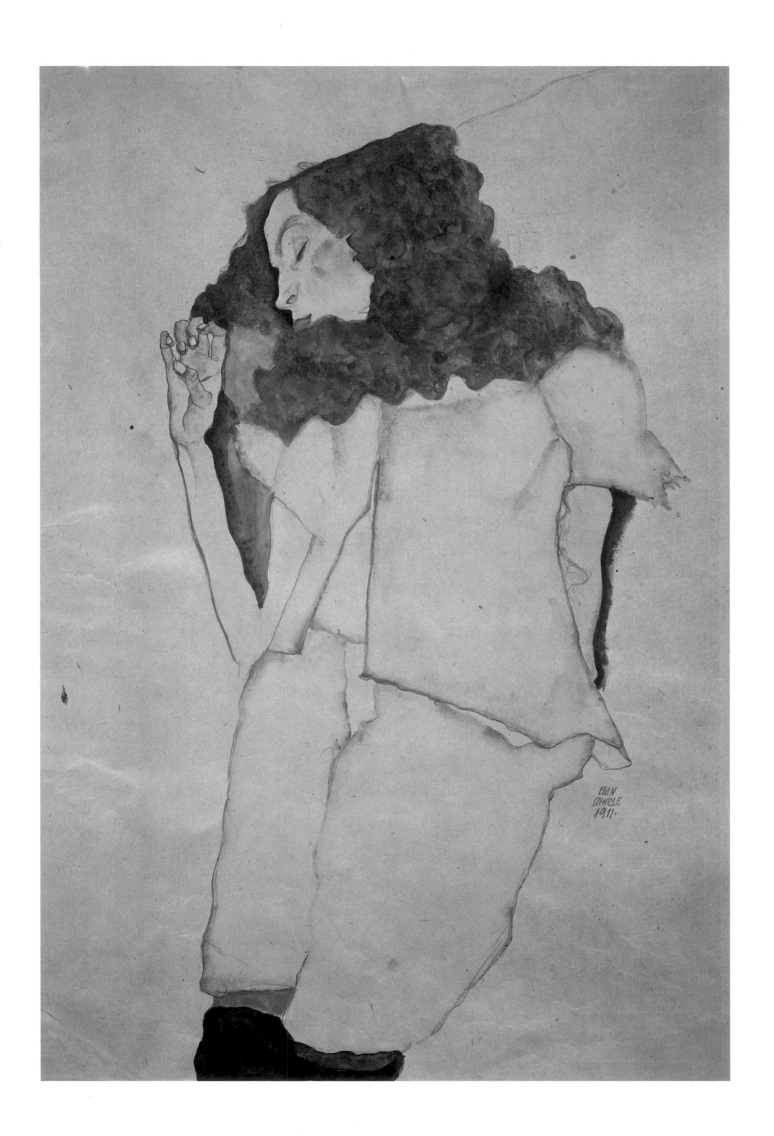

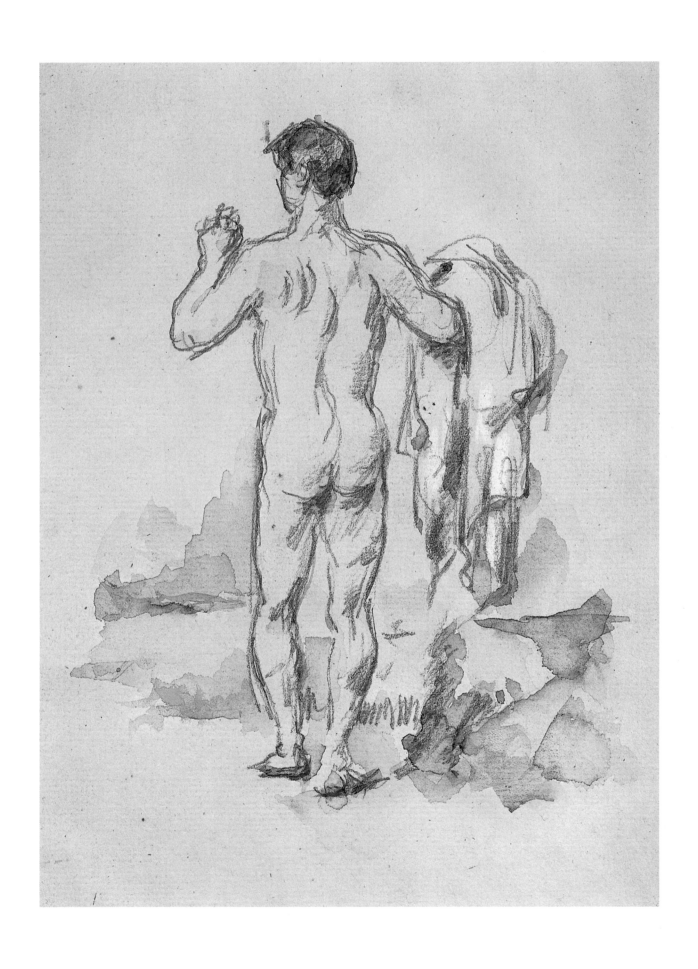

At the dawn of the twentieth century the art of watercolor painting was riding on a crest of popularity that would have been unthinkable less than a hundred years earlier. In the early nineteenth century watercolor had been practiced enthusiastically and skillfully in the British Isles, but elsewhere it was largely the domain of isolated *petits maîtres*. Gouache was more widely used but generally only as a study medium or—as in the highly finished works of artists such as Nicolas Lavreince—as an alternative to oil paint. In part this lack of interest in water-based media was due to a lack of suitable materials. Paper ready prepared for watercolor was difficult to find in continental Europe, meaning that artists had to size their own, a nuisance that detracted from one of the charms of the medium, its freedom from fuss. In Britain, on the other hand, demand from professionals and amateurs alike had encouraged manufacturers such as James Whatman to produce special sized and textured papers, just as colormen such as William Reeves had begun to produce easily portable cakes of color. Thus, technical advances aided the British school in its rise to dominance in the field.

From about 1820 onward, however, French artists—including such major figures as Théodore Géricault and Eugène Delacroix—became increasingly aware of the work of English masters such as Joseph Mallord William Turner, John Constable, and Richard Parkes Bonington. Inspired by Bonington, who spawned a whole school of followers in France, Delacroix became a highly skilled and original watercolorist, using the chromatic brilliance of the medium to explore color theory in an informal way. As the popularity of the medium increased, British paints and paper found their way onto the European market, and soon manufacturers in France and elsewhere began to compete directly with the British. By mid-century the popularity of watercolor was assured. In France it became a favorite medium for social commentators such as Eugène Lami, Constantin Guys, and Honoré Daumier, as well as for landscapists such as Théodore Rousseau and Eugène Boudin. Edouard Manet made considerable use of watercolor, and most of the Impressionists employed it on occasion, with Pierre-Auguste Renoir displaying a particularly delicate touch.

The popularity of the medium spread throughout the rest of Europe as well. The Dutchman Johan Barthold Jongkind, who was an important influence on the Impressionists, painted evocative, flickering watercolor landscapes, while in Italy artists such as Domenico Ranzoni and Giovanni Boldini used the medium for delicate portrait studies. Turner even found followers as far away as Budapest, where Niklós Barabás was a skillful practitioner of the English master's atmospheric style.

By the second half of the nineteenth century there was hardly a significant artist

who did not possess a box of watercolors, and an increasing number employed the medium as an important means of expression. The portability of watercolor served the plein-air tendencies of the period, but above all the freedom and breadth of handling that it offered made the medium appealing to the advanced painters of the day. This in turn influenced the way that some painters used gouache, although body color continued to be employed as an alternative to oil paint by artists such as Ernest Meissonier, whose tightly painted genre scenes enjoyed tremendous popularity. In some works Meissonier combined body color with transparent color, a technique known as *aquarelle-gouache,* which found one of its greatest exponents in the Berlin-based realist Adolf von Menzel.

Clearly, a young artist with an interest in watercolor had no shortage of examples at the turn of the century. If this young artist lived in the English-speaking world, he was most likely to be attracted to some development of the classic watercolor tradition that had evolved in England a century earlier. If this sounds reactionary, it should be remembered that British watercolor—with its emphasis on spontaneity and economy of means—embraced many of the same principles as did the young radicals of the early twentieth century. Indeed, many of the finest British watercolorists from the first half of the nineteenth century—John Sell Cotman and David Cox, for example— had to wait until modernism changed the artistic climate before their work could be fully appreciated.

At the turn of the century, however, no Cotman or Cox graced the British scene, and certainly there were no watercolorists there who approached the stature of Turner or Constable. There were, however, able men who had thoroughly absorbed the lessons of those masters. One interesting artist of the day was Hercules B. Brabazon, a gentleman painter who at the end of a long life attracted a good deal of attention by taking his cue from Turner's most enigmatic watercolors, the so-called Color Beginnings. A master of rapid brushwork and limpid washes, Brabazon was a truly transitional figure. His roots were firmly in the Victorian era, yet his best sheets display a freshness that pointed forward to the spirit of the new age (plate 6).

A younger contemporary, Philip Wilson Steer, was more self-consciously a modernist to the extent that he produced in the 1890s some of the finest British variants on French Impressionism. George Heard Hamilton has pointed out, however, that painters such as Steer had considerable difficulty, in the long run, accommodating the analytical vision of the French to the very real strengths of their native landscape tradition.[1] From around 1900 on Steer painted many watercolors in an idiom that, even

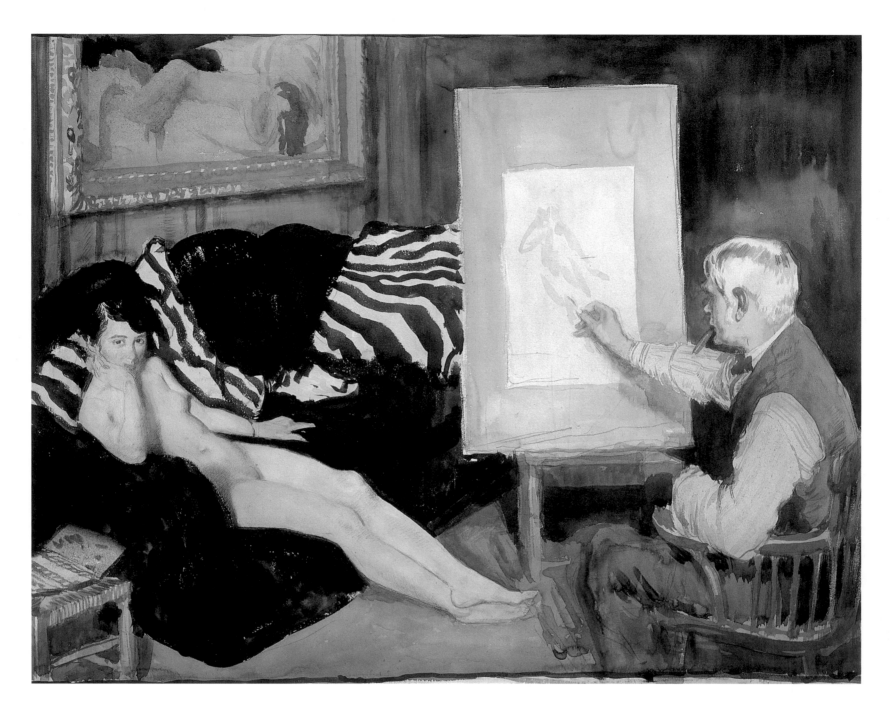

though it took some note of recent developments, would not have seemed unfamiliar to someone of Bonington's generation (plate 7).

Of those British artists who matured in the first decade of the century, Sir William Orpen might be described as a conservative who remained open to just enough of the new theories to avoid being labeled a reactionary. As a watercolorist he drew directly, and with great virtuosity, upon the accumulated skill and knowledge of the British tradition, and it might be argued that in this century nobody except Sargent has applied orthodox watercolor techniques to the representation of the human figure more successfully than Orpen (plate 8).

A far greater artist, and one much more successful in reconciling Gallic innovations with Anglo-Saxon traditions, was the London-based American James Abbott McNeill Whistler, whose influence was deeply felt in some quarters at the turn of the century. Whistler's ability to absorb the lessons of Manet and Edgar Degas without submerging his own personality has been much remarked, as has his fruitful involvement with Oriental art, and both these influences are apparent in watercolors such as *Blue and Silver—Chopping Channel* (plate 9). At the same time, this tiny masterpiece, with its swift calligraphy and its utter simplicity of concept, can be seen as a logical extension

8. William Orpen (1878–1931)
 The Model, 1911
 Watercolor on paper, 21¼ × 27¼ in.
 Tate Gallery, London

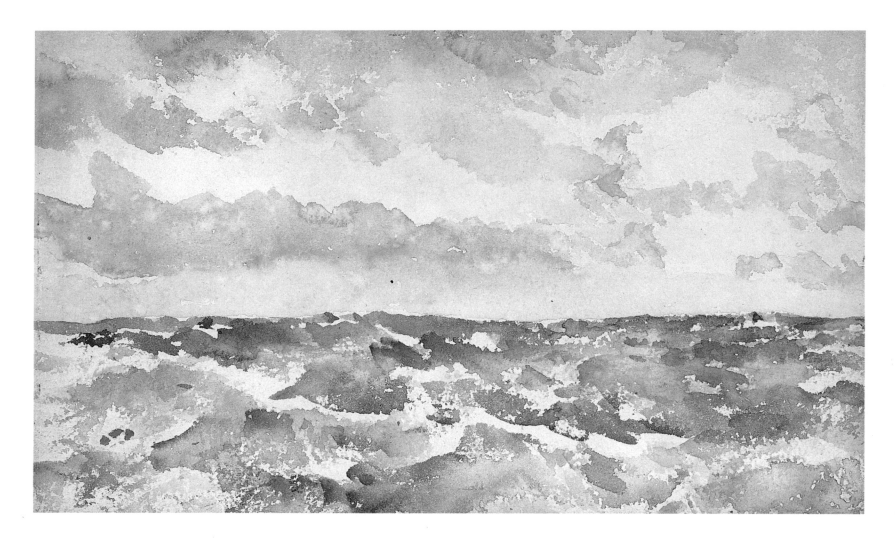

9. James Abbott McNeill Whistler
 (1834–1903)
 Blue and Silver—Chopping Channel,
 1890s
 Watercolor on paper, 5½ × 9½ in.
 Freer Gallery of Art, Smithsonian
 Institution, Washington, D.C.

of the values of the British watercolor school.

Another London-based American, John Singer Sargent, turned to watercolor around 1900—largely as a relief from painting portraits, which he was beginning to find odious—and quickly established himself as the leading bravura watercolorist of the day. From the point of view of radical artists, the age of bravura painting was very much on the wane, and certainly Sargent's extraordinary facility proved to be something of a liability, especially when contrasted with now-treasured work by artists such as Paul Cézanne and Vincent van Gogh—artists who were once considered clumsy and far less talented than Sargent. Watercolor, a surprisingly difficult medium, sometimes responds to virtuosity, however, and Sargent had the ability to conjure up a whole world with the rapid calligraphy that in his formal portraits was reserved for suggesting the intricacy of a lace collar or the glow of light on satin. These portraits are loaded with echoes of aristocrats painted by Thomas Lawrence, Diego Velázquez, Anthony van Dyck—an oblique way of flattering Sargent's sitters. But in his watercolors Sargent was responding directly to the world around him, and this released him from the tug of historical association that, however lightly handled, diminishes the impact of his more ambitious works. Naturally enough, Sargent had a sure way with figures (plate 10), but he was equally adept at setting down landscapes and especially at capturing the shifting effects of sunlight on surfaces as varied as rock, tent canvas, and running water. His landscapes —which might be described more properly as paintings about place—are unusual in that they frequently dispense with a horizon line and rely on a close viewpoint, often from an unexpectedly high or low angle, which provides a rather flat, allover composition instead of one divided into foreground, background, and sky. In this respect, as well as in his improvisational brushwork, Sargent's watercolors are sometimes more advanced in concept than might at first be thought (plate 11).

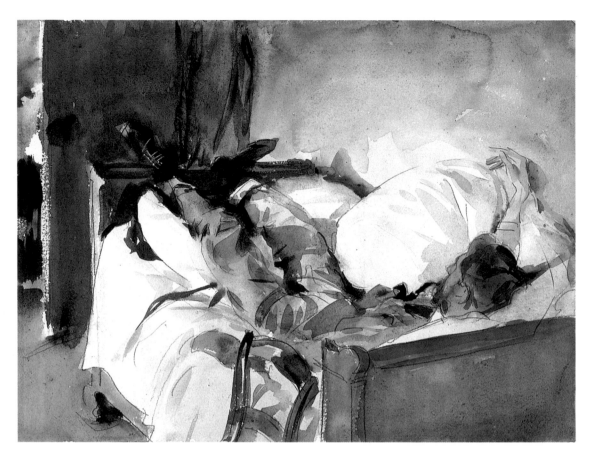

10. John Singer Sargent (1856–1925)
 In Switzerland, 1908
 Watercolor and pencil on paper,
 9¾ × 13 in.
 The Brooklyn Museum; Purchased by
 special subscription

11. John Singer Sargent (1856–1925)
 Gourds, c. 1905–8
 Watercolor on paper, 14 × 20 in.
 The Brooklyn Museum; Purchased by
 special subscription

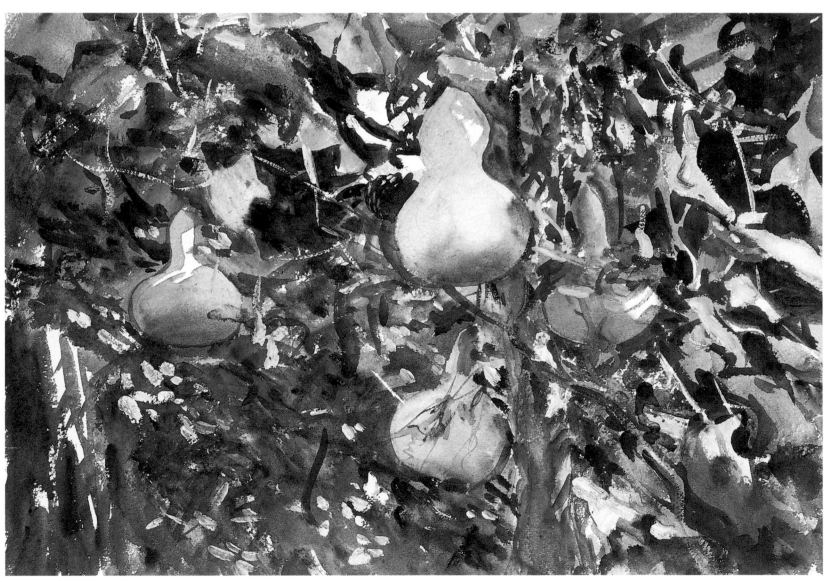

The greatest American watercolorist of that generation, and one whose art was at its prime in the early 1900s, was Winslow Homer. An illustrator early in his career, Homer began to paint seriously in oils in his mid-twenties and in watercolor in his late thirties. The early watercolors, though charming, are not remarkably original, and it was not until 1881 and 1882, while the artist was in residence at the English fishing village of Cullercoats, that he began to produce powerful work in the medium. Returning to America, he settled on the Maine coast. It was there, as well as on his travels to such places as New York's Adirondack Mountains and the Caribbean, that he produced, over a period of almost three decades, scores of paintings that entitle him to be considered among the greatest watercolorists of any period.

It was Homer's great achievement that he took the liveliest aspects of the British school (though he was not one to acknowledge antecedents) and breathed new life into them, imbuing the Anglo-Saxon tradition with a Yankee robustness that was all his own. It would be an oversimplification to accuse the British school of limiting itself to the portrayal of graceful scenes under gentle skies—Turner alone can provide plenty of exceptions to that—but it is difficult to imagine any British nineteenth-century water-colorist taking on the subject of canoeists fighting white water and treating it with the matter-of-fact pragmatism that is one of Homer's trademarks (plate 12). His technique —the fluent use of transparent washes—clearly derives from British practices, but the image that Homer captured has the spontaneity of a snapshot (though no snapshot could match the energy recorded in pigment by the passage of Homer's sable brush).

If Homer's wilderness scenes often portray man pitted against nature at its

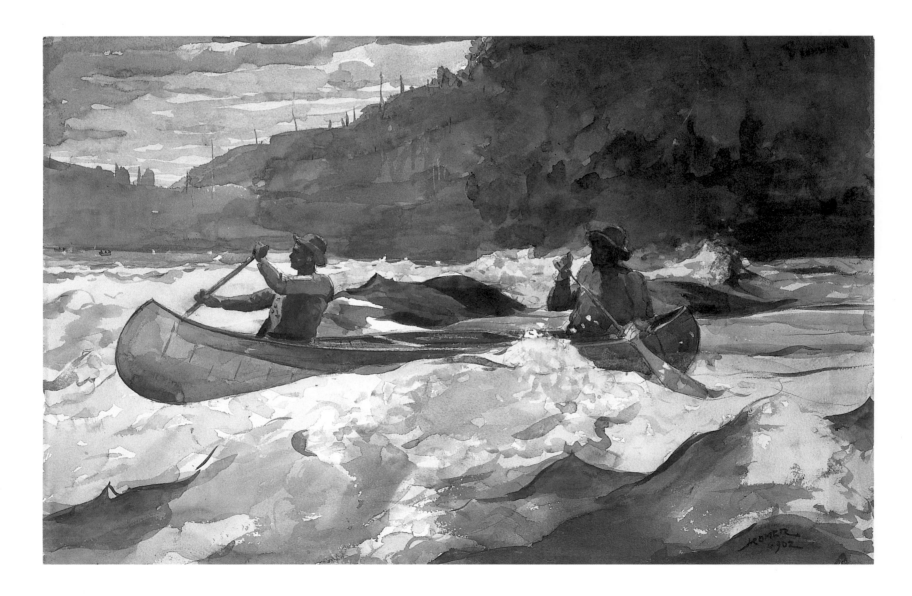

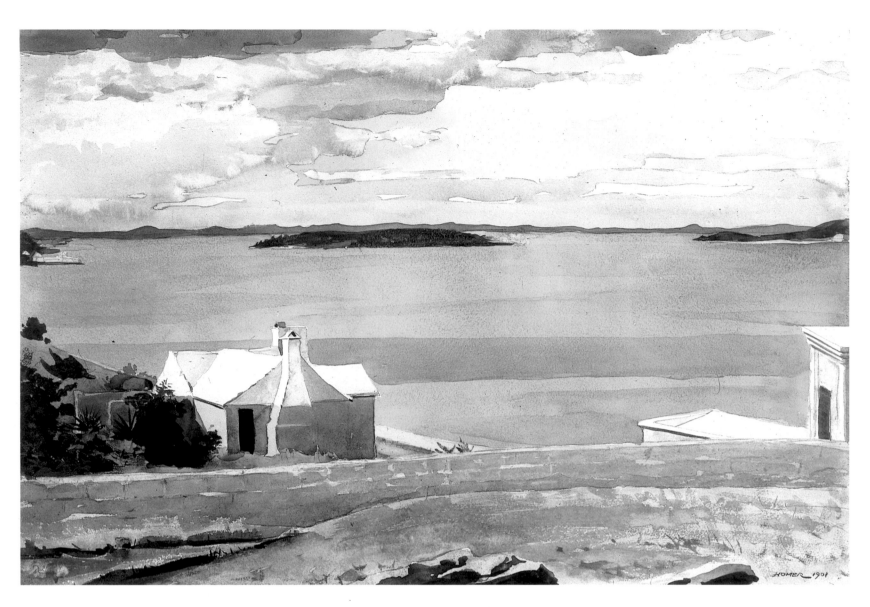

wildest, they do so without any hint of Victorian romanticism or sentimentality. His hunters and guides are generally presented not as heroic figures but as somewhat anonymous modern men discovering pleasures not to be found in the city. But while Homer's wilderness paintings are filled with bracing air and icy streams, some of the scenes he painted in Florida, the Bahamas, Cuba, and Bermuda are positively voluptuous in their acceptance of sunlight and warmth. In *Bermuda* (plate 13), one of the local white houses gleams against blue water dotted with islands. Areas of the paper support that have been left untouched establish the white of the roofs, while a dark accent is provided by tropical vegetation seen in partial silhouette against one corner of the building. The scene is almost idyllic but—a typical Homer touch—the artist has refused the temptation to eliminate an ugly cinder-block wall that has been erected to separate the well-to-do inhabitants of this Arcadian home from the natives who use the dirt road that can just be glimpsed in the foreground. (This is not to say that Homer was making a political statement, merely that he was scrupulously honest with regard to visual material.) In another of his southern watercolors, *Key West* (plate 14), Homer demonstrated how persuasively he could create atmosphere—in this case a feeling of oppressive humidity—with the sparest of means. The sultriness of the day is suggested by the way the dark wash representing the sea, edged at the horizon with green, has been dragged across the paler washes with which the paper has been saturated and which also serve to conjure up the overcast sky.

Homer had little or no influence in Europe, but in America his example was followed, in spirit at least, by many younger artists who recognized that even though his means were not novel his way of looking at the world was distinctly new. America seemed inherently modern, and so the very act of looking at it with an honest, unbiased eye—as a photographer might—seemed a valid activity for young men and women who thought of themselves as progressive. Thus, Homer helped foster a tradition of

15, 16. Gustave Moreau (1826–1898)
The Temptation of Saint Anthony,
n.d.
Watercolor on paper,
5¼ × 9½ in.
Musée Gustave Moreau, Paris

realism that would remain valid in America long after it seemed anachronistic to advanced European artists.

As the century opened, young artists in Europe were being attracted to models very different from those available to Americans. Some of the painters these young Turks of the Old World admired undoubtedly thought of themselves as realists, though of a new sort, while others were more interested in exploring the imagination and the inner life of the spirit. If a young artist lived in Paris and was temperamentally inclined toward the writing of J. K. Huysmans and Stéphane Mallarmé, then he might well find himself attracted to the watercolors of Gustave Moreau.

Even if he had not been a highly original artist in his own right, Moreau would still be honored as the teacher who exerted considerable influence on Henri Matisse and Georges Rouault. Nor is it surprising that painters associated with the Fauves—Albert Marquet, for example—emerged from his studio, for Moreau was a superb colorist. Nowhere is this more apparent than in his watercolors. Early in his career he used the medium to paint Italian landscapes, somewhat in the British idiom, and to make faintly satirical social comments in the wake of Guys. Soon Moreau became excited by images from the Bible as well as from the mythologies of Greece, Egypt, and the Far East, sometimes combining characters from these varied cultural sources within a single composition and recasting them into roles that owed little to any source but his own highly charged imagination. In his oil paintings the constraints of the medium frequently seemed to deaden his visionary world, so that his angellike poets and his innumerable incarnations of femmes fatales sometimes seem trapped in an airless environment. The fluidity of watercolor, however, enlivened his scenes in that medium, and even relatively conservative examples display an energy rarely found in his works on canvas.

In *The Temptation of Saint Anthony* (plate 16), Moreau played with watercolor in a way that was unusually bold for his generation. Here the saint and his tormentors are almost swallowed by a landscape made up of seemingly random blots and spatters of pigment laid over fluid sheets of transparent wash. This is an approach to painting so radical that it anticipates the methods of the mid-twentieth-century *tachistes* and action painters. Color is set free, and the image materializes almost magically. As a watercolorist Moreau must be counted as one of the most inventive figures of the late nineteenth century, and he was to have a significant influence on many twentieth-century painters, from the Fauves to the Surrealists.

As a visionary, too, Moreau had few equals, one of whom was his younger contemporary Odilon Redon, who was still very active at the turn of the century. Until the 1890s Redon had worked almost exclusively in black and white, setting down Goya-like chimeras and nightmares in charcoal or upon the lithographer's stone. When he finally turned to color, he did so as if its energy had been pent up inside him for years (as may indeed have been the case). So intensely luminous are the oils and pastels that Redon painted, starting in the 1890s, that it seems surprising that he began to experiment, around 1900, with a medium as delicate as watercolor. Great watercolorists know, however, that there is a unique richness of color to be found in transparent washes, and this is fully apparent in Redon's work in the medium. *Woman, Half-Length, with Outstretched Arms* (plate 17) exemplifies a classic use of transparent pigment handled in a broad, painterly way. The figure emerges from a cocoon of color, even as she seems to dissolve into the background. As is the case with Moreau, watercolor was well adapted to the elliptical nature of Redon's art.

Moreau and Redon are among the artists sometimes described as Symbolists—indeed, they were progenitors of that elusive movement. As the century changed, many other artists were caught up in the ideals and ambitions of a tendency that embraced subtlety and banality with equal ease. Among the Symbolists who made frequent use of

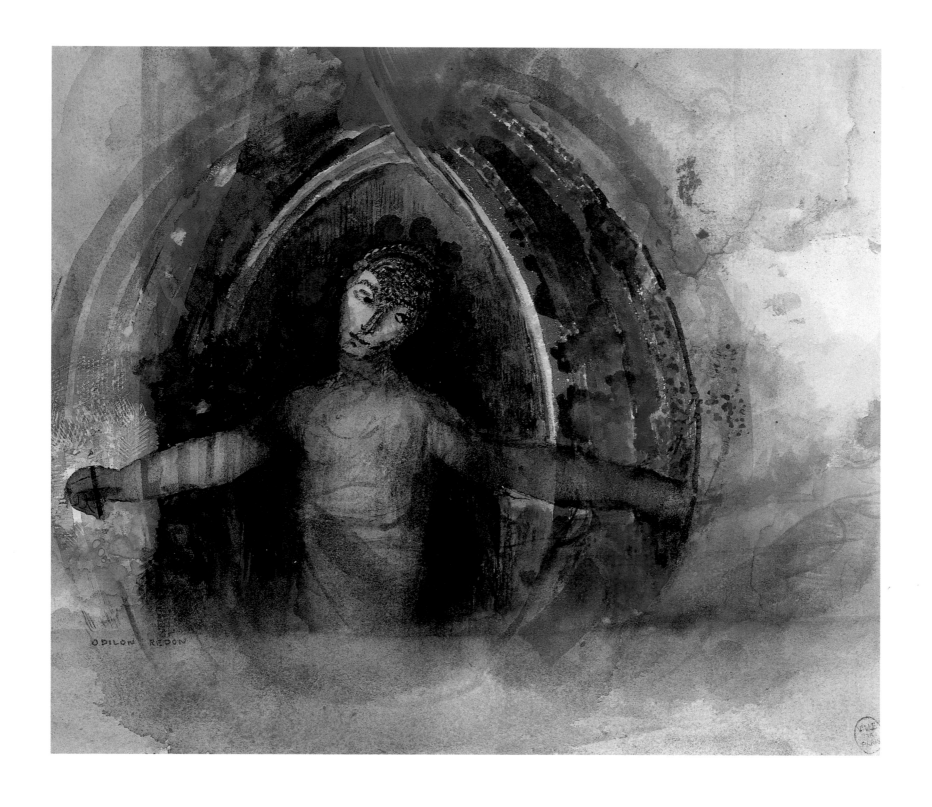

17. Odilon Redon (1840–1916)
 Woman, Half-Length, with Outstretched
 Arms, 1910–14
 Watercolor on paper, 6¾ × 7⅞ in.
 Musée du Petit Palais, Paris

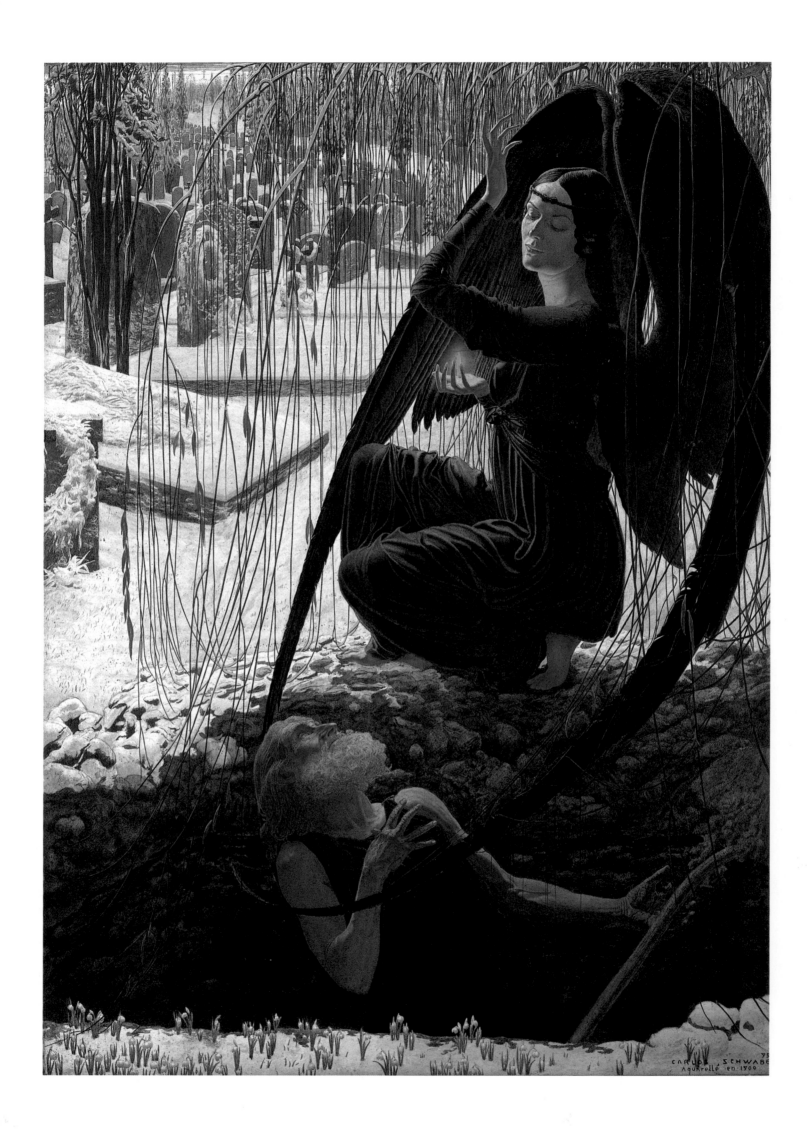

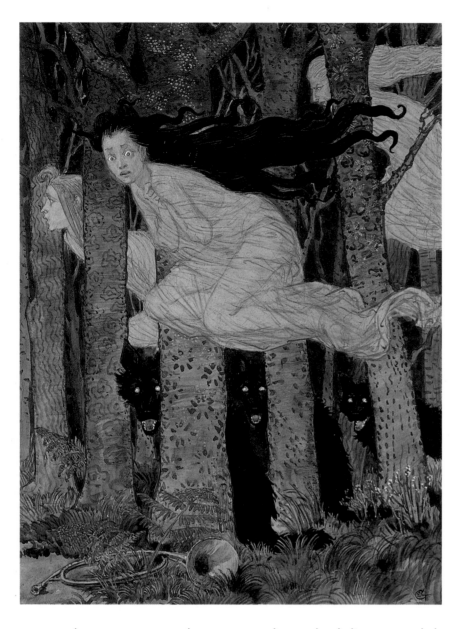

watercolor were some whose approach was both literary and decorative. (It must be remembered that this was a period when the term *decorative* was often used to describe innovative work.) Carlos Schwabe, a Swiss of German extraction, became a fixture in the Parisian art world, illustrating works by Charles Baudelaire, Maurice Maeterlinck, and Emile Zola and exhibiting at the Rosicrucian salons organized by the exhibition-istic Sâr Péladan, a Swedenborgian mystic. Replete with rather obvious symbolism, Schwabe's *Death and the Grave Digger* (plate 18) portrays death as a beautiful woman—yet another variant on the femme fatale. The decorative aspects of his oeuvre, seen more clearly in his black and white illustrations, now seem tame but were originally quite striking and significantly influenced the development of Art Nouveau. Schwabe is typical of artists who seem minor today but who were taken quite seriously at the turn of the century by some of the young artists who would become the revolutionaries of the next decade.

Another Swiss artist based in Paris and associated with both Symbolism and the evolution of Art Nouveau is Eugène Grasset, best known as a poster designer. He traveled to Egypt and was much taken by its exotic atmosphere, as well as by Japanese prints. His most interesting works display a powerful sense of design allied to an imagination that sometimes had a genuinely dreamlike edge to it. *Three Women with Three Wolves* (plate 19) is dominated by pattern—and the use of gold adds to its decorative feel—but the image, if a trifle comical, is also genuinely disturbing, with strongly sexual overtones.

OPPOSITE
18. Carlos Schwabe (1866–1926)
Death and the Grave Digger,
1895–1900
Watercolor and gouache on paper,
29½ × 22 in.
Musée du Louvre, Paris

19. Eugène Grasset (1841–1917)
Three Women with Three Wolves, n.d.
Watercolor with gold on paper,
12⅝ × 9½ in.
Musée des Arts Décoratifs, Paris

20. Koloman Moser (1868–1918)
The Dancer Loie Fuller, n.d.
Watercolor and ink on paper,
5⅞ × 8½ in.
Graphische Sammlung,
Albertina, Vienna

Koloman Moser is another of the artists connected to both Symbolism and Art Nouveau, though his base was not Paris but Vienna, where he was a founder of the Secession. Like many artists of the period he was entranced with the American dancer Loie Fuller, whose famous dance of "butterfly veils" had made her the toast of Europe. In this dance it was the veils rather than her body that formed the prime expressive element. As she swirled and pirouetted, the fabric made arabesques in the air. It was almost impossible to make a sculpture, painting, or drawing of Loie Fuller at work without creating an example of Art Nouveau, and in this respect Moser's portrayal is merely typical (plate 20). What makes this of interest here is that it illustrates how freely some artists at the turn of the century had begun to combine watercolor with various opaque media—in this case, ink. Clearly this is not a watercolor in the classic sense that a Winslow Homer is a watercolor, yet the use of transparent pigment here serves a purpose that could not be served by anything else since that is what gives the image its luminosity. In its emphasis on pattern, Moser's painting presages certain tendencies in twentieth-century art, and technically it serves to introduce the notion, much acted upon as the century progressed, that watercolor could usefully be employed in "mixed-media" works. While some artists continued to find watercolor challenging for its own sake, others embraced it as an adjunct to almost anything else that could be used to make a mark on paper. That willingness to combine media is itself a characteristic of twentieth-century art.

Another artist sometimes identified as a Symbolist is Alfred Kubin, born in what is now Czechoslovakia but brought up in Austria. Unlike so many of the Symbolists, Kubin did not have to go far afield for mystifying images. Like Redon, whom he admired and was encouraged by, Kubin seems to have dredged up dreams and nightmares almost effortlessly from his unconscious mind. Primarily he was a pen and wash artist, with a wonderfully nervous line that sometimes seemed to have a will of its own, but his drawings are often effectively enlivened with watercolor (plates 21, 22). It is tempting to think of Kubin as an eccentric who had little impact on the mainstream, but it should not be forgotten that he exhibited with the Blue Rider group and maintained contact

21. Alfred Kubin (1877–1959)
 Panther Woman, n.d.
 Pen and ink, wash, spray, and
 watercolor on paper, 6⅛ × 13½ in.
 Graphische Sammlung,
 Albertina, Vienna

22. Alfred Kubin (1877–1959)
 The Laughing Sphinx, 1912–15
 Pen and ink and watercolor on paper,
 11¾ × 7⅝ in. (image)
 Private collection

23. Paul Gauguin (1848–1903)
Still Life with Cat, 1899
Watercolor on paper, 24⅞ × 14⅛ in.
The Art Institute of Chicago; Helen
Tieken Geraghty Gift in Memory of
Dr. and Mrs. Theodore Tieken

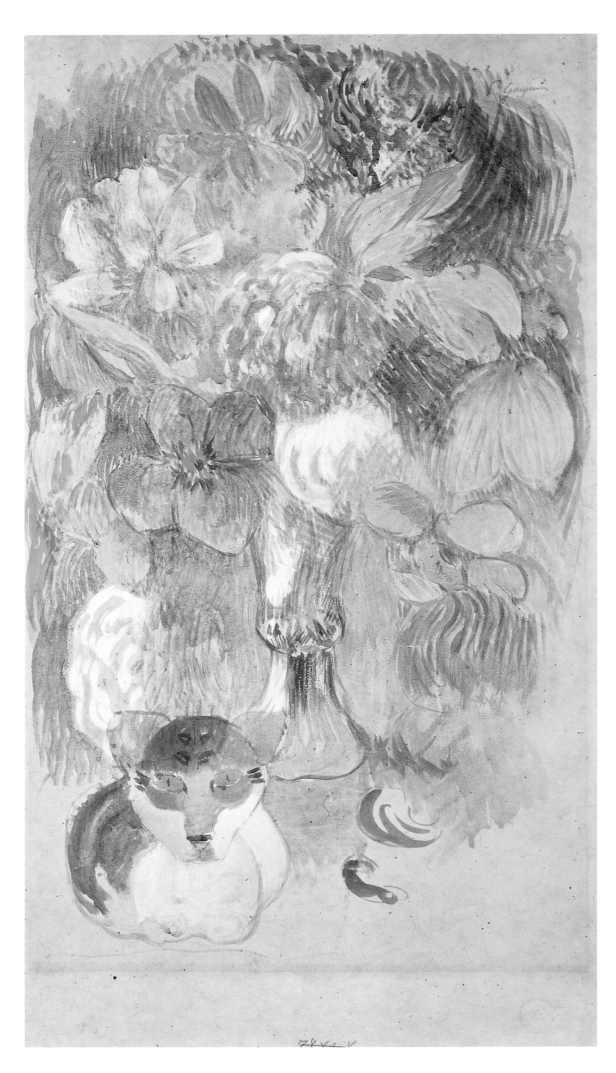

with many important modernists, including Wassily Kandinsky, Paul Klee, Franz Marc, and Lyonel Feininger. Klee's early work has some direct affinities with Kubin's paintings, but even more important is the possibility that Klee, even after he had arrived at his mature vocabulary, continued to play the sorts of psychological games that are found in Kubin's art.

Paul Gauguin, too, is counted among the Symbolists, but beyond that he was, of course, a major and independent figure whose ambitious program for the future of art escapes any narrow categorization. He left for his final voyage to the South Seas in 1895, but his influence was felt in France and throughout Europe long after he had departed. Gauguin is not often thought of as a watercolorist, yet he worked in the medium a good deal and knew how to use it with the directness of touch that is characteristic of his work as a whole. In *Still Life with Cat* (plate 23), he made expert use of the paper while applying color in bold strokes to build up a rich, pastellike texture.

Like Gauguin, van Gogh is rarely considered as a watercolorist, but he was capable of powerfully expressing himself in the medium, building up the image from

24. Vincent van Gogh (1853–1890)
Old Vineyard with Peasant Woman,
1890
Watercolor, gouache, and pencil on paper, 17⅛ × 21¼ in.
Vincent van Gogh Foundation/National Museum Vincent van Gogh, Amsterdam

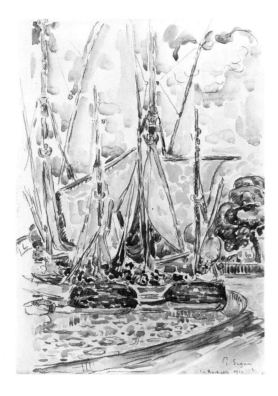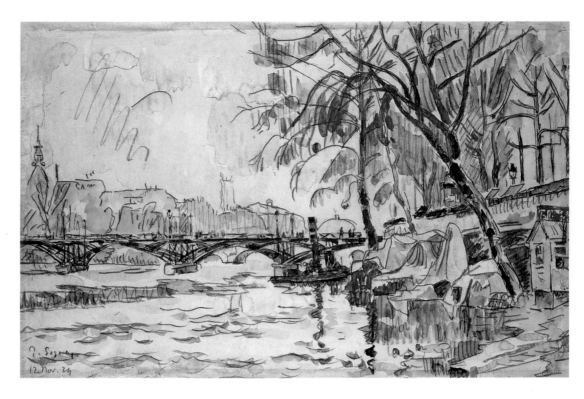

25. Paul Signac (1863–1935)
Tuna Boats, 1911
Watercolor and charcoal on paper,
15 × 10¾ in.
Wallraf-Richartz Museum, Cologne,
West Germany

26. Paul Signac (1863–1935)
View of the Seine in Paris, n.d.
Watercolor on paper, 10⅜ × 16¼ in.
Hamburger Kunsthalle, Hamburg,
West Germany

confidently applied directional strokes of color, much as he did in his oil paintings. In *Old Vineyard with Peasant Woman* (plate 24), the spiraling clouds are echoed by the gnarled vines twisting around trellises. As is usual in van Gogh's later work, the image seems to be transformed into energy fields, each field indicated by an accrual of sinuous brush-strokes that are organized with the inevitability of iron filings responding to a magnet. Each brushstroke has a color value, so line becomes color, color becomes line, and categories of visual information are fruitfully confused in a way that gives the image great vitality. It would be meaningless to talk of van Gogh's influence as a watercolorist, yet in the early 1900s people were looking at and learning from everything he did.

Paul Signac, ten years younger than van Gogh, was active well into the twentieth century and had an important influence upon the Fauves, especially Matisse and André Derain, and upon other modernists as well. He was a disciple of Georges Seurat and one of the chief theorists of Divisionism. In his oils this theory is sometimes employed so rigorously that it becomes suffocating, but in watercolors such as *Tuna Boats* (plate 25) Signac made less determined use of Divisionist techniques, often with happier results. When working in watercolor he was, in fact, sometimes able to abandon theory entirely and set down a scene with directness and spontaneity, as in *View of the Seine in Paris* (plate 26). Signac's presence as a watercolorist continued to be felt long after the flood tide of modernism had swept past him.

All of these artists contributed to a language of watercolor that would be appropriate to the twentieth century, but the two who contributed most to defining the spirit and methodology of the new approach were Paul Cézanne and Auguste Rodin. Both, of course, are best known for their work in other media, but both were water-colorists of the first order. For Cézanne watercolor was a true branch of the art of painting, whereas for Rodin it was primarily an extension of the art of drawing.

Cézanne employed watercolor for studies relatively early in his career, including *The Bather* (plate 5), which he used as the basis for other bathers in at least four oil paintings of the period. The draftsmanship, typical for Cézanne's work of this period, is vigorous but a little awkward, but his clumsiness should not blind us to the fact that these early watercolor sketches anticipate much that was to be perfected later on. Already he intuitively understood—better perhaps than anyone before him—that the

white of the paper support could be used as a primary element in the composition. It was one of the great achievements of the British school that its masters, from J. R. Cozens onward, knew how to exploit the white ground both by letting it glow through the transparent colored washes and by leaving patches of paper entirely untouched to represent the effects of sunlight on water, for example, or to stand for a chalk cliff face or a whitewashed building (as in Homer's *Bermuda,* plate 13). As soon as the virgin paper is used in this way, it takes on the secondary responsibility of performing a spatial function. It was Cézanne's discovery that this function need not remain secondary but could become the key factor in organizing the signs and marks that make up any image.

In Cézanne's late watercolors—those done in the decade before his death in 1906—the notion of using virgin paper as an expression of spatial values is carried to a conclusion that was to have a profound impact upon his younger admirers. *Bathers under a Bridge* (plate 27) relates to his earlier bathing subjects but by the turn of the century Cézanne's hard-won confidence in the technical means at his disposal made it possible for him to conjure up a complex Arcadian scene with just a few strokes of pencil enlivened by dabs of watercolor that elliptically evoke surface and volume. Here the

27. Paul Cézanne (1839–1906)
Bathers under a Bridge, c. 1900
Watercolor and lead pencil on paper,
8¼ × 10¾ in.
The Metropolitan Museum of Art,
New York; Maria De Witt Jesup Fund,
1951, from The Museum of Modern
Art, Lillie P. Bliss Collection

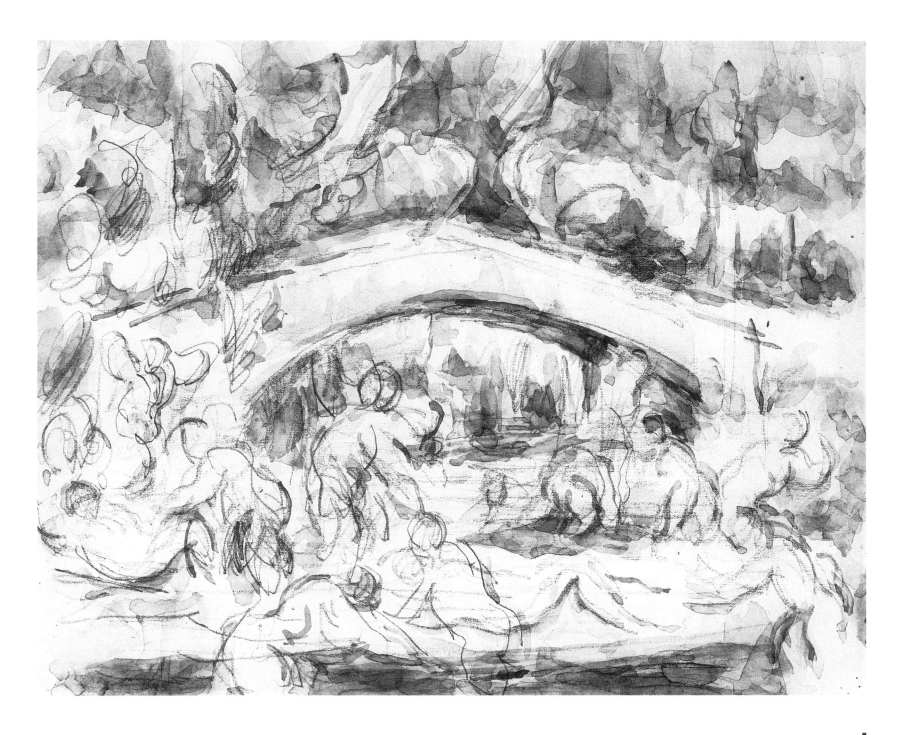

white of the paper support is used to represent light in a completely conventional way (though with almost unprecedented boldness), but it also represents the space within which the trees, the bridge, the tangle of bodies exist. It might be said that it becomes the air these hedonistic bathers breathe, but from another point of view—one that was to become crucial for the art of the next few decades—the white paper represents the integrity of the picture plane and thus proclaims that the painting is an arrangement of marks and colors on a flat surface. It was this integrity of the picture plane that some future artists would insist was inviolable, though Cézanne, with his pencil and brushes and little pans of paint, still performed the magic of the post-Renaissance artist by creating the illusion of deep space. The viewer can read this painting equally well as a description of receding planes or as a flat surface covered with line and color. This is one of those rare works in which past and future ambitions are held in perfect balance.

Cézanne's distrust of outlines has often been remarked and it is certainly evident in *Bathers under a Bridge*. The forms of the bathers are not delineated as they would be

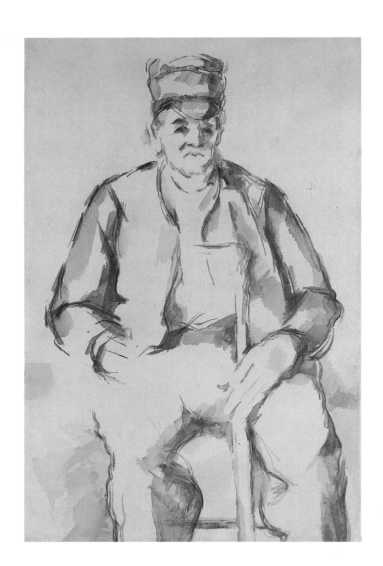

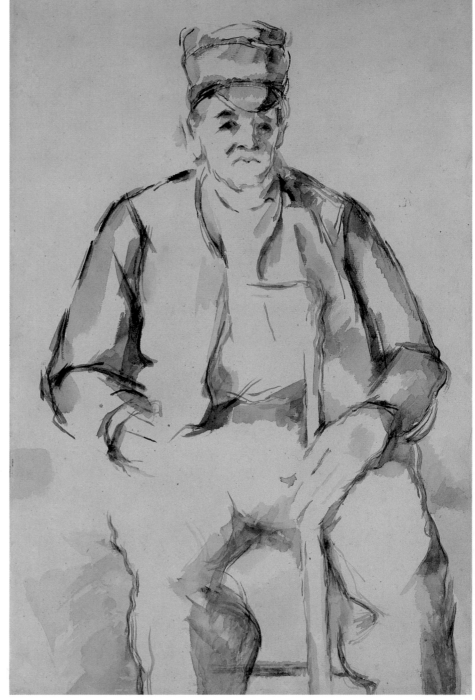

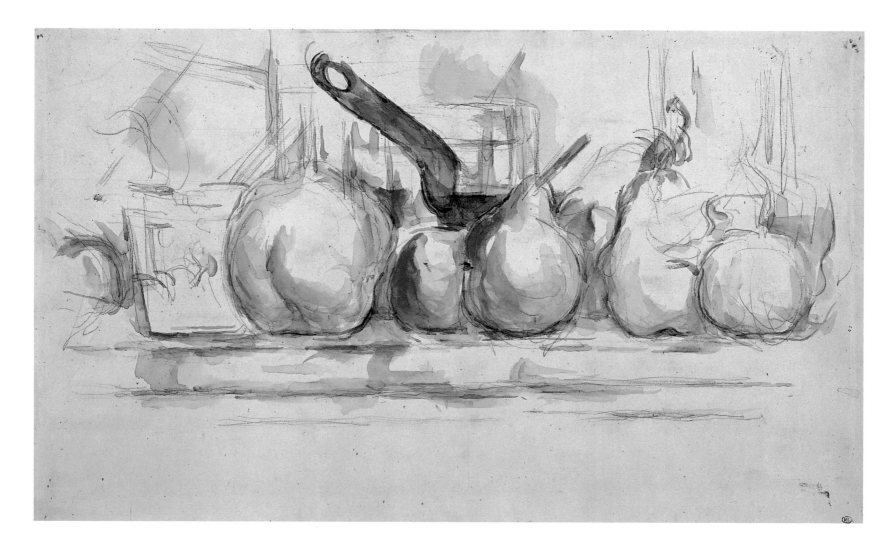

in, for example, a drawing by Jean-Auguste-Dominique Ingres but are suggested by idiosyncratic calligraphy, which is effective largely because of the remoteness of the viewpoint. (At this distance from the figures a scribble is enough to suggest the curve of a spine, the twist of a shoulder.) More often, when the subject was viewed from closer range, Cézanne defined (or refused to define) the perimeters of an object or person by employing multiple lines, rather than a single firm edge, with the result being a tremulous life that no academic draftsmanship could provide. Many of Cézanne's watercolors are underscored with nervous pencil lines that hint rather than describe. Watercolor lent itself especially well to Cézanne's strategy in that its transparency resulted in a line that was not quite so immutable as one made with pencil or India ink. Not only does the watercolor line have a color value, but it also modifies rather than obliterates the background, so that line and ground remain part of a continuum. The problem of committing oneself to a definite outline is diminished, especially since the watercolor line can easily be dissolved into a wash indicating a plane or depth. This is not to say that Cézanne was ducking the challenge of draftsmanship. By refusing to use traditional methods of outlining form he was paradoxically forced to develop linear flexibility that helped create new standards of draftsmanship, standards that were to have great impact on the draftsmen of the next generation, including Matisse and other masters of the firm line drawn in black on white.

It is instructive to look at Cézanne's *Seated Peasant* in color (plate 29) and then in black and white (plate 28). In color, as the watercolor was meant to be seen, it reads as a subtle painterly statement in which the delicate tints are allied with a compositional simplicity to create a powerful image that is monumental despite its diminutive size. In monochrome the monumentality remains but it seems to derive from Cézanne's vigorous delineation of outline. Matisse would talk about how black and white could evoke

30. Paul Cézanne (1839–1906)
*Still Life: Apples, Pears and a Pot
(The Kitchen Table),* 1900–1904
Pencil and watercolor on paper,
11 × 18¾ in.
Musée du Louvre, Paris

31. Paul Cézanne (1839–1906)
Pine and Rocks at the Château Noir,
1900
Pencil and watercolor on paper,
18¼ × 14 in.
The Art Museum, Princeton
University, Princeton, New Jersey;
Anonymous gift

color, but for Cézanne the opposite was also true. The white expanses in a painting such as *Seated Peasant* play off the watercolor marks in much the same way that the white areas in a Matisse drawing interplay with the ink or charcoal lines. What this brings home is the fact that while paintings and drawings are sometimes treated as radically different approaches to representation, in the works of great artists the two disciplines often intersect in marvelous ways. Nowhere is this intersection more apparent than in the watercolors of Cézanne.

Still Life: Apples, Pears and a Pot (The Kitchen Table) (plate 30) has all the economy of a great drawing yet it is also, as Lawrence Gowing has pointed out, a splendid example of how Cézanne could create form by means of color modulations: "The simplest progressions of primary colors are arranged in order: from red through yellow, then from yellow into green and from green to blue. The culminatory point, which is always nearest to the eye, is the violet-blue handle of the saucepan projecting where the color scales converge."[2] Color modulations such as this grew out of Impressionist practice, but as carried out by Cézanne, especially in the late watercolors, they both describe form and—another of the paradoxes that would make his work so fascinating for the Cubists—at the same time seem to dissolve form. This little still life is another example of the way Cézanne united painting and draftsmanship. There is a pencil underpinning, but it was primarily with the brush that the artist did the work of defining the perimeters of the various forms, and these "outlines" are integral with the color modulations that are the primary means of modeling form. Again we see the evidence of Cézanne's famous comment, "Drawing and color are not all that separate."

The truth and ambiguities inherent in this statement are put to the test in watercolors such as *Pine and Rocks at the Château Noir* (plate 31). The viewer's first impression of this painting is that Cézanne has deliberately emphasized strong linear elements in order to create an almost abstract composition. This is perhaps too much a present-day interpretation, however, and there is photographic evidence that proves the artist was actually making a very accurate representation of the scene before him.[3] The space here is shallow, in a way that would appeal to the Cubists, but it is shallow for the wholly practical reason that a wall of rock interrupted the artist's field of vision. In other words, the nature of the subject invited a somewhat two-dimensional approach. Nevertheless, Cézanne—who was never one to oversimplify—used hatched pencil marks and patches of wash to articulate what limited recession there is. There is not quite as much virgin paper in this composition as in some other watercolors of the period, probably because more untouched white would have implied a depth of field that was not there.

Very different in this respect are Cézanne's several watercolor treatments of his most famous landscape motif, Mount Sainte-Victoire (plate 32). In this example the subject is seen from a great distance and from an elevated viewpoint, so that the painting encompasses an immense light-filled space that is suggested in large part by untouched or lightly washed areas. At the same time, this expansive use of the paper support again emphasizes the picture plane and again the image becomes easy to read as dabs of color organized on a flat surface. Even though this interpretation of Cézanne's work was to fascinate younger artists, the artist himself was seeking to express volume—in this instance the receding tracts of landscape—not to dissolve it. Read as Cézanne presumably intended it to be read, this painting is not only a precursor of modernism but also a great summing up of the nineteenth-century landscape tradition, a work that in its elegance, simplicity, and understated grandeur recalls Constable and Jean-Baptiste-Camille Corot, while as a watercolor it can stand beside Turner's greatest sheets.

It is pertinent to compare the ways Cézanne and Turner created their watercolors. Turner began by spreading his washes in broad sheets across the entire surface

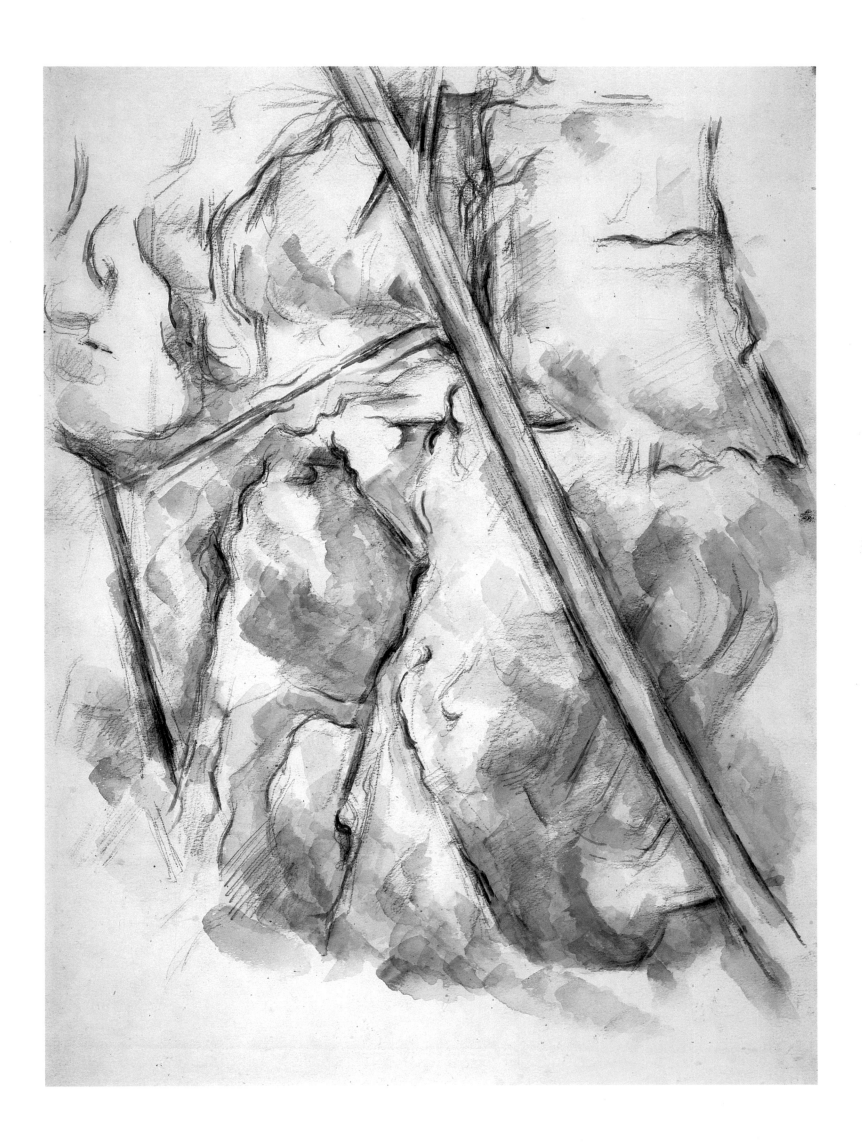

32. Paul Cézanne (1839–1906)
Mount Sainte-Victoire, 1905–6
Watercolor on paper, 14¼ × 21⅝ in.
Tate Gallery, London

of the support, then he would draw into these washes with whatever suited the subject —wet brush, dry brush, sponge, blotting paper, razor blade—so that, through addition or subtraction, form would begin to emerge from the skeins of color. Cézanne, by contrast, began by describing form from the outset, using pencil and brush or brush alone; but he did so in his own enigmatic way, laying down dabs of color that began to activate the white paper surrounding them. In a sense a Turner watercolor could be considered complete soon after he started it: once the tonal and chromatic balance had been established, only the degree of finish remained to be determined, and Turner showed very little interest in detail except when it was needed to guide a printmaker. Cézanne, on the other hand, began by making a record—tentative at first, then more and more confident—of the visual information in front of him, and this information continued to activate greater and greater areas of surrounding whiteness until the entire picture plane was brought to life. At that point, he considered the picture finished, though to the untutored eye it might appear that he had just begun. Ironically, both Cézanne and Turner were accused of producing works that looked incomplete.

A splendid example of everything that is finest and most original in Cézanne's watercolors is *The Bridge of Trois Sautets* (plate 33), one of the last he ever painted. It is possible to see very clearly how this image is activated by the application of hundreds of colored marks and how they bring the untouched white areas to life. The textures of the background vegetation allow Cézanne to use color modulations that, again, both define and dissolve form. The bridge itself is so uncompromising that it enabled the

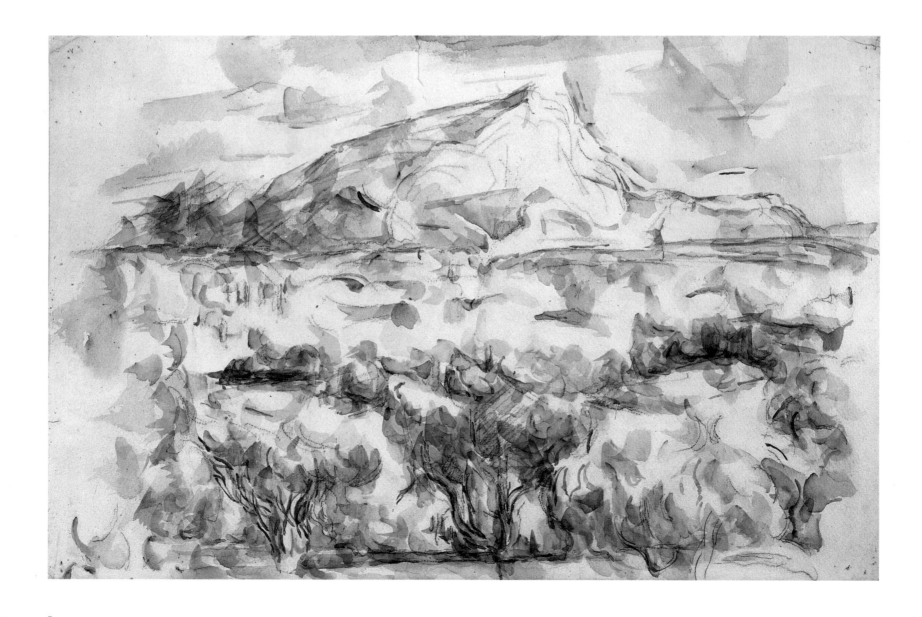

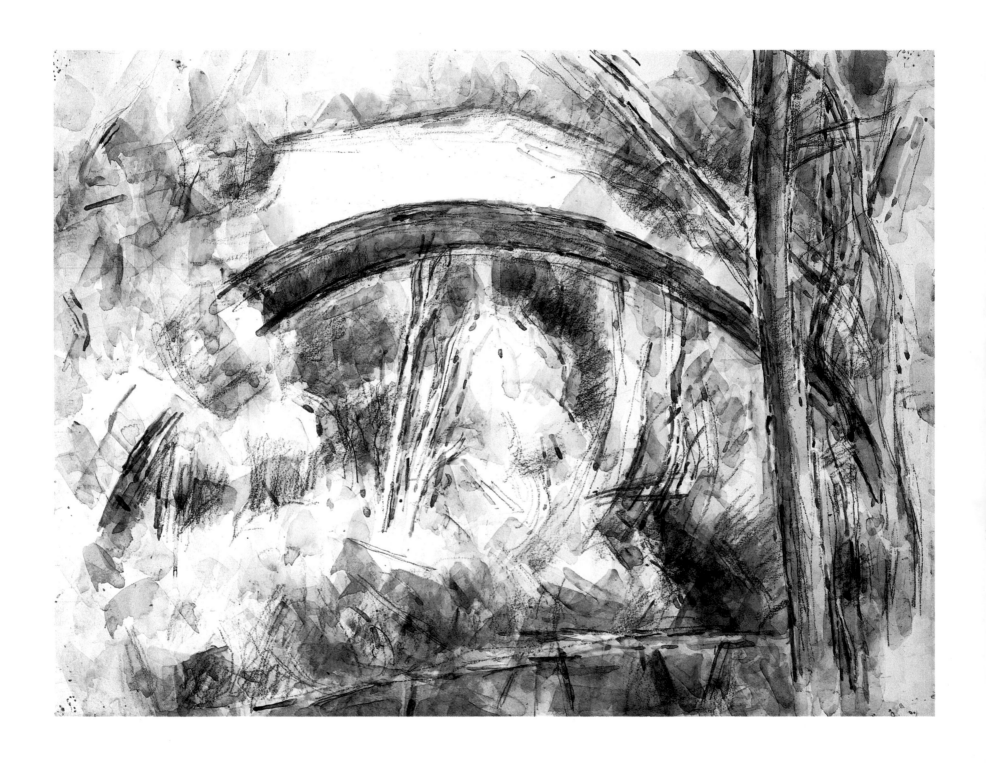

33. Paul Cézanne (1839–1906)
The Bridge of Trois Sautets, 1906
Watercolor and pencil on paper,
16 × 21⅜ in.
Cincinnati Art Museum; Gift of
John J. Emery

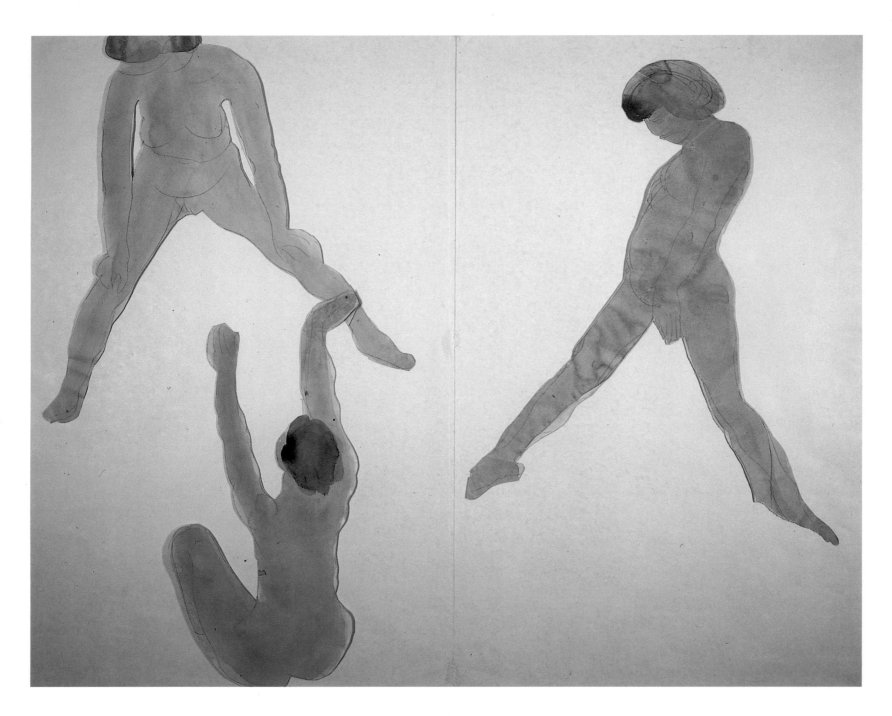

34. Auguste Rodin (1840–1917)
Montage Sheet with Three Cut-Out Figures, c. 1900–1905
Cutouts in pencil and watercolor wash, glued down, 22 × 28¼ in.
Graphic Arts Collection, Princeton University Library, Princeton, New Jersey

artist to build a powerful contrast between its very solid arch and the fragmented planes of the trees. (It should be noted that Cézanne's technique was well able to differentiate between masonry and foliage.) This painting is a fine instance of Cézanne's work at its most architectonic.

Cézanne's late watercolors were occasionally exhibited during his lifetime, in Paris and elsewhere; in the years immediately following his death, they enjoyed considerable visibility. In 1907, for example, seventy-nine were shown at the Galerie Bernheim-Jeune, and a smaller but still significant group was gathered four years later by Edward Steichen and shown by Alfred Stieglitz at the Photo-Secession Gallery in New York. As will be seen, the impact of these watercolors was substantial. During the same period Rodin's late watercolors were also beginning to exert an influence, having been first exhibited in Paris around 1900 before being introduced to America, again by Steichen and Stieglitz, in 1908.

Initially, Rodin's watercolors probably made a greater impression than Cézanne's by virtue of the fact that he was already an immensely famous sculptor. The spare wash drawings that he had begun to make in the 1890s, however, were far more advanced conceptually than anything he ever did in three dimensions. The subject was, as might

be expected, the human figure—generally female, sometimes nude, sometimes clothed, often in poses that relate to dance. Unlike earlier Rodin watercolors, some of which had a Moreau-like quality, these late drawings are remarkable for their extreme simplicity, a simplicity that caused many critics of the day to dismiss them as the casual doodles of a great man who should have known better than to exhibit them outside his studio. These drawings are also remarkable for presenting models in startlingly naturalistic poses, which some observers found shocking. Some of these poses were genuinely erotic, though hardly lascivious, but what seems to have bothered people at the time was their informality. It was as if the artist had asked his model to step down off the pedestal of Victorian propriety and relax—to stretch and bend and twist as she might in the shelter of her own room. It was this seeming invasion of privacy that shocked contemporaries, while firing the imagination of young artists. These were not art school poses and that was troublesome.

Not that this was entirely without precedent. Degas had taken his drawing board into the bathroom, and Henri de Toulouse-Lautrec took his into the brothel; but Rodin added insult to injury by not only presenting his models in casual poses but by doing so without alleviating the shock—without placing them in naturalistic surroundings. (Even a brothel scene could be perceived, by the broad minded, as part of the genre tradition.) There was, of course, a time-honored tradition of depicting the female nude, but implicit in it was the curious moralistic idea that requiring a woman to pose naked could be redeemed by the hard work of producing a highly finished figure painting or sculpture. The privilege of breaking social tabus could be paid for by spending as much time representing landscape and still-life elements as undraped flesh. Rodin's drawings failed to pay these dues. Each appeared to have been done in about five

35. Auguste Rodin (1840–1917)
 Dancing Figure, c. 1900–1905
 Pencil and watercolor wash on paper,
 12⅞ × 9⅞ in.
 National Gallery of Art, Washington,
 D.C.; Gift of Mrs. John W. Simpson

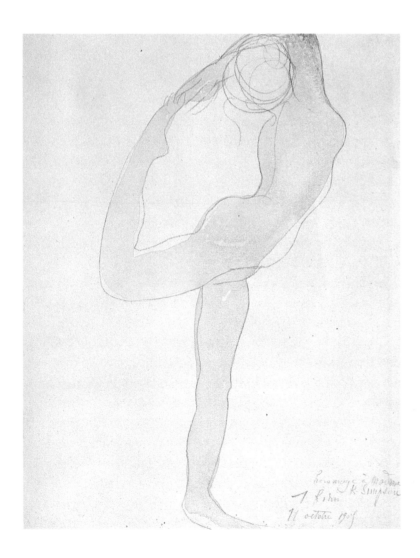

36. Auguste Rodin (1840–1917)
Cambodian Girl Dancing, 1906
Pencil, watercolor, and gouache on
cream paper, 11¾ × 7¾ in.
Musée Rodin, Paris

minutes, and they hinted at a dangerous precedent—namely, that making them might have been a very pleasurable experience.

Unlike Cézanne, Rodin was a virtuoso draftsman in the conventional sense, one of the greatest of his generation. In these late wash drawings he reduced outline to the most elliptical of statements based on decades of experience, statements in which musculature is perfectly expressed in a line that barely ripples to describe the way a thigh melts into a hip, with a mastery of foreshortening so complete and so casual that the struggles of Andrea Mantegna seem not merely centuries but eons in the past. But, like Cézanne, Rodin did not, at this point in his career, seem to trust the outline entirely. When he added a colored wash to a figure it would edge up to the outline but not quite touch it or else spill over onto the background so that the pigment, while suggesting volume, also creates a secondary silhouette, which is sometimes at odds with the pencil description of the figure. This has the effect of encouraging the viewer to read the wash areas as abstract patches of color, and the way the image is isolated against blank white paper furthers this reading. The more these works are studied, the more it becomes apparent that they belong wholly to the modern age.

The three figures montaged onto the Princeton sheet (plate 34) show Rodin's draftsmanship at its most sparely brilliant. In this case the artist has cut out the figures and rearranged them on a fresh piece of paper so that they seem to interact. The effect is that of a frozen moment in a dance with three participants, and if we think of Matisse's variations on the theme of dancers, made just a few years later, a relationship between the two artists becomes clear. *Dancing Figure* (plate 35) makes it even more obvious what Matisse learned from Rodin's wash drawings: lessons regarding not only economy of line and directness of statement but also related to pose and placement.

Early in the twentieth century a Cambodian dance troupe visited Paris, and Rodin made numerous pencil and wash drawings of members of the company. Some of

these are very similar in style to the drawings already discussed, while others, such as *Cambodian Girl Dancing* (plate 36), are less concerned with outline and depend more on an almost scribblelike calligraphy that transcribes amazingly well both volume and the movement of costume. Again the relationship between the pencil marks and the economically applied patches of colored wash is what brings the entire thing to life. It is as if Rodin has laid one form of description over another, creating with the slenderest of means an ambiguity that has the ability to bring the figure to life in a way that an unambiguous academic drawing could never hope to do.

In addition to the direct influence that these drawings had on Matisse, they also had a powerful impact on other Europeans such as Gustav Klimt and Egon Schiele, as well as on many Americans, including Charles Demuth. It is impossible to suppose that anyone dealing in an original way with the human presence did not pay close attention to Rodin's achievement. Oskar Kokoschka's watercolor figures may well have benefited

37. Pablo Picasso (1881–1973)
 Seated Woman Reading, c. 1899
 Watercolor on paper, 7½ × 5½ in.
 Museo Picasso, Barcelona

from this example and, while there is no question that Cézanne was the crucial influence, it seems likely that Picasso learned much as a draftsman from Rodin.

Picasso himself was living in Barcelona at the turn of the century and making paintings that were precociously accomplished but not yet particularly advanced. He made frequent use of watercolor, as he would continue to do throughout his career, and at this time his work in the medium was even more conservative than his work in oils. *Seated Woman Reading* (plate 37) is a completely straightforward treatment of a traditional genre scene, untouched even by the influence of Lautrec, who would soon open the young Spaniard's eyes to a new world of possibilities. The only thing here that points to the future is the artist's obvious facility.

Much of Picasso's work from the Barcelona period has a distinctly illustrational slant, and in fact many of the artists who would make their mark as the century progressed began their careers by supporting themselves as illustrators, an activity that often required a working knowledge of watercolor. Jacques Villon was one of those who had a successful career working for newspapers and magazines. His *Elderly Couple* (plate **38**), freely executed in watercolor and pencil, displays an almost Daumier-like

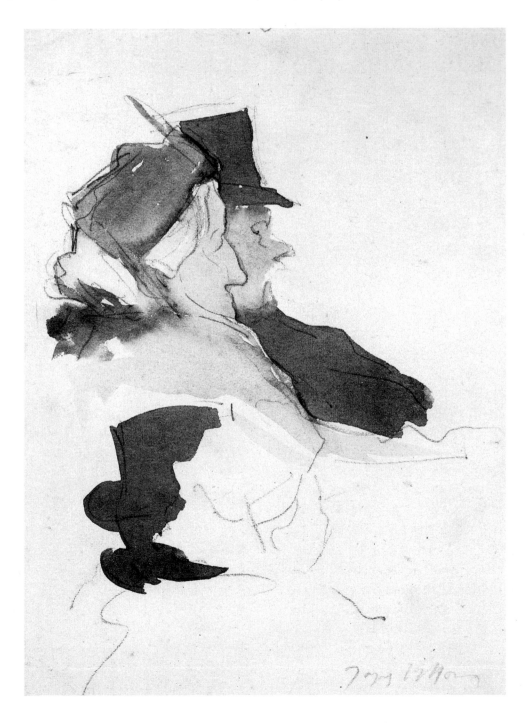

touch, a characteristic that would soon dissolve into the delicate geometries of Villon's mature style (plate 139).

One of the chief architects of modern art, Piet Mondrian, spent the early years of the twentieth century working in realist and Symbolist idioms before slowly making his way toward a theory of abstraction that was rigid in its principles and (in his own hands, anyway) flexible in their application. At first a drawing such as *Amstel River* (plate 39) seems to have very little relationship to later masterpieces in oil such as *Broadway Boogie-Woogie,* yet the powerful sense of structure that underlies *Amstel River* offers a hint of what is to come. A remarkably handsome work, it already has the authority of the mature artist.

The distance that some artists had to travel can be illustrated even more clearly by František Kupka's painting *The Wave* (plate 40). Kupka would become a standard-bearer of nonfigurative art (see chapter 5), but at the turn of the century he was active in what might be dubbed, in retrospect, the precisionist wing of the Symbolist movement. The watercolor and gouache technique employed here is one that Meissonier would have felt completely at ease with, while the image of the crouching woman about to be overtaken by an ocean swell resonates with the prurience of the time. Yet underlying this faintly absurd image is a concern with art as an expression of psychological and spiritual states, a concern that would persist throughout Kupka's long years of exploring abstraction.

At this early stage in his career, Kupka was capable of something as outlandish as *View from a Carriage Window* (plate 41), a late example of the Victorian obsession with realism for its own sake overlaid with a fashionable touch of fin-de-siècle deca-

39. Piet Mondrian (1872–1944)
Amstel River, 1907
Watercolor on paper, 27⅛ × 43¼ in.
Collection, The Museum of Modern Art, New York; Fractional gift of Sheldon Solow

40. František Kupka (1871–1957)
The Wave, 1902
Watercolor and gouache on paper,
16⅛ × 19⅝ in.
National Gallery, Prague

dence. The fact that this could be perpetrated by someone who would go on to play a significant role in the evolution of modern art is indicative of the rapid transformations that were occurring within the art world, especially in Western Europe, at the turn of the century. From our own standpoint—given the present acceptance of novelty for its own sake—it is difficult to fully comprehend a time when the great innovators were reviled by all but a few disciples.

In 1900 the academic establishment appeared to be a monolith, though in fact it was riddled with fractures and fissures and would crumble far more rapidly than even the most optimistic revolutionary could have imagined. The great shock waves of Fauvism, Cubism, abstraction, and Dada had not yet struck, but the establishment was already thoroughly undermined, and some of the greatest damage had been inflicted by artists such as Cézanne, who advanced their cause significantly by means of that most innocent-seeming of media, watercolor.

41. František Kupka (1871–1957)
View from a Carriage Window, 1901
Gouache and watercolor with
cardboard cutout overlay on paper,
19⅞ × 23⅝ in.
Collection, The Museum of Modern
Art, New York; The Joan and Lester
Avnet Collection

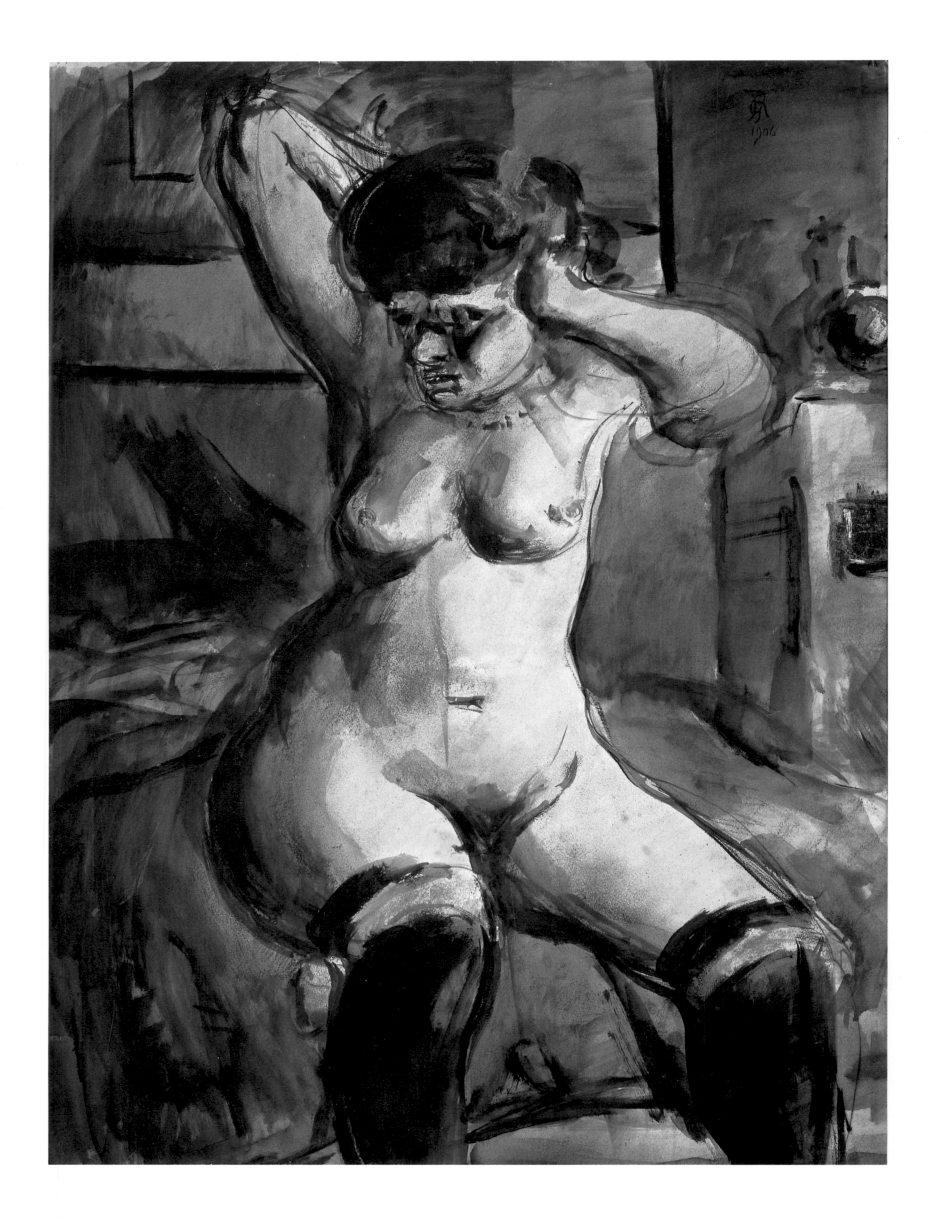

CHAPTER TWO
THE NEW SPIRIT

Art historians sometimes set themselves the task—which can be amusing, stimulating, or merely frustrating according to temperament—of defining the moment, or the continuum of moments, when "Modern Art" came into being. This is not the place to reconsider that particular conundrum, but it is relevant to note that there was a radical change in intellectual attitude between the last wave of nineteenth-century pioneers—Cézanne, van Gogh, Gauguin, and the rest—and the first generation of young Turks to come to maturity in the twentieth century. This break resulted in a frenzy of experimental activity that would sweep Europe from Paris to Moscow before the first decade of the century was over, and that would infiltrate the New World not long after. This shift in attitude was expressed by the artists themselves in phrases such as l'Esprit Nouveau (the new spirit). In part it owed its existence to the fact that the century was turning, which encouraged fresh beginnings, and it certainly capitalized upon the fact that such inventions as radio, film, the automobile, and the airplane heralded a new age that was at once exciting and rather frightening.

Through at least the last three quarters of the nineteenth century there was a clear continuity of vision from one generation of innovators to the next, from realists such as Constable, Corot, and Gustave Courbet to proto-Impressionists such as Boudin, on to Manet and the Impressionists proper, and from Impressionism to the various branches of Post-Impressionism. The continuity was not always clear, of course, but the historian has no difficulty tracing it now. Each generation, or half-generation, seemed to take note of its predecessors' achievements and then proceed to build on them. To give a single example: Georges Seurat looked carefully at the color experiments of his Impressionist forebears and then, in accordance with his personal classicizing bent and quasiscientific theories, he formalized them into the system known as Pointillism or Divisionism. The point is that the step was logical, almost excessively so in Seurat's case. When he looked, in the 1880s, at a canvas painted a decade earlier by Monet, for instance, he saw very much what Monet had seen when he made the painting. Seurat did not wish to repeat Monet's achievement but he did want to carry forward principles that he saw embodied in Monet's work.

If we turn to Cézanne, the relationship of his work to that of his Impressionist predecessors is less clear-cut; yet the way he built form with color in his mature work indicates how thoroughly he had absorbed the example of Renoir. Once again, we may be reasonably sure that when looking at a still life by Renoir, Cézanne saw much what Renoir himself had seen. There is reason to suppose, however, that when Matisse or Picasso looked at a canvas by Cézanne, they saw something quite different from what

he had seen. There was a break in the continuity—perhaps because Cézanne was so searching and ambitious an artist that he intuitively posed problems he had no time to answer, perhaps because the next generation was looking for springboards that would carry them beyond the boundaries of realism, however radical. To pursue this single example (because Cézanne was so great a watercolorist and because his watercolors were among his most advanced and stimulating works): Cézanne saw all his efforts as being engaged in convincingly defining space, form, and volume. Many of his young admirers, on the other hand, took it as his greatest achievement that he had evolved a technique that permitted an artist to *dissolve* space, form, and volume.

The artists who came to prominence in the decade or so before World War I were ready to acknowledge the enormous lessons they had learned from their great predecessors—Cézanne in particular—but they were also eager to break the continuum. In one important sense, in fact, they had already made this break simply by perceiving in the work of their predecessors qualities that the authors themselves had not perceived.

Certainly this is apparent in the early career of Henri Matisse. By 1905, when he became notorious as the leader of the Fauves, he had absorbed the color lessons of his teacher, Moreau, and had revamped for his own purposes the theories of the Symbolists, for whom antinaturalistic color held the promise of an art that would go beyond realism toward a more universal and spiritual experience. Matisse had also experimented with Divisionist techniques, refined during the summer of 1904, when he worked in the south of France with Paul Signac, Seurat's principal disciple. Matisse's

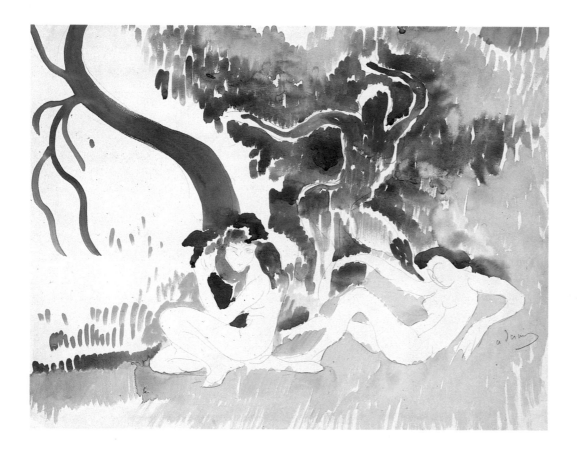

achievement as a watercolorist during this period is well illustrated by *Harbor of Collioure* (plate 43), a spare work, almost Oriental in its economy, that makes confident use of pure color against a white ground. It is an advanced work for the time, but not that far removed from the spirit of Signac's watercolors. In this little sketch the continuity with advanced nineteenth-century art is still intact. That would change over the next year or two, but unfortunately Matisse made relatively few watercolors during this period. It may be that a growing emphasis on the juxtapositioning of areas of intense color made watercolor an unsuitable medium for his experiments.

Matisse was the most gifted of the Fauves but that he was not working entirely alone is obvious from the versions of *Bacchic Dance* (plates 44, 45) painted by André Derain in the year immediately following the Fauves' first success at the Salon d'Automne of 1905. Ten years his junior, Derain had met Matisse at the van Gogh exhibition held at the Galerie Bernheim-Jeune in 1901. They discovered that they shared many ideas, including the suspicion that the pursuit of realism for its own sake had outlived its usefulness. In 1905 they spent most of the summer together, at Collioure on the Mediterranean, and working side by side they pushed each other toward new frontiers. Derain began to talk of "color for color's sake," and before the year was out he was at work on ambitious canvases such as *The Golden Age* and *The Dance,* in which Arcadian themes looking back to some mythical past were wed to radical concepts of color and pattern that pointed to the future. The *Bacchic Dance* watercolors—though relatively subdued in palette, because of the character of the medium—belong to this group of works. It is easy enough to see that Matisse may have drawn some inspiration from them when he turned to similar themes, although his vision has a more measured, fully realized quality even in his most casual watercolors.

Closely allied with Derain (and hence with Matisse) was Maurice de Vlaminck. Both were large, very physical men, but in other ways the two friends could not have been more different. Derain was from a middle-class family, had undergone conventional academic training, and was fond—perhaps overly fond—of philosophical and art-historical discourse. Vlaminck, on the other hand, had a blue-collar background and supported

44. André Derain (1880–1954)
 Bacchic Dance, 1906
 Watercolor on paper, 19½ × 25½ in.
 Collection, The Museum of Modern
 Art, New York; Gift of
 Abby Aldrich Rockefeller

45. André Derain (1880–1954)
 Bacchic Dance, c. 1905–7
 Watercolor on paper, 19 × 25 in.
 Victoria and Albert Museum, London

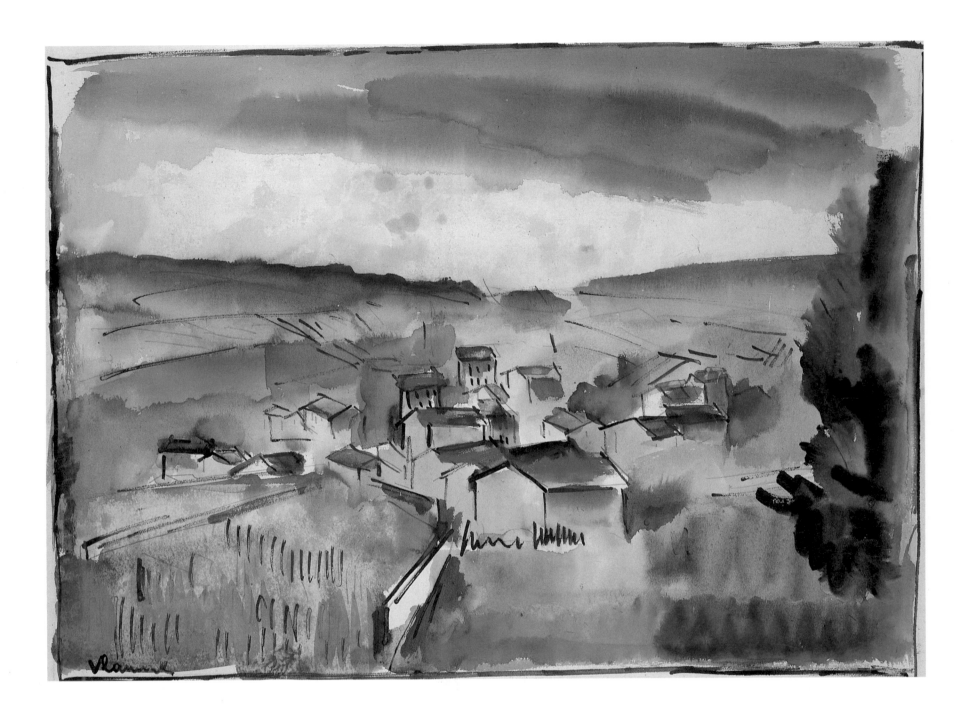

46. Maurice de Vlaminck (1876–1958)
 Southern Landscape with Village,
 c. 1919
 Pencil, ink, and watercolor on paper,
 14⅜ × 19 in.
 Graphische Sammlung, Staatsgalerie
 Stuttgart, Stuttgart, West Germany

his family by means as varied as professional bicycle racing and writing semipornographic novels. In contrast with Derain, he despised theory and boasted that he never set foot in the Louvre. His sometimes philistine attitudes may have prevented his art from reaching its full potential, but his lack of respect for conventions may also have contributed much to making his work a primary factor in the Fauve movement. In his oils of the period Vlaminck followed van Gogh's example and used an almost raw palette that emphasized primary colors along with the Dutchman's trademark oranges. In Vlaminck's watercolors this palette became somewhat more subdued. *Southern Landscape with Village* (plate 46) shows both the strengths and limitations of his art. The scene is set down with an unfussy directness that is decidedly refreshing. Instinctively Vlaminck obeyed the canons of early twentieth-century modernism, but we do not sense, as in Derain and especially in Matisse, that the artist has struggled with fundamental issues of representation and plastic integrity. Rather, the work elicits an intuitive and emotional response that links Vlaminck as closely to Northern Expressionists such as Erich Heckel and Karl Schmidt-Rottluff as to his Gallic contemporaries.

Raoul Dufy's contribution to Fauvism, though early, was not as crucial as that of

the three artists considered so far in this chapter, and he was to become the painter most guilty of reducing Fauvist innovations to an agreeable decorative formula (see chapter 8). At his best, however, Dufy was capable of strong work, and he possessed an especially felicitous touch with watercolor, as is apparent in *Pear Blossoms in Normandy* (plate 47). Dufy's brushwork here is very sure, and this sheet demonstrates his highly personal way of conjuring up an image by means of superimposing layers of transparent calligraphy. In *The Opera, Paris* (plate 48), Dufy's calligraphy once again pulls together many different elements. He has chosen an angle from which the stage itself cannot be seen—it is concealed by the column at left—so that the auditorium becomes the scene of the drama and the audience provides the players (though from this distance they are merely extras).

Dufy's work brings up the point that when discussing works in a specific medium, such as watercolor, the established chronology of art history does not always hold up. Dufy's most significant contributions to the art of our century were made at the outset of his career, roughly in the years 1905–8, and because of this it is natural to group him with Fauves such as Derain and Vlaminck. But it was at a later stage of his career that

47. Raoul Dufy (1877–1953)
Pear Blossoms in Normandy, c. 1932
Watercolor on paper, 20 × 25⅝ in.
Musée National d'Art Moderne,
Centre Georges Pompidou, Paris

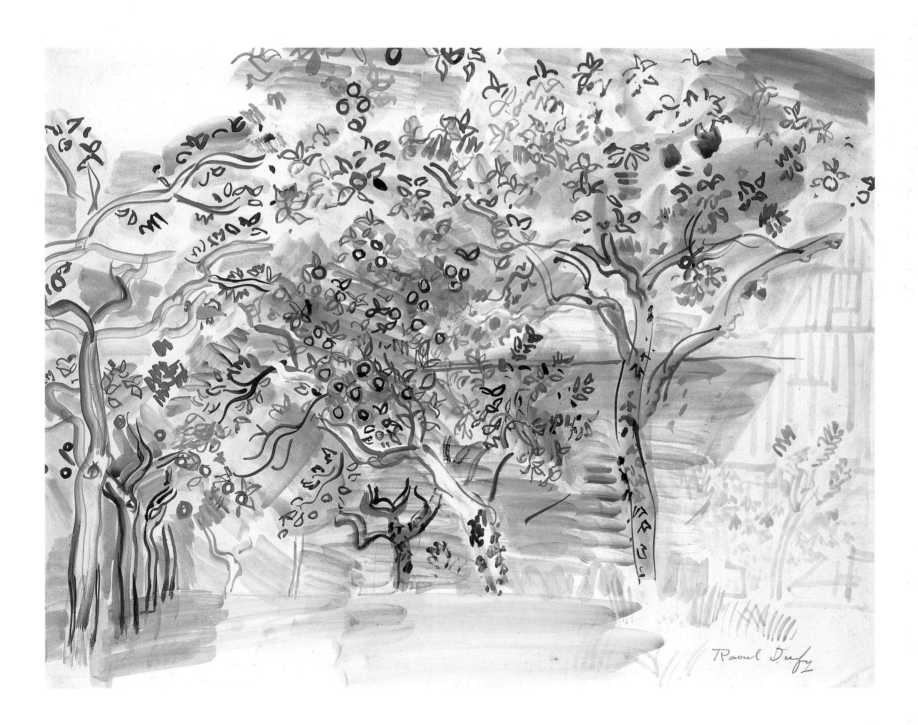

Dufy excelled as a watercolorist, and indeed, he continued to produce handsome watercolors until he was crippled in old age by arthritis. Even when these bear dates from the 1940s and 1950s, however, they belong in spirit to the first decade of the century since, unlike Matisse, Dufy was not an artist to embark on daring voyages of aesthetic adventure.

Much the same might be said about André Dunoyer de Segonzac, who never adhered to any movement but developed a style that, while relatively conservative, was firmly based on the experiments carried out in Paris during the early years of the century. Segonzac is often to be seen at his best in his watercolors, which display a freshness that is found less frequently in his oils. *Young Girl with Red Umbrella* (plate 49) has been loosely drawn in pencil, with color added quickly and boldly. The overall effect is casual but Segonzac had an undeniable gift for exploiting the medium in a way that acknowledged both traditional values and new aspirations.

A very different and much greater artist was Georges Rouault, who studied under Moreau along with Matisse and participated with the Fauves in the 1905 Salon d'Automne. Rouault displayed as much expressionistic vigor as Vlaminck and as bold a

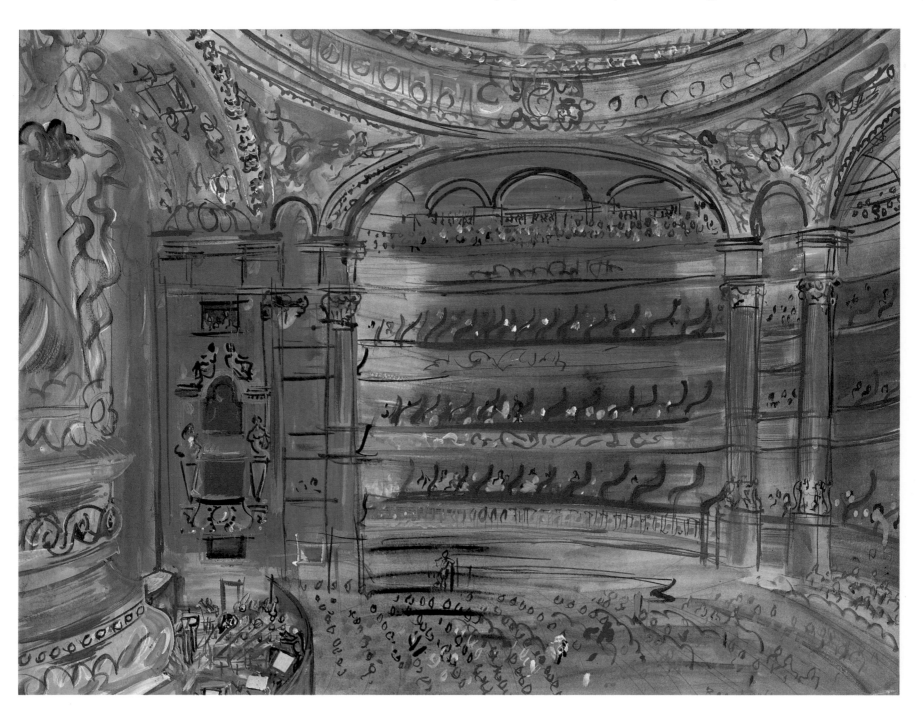

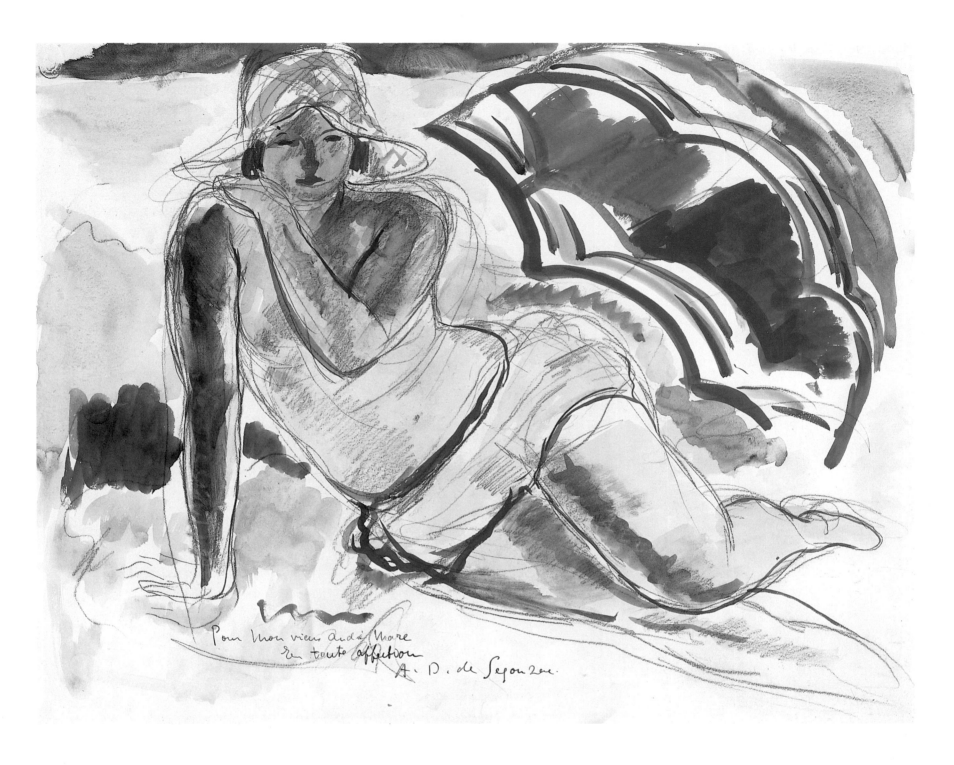

49. André Dunoyer de Segonzac
(1884–1974)
Young Girl with Red Umbrella, 1925
Pencil and watercolor on paper,
18¼ × 24 in.
The Brooklyn Museum;
Henry L. Batterman Fund

sense of color as Derain, yet he cannot be counted a true Fauve because he was in fact pursuing his own ends, aiming for an art that addressed religious matters (or matters of religious doubt) through the least likely of means and subject matter. By turning an unblinking but sympathetic eye on characters such as prostitutes and clowns, he hoped to transcend the dead weight of the flesh and achieve, or at least point to, some kind of spiritual redemption.

Girl (plate 42) is typical of the work that Rouault was doing early in the century. The figure of the prostitute is strongly drawn, and washes have been skillfully applied to create solidity and volume. (In the latter respect Rouault's work differs greatly from that of Matisse.) Superficially the subject seems to derive from Degas and Lautrec, yet the treatment is quite different. There is none of Degas's apparent detachment, none of Lautrec's worldliness. Rouault's viewpoint is that of the zealot who seeks to scourge the flesh—not only his own, but that of all mankind—in order to achieve redemption. His prostitutes horrified contemporary viewers, and they remain powerful statements today. The present example, as she fixes her hair, strikes the conventional pose of the

50. Georges Rouault (1871–1958)
Group of Rustics, 1911
Watercolor and gouache on paper,
22⅛ × 18 in.
Norton Gallery of Art,
West Palm Beach, Florida

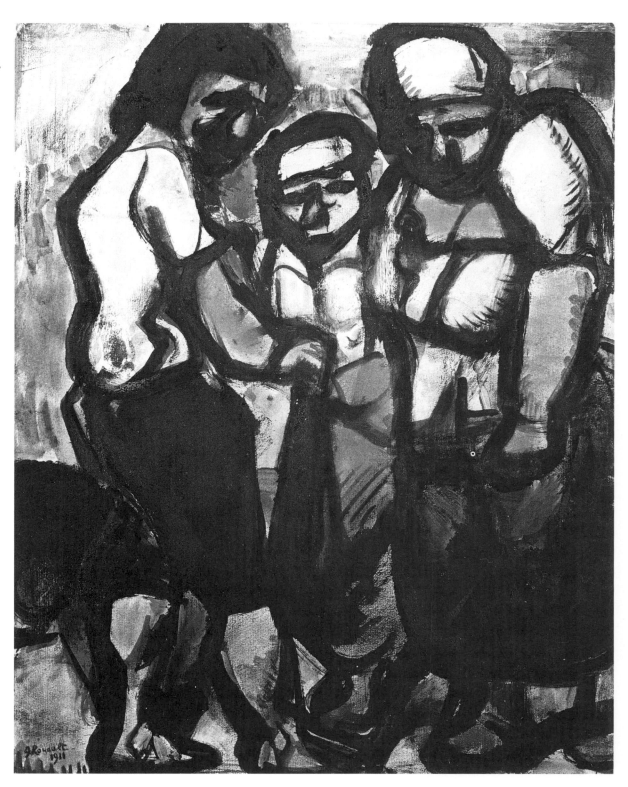

coquette, but her body is that of a peasant. This is no sentimental portrait of some conventional whore with a heart of gold. At the same time, Rouault was honest enough not to excise lust entirely from his vision, and it is this honesty that gives his work its special strength.

As an adolescent Rouault had spent some time apprenticed to a stained-glass craftsman, and in later watercolors and gouaches such as *Group of Rustics* (plate 50) he often achieved a stained glass–like style, in which black or blue-black outlines were used to enclose areas of pigment that display an iridescence which sometimes recalls Moreau's palette. Often the subject matter of these works brings Daumier to mind, but Rouault's paintings—even when they hark back to such ancient techniques as stained glass—are always of the twentieth century, both in their directness and, as his work matured, in their handling of color and space.

Rouault used both watercolor and gouache extensively throughout his career, often displaying a kind of casual virtuosity that is characteristic of some of the greatest exponents of these media. He understood very well the value of the bold, painterly gesture: of taking a brush that might have appeared too broad and too loaded with pigment for the task at hand and using it to make a mark that would define at once edge, cast shadow, and volume. This skill was well suited to the aims of modernism, though it was in fact one that had served watercolorists well ever since the days of J. R. Cozens.

On casual consideration it would seem that no two artists could have less in common than Rouault and Jules Pascin. Born in Bulgaria, Pascin came to Paris as a young man and took easily to the life of the boulevards. He is reputed to have made and lost several fortunes and seems to have been equally at home in the glittering salons of the

51. Jules Pascin (1885–1930)
Women Dressing, n.d.
Ink, graphite, pastel, and watercolor
on paper, 10⅞ × 12¼ in. (sight)
Columbus Museum of Art, Columbus,
Ohio; Gift of Ferdinand Howald

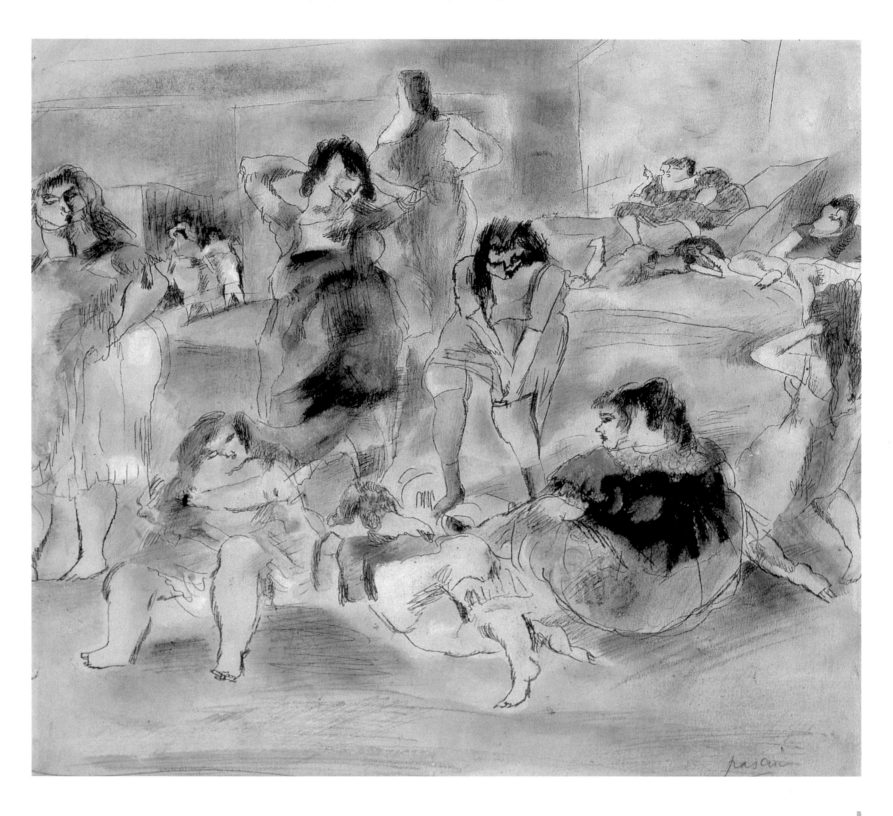

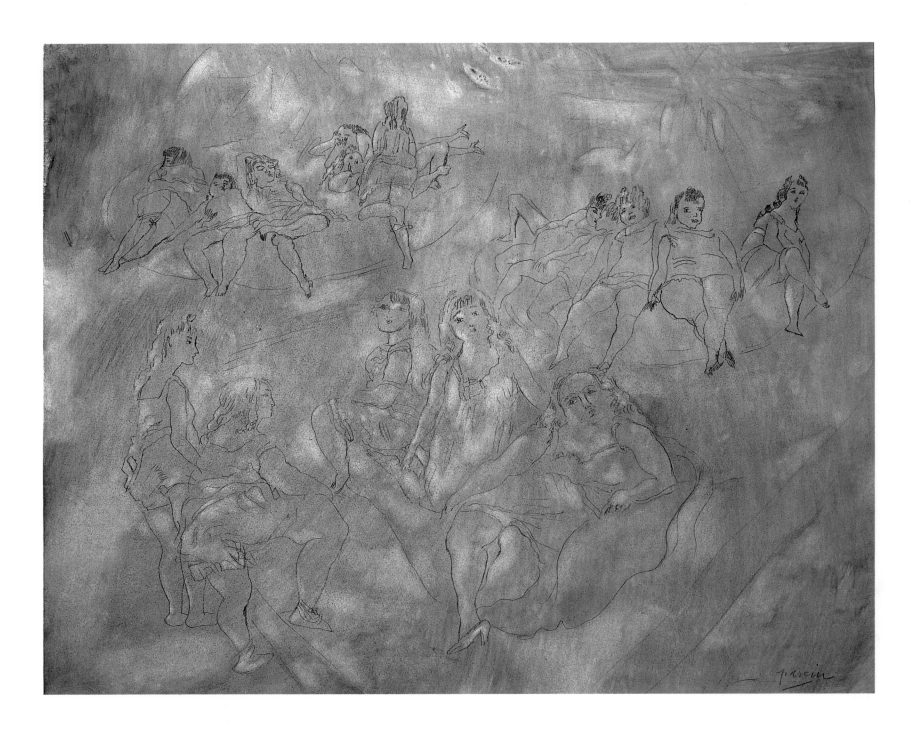

52. Jules Pascin (1885–1930)
 "Salon" at Marseilles, c. 1929
 Ink wash, pen and ink, and pencil on
 paper, 17⅞ × 22⅜ in.
 Hirshhorn Museum and Sculpture
 Garden, Smithsonian Institution,
 Washington, D.C.; Gift of
 Joseph H. Hirshhorn, 1972

avenue Foch and in the red-light district of the rue Blondel. Famous for his erotic paintings of female nudes, he has been taken for a decadent, and yet his was not an untroubled hedonism but rather one with which Baudelaire might have identified. Pascin was a sensualist whose pleasures were always tempered by angst, a lover of good company who always seemed to be at odds with the world. Friends were not entirely surprised when he killed himself in his Montmartre studio.

Suicide is, of course, the ultimate mortification of the flesh, and it quickly becomes clear, as one studies his work, that Pascin had more in common with Rouault than is initially apparent. They shared an interest in portraying prostitutes, of course, and certainly Pascin did bring to this subject some of Lautrec's knowingness, but at the same time his vision was in some ways as moralistic as Rouault's. Certainly his brothel scenes, such as *Women Dressing* and *"Salon" at Marseilles* (plates 51, 52), are not exactly celebrations of the demimonde but in fact portray a world populated by grotesques and lost souls. On occasion Pascin portrayed nudes of great beauty, but he was also capable of investing his prostitutes with all the human failings that we expect to find in Rouault's work. Even Pascin's most gentle nudes are suffused with a sense of mortality.

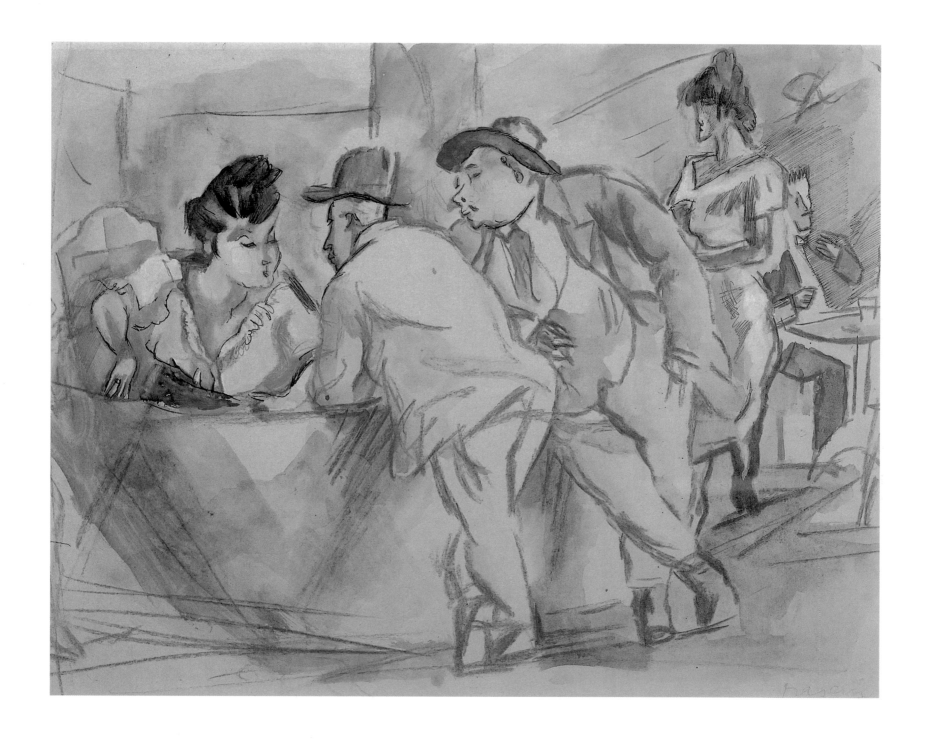

53. Jules Pascin (1885–1930)
Lunch Room, c. 1917
Charcoal, ink, and watercolor on
paper, 9⅝ × 12⅝ in. (sight)
Columbus Museum of Art, Columbus,
Ohio; Gift of Ferdinand Howald

Technically, the two brothel scenes reproduced here are tours de force. In both examples line does much of the work, but the use of washes to express form and delineate space is extremely skillful, especially in *"Salon,"* where freely employed washes bring the entire picture plane to life. Except for highlights and accents, Pascin seldom confined his washes within the linear structure but rather let them overflow borders, thus dissolving space in a thoroughly modern way. It was a technique that was influenced by Rodin and that in turn would influence other artists, including Charles Demuth, who came to know Pascin in the course of the latter's extended stay in New York (during which Pascin actually took out U.S. citizenship). Pascin studied the social scene in New York as assiduously as he had in Paris, and *Lunch Room* (plate 53) is one of the products of his observation.

Something else links Pascin and Rouault: both were very much products of the School of Paris, sharing a certain respect for their materials and for the well-made painting, however informal or crude certain of their works might seem at first glance.

54. Amedeo Modigliani (1884–1920)
Caryatid, 1914–15
Watercolor over pen and ink
and pastel crayons on paper,
11¼ × 9½ in.
Musée National d'Art Moderne de la
Ville de Paris

OPPOSITE
55. Constantin Brancusi (1876–1957)
Reclining Head (The First Cry), 1915
Gouache and pencil on paper,
15 × 21 in.
Hirshhorn Museum and Sculpture
Garden, Smithsonian Institution,
Washington, D.C.; Gift of Joseph H.
Hirshhorn, 1972

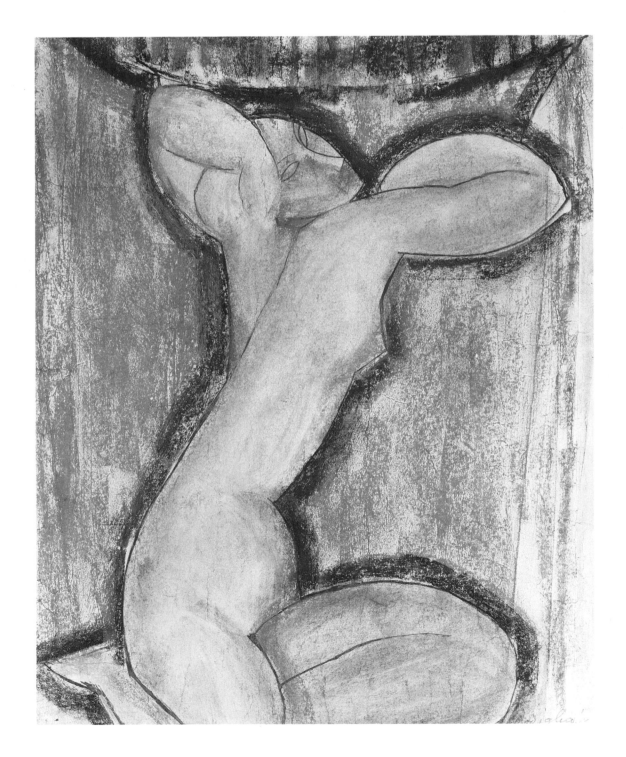

The same might be said of Amedeo Modigliani, who was born in Leghorn, Italy, but whose art was primarily a product of the Parisian art world that attracted so many foreigners. As a painter Modigliani developed a style that did not translate well into watercolor, but he sometimes used watercolor or gouache in his studies for sculptures. Many of these, such as *Caryatid* (plate 54), have a monumental strength allied to a simplicity of form that is reminiscent of Matisse.

The greatest sculptor of the period, the Romanian Constantin Brancusi, used gouache often and with considerable vigor. *Reclining Head (The First Cry)* (plate 55) is not so much a study *for* a sculpture as a study *of* a sculpture. Executed with marvelous economy and authority, it anticipates in mood the still lifes of Giorgio Morandi. Brancusi's *View of the Artist's Studio* (plate 56) is not as startling a work as Matisse's *The Red Studio,* but it is a powerful composition that describes the contents of the studio within the conventions of advanced Parisian art. By the time this gouache was made, those conventions had been established for a decade or more. Watercolor had played a small but significant role in establishing them, and it would continue to play a role in some later developments within the School of Paris (see chapter 8), but in these early years of the twentieth century the greatest flowering of the medium was to take place in Germany, Austria, and Northern Europe.

56. Constantin Brancusi (1876–1957)
View of the Artist's Studio, 1918
Gouache and pencil on paper,
13 × 16¼ in.
Collection, The Museum of Modern Art, New York; The Joan and Lester Avnet Collection

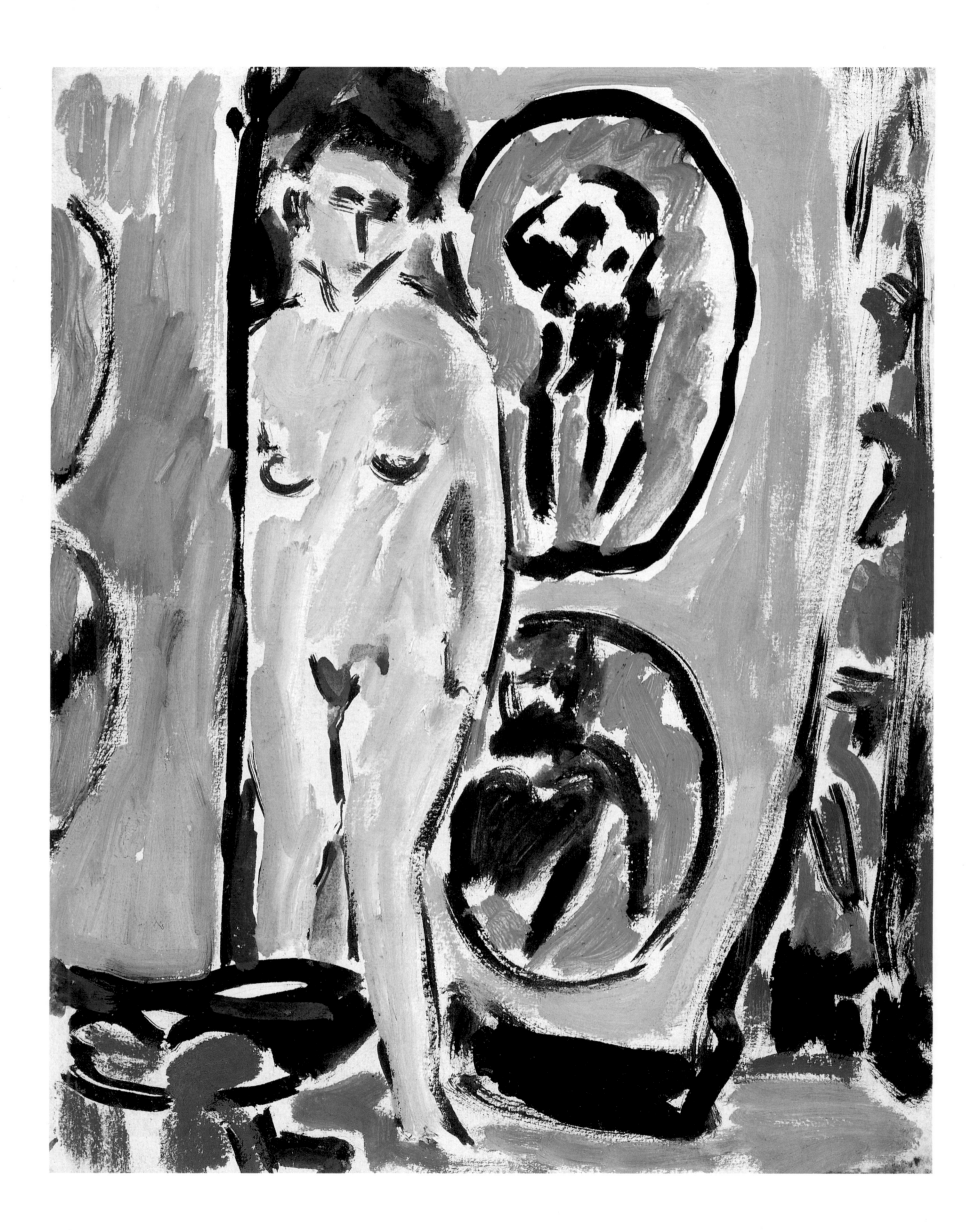

If there was one dominant idea underlying most advanced European art at the turn of the century, it was the notion that it was possible—even necessary—for painting to transcend realism. In a sense this had been implicit even in the work of the Impressionists. Although in certain ways they were dedicated realists, their system of fragmenting light into flecks of color had the effect of setting color free on the canvas, and this in turn led to the theory that color could be expressive in its own right. And if color could have an expressive function, then why not pattern? Why not line?

For Gauguin and his followers, and for the Symbolists in general, it was the expressive power of color and pattern that was dominant. In the work of van Gogh, on the other hand, the expressive use of color and pattern was matched by the expressive exaggeration of line. (His method of applying color was linear, and to appreciate his mastery of line one need only look at his black and white drawings.) Like the Art Nouveau designers, van Gogh used linear exaggeration to generate pattern—having learned the lesson of Japanese prints well enough—but he also used it to generate forms that were expressive in their own right, as opposed to being expressive as design elements. This was not entirely new to Western art, of course. Such linear exaggeration can be found in the work of El Greco and of Mannerists such as Parmigianino; it has also been the basis of caricature throughout the ages. Van Gogh went far beyond these traditions by using linear exaggeration, as well as color and pattern, to express his own state of mind.

Gauguin also used color and pattern to express psychological states, but in a less subjective way. For all his exotic subject matter and assumed primitivism, Gauguin was always bound, at some deep level, by the traditions of French art, and these traditions, which even radicals could not shed entirely, have a strong classical underpinning. Gauguin, like most French Symbolists, filtered the expression of psychological states through a sieve of aesthetics. Van Gogh was not innocent of aesthetic theory, but he had a way of riding roughshod over it. For him, the expression of psychological states quickly became self-expression—the objectification of his own psychological states—and it was this phenomenon that came to be known as Expressionism.

In the decade following van Gogh's death, Expressionism was given new impetus by another major figure who was struggling to give form to his own melancholic psychology. The son of a Norwegian doctor, Edvard Munch was raised in Christiania (now Oslo) and was soon exposed to the advantages and disadvantages of making an artistic career in a provincial center. It is relatively easy to make one's mark there, but one is also subject to the strictures of provincial taste. Munch never suffered the neglect

that was van Gogh's lot, but he was the subject of scandal, almost from the outset of his career, and felt isolated among the bourgeoisie of Norway. That sense of isolation was heightened by long years of self-imposed exile in France and Germany, where he found people more sympathetic to his work, but where he remained nonetheless an outsider, always aware of his dependence upon his Norwegian roots.

If Expressionism is concerned with self-expression, then Munch is the quintessential Expressionist, since his work is highly autobiographical. Just as the figures in many of his paintings are reflections of his own sometimes tormented mental state, so are his landscapes and cityscapes embodiments of his own experience. And by exaggerating line and form in portraying the fiords of Norway and the streets of Christiania—often silhouetted against the pale skies of Scandinavia's long summer nights—Munch gave these scenes a psychic dimension that landscape had never possessed before.

From 1893, the year he painted *The Scream,* to 1908, when he suffered a debilitating breakdown, Munch produced a succession of remarkable images in a variety of media. In *The Empty Cross* (plate 58), Munch's art is seen at its rawest. A monklike figure, taken to represent the artist, turns his back on an empty cross, a setting sun, and scenes of debauchery. The symbolism could not be more straightforward, and Munch even amplified it in a commentary describing a time when God was overthrown and "everyone raced about in an insane dance of life."[4] The watercolor reproduced here, one of several related to the same subject, shows how the medium—in this case allied

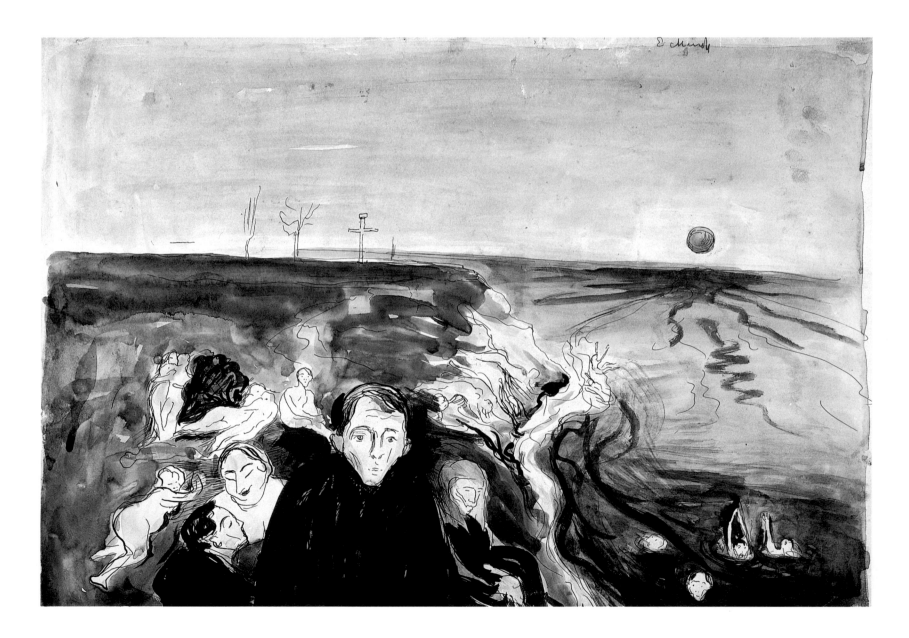

to pen and ink—satisfied the needs of an artist who sought a very direct way of setting down his inner states. In some ways this is little more than a scribble, yet it conveys with great immediacy the artist's ideas and emotions—indeed, it goes beyond that. It is almost as if the viewer were given access to Munch's subconscious. The very fact that it is so rough and unfinished makes the work even more poignant. Dividing the landscape portion of *The Empty Cross* into land and sea is a white cliff. At first glance, it seems crudely drawn, but closer inspection reveals it to be made up of human figures who are metamorphosed into rock even as they seem to tumble from the clifftop to the water's edge. This is an unusually overt example of the way Munch charged landscape with human significance.

Standing Blue Nude (plate 59), a relatively late effort, demonstrates that Munch could handle watercolor with great economy when he chose to. Here the figure is evoked with fluid brush-drawn outlines, and except for some dabs of ocher around the face everything else is left untouched. Spare as this study is, it is charged with the same kind of psychological insight that Munch injected into oil paintings such as *Puberty* and *The Sick Child.*

Though a proficient watercolorist, Munch was not a prolific one nor did his limited exploration of the medium contribute substantially to the development of his iconography. For the generation of Expressionists that followed, however, watercolor was an important tool, offering a flexible and inexpensive way of exploring new avenues of invention. Some artists, such as Oskar Kokoschka and Emil Nolde, displayed great virtuosity in the medium. Others lacked exceptional skill but used watercolor with an energetic disregard for traditional techniques. In general the Expressionists worked with a healthy lack of inhibition, often drawing directly with the brush in a freehand way that had very little to do with the established practice of building an image from carefully superimposed washes. This improvisational approach did not subvert the basic character of the medium, however. Indeed, it capitalized on watercolor's fluidity and on the freshness of the white support sparkling through transparent color. The way the young Expressionists applied paint to paper was sometimes crude, but the results were usually invigorating and sometimes remarkably original.

German and Austrian painters who came of artistic age early in the twentieth century were strongly attracted to the work of van Gogh and Munch, as well as to that of the Belgian master James Ensor. Around 1905 four young architectural students— Ernst Ludwig Kirchner, Erich Heckel, Fritz Bleyl, and Karl Schmidt-Rottluff—came together in Dresden to form the group known as Die Brücke (the Bridge), which combined enthusiasm for artists such as van Gogh, Munch, and Ensor with a social program that included the formation of artists' communities along the lines of those earlier envisioned by Gauguin. Perhaps because they had little formal training, this group arrived at a startlingly aggressive iconography, full of jagged shapes and references to primitive art. Bleyl left the group early on, but two new members—Max Pechstein and Otto Mueller—added considerable energy to the cause; an important older contemporary, Emil Nolde, also exhibited with Die Brücke for a while.

Nolde was one of the greatest watercolorists of the century, and it may be partly due to his influence that some members of Die Brücke, though not all, embraced the medium with enthusiasm. They were among the first of many twentieth-century innovators to discover that watercolor was an ideal medium for experimentation. Kirchner, the leader of the group, was given to mixing watercolor with other media, such as colored crayon, and he had a particularly strong feel for gouache, as is evident in *Barges on the Elbe* (plate 60). Here the subject is established with a few bold strokes of bright color, and the work has a superficial resemblance to watercolors by the Fauves. The mood is almost idyllic, but the factory chimneys in the background remind the

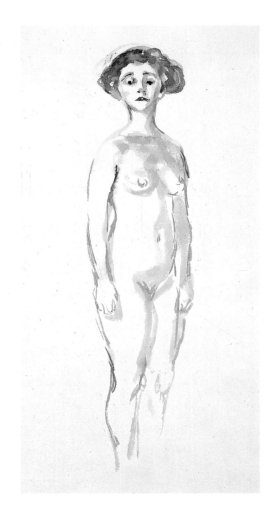

59. Edvard Munch (1863–1944)
Standing Blue Nude, after 1920
Watercolor on paper, 22 × 13⅜ in.
Munch-Museet, Oslo

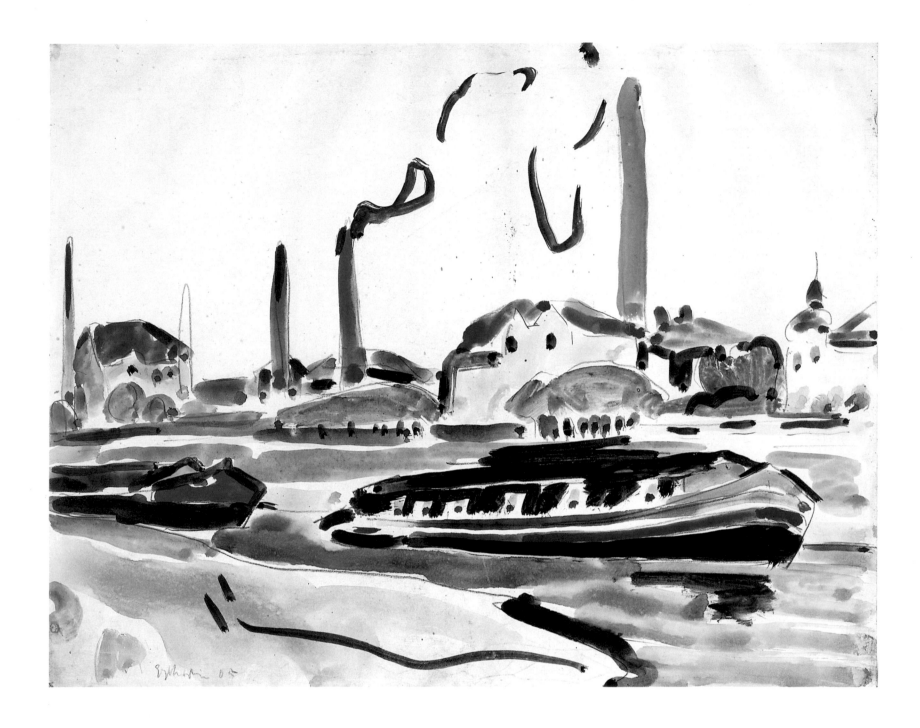

60. Ernst Ludwig Kirchner (1880–1938)
Barges on the Elbe, 1905
Watercolor, gouache, and pencil on
paper, 13¾ × 17¾ in.
Museum Folkwang, Essen,
West Germany

viewer that the youthful members of Die Brücke held well-developed political opinions and had little positive to say about modern society.

Kirchner's slightly later *Nude Girl in Front of Patterned Curtain* (plate 57) is a truer measure of the German group's achievement. Again Kirchner relied on rapid execution to give the composition energy, but this time the vivid colors—orange, yellow, pink, blue—are organized by black lines that give the nude figure, in particular, an almost cartoonlike quality. Compared to works by French artists such as Matisse and Derain this is positively crude, but it is precisely the crudeness that gives Kirchner's work its bite. Given that Germany's official art circles were considerably more conservative than France's at that period, Die Brücke's imagery must have seemed not only shocking but also deliberately ugly.

This ugliness is even more evident in Erich Heckel's *Two Nudes* (plate 61). If Rodin's nudes caused offense, then what was the public to make of these angular graces at their toilet? A viewer who had seen any African art might have guessed that Heckel was feeling its influence, as were many other artists at the time. That influence is even more apparent in *Woman at Rest* (plate 62), painted four years later. Here we have an

example of German Expressionism at its most basic, empty of the ecstasy that van Gogh brought to the most intransigent subject matter, denuded of the subtlety that Munch applied to his most subjective statements. Heckel's image is as blatantly ugly as graffiti in a public restroom. In its distortion it is highly expressive, but the work is expressive not so much of a psychological state as of a passionate response to the aesthetic challenges of the day.

Heckel seldom displayed much technical subtlety as a watercolorist, but the directness of his approach often paid handsome dividends. In the landscapes he painted after the breakup of Die Brücke as an organized group he sometimes achieved an equilibrium between Expressionist practices and conventional descriptive aims that enabled him to produce the kind of watercolor that even a traditionalist could approve of. Some of these landscapes were highly atmospheric and somewhat pantheistic. Others, such as *Ostende* (plate 63), were topographic, in a stripped-down way, and gave evidence of a strong sense of design.

The boldest colorist of Die Brücke, Karl Schmidt-Rottluff, was also the member most capable of radically simplifying form. He was often at his best when working on a smallish scale, as in his prints—among the most striking to emerge from the Expressionist movement—and in his drawings and watercolors. *Landscape with Moon* (plate 64) was painted after Die Brücke broke up, but it displays the group's stylistic directness

61. Erich Heckel (1883–1970)
Two Nudes, 1910
Gouache and graphite on paper,
23½ × 19½ in.
Collection, The Museum of
Modern Art, New York;
Gift of Ronald S. Lauder

62. Erich Heckel (1883–1970)
Woman at Rest, 1914
Pencil and watercolor on paper,
18¹⁵⁄₁₆ × 14¼ in.
Museum Ludwig, Cologne,
West Germany

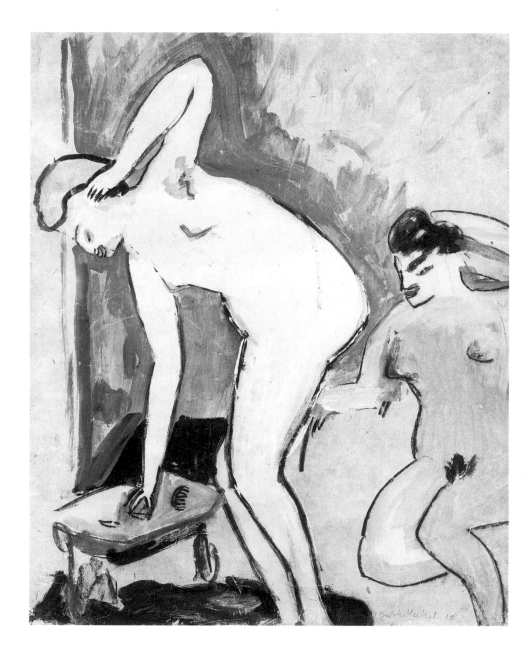

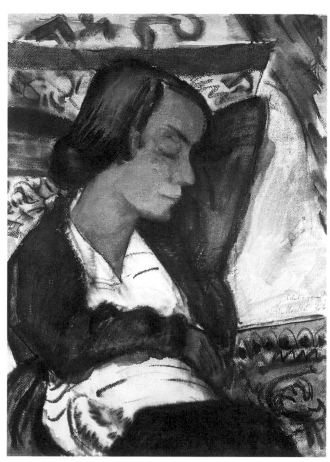

at its best. Drawn with the brush, the image is established with a few swiftly laid down strokes, then color—somewhat naturalistic but heightened and simplified—is added in the form of saturated washes that are permitted to record individual brush marks. There is nothing subtle about this approach, but it is extremely effective, and Schmidt-Rottluff established a strong sense of pattern. Later he softened his approach somewhat, and *Blossoming Trees* (plate 65) is a delightful demonstration of how the Expressionist style could be modified and made more gentle without entirely losing its character. In this lyrical painting, reminiscent of Dufy's *Pear Blossoms in Normandy* (plate 47), Schmidt-Rottluff made good use of the white paper to evoke the clouds of petals that cluster against the rooftops.

With Otto Mueller's *Crouching Woman* (plate 66), we are back to the angular world of Die Brücke's early period. Mueller's women are as spiky as Heckel's, but he often placed them—as in the present example—in a bucolic setting that takes the edge off the harshness of his vision. In addition, his light touch with watercolor gives this work an air of benevolence that is atypical of German Expressionism at this period.

While the Brücke artists were formulating their ideas in Dresden (and, from 1911, in Berlin), Expressionism was also fermenting in Munich, which had been an important center for progressive tendencies ever since the second half of the nineteenth century. Open to outside influences—especially from Paris—the city was also evolving its own vigorous realist tradition. That realism was rejected early in the twentieth century by younger artists who embraced Art Nouveau and Symbolism. Prominent among them was the dynamic Russian expatriate Wassily Kandinsky. As early as 1901

67. Franz Marc (1880–1916)
 Two Horses, One Crying, c. 1912
 Watercolor on paper, 8⅝ × 6¾ in.
 Sprengel Museum, Hanover,
 West Germany

OPPOSITE

68. Franz Marc (1880–1916)
 Red Deer, 1913
 Watercolor and gouache on board,
 16¼ × 13⅜ in.
 Solomon R. Guggenheim Museum,
 New York

69. August Macke (1887–1914)
Nude Standing before a Mirror, 1911
Watercolor over graphite pencil on
paper, 4⅝ × 5¼ in.
The Detroit Institute of Arts; Bequest
of Robert H. Tannahill

he founded an artists' organization known as Phalanx; eight years later he formed a new and more radical group known as the New Artists' Association (Neue Künstler Ver-einigung), which encompassed important figures such as Alfred Kubin, Franz Marc, and Alexey von Jawlensky. A split in this alliance led to the establishment of what was to become a far more famous group, the Blue Rider (Der Blaue Reiter), named after the title of a book by Kandinsky and Marc. Along with those two, the group included Kubin, Heinrich Campendonk, August Macke, Gabriele Münter, and the composer Arnold Schönberg; an important later addition was Paul Klee. Another significant figure, Lyonel Feininger, also exhibited with the group, as did Jawlensky and Nolde, although they never became official members.

The Blue Rider painters were quite varied in their aims, although most were bound together by a belief that art should have a spiritual dimension, as expressed in Kandinsky's famous tract, *On the Spiritual in Art,* published in 1912. Kandinsky, always the leader, had been through Art Nouveau and Fauve-like phases and was already pressing on into the unknown territory of nonfigurative art. So advanced were his concepts and so important were his watercolors to the future of twentieth-century art that he is more appropriately discussed later, in chapter 5; Paul Klee, who did not reach his full creative potential until after the Blue Rider period, is discussed in chapter 6.

As for the other members of the Blue Rider circle, several—notably Marc and Macke—displayed a considerable affinity for watercolor and employed the medium with both skill and feeling. Unlike the Brücke artists, they did not use watercolor in a slashing, gestural way but tended to build images from patches of wash, relying on well-tried methods but deploying them in a novel way in which the emotional impact of color played a paramount role. Relevant to this rather restrained approach to watercolor, which often emphasized a geometric restructuring of the image, was the influence of Cézanne and the impact of Cubism and of neo-Cubist tendencies such as Orphism.

70. August Macke (1887–1914)
Woodcutters from Kandern I, 1911
Charcoal and watercolor on paper,
11¾ × 10¼ in.
Private collection

Franz Marc was exposed to these new movements after responding to the influence of van Gogh and after beginning his own experiments with the expressiveness of color (plate 67). By the time he painted *Red Deer* (plate 68), Marc was introducing planar fragmentation into his work, but in this watercolor the Cubist influence coexists with the curvilinear shapes that had dominated his earlier paintings. What holds these divergent forces together is Marc's personal vision and his skillful use of color, which at first glance seems arbitrary but is in fact thoughtfully controlled.

One of the most gifted of the Blue Rider artists, especially as a watercolorist, was Marc's friend August Macke, whose career, like Marc's, ended with his death in World War I. Since Macke did not begin painting mature works until around 1910, his career lasted only about four years, but during this brief period he produced a body of work that advanced the progress of twentieth-century art and remains satisfying today.

Nude Standing before a Mirror (plate 69) shows Macke's talent at its most basic. Although the informality of the drawing and the nonnaturalistic color show that he has absorbed the lessons of the Fauves and of his German contemporaries, this is essentially a beautifully executed little sketch with timeless appeal. His use of transparent pigment shows that he had a sound grasp of the watercolor medium. *Woodcutters from Kandern*

I (plate 70) is a more overtly modern work, rather densely painted and with the forms somewhat abstracted. The saturated colors show the influence of the Fauves and perhaps also of the Brücke group even more clearly than in his earlier work.

In 1912 Macke, along with Marc, visited Paris and there met Robert Delaunay, whose marriage of Cubist space to advanced color theory greatly impressed the young Germans. Delaunay believed that Cézanne's late watercolors were at the root of all modernism, and it may be assumed that Macke looked at those paintings with newly aroused interest. Certainly his own work began to display the influence of both Cézanne and Delaunay. Even in his oils he began to use diluted paint capable of some of the effects of watercolor, and his watercolors themselves took on a new brilliance and an increased prominence within his oeuvre. *Fashion* (plate 71) employs high-keyed saturated color once more, but the color now is allied to a fragmentation of space and form that is not so much Cubist as it is a synthesis of various influences (Cubism included)

71. August Macke (1887–1914)
 Fashion, 1913
 Watercolor on paper, 11 × 9 in.
 Museum Ludwig, Cologne,
 West Germany

that were in the air at the time. As is frequently the case in Macke's work, the figures are less subject to simplification and distortion than the settings, but he managed to wed naturalistic elements to geometrical structure with apparent ease.

Just a few months before his death Macke took another trip, this time to Tunisia in the company of Paul Klee. There he made a number of delightful watercolors in which the geometry inherent to the architecture of North African cities was translated into Cézannesque patterns organized in shallow space. As always with Macke, the use of color was inventive, and in *Kairouan I* (plate 72), luminous washes are carefully laid down within a well-thought-out grid to give the picture its underlying structure. The way this grid is employed and the childlike way in which the camels are drawn inevitably call to mind Klee's later work, and one regretfully wonders what Macke might have achieved had he lived longer.

Born in New York to German parents, Lyonel Feininger was sent to Germany as a teenager to study music, but while there he switched his primary attention to the visual arts. For some years he contributed cartoons and comic strips to newspapers and magazines on both sides of the Atlantic (his "Kind-der-Kids," drawn for the *Chicago Tribune,* is one of the joys of early comic-strip art). Around 1911, while living in Paris, Feininger came into contact with Cubism and, like Macke and Marc, he was especially attracted to the art of Delaunay. Marc invited Feininger to exhibit with the Blue Rider, and from 1913 on, he was closely associated with the group. Later, while teaching at the Bauhaus, he teamed with Kandinsky, Jawlensky, and Klee to form the Blue Four, a

72. August Macke (1887–1914)
Kairouan I, 1914
Watercolor on paper,
8⅜ × 10⅝ in.
Staatsgalerie Moderner Kunst, Munich,
West Germany

73. Lyonel Feininger (1871–1956)
 Street in Paris, 1915
 Ink and watercolor on paper,
 12½ × 9⅜ in.
 Private collection

 OPPOSITE, TOP
74. Lyonel Feininger (1871–1956)
 Strand, 1925
 Ink and watercolor on paper,
 11½ × 17 in.
 The Brooklyn Museum; Museum
 Collection Fund

 OPPOSITE, BOTTOM
75. Lyonel Feininger (1871–1956)
 Harbor Entrance, 1927
 Pen and watercolor on paper,
 11¾ × 15⅜ in.
 Graphische Sammlung, Staatsgalerie
 Stuttgart, Stuttgart, West Germany

group that often exhibited together. Feininger was not as radical as some other members of the Blue Rider and, for all his interest in Cubism, his early works occasionally have as much to do with his background as a cartoonist as with his infatuation with Delaunay. This is certainly true of *Street in Paris* (plate 73), in which the elongated figures might almost have been transplanted from the Sunday funny pages. Already, however, Feininger's nervously expressive line and subtle sense of color are fully in evidence.

　　Two themes came to dominate Feininger's work. One—an exploration of the geometrics of medieval towns—lent itself very well to his highly personal post-Cubist idiom and found its richest expression in his oils. The other—boats, the sea, and the shore—proved especially well suited to watercolor. *Strand* (plate 74) is an example of landscape—specifically beachscape—reduced to a minimal grid of lines, drawn with the

Feininger Strand Dienst. d. 5. 5. 25

Feininger Einfahrt 26 8 27

76. Lovis Corinth (1858–1925)
Walchensee in Winter, 1924
Watercolor on paper, 16⅞ × 19 in.
Graphische Sammlung, Staatsgalerie
Stuttgart, Stuttgart, West Germany

aid of a ruler, over which has been laid the most delicate of washes. More typical of Feininger's style is *Harbor Entrance* (plate 75), in which the boats are vigorously evoked, as is the squally sky, and the washes are applied densely enough to create a feeling of substance sometimes lacking in his other watercolors.

It should not be thought that German Expressionism was confined to the members of Die Brücke and the Blue Rider. Also relevant is the work of two artists—one who was the product of another century, the other a man who would make major contributions to other movements during the decades that followed. Lovis Corinth was just five years younger than van Gogh. Sometimes called a German Impressionist, he actually worked for many years in a naturalistic tradition that owed much to the bravura brushwork of artists such as Peter Paul Rubens and Frans Hals. But Corinth lived well into the twentieth century and was exposed to the work of the young revolutionaries. In 1911 he suffered a stroke, and when he recovered he began to paint in a much looser manner that can only be described as Expressionist. His watercolor landscapes of the 1920s are especially striking, combining an almost Chinese economy with a palette that at times was positively fierce (plates 76, 77).

By the time Corinth painted these works, Max Ernst was already a leading participant in the Dada-Surrealist adventure, but he too had been touched by Expressionism—he had met Macke in 1910, which led to his exhibiting alongside members of the Blue Rider. *Paris Street* (plate 78) is a lively work that shows Ernst had thoroughly absorbed the lessons of Expressionism before moving on. There are hints here—in the fragmentation, the bustle, and the emphasis on details such as the car's headlights—that he had also been exposed to Futurism. Indeed, by 1912 many streams were beginning to flow together, and Expressionism was becoming one of several tributaries that ran into the mainstream of twentieth-century art.

For some major figures, however, Expressionism was more than just an episode in the history of modern art. Three artists who fall into this category are Oskar Kokoschka, Egon Schiele, and Emil Nolde. Each evolved a highly personal form of the Expressionist idiom, and each worked extensively in watercolor, contributing works that are among the most striking examples of the medium made during this century.

If Dresden, Berlin, and especially Munich were the centers of advanced art in

77. Lovis Corinth (1858–1925)
Pink Clouds, Walchensee, 1921
Watercolor on heavy cream wove
paper, 14¼ × 20 in.
The Detroit Institute of Arts; Bequest
of Robert H. Tannahill

78. Max Ernst (1891–1976)
Paris Street, 1912
Watercolor on paper, 13⅜ × 17⅜ in.
Städtisches Kunstmuseum Bonn

Germany, they had one great rival in the German-speaking world: Vienna. Long an important site of musical innovation, at the turn of the century Vienna became the arena for a revolutionary new discipline—psychoanalysis—that would profoundly affect all of the arts. Starting in 1897 the city also became home to the Vienna Secession, which was among the most important of the alternative salons and would have particularly far-reaching effects on the decorative arts. Indeed, the Secession's first president, Gustav Klimt, was one of those hybrid figures, so typical of the Art Nouveau era, who was part easel painter, part designer. Today Klimt is best remembered for his mural designs for such projects as Josef Hoffmann's *Stoclet Palace* (plate 79), in which his emphasis on pattern anticipated some aspects of abstract art. But Klimt was also a gifted draftsman—one who felt the influence of Rodin—and his sometimes erotic drawings of female nudes display a sinuosity of line that tends toward the expressionistic. Among those who responded enthusiastically to this aspect of his work were Oskar Kokoschka and Egon Schiele.

Kokoschka was born in Pöchlarn, Austria, and studied at the Vienna School of Arts and Crafts, where he came under the influence of the Secession artists, especially Klimt. In 1906 he saw an exhibition of van Gogh's work and soon after began a series of portraits in which he employed expressionistic distortion to capture the subject's psychic state. His drawings of the same period still owe a great deal to Klimt's example

OPPOSITE

79. Gustav Klimt (1862–1918)
Study for "The Kiss" (design for Josef Hoffmann's Stoclet Palace), 1909
Watercolor and gouache on paper,
75⅝ × 46½ in.
Musée d'Art Moderne, Strasbourg, France

80. Oskar Kokoschka (1886–1980)
Nude Youth Seen from the Back, c. 1907
Pencil and light red and gray wash on paper, 17⅜ × 12 in.
Allen Memorial Art Museum, Oberlin College; Elisabeth Lotte Franzos Bequest

81. Oskar Kokoschka (1886–1980)
Seated Nude, c. 1907
Pencil and watercolor on paper,
17¼ × 12 in.
Private collection

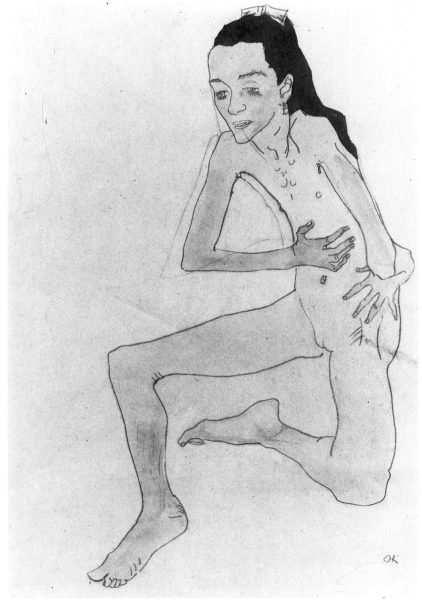

82. Oskar Kokoschka (1886–1980)
Reclining Nude, 1911–12
Black chalk and watercolor on paper,
12⅜ × 17¾ in.
Private collection

although Kokoschka, unlike Klimt, often employed watercolor as an adjunct to line in much the way that Rodin had done.

Looking at the c. 1907 *Nude Youth Seen from the Back* (plate 80), it should be remembered that this was painted by a young man barely out of his teens, which makes it a remarkable achievement, spare and free from any of the modeling devices that were common to almost all student work of the period. This spareness is displayed even more effectively in *Seated Nude* (plate 81), a drawing that few artists could have made at this time, which has a simplicity almost worthy of Matisse. Particularly expressive is the way the young Kokoschka employed extreme foreshortening—handled with the offhand skill of a master—to push the girl's body into a shape that makes a powerful design statement (part of his legacy from the Secession). This feeling for design is also apparent in *Reclining Nude* (plate 82), but in this case it is the forceful draftsmanship that makes the greatest impact.

Besides being a painter, Kokoschka was also a writer and playwright, and in 1909 two of his plays caused such a scandal that he was obliged to leave Vienna. This had the salutory consequence of bringing him into contact with other modernists, especially in Germany, leading him to even greater confidence in his expressionist instincts, as did his discovery of the art of Edvard Munch. This confidence is apparent in his watercolors of the early 1920s. Whereas Kokoschka's early figure studies can properly be described as tinted drawings, these later works—made during an extended residence in Dresden —are quite different. He had come to rely upon a fluid brush calligraphy that was beautifully attuned to his expressive needs, enabling him to produce some of the land-mark watercolors of the century.

Reclining Girl in Red Dress (plate 83) is a good example of Kokoschka's work during the Dresden period. The model reclines against brightly colored cushions, one arm raised above her head. As in some of his earlier drawings, the pose is characterized by an informal handling of tricky problems in foreshortening. The confident calligraphy combines with a bright palette, the luminous brush lines being used both to describe edges and to suggest volume. Kokoschka's use of color was, by now, much bolder than

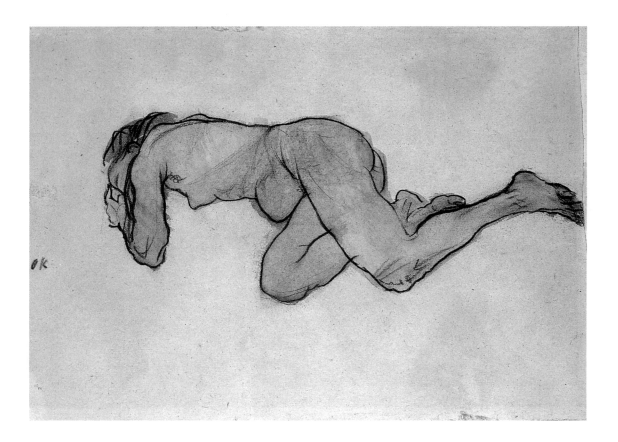

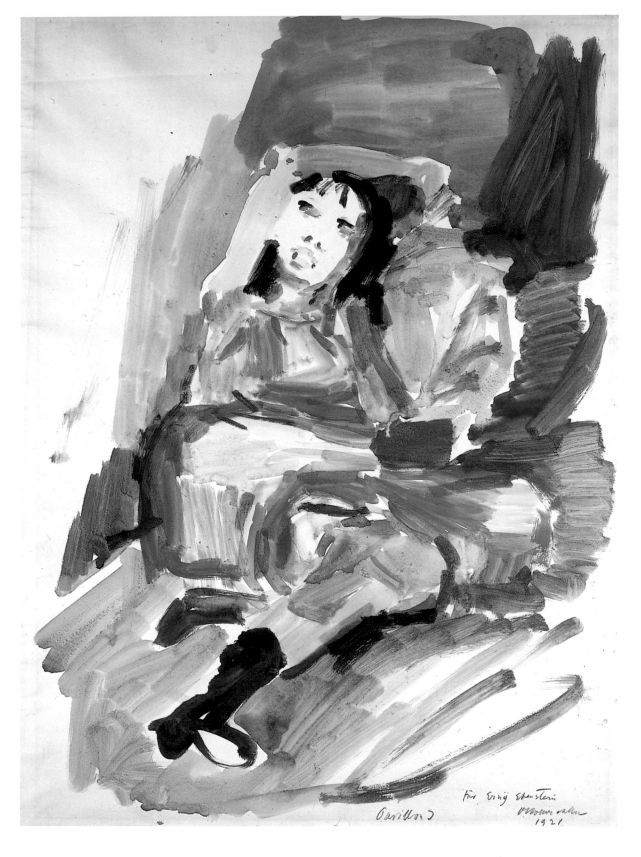

83. Oskar Kokoschka (1886–1980)
Reclining Girl in Red Dress, 1921
Watercolor on paper,
27¾ × 20⅝ in.
Private collection

in his Vienna days. He used it to establish mood and to evoke psychological states, in a typically Expressionist way, but in these watercolors he sometimes pushed beyond those conventions, employing color combinations completely independent of the subject matter. This use of color is similar to what is sometimes found in children's drawings, where line and form are used to describe, while color is used to express. That is certainly the case in *Woman with Right Arm on Hip* (plate 84). This painting, though, is no mere imitation of children's art since the childlike vision is complemented by the professional artist's accuracy of drawing (even though the forms are deliberately exaggerated and simplified). Kokoschka sometimes took an entirely different approach. There is nothing childlike about *Seated Nude* (plate 85), which is a wonderfully comic statement reminis-

84. Oskar Kokoschka (1886–1980)
Woman with Right Arm on Hip, 1921
Watercolor on paper, 27¾ × 20⅝ in.
Private collection

85. Oskar Kokoschka (1886–1980)
Seated Nude, c. 1921
Watercolor on paper, 17¾ × 23 in.
Private collection

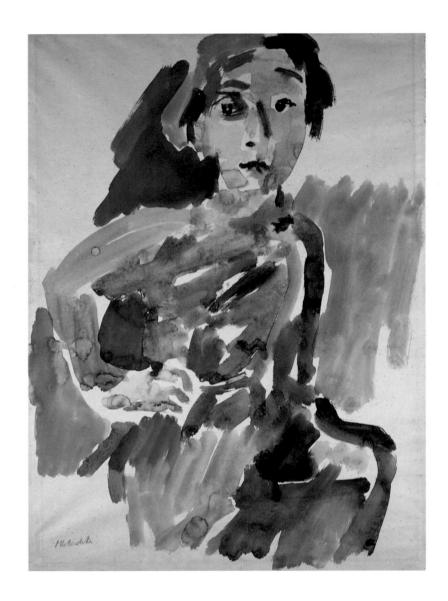

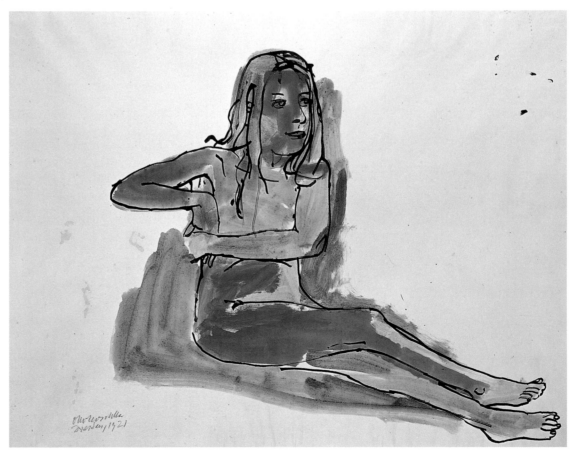

cent of Japanese art—a connection suggested by Kokoschka's use of black outlines—but also of portraits by Rembrandt.

Many of these different qualities come together in *Seated Girl* (plate 86), one of Kokoschka's greatest watercolors. Again the skill with which Kokoschka has caught the model's pose suggests Rembrandt, again the calligraphy recalls Oriental art. The vision is that of a supremely self-assured and sophisticated artist, yet it has not lost the innocence of the child. What is particularly original here is the use of color and texture. The blue hat is ordinary enough, but note the way that the line describing the girl's cheek and jaw shifts, for no apparent reason, from firm purple to blurred green. Such arbitrary changes in color and texture occur throughout the image, creating the effect that far more colors have been used than is in fact the case. The half-dozen colors actually employed are applied in ways that take full advantage of the medium's transpar-

86. Oskar Kokoschka (1886–1980)
 Seated Girl, 1922
 Watercolor on paper, 27⅜ × 20⅜ in.
 Collection, The Museum of Modern
 Art, New York

87. Oskar Kokoschka (1886–1980)
 Sitting Woman, c. 1922–23
 Watercolor on paper, 27⅜ × 20½ in.
 Museum Ludwig, Cologne,
 West Germany

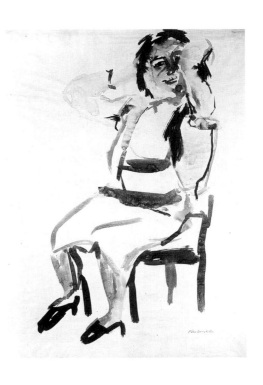

ency. *Sitting Woman* (plate 87), from about the same period, shows Kokoschka's calligraphy taken to an extreme. In paintings such as this he echoed the spirit of such Zen-influenced Japanese artists as Sesshū.

Four years younger than Kokoschka, Egon Schiele studied from 1906 to 1909 at the Vienna Academy, where he too fell under the spell of Klimt, whose influence permeated Schiele's work throughout his brief career. He also saw Kokoschka's tinted drawings and was inspired by them to the extent that Kokoschka—one of the more outspoken figures in twentieth-century art—openly accused Schiele of plagiarism. This was an exaggeration, but the link between Schiele and Kokoschka is obvious enough in drawings such as *Nude Girl with Crossed Arms* (plate 88), a portrait of the artist's sister. As in early Kokoschkas such as *Seated Nude* (plate 81), it is line that does most of the work here, though Schiele's watercolor washes are always applied with conviction and in this instance do much to create a sense of solidity. Like Kokoschka—although with more direct ties to Klimt and the Secession artists—Schiele exaggerated the pose slightly so that it would read as a design. At the same time the distortion also helps depict a psychological state—whether the artist's or the model's is impossible to determine—in a truly expressionistic way. Schiele's draftsmanship differs from Kokoschka's, however, in tending toward mannerism. Schiele's works can usefully be divided into two categories: those in which mannerism is held in check, sometimes just barely, and those in which it overpowers the subject and interferes with the impact of the work.

Seated Woman (plate 89) is typical of Schiele's mature style. The draftsmanship is firm and the colored washes are used skillfully to articulate form, as is also the case in *Reclining Woman with Blond Hair* (plate 90). These are both remarkably fine watercolors, but by comparison with Kokoschka—or with the German Expressionists, for that matter—these are not advanced works. What enables them to hold their own is that they seem to epitomize the spirit of one of Europe's great capitals at the moment of traumatic change. Schiele's Vienna is not the Vienna of Strauss waltzes and operettas. Rather, it is the Vienna that produced Arthur Schnitzler, Karl Krauss, Ludwig Wittgenstein, and Sigmund Freud. His is a time and place in which a sense of alienation had been laid bare, an environment in which previously hidden currents of sexuality were bursting into the open.

Schiele's work tapped both the alienation and the eroticism of the period, but it was the eroticism that got him into trouble. Uncommonly explicit for the time, his drawings did not shy away from the portrayal of sexual organs, and this frankness eventually brought him into conflict with the authorities. In 1912 Schiele was taken to court and found guilty of "immorality" and "seduction," spending several months in jail. In retrospect this persecution of the artist seems absurd, but it is not difficult to imagine how the eroticism of his art shocked his contemporaries. So skillfully did he encode sexuality into his drawings that they still have an erotic jolt today, despite the permissiveness that has become commonplace.

Kokoschka and Schiele also painted landscapes in watercolor (plate 91), but the greatest landscapist to emerge from the Expressionist milieu, and one of the most gifted watercolorists of the century, was Emil Nolde. Older than most of the Expressionists, Nolde was born in 1867 in the Schleswig area of Germany, near the Danish border—a windswept region of dykes and canals, scattered farms and mills, its coast battered by the stormy North Sea. It was an environment that was to have an enormous impact on Nolde's work, a fact that he recognized by changing his birth name—*Housen*—to *Nolde,* which was the name of the small community in which he was born. A farmer's son, he trained as a woodcarver and in 1888 moved to Munich, where he carved moldings for furniture. A brief spell in Berlin was followed by six years of teaching at the Museum of

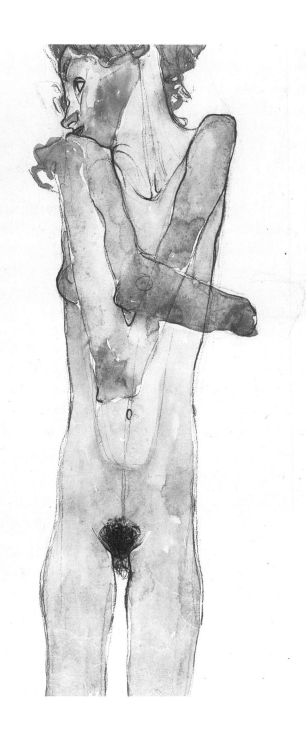

88. Egon Schiele (1890–1918)
Nude Girl with Crossed Arms, 1910
Black chalk and watercolor on paper,
17⅞ × 11⅛ in.
Graphische Sammlung,
Albertina, Vienna

89. Egon Schiele (1890–1918)
Seated Woman, 1914
Pencil and watercolor on paper,
19⅛ × 12⅝ in.
Graphische Sammlung,
Albertina, Vienna

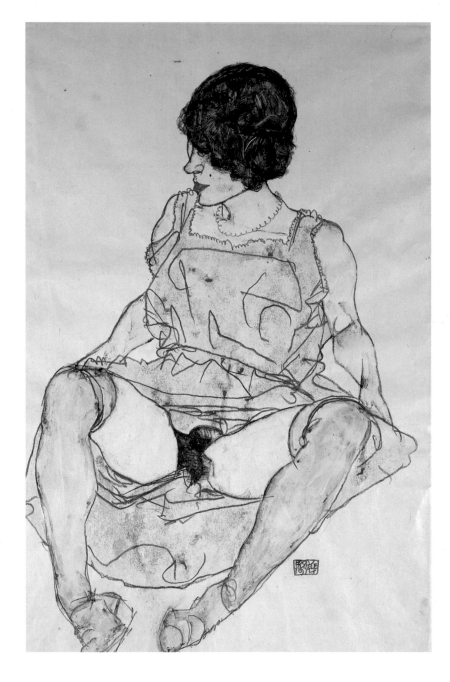

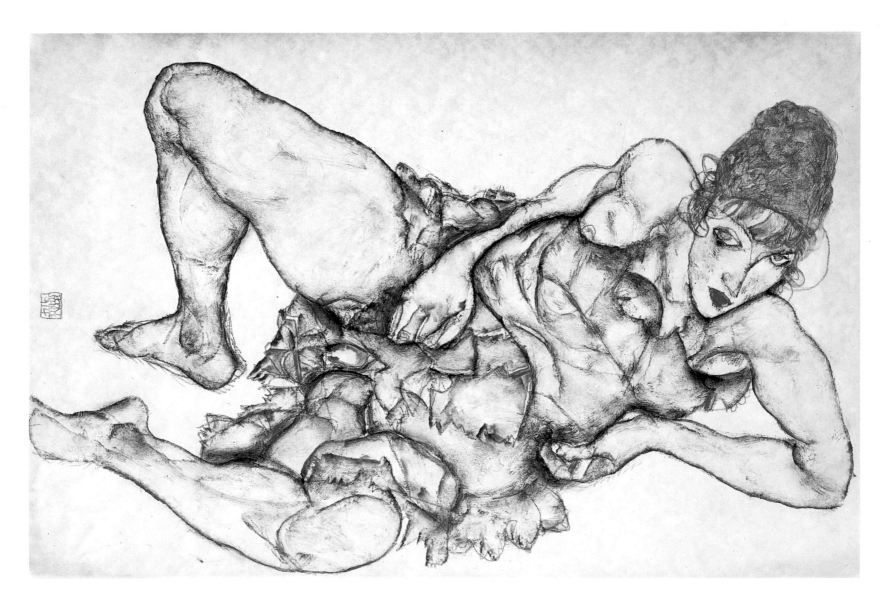

90. Egon Schiele (1890–1918)
Reclining Woman with Blond Hair, 1914
Watercolor and gouache over soft
lead pencil on Japan-finish paper,
12½ × 19⅛ in.
The Baltimore Museum of Art;
Fanny B. Thalmeier Memorial and
Friends of Art Funds

91. Egon Schiele (1890–1918)
A Hill near Krumau, 1910
Watercolor on paper,
12½ × 17½ in.
Graphische Sammlung,
Albertina, Vienna

Industry and Trade in St. Gallen, Switzerland. During that period he began to paint, often in watercolor, but in a generally conservative style with only occasional hints of what was to come. A classic example of the late developer, he did not begin to study art full time until 1898, a course of action that took him to Munich once again, then on to Paris and Copenhagen. Nolde absorbed the lessons of Rembrandt, Goya, and Arnold Böcklin, and eventually—well after the turn of the century—was introduced to work by Gauguin and van Gogh. Slowly his work became more modern, and by 1906 he was advanced enough to be invited to join Die Brücke in Dresden. But Nolde was solitary by nature, and his association with Die Brücke lasted less than two years. He belonged to the Berlin Secession as well, but again his prickly temperament brought him into conflict with the leadership, this time in the person of Max Liebermann, and Nolde was expelled with much fanfare.

By now, however, Nolde was a mature artist and a figure to be reckoned with. Two studies of steamboats are exercises in economy that none of his contemporaries could surpass. *The Steamer* (plate 92) features a black boat, with reddish-brown high-lights, against a field of densely saturated and blobby blue washes that suggest both sea and sky. In its Orientalism this work recalls some of Whistler's watercolors, a resemblance that is even more evident in *Steamboat on the Elbe* (plate 93), in which a few calligraphic marks conjure up a grimy tramp steamer, the smoke from its smokestack, and a distant shore.

At the Inn (plate 94) is a good example of Nolde's early way with figures. Like the two steamboat paintings, it depends for its impact upon a shorthand calligraphy, and

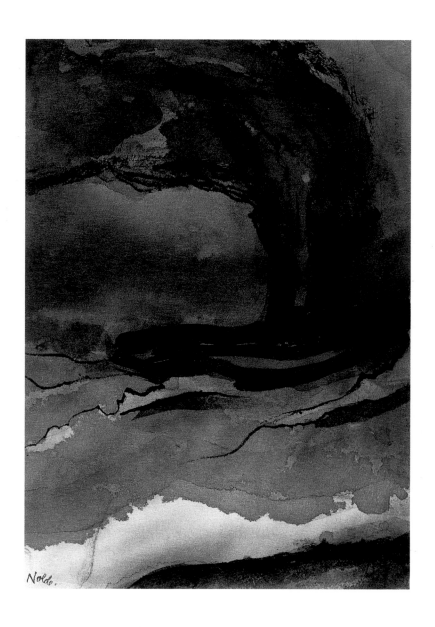

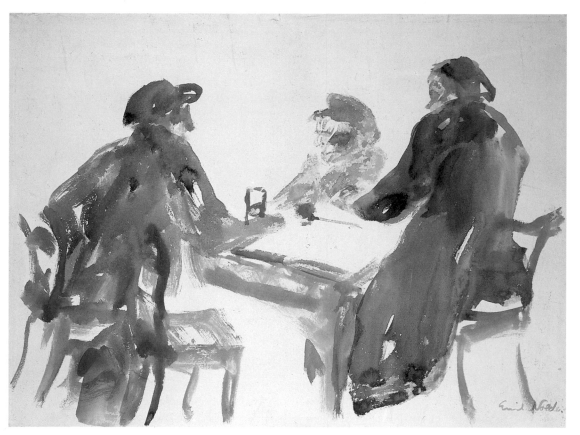

CLOCKWISE FROM TOP LEFT

92. Emil Nolde (1867–1956)
 The Steamer, c. 1910
 Watercolor on paper, 7¾ × 5½ in.
 The Detroit Institute of Arts; Bequest
 of Robert H. Tannahill

93. Emil Nolde (1867–1956)
 Steamboat on the Elbe, c. 1910
 Watercolor on paper, 13³⁄₁₆ × 9⅞ in.
 Museum Ludwig, Cologne,
 West Germany

94. Emil Nolde (1867–1956)
 At the Inn, 1908
 Watercolor on paper, 14⅛ × 19¼ in.
 Private collection

95. Emil Nolde (1867–1956)
Two Peasants, c. 1930
Watercolor and black ink on paper,
7⅝ × 5¾ in.
The Detroit Institute of Arts; Gift of
John S. Newberry

this links it to some of Kokoschka's watercolors. However, Kokoschka's skill as a draftsman was paramount in even his most painterly watercolors, whereas Nolde is always first and foremost a painter. The way that he massed the forms on the paper takes precedence over line. *Two Peasants* (plate 95) demonstrates this even more clearly. There is something reminiscent of Rouault in this work in which Breughel-like figures are delineated with bold black outlines. This emphasis on outline does not, however, imply a dependence on line, since the outlines are so thick and dense that they take on the property of blocks of color. As in Rouault's work, these black forms play off against the rich chromatic texture of the background to call up the image of stained glass. A similar effect appears in Nolde's portrait of Emmy Frisch (plate 96) and in a 1917 self-portrait (plate 97), though in the latter the web of black lines is more

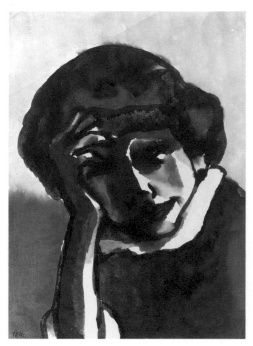

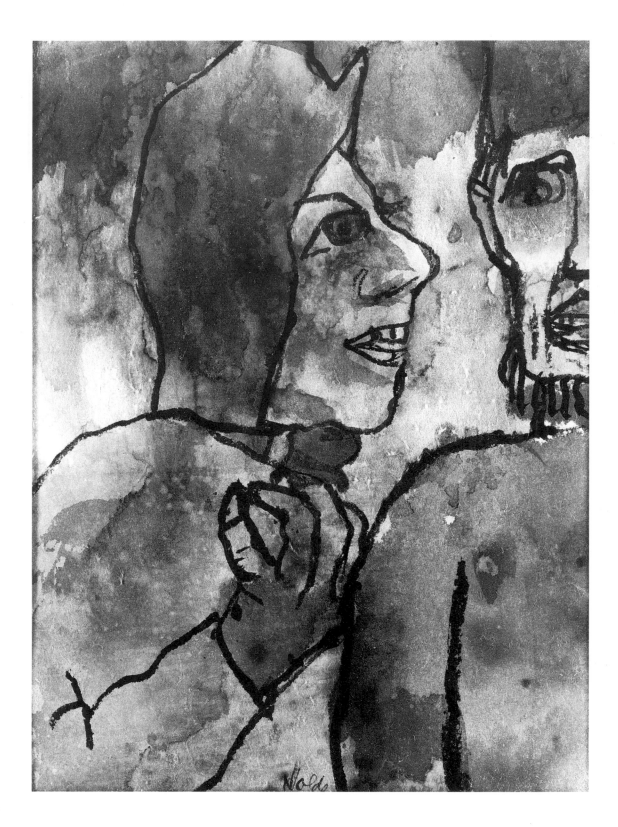

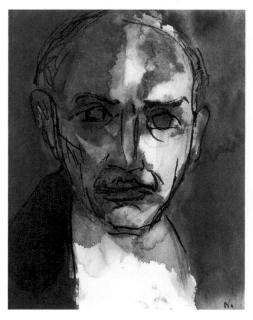

delicate and is laid over variegated washes that have been permitted to run together. It may be, in fact, that Nolde dipped the entire sheet in water before adding the final linear overlay.

In 1913–14, Nolde traveled to the Far East and followed this with trips to Italy and Spain (plate 98). Soon after this, however, he took up residence in his native Schleswig, living first on a farm on what is now the Danish side of the border. In 1926 he moved to Seebüll, on what is now the German side of the border, which remained his home for the rest of his life, though for some years he maintained an apartment in Berlin. It was in Schleswig that Nolde painted the cycle of watercolors that is perhaps his finest achievement. These paintings of flowers, animals, the always-present sea, and

the stormswept landscape were made throughout his last four decades. The evidence suggests that Nolde was at his most active in the 1930s, but he refused to date his watercolors and since his style changed little after about 1920 it is difficult, and probably unnecessary, to establish any sequence.

Many of Nolde's earlier watercolors had been painted on the hard-sized paper favored by most watercolorists—paper that does not absorb the pigment. By the time of his return to his native landscape he had come to prefer a kind of Japanese vellum that was somewhat absorbent, permitting him to saturate the surface in a particularly dense way. The technique this permitted can be seen in *Landscape with Mill* (plate 99), in which the mill itself and a farmhouse on the chalky hillside are silhouetted against great storm clouds of red, purple, gray, and ocher, which occupy perhaps three-quarters of the entire area. The foreground forms are firmly outlined in black but it is the churning sky that is the real subject of the painting, and it is entirely the product of Nolde's highly evolved watercolor technique, of the way that wet-into-wet washes coagulate in the fibers of the Japanese paper.

This method can be seen again in *Flood* (plate 100), in which the image is little more than a horizon line dividing sky from water, which consist of complementary expanses of wet-into-wet wash. This is clearly a representational painting, yet its descriptive quotient is so low that the demarcation between this and nonfigurative art is

OPPOSITE, TOP
99. Emil Nolde (1867–1956)
 Landscape with Mill, n.d.
 Watercolor on paper, 12 × 18 in.
 Nolde-Stiftung, Seebüll,
 West Germany

OPPOSITE, BOTTOM
100. Emil Nolde (1867–1956)
 Flood, n.d.
 Watercolor on paper,
 13¾ × 18½ in.
 Nolde-Stiftung, Seebüll,
 West Germany

101. Emil Nolde (1867–1956)
 Reflections, c. 1935
 Watercolor and brush and black ink
 on paper, 13½ × 18½ in.
 The Detroit Institute of Arts;
 Bequest of Robert H. Tannahill

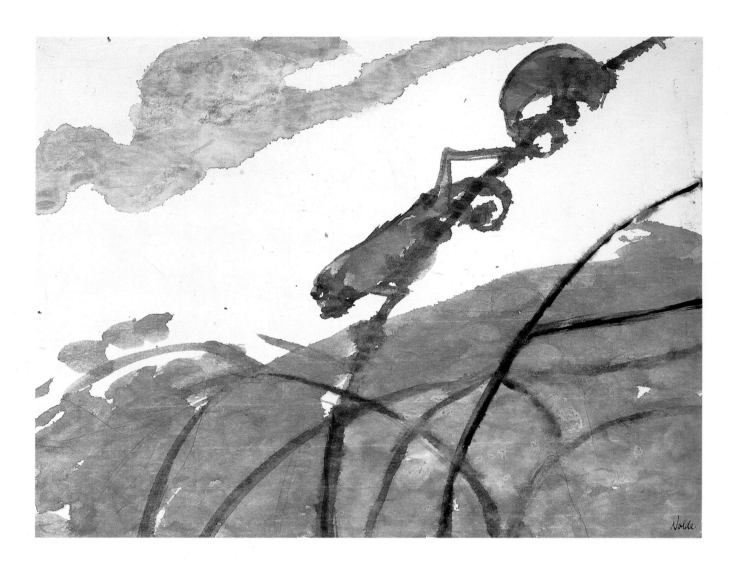

102. Emil Nolde (1867–1956)
Chameleons, n.d.
Watercolor on paper,
13½ × 18½ in.
Nolde-Stiftung, Seebüll,
West Germany

OPPOSITE
103. Emil Nolde (1867–1956)
Blue Bells, n.d.
Watercolor on paper,
16¾ × 13⅝ in.
Nolde-Stiftung, Seebüll,
West Germany

very blurry indeed. *Reflections* (plate 101) is a less extreme but very beautiful example of Nolde's mature style in which the watery landscape, saturated with blues and purples, is articulated by means of black calligraphy, the somber tonality relieved only by the yellow reflections of the title. It is reported that Nolde loved to improvise, allowing the wet-into-wet pigments to suggest clouds or mist or surf and then following these chance suggestions rather than attempting to make the washes follow some preordained plan.[5] One must assume that *Sea with Mauve Clouds* (plate 3) was created in this way. The clouds, pitched against the cadmium reds and yellows of the sunset, seem to have a life of their own, and yet the artist clearly did maintain enough control to take advantage of the forms' energy. Nolde is one of the great masters of the seascape, and sheets such as this make it easy to understand why Whistler's work was one of his early models.

Nolde responded not only to the macrocosm but also to the intimate world of his domestic surroundings, as well as to such subjects as tropical fish and small animals. This led to such paintings as *Chameleons* (plate 102), which vividly conveys a simple delight in pure color and fanciful form. Nolde took a special pleasure in the flower garden that he and his wife cultivated at Seebüll—something of an anomaly within that bleak landscape—and his many paintings of flowers are among his richest works of the late period (plates 103, 104).

When the National Socialists came to power, Nolde made the great mistake of perceiving them as the saviors of German culture. Events quickly disillusioned him, and he found himself among those artists labeled as "degenerate." Eventually the Nazis confiscated over a thousand of his works and informed him that he was "forbidden from exercising any professional or avocational activity in the fine arts."[6] In effect, Nolde had been forbidden to paint, but he responded by shutting himself in a small room and

104. Emil Nolde (1867–1956)
Tulips and Irises, n.d.
Watercolor on paper, 10¼ × 18 in.
Private collection

painting hundreds of brilliant little watercolors intended as studies for oil paintings that he might never have the opportunity to paint. He referred to these as his "unpainted pictures," and they often have the look of being illustrations to some unwritten epic (plate 105).

In the end, it is by the landscapes, seascapes, and flower paintings that Nolde's achievement as a watercolorist must be judged, and this achievement is of the highest order. His color sense, his ability to synthesize, and his skill in turning plastic devices to expressive purpose place his art firmly in the twentieth century. Yet at the same time his feeling of awe before the forces of nature makes him one of the last great representatives of the Northern Romantic tradition that began with artists such as Caspar David Friedrich and Philipp Otto Runge.

No twentieth-century movement has produced a more substantial body of watercolor than Expressionism, and no medium proved better suited to the freedom of approach demanded by the Expressionists. In the masterpieces by artists such as Kokoschka and Nolde, watercolor found new champions to set alongside the great masters of the past.

105. Emil Nolde (1867–1956)
Little Faun, 1938–45
Watercolor and gouache on Japan
paper, 9 × 5⅝ in.
Nolde-Stiftung, Seebüll,
West Germany

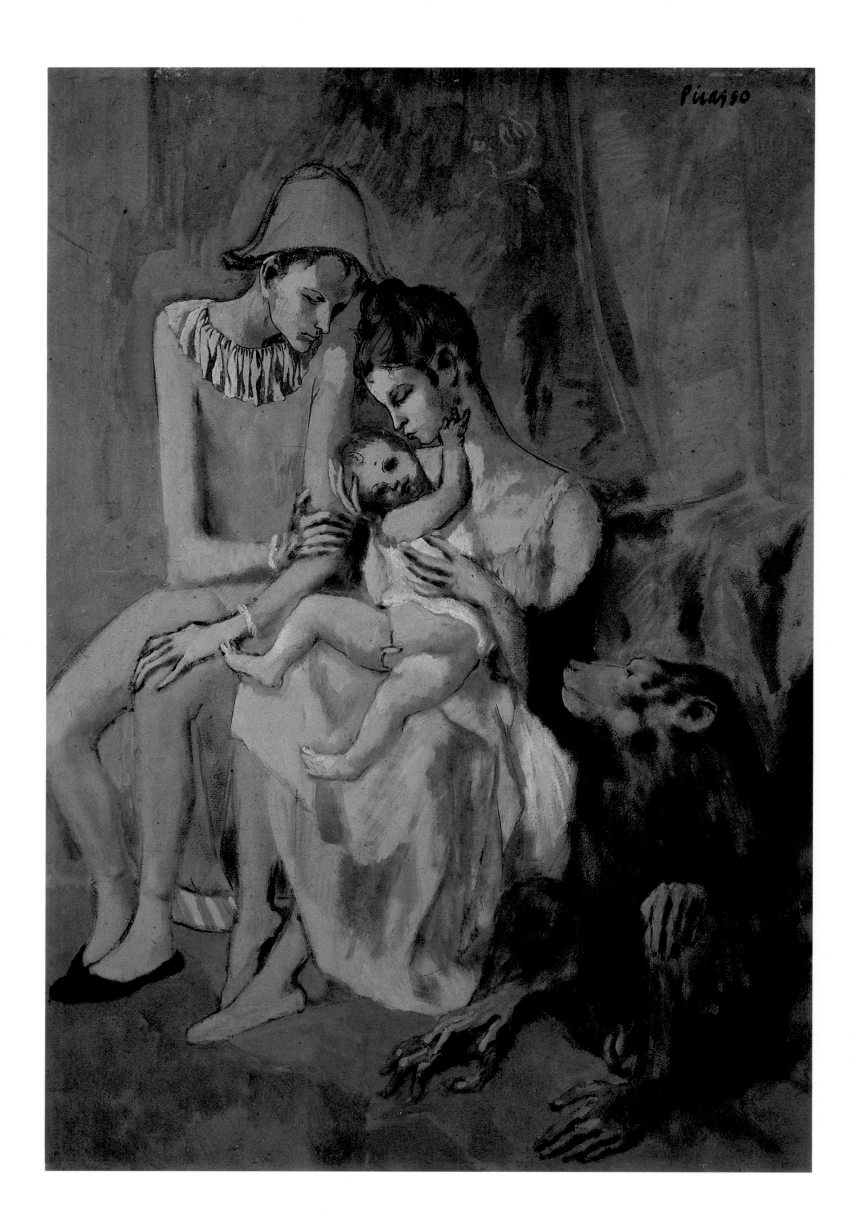

Whatever else one might say about Pablo Picasso, he was undoubtedly the most versatile artist of the twentieth century, and his work in any one of half a dozen different media would assure his eminence in the history of modern art. It is especially appropriate that the master of experimentation and spontaneity felt so at home working with watercolor, since the medium lends itself so well to improvisation. It can be argued that drawing in pencil or ink was Picasso's primary means of expression on paper, but the fact remains that he used watercolor and gouache with great frequency and evident pleasure throughout his career.

The Museo Picasso in Barcelona owns a portrait of the artist's mother, painted by the adolescent Picasso in 1895–96 (plate 107); this is said to be his first watercolor. It is just a little sketch isolated in the middle of the sheet against a patch of wash, but it indicates that even at this tender age Picasso possessed remarkable skill and technical aplomb. The fact that he was the son of a drawing master may explain in part why he attained mastery of academic procedures at such an early age, a mastery even more apparent in the portrait of Picasso's father painted c. 1896 (plate 108). But there was more than training involved in such precocious achievement. Picasso possessed an extraordinary gift that permitted him to skip the awkward stages that normally mark the passage from childhood to adolescence of even the most talented youngster. Indeed, Picasso had to unlearn some of his more conventional skills before he could fully come to grips with the challenge of twentieth-century art. Visiting a show of children's art with Roland Penrose, the aging artist remarked, "When I was their age I could draw like Raphael, but it took me a lifetime to learn to draw like them."[7]

When Picasso first visited Paris in 1900, he was much impressed by the work of Lautrec and Théophile-Alexandre Steinlen, which he emulated without submerging his personality in theirs. If there is a consistent thread through Picasso's work, it is his refusal—perhaps inability—to suppress his personality, and that personality was asserting itself very powerfully by 1904 (the year he moved permanently to Paris), when he painted *Woman with a Crow* (plate 109). Painted at the culmination of his Blue Period, this is an extraordinary image—the woman with a bony face and elongated fingers holding the bird to her lips and passionately kissing its beak. The strangeness of the iconography recalls Redon and Kubin, yet the atmosphere and idiom belong entirely to Picasso—indeed, the mannerism of the image is so extreme that it would curdle in the hands of most artists.

It is one of the great mysteries of Picasso's evolution that he was so unaffected by contemporaneous Paris influences at this point in his career. We know, for example,

PAGE 94
106. Pablo Picasso (1881–1973)
The Acrobat Family, 1905
Gouache, watercolor, pastel, and ink
on cardboard, 41 × 29½ in.
Göteborgs Konstmuseum,
Göteborg, Sweden

ABOVE
107. Pablo Picasso (1881–1973)
Portrait of the Artist's Mother,
1895–96
Watercolor on paper, 12 × 9⅜ in.
Museo Picasso, Barcelona

RIGHT
108. Pablo Picasso (1881–1973)
Portrait of the Artist's Father, c. 1896
Watercolor on paper, 7 × 4⅝ in.
Museo Picasso, Barcelona

OPPOSITE
109. Pablo Picasso (1881–1973)
Woman with a Crow, 1904
Charcoal, pastel, and watercolor on
paper, 25½ × 19½ in.
The Toledo Museum of Art,
Toledo, Ohio;
Gift of Edward Drummond Libbey

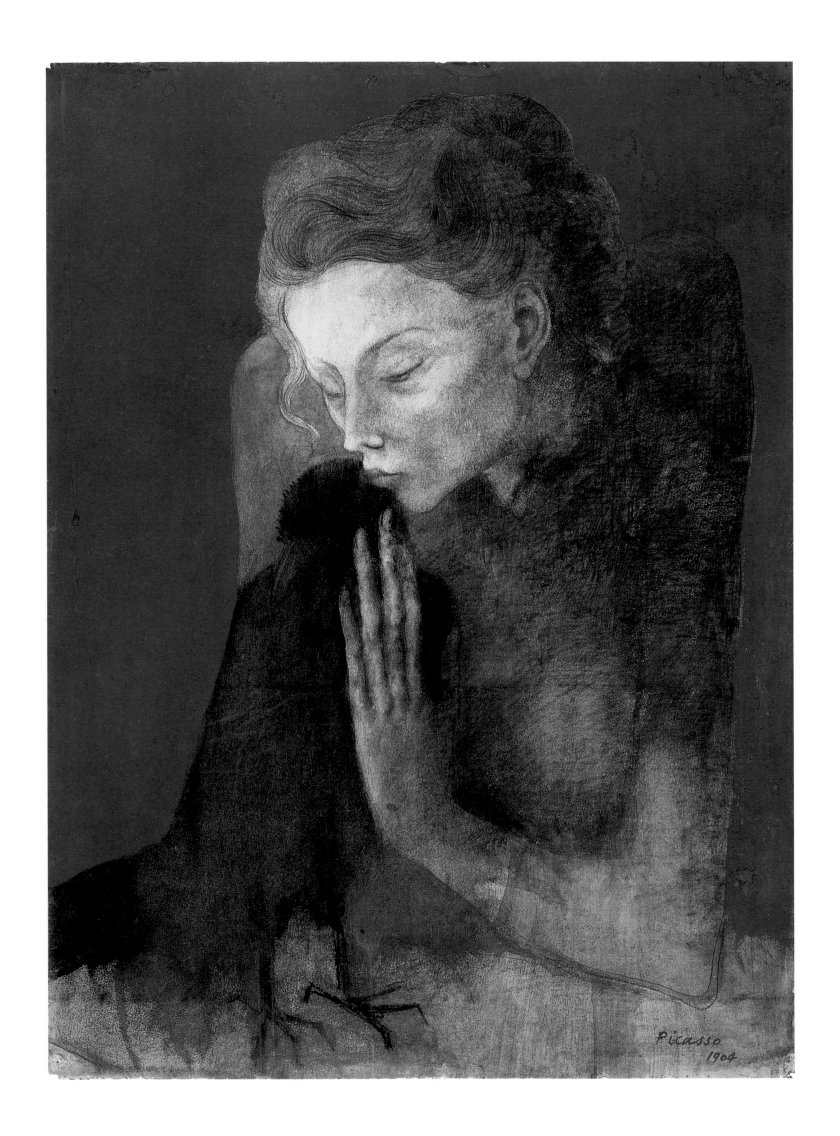

110. Pablo Picasso (1881–1973)
 Young Acrobat and Child, 1905
 Ink and gouache on cardboard,
 12⁵⁄₁₆ × 9⁷⁄₈ in.
 Solomon R. Guggenheim Museum,
 New York; Justin K. Thannhauser
 Collection

that he became acquainted with Matisse soon after moving to Paris and that he was thoroughly familiar with—and apparently approving of—the Fauves' involvement with pattern and color, yet such influences seem hardly to have touched Picasso's own work. Perhaps he was determined to establish a clear identity before opening himself to such sources. It is apparent, nonetheless, that he was vulnerable to the backwash of the international Symbolist movement and that he was contributing to the growing swell of Expressionism insofar as his work of the Blue and Pink periods is intensively subjective and capitalizes upon linear exaggeration.

These traits are also apparent in the remarkable *The Acrobat Family* (plate 106), a highly finished work that nobody but Picasso could have painted. Critics have pointed out that iconographically this is plainly a variant on the Renaissance theme of the Holy Family, made bizarre by the circus costumes and the presence of the baboon. There is nothing implausible about a circus family's being joined by a tame monkey (monkeys would continue to play a role in Picasso's universe as intelligent, almost human observers), yet there is no denying that this image remains disturbing to this day.

The technique that Picasso employed when working in watercolor and gouache during this early period was unorthodox chiefly in his willingness to mix media. This is not to say that he did not occasionally make colored wash drawings that would satisfy any purist. At the same time, however, he felt no qualms about mixing transparent color and gouache in a single image, nor about highlighting a gouache drawing with chalk or pastel. And just as Picasso casually combined media, so he freely plundered the art of the past for technical devices. Within the same sheet may be juxtaposed passages of limpid wash worthy of Bonington and areas of body color that recall the art of an eighteenth-century painter such as Nicolas Lavreince. Even in these relatively conventional works Picasso already seemed to be saying that in art the only rule is that there are no rules. Yet underlying his willfully eclectic approach was a thoroughly grounded understanding of traditional forms and idioms.

Picasso's depiction of circus people, *saltimbanques,* and characters from the commedia dell'arte links him with Rouault, who used clowns to serve similar emotional ends. It ties him even more closely to a French literary tradition—typified by poets such as Jules Laforgue and Guillaume Apollinaire—that made extensive use of the symbolism inherent in the circus and the world of the Harlequin. In this early period of Picasso's career, when he was living at the celebrated Bateau-Lavoir, he was already on friendly terms with Apollinaire, Max Jacob, André Salmon, and other poets, and sometimes his paintings are almost like illustrations of their works. It should be remembered, too, that although Picasso continued to resist the obvious influences of his Paris contemporaries, he did owe a debt, dating back to his Barcelona days, to English illustrators such as Randolph Caldecott and Aubrey Beardsley. Beardsley in particular drew on commedia dell'arte themes. What Picasso brought to these themes was a twentieth-century sense of alienation. *Young Acrobat and Child* (plate 110) conveys that sense of alienation very strongly. The acrobat's costume becomes a poignant foil for the child's tatters, and both figures seem lost in a landscape devoid of warmth. What we have here is an anticipation of the mood—sentimental yet genuinely moving—of Charlie Chaplin movies such as *The Kid.*

Sometimes the imagery becomes heavy-handed and the sentimentality cloying, as in *The Death of Harlequin* (plate 111). It may be that this image is simply too conventional, lacking the novelty provided by the baboon in *The Acrobat Family* or the acid bite of alienation in *Young Acrobat and Child.* There would soon be more than enough novelty in Picasso's work, but he was always capable of returning to academic standards. This is quite evident in the wonderfully economical sketchbook study of a nude brushing her hair (plate 112), in which the softly rounded figure is evoked with

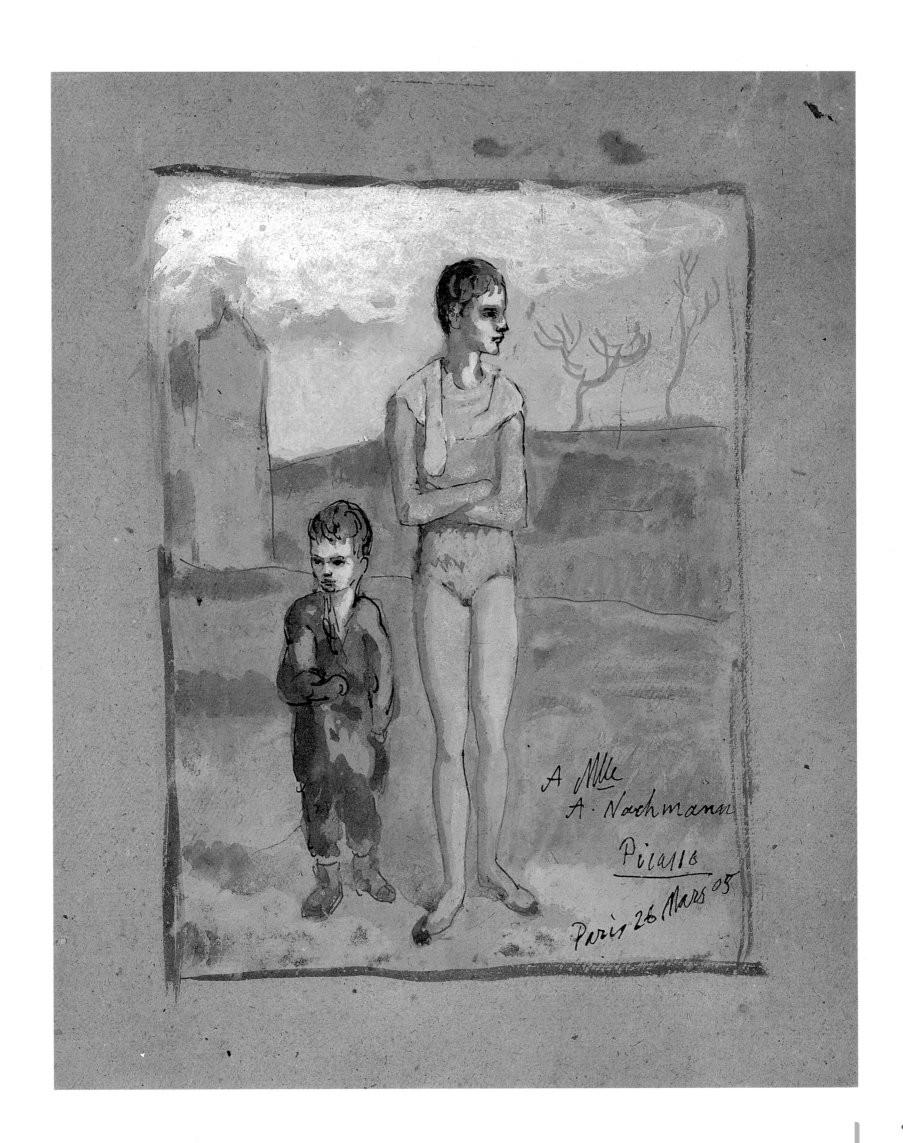

111. Pablo Picasso (1881–1973)
The Death of Harlequin, 1905–6
Gouache on cardboard,
26 × 36½ in.
Mr. and Mrs. Paul Mellon,
Upperville, Virginia

112. Pablo Picasso (1881–1973)
Sketch: Notebook No. 36, Page 58,
1905–6
Pencil and watercolor on paper,
7¼ × 5⅛ in.
Estate of the artist

deft calligraphy against a pink-washed background. Equally impressive is the gouache portrait of Leo Stein (plate 113), in which the collector's bearded face is set down with supreme confidence and with a technical facility that Sargent might have envied.

After just a couple of years in Paris, Picasso was poised on the edge of a leap into the unknown, ready to effect what would be the most radical change in painting since the rediscovery of perspective. By 1907, when he began work on the canvas that would become known as *Les Demoiselles d'Avignon,* Picasso had become more open to

114. Pablo Picasso (1881–1973)
 Study for "Les Demoiselles d'Avignon,"
 1907
 Watercolor on paper, 6¾ × 8⅝ in.
 Philadelphia Museum of Art;
 The A. E. Gallatin Collection

115. Pablo Picasso (1881–1973)
Saint Anthony and Harlequin, 1908
Watercolor on paper,
23⅛ × 18⅛ in.
Moderna Museet, Stockholm

influence. Gauguin and van Gogh had already made their mark on his work, and the 1907 Cézanne memorial exhibition came as a great revelation. Picasso had also been looking at Egyptian art and at pre-Roman Iberian sculpture, notable for their successful simplification of form, and he was becoming increasingly aware of the expressive power of African primitive carvings. With these various influences acting upon him, he set to work on *Les Demoiselles d'Avignon.* This monumental oil painting would go through substantial changes before it found its final form, and these changes would be the consequence of many studies.

Picasso has described how the painting was intended to represent a brothel in Avignon (it was André Salmon who gave it its eventual title, which Picasso disapproved of). At first there were at least two male figures in the composition, one holding a skull, but Picasso replaced them with female figures, one of which, Max Jacob insisted, looked like his own grandmother. Jacob's grandmother lived in Avignon and this is apparently one reason why the fictional brothel was given that location. Another was revealed to Daniel-Henry Kahnweiler in a 1933 interview with Picasso: "You know very well that the original title from the beginning had been *The Brothel at Avignon.* But do you know why? Because Avignon has always been a name I knew very well and is a part of my life. I lived not two steps from the Calle d'Avignon where I used to buy my paper and my watercolors."[8]

It is appropriate, then, that some of the most significant studies for *Les Dem-*

116. André Derain (1880–1954)
Study: Woman and Mountain,
c. 1907–8
Watercolor on paper, 7⅞ × 8⅞ in.
Yale University Art Gallery, New
Haven, Connecticut; Gift of Miss
Katherine S. Dreier for the
Collection Société Anonyme

oiselles were done in watercolor. A sheet in the collection of the Philadelphia Museum of Art (plate 114) presents a nearly complete study for the final painting, except that Picasso had not yet introduced the heads based on African sculpture that would give the big canvas so much of its impact. What is very clear here is the influence of Cézanne's late watercolors, which in all likelihood Picasso had recently studied at the Galerie Bernheim-Jeune. In contrast to the prominent use of opaque color in his Blue and Pink period works on paper, Picasso here followed Cézanne's example, taking advantage of the transparency of the medium to invent form by means of layering. The fragmentation of the planes resulted as much from the process he adopted as from his blatantly imitating Cézanne's imagery. To some extent, at least, the use of watercolor in studies such as this helped determine the kinds of forms that found their way onto the finished canvas, especially those in the fragmented background.

Some historians have labeled *Les Demoiselles* the first Cubist picture, while others have described it as taking a giant step toward Cubism that, impressive as it is, does not quite reach the promised land. The latter interpretation is supported by works such as *Saint Anthony and Harlequin* (plate 115), painted the following year, in which anecdotal elements derived from the Blue and Pink periods are combined with aspects of planar simplification related to Cézanne's late work. By the time Picasso arrived at Cubism proper, he had left behind the literary devices that still permitted him to incorporate one of his beloved commedia dell'arte figures into this version of the Temptation of Saint Anthony.

Other artists quickly responded to the challenge of *Les Demoiselles*. By far the most important of these was Georges Braque, who took the next major step. Unlike Picasso, however, Braque did not use watercolor as one of his everyday experimental

tools, and so his role in the drama is outside the realm of this investigation. André Derain, however—the ardent Fauve—had been drawn into Picasso's circle, and with his customary knack for rapid assimilation, he soon absorbed some of the lessons of *Les Demoiselles*. His response is apparent in *Study: Woman and Mountain* (plate 116), in which some compositional elements, such as the foreground trees, derive directly from Cézanne, while others, especially the figure itself, are seen as if through Picasso's eyes.

Picasso himself proceeded relatively slowly, and by 1909 he was still attempting to tackle the human figure in terms derived directly from Cézanne's bathers (see chapter 1). A gouache now in the Art Institute of Chicago exemplifies how Picasso combined several approaches within a single image (plate 117). The head and torso, for

117. Pablo Picasso (1881–1973)
Seated Nude, 1909
Gouache on illustration board,
24¾ × 19 in.
The Art Institute of Chicago;
Gift of Florence M. Schoenborn and
Samuel A. Marx

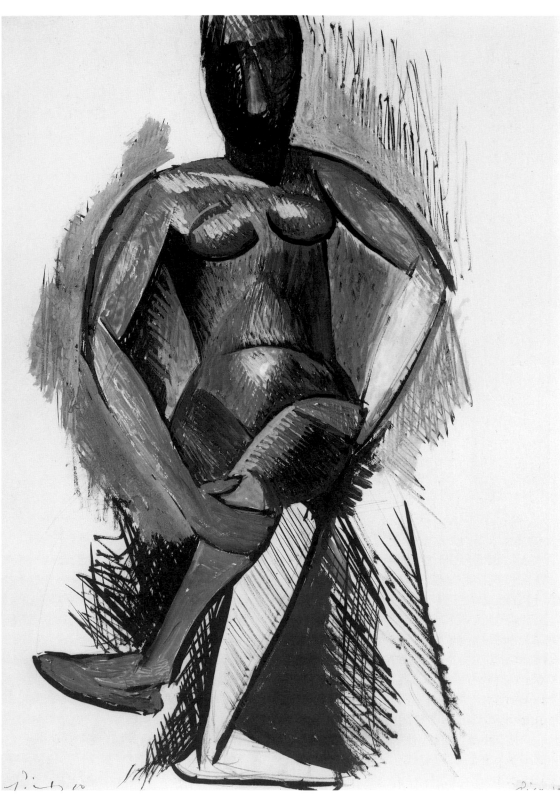

example, are heavily modeled, whereas the arms and legs are hardly modeled at all. The radical fragmentation that was to be the hallmark of full-blown Cubism is not yet in evidence. It was soon after this gouache was painted that first Braque and then Picasso began to take images completely apart and reconstruct them in entirely fresh and novel ways, a trend that had one of its culminations in the art of collage, or *papier collé*.

Much could be written about parallels between collage and watercolor, but that is beyond the scope of this text. It is worth noting, however, that Cubist *papiers collés* made frequent use of hand-painted elements, often rendered in watercolor and gouache, and it is amusing to consider some of these elements in isolation—for example, three cut-out pipes that Picasso prepared in 1912 but never used (plates 118–20). These pipes can tell the careful observer much about the language of Cubism. Look, for instance, at the way Picasso deployed circles, semicircles, and ellipses in various configurations to suggest foreshortening, multiple viewpoints, and so on. These devices demonstrate that one of Cubism's achievements was finding new ways to render individual objects, even when those objects were not being torn apart and reassembled. At one level this new way of representing objects was the consequence of planar simplification, deriving from practices established by Cézanne, notably in his watercolors. At another level, however, it was the offshoot of Cubism's more radical procedures, such as the utilization of multiple viewpoints.

Cubist "distortion" in its mildest form can be found in such works by Juan Gris as *Three Lamps* (plate 121). A younger compatriot of Picasso and a fellow tenant at the Bateau-Lavoir, Gris was intimately familiar with Picasso's experiments, but relatively slow to join in them. This slowness was apparently not because of lack of interest but because temperamentally he preferred analysis to experimentation. Gris was most comfortable with Cubism when it reached its Analytical and Synthetic phases, but from the time he began painting seriously at the Bateau-Lavoir, his exposure to Picasso's and Braque's work so affected his way of seeing things that even straightforward subjects such as *Three Lamps* have a distinctly Cubist edge. This is evident in the use of multiple light sources in the painting, which allowed the artist to "reconstruct" the image in more abstract terms by stressing the geometric patterns of light and shade.

By 1913 Gris had achieved a far higher degree of sophistication, and his synthesizing instincts came to the fore. If *Still Life with Guitar* (plate 122) were not so skillfully carpentered, it would be almost a parody of Cubist art, right down to its use of the guitar as central icon. Gris is so serious and authoritative, however, that parody is avoided in favor of a concise summation of Cubism in its most classical phase. Whereas Braque and Picasso proceeded from the particular—a guitar, a bottle, a pipe—toward the abstract, Gris tended to work in the opposite direction, starting with the overall concept and then, when the composition was firmly established, particularizing certain items.[9] In the case of *Still Life with Guitar,* Gris started not by analyzing a particular

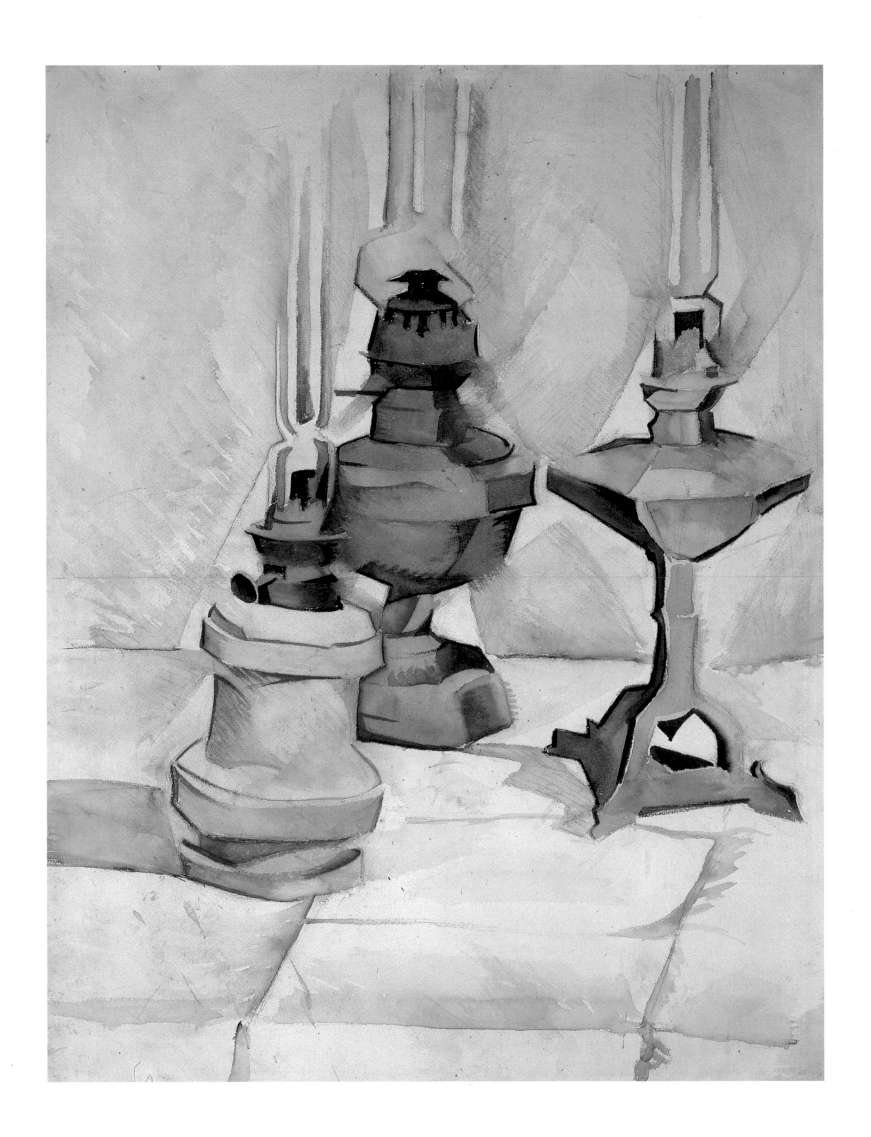

group of objects but by devising a geometrical foundation that provided the image with its structure. Only when the structure was established did he introduce the objects that give the piece its title, and even then they serve a secondary, almost decorative purpose. (It is no accident that Gris had a particularly potent influence on posters and other branches of commercial art. His synthetic version of Cubism—one that approached abstraction—could easily be combined with the decorative and made to accommodate a Pernod bottle, for example, or the suggestive silhouette of an aperitif glass.)

By comparison, *Pipe, Glass, Bottle of Rum* (plate 123)—fragmented as it is—has a spatial integrity that derives from the subject itself. To oversimplify, it is as if Picasso looked at a still life on a tabletop, chopped it up, and then reassembled it. The forms

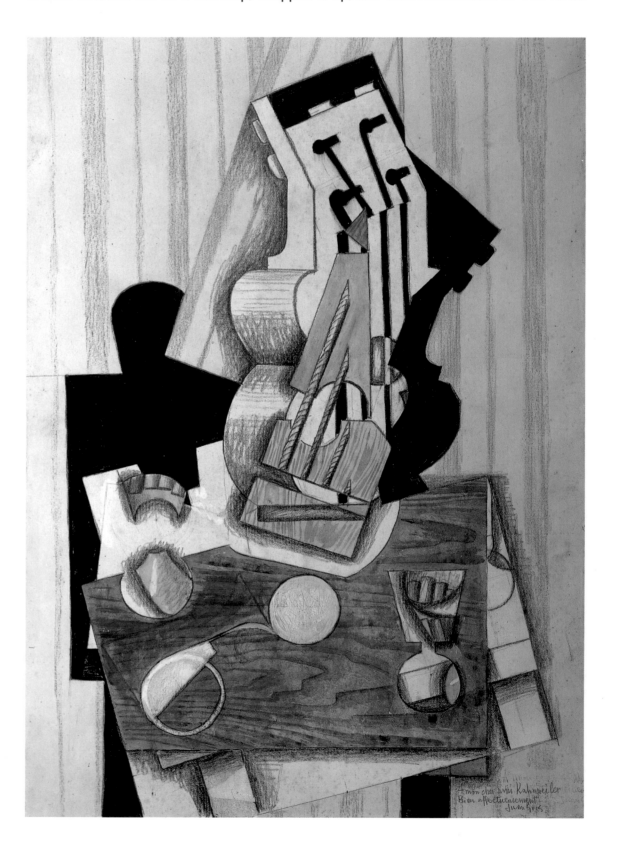

122. Juan Gris (1887–1927)
Still Life with Guitar, 1913
Watercolor, gouache, and charcoal
on paper, 25⅝ × 18¼ in.
Private collection

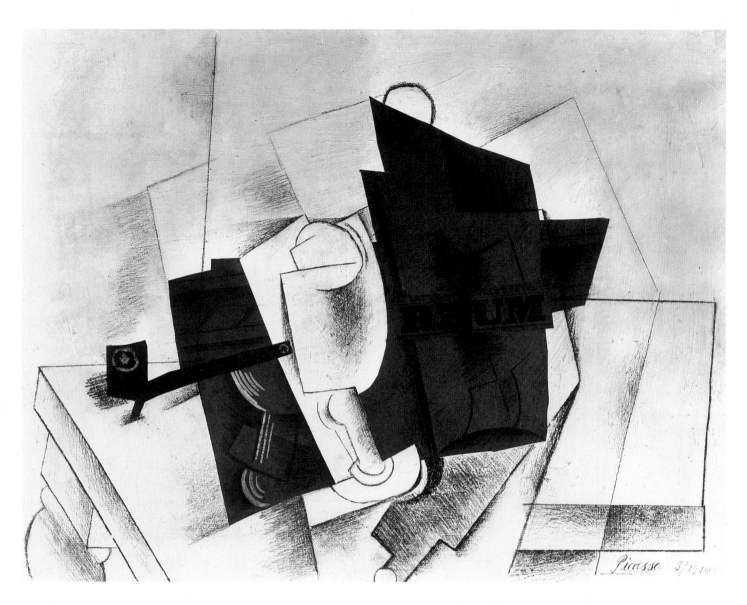

have been shuffled but the sum of the parts is still the same. By reversing the procedure a clever artist might create a convincing conventional still life. Such a reversal would not work for Gris's mature paintings; it would produce, instead, a few objects devoid of context plus a powerful abstract design related not to still life but to the evolution of nonfigurative art. Such a comparison illuminates why Picasso, throughout his life, denied that he had ever made an abstract painting. Some of his notebook sketches from the Synthetic Cubist period (plates 124, 125) seem very close to abstraction, but that is generally because he apparently felt no compulsion to provide much visual information in these informal works. Close inspection generally reveals their origins in observed reality, and certain series of drawings demonstrate clearly how he moved from observed reality toward the fragmentation and then the restructuring of form. Such restructuring could be radical, as in the splendid *Woman in an Armchair* (plate 126), but it was always the end result of a logical process that had its beginning in the everyday world. Much the same can be said of Braque's *Musical Forms* (plate 127), which belongs only marginally to the history of watercolor but demands a place here nonetheless, in order to represent the other progenitor of Cubism.

Fernand Léger is another major figure who is conventionally, and correctly, counted among the Cubists, although his work differs greatly from that of Picasso, Braque, and Gris in emphasis and ambition. An exact contemporary of Picasso, Léger trained as an architect, and a strongly architectural sense of form marked his work almost from the beginning. Like the other Cubists, he was inspired by the Cézanne show of 1907, and his early efforts tend to emphasize, in exaggerated form, Cézanne's

123. Pablo Picasso (1881–1973)
Pipe, Glass, Bottle of Rum, 1914
Pasted paper, pencil, and gouache on cardboard, 15¾ × 20¾ in.
Collection, The Museum of Modern Art, New York; Gift of Mr. and Mrs. Daniel Saidenberg

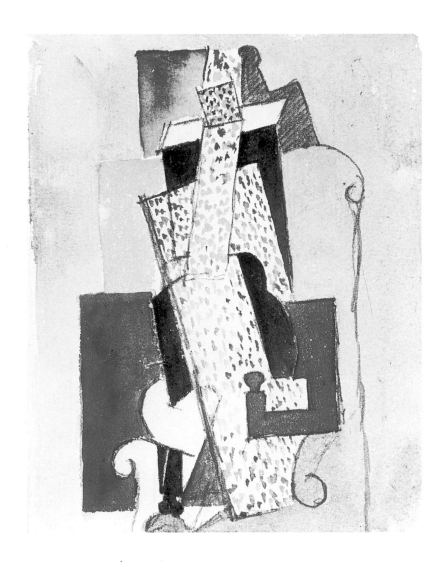

ABOVE, LEFT
124. Pablo Picasso (1881–1973)
Sketch: Notebook No. 57, Page 18,
1915
Watercolor and crayon on paper,
16 × 14 in.
Estate of the artist

ABOVE, RIGHT
125. Pablo Picasso (1881–1973)
Sketch: Notebook No. 57, Page 19,
1915
Watercolor and crayon on paper,
16 × 14 in.
Estate of the artist

RIGHT
126. Pablo Picasso (1881–1973)
Woman in an Armchair, 1916
Pencil, gouache, and watercolor on
paper, 6 × 4⅞ in.
The Art Institute of Chicago; Gift of
Robert Allerton

127. Georges Braque (1882–1963)
 Musical Forms, 1918
 Pasted paper, corrugated cardboard,
 charcoal, and gouache on paper,
 30⅜ × 37⅜ in.
 Philadelphia Museum of Art; The
 Louise and Walter Arensberg
 Collection

128. Fernand Léger (1881–1955)
Study for Woman in Red and Green,
1913
Watercolor and gouache on paper,
24½ × 18½ in.
Philadelphia Museum of Art;
The A. E. Gallatin Collection

simplification of form into spheres, cubes, cones, tubes, and so on. (Indeed, Léger's art was mockingly dubbed "tubism.") *Study for Woman in Red and Green* (plate 128) can usefully be compared with Picasso's *Seated Nude* (plate 117), painted four years earlier. Both clearly derive from Cézanne, yet the Picasso, as already noted, displays a varied approach to representing volume. The lack of modeling in key areas emphasizes the flatness and patterning that would become a major aspect of later Cubism. Léger, by contrast, modeled everything, emphasizing volume and creating a figure that rather resembles a robot or a Joan of Arc in futuristic armor.

World War I had a profound effect on Léger's art, both because of what he saw at the front and because his experience there brought him in touch with members of the working class, whom he began to envisage as the ideal audience for his new art. In his study of a crashed biplane (plate 129) the fragmentation of the aircraft that had occurred on impact made the subject itself cubistic; Léger had to perform only minimal

adjustments. The treatment is rather loose, as if this was painted hurriedly on the spot, but the rapidity of the execution highlights the sureness of Léger's touch with watercolor and gouache. An especially fine World War I painting is *Landscape of the Front* (plate 130), in which the trenches, bomb craters, and scaling ladders of the front line are reduced to a powerful abstract landscape that points beyond Cubism.

After the war Léger attempted to combine his new philosophy of "art for the people" with his Cubist-derived plastic language to create a celebration of the modern world. His famous painting *La Ville,* now in the Philadelphia Museum of Art, employs a foundation of vertical stripes not unlike that found in some paintings by Juan Gris. But in Léger's work the foundation takes on an architectural significance and is combined with robotlike human forms, mechanistic fragments, and elements resembling advertising signs to create an impression of a city. The watercolor study for the painting reproduced here (plate 131) represents only one segment of the whole, emphasizing structural and abstract elements rather than the iconography. It is, however, a powerful little painting in its own right.

Equally fascinated with the dynamics of the modern world was Robert Delaunay, another artist who evolved his own variant on Cubism. Sometimes called Orphic Cubism, it developed alongside the Cubism of Picasso and Braque, rather than deriving from it (though clearly there was a point at which their methods interacted). Like Picasso and Braque, Delaunay had been much impressed by Cézanne's watercolors in 1907, but this influence is most fully felt in his oils. Delaunay did, however, make some fascinating

129. Fernand Léger (1881–1955)
 The Broken Airplane, c. 1916
 Wash and gouache on paper,
 9¾ × 12 in.
 Musée National Fernand Léger,
 Biot, France

large-scale watercolors, such as *Homage to Blériot* (plate 132). In this oversize sheet airplanes and a distant view of the Eiffel Tower are combined with concentric colored circles, reminding the viewer that Delaunay was one of the earliest artists to achieve a wholly abstract art.

The somewhat later *Study for Portrait of Philippe Soupault* (plate 133)—more than six feet tall—is an example of another aspect of Delaunay's eclectic art: his ability to convincingly combine relatively naturalistic imagery with imagery that has undergone radical fragmentation. Here the device of showing the cubistic Eiffel Tower through a window facilitates the passage between two interpretations of space contained within a single canvas.

Among the lesser Cubists was Albert Gleizes, who also responded to the excitement of city life. On the first night of a visit to New York he found himself in a

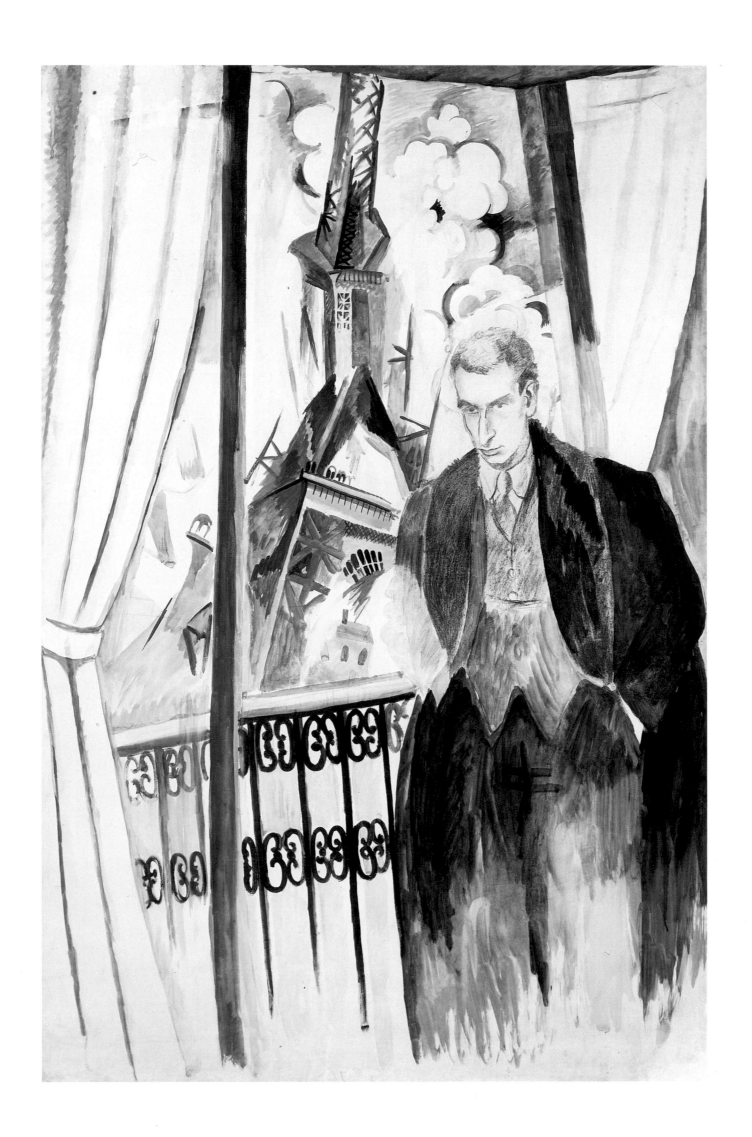

Harlem nightclub and, bowled over by the music, translated that impression into *Composition (for "Jazz")* (plate 134), a fragmented banjo player conceived largely in energetic diagonals. More successful, perhaps, is *Kelly Springfield* (plate 135), a composition based on Times Square architecture superimposed with a Kelly Springfield tire sign seen from behind. Compared with the work of Picasso and Léger, this is a very schematic version of Cubism, though not without period charm. Other followers of the Cubist pioneers were content to refine the vocabulary, sometimes with agreeable results. The Polish-born Louis Marcoussis, for example, produced some handsome paintings, including *Still*

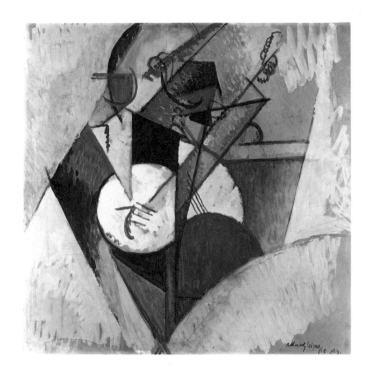

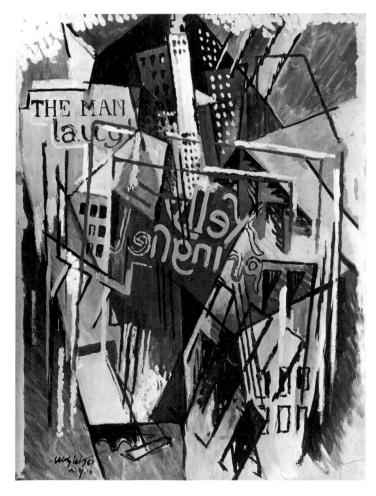

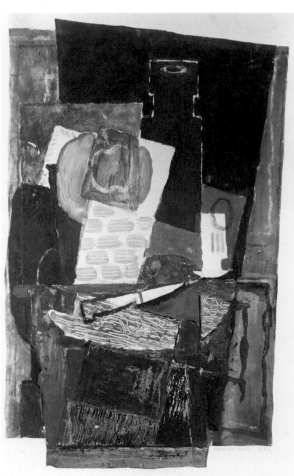

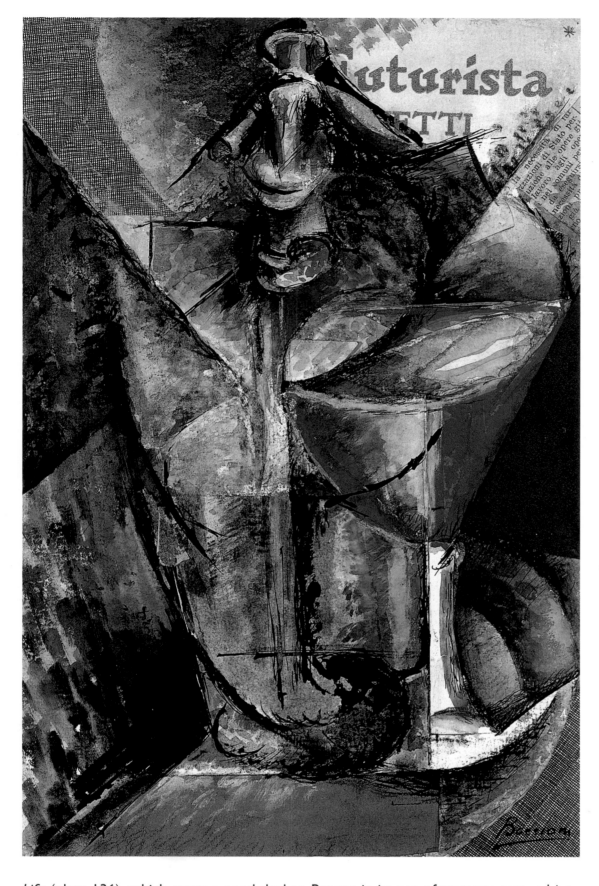

137. Umberto Boccioni (1882–1916)
Still Life, c. 1914
Collage, gouache, pen and ink,
newspaper, and colored paper,
12¼ × 8⅜ in.
Yale University Art Gallery,
New Haven, Connecticut; Gift of
Miss Katherine S. Dreier for the
Collection Société Anonyme

Life (plate 136), which owes a good deal to Braque in its use of textures scraped into the paint, yet retains a distinctive personal inflection.

Best known of the groups that took their lead from the Cubists were the Italian Futurists. Under the leadership of Filippo Marinetti, the Futurists preached the overthrow of the academies and sought to portray the brash new energy of a world transformed by airplanes and automobiles. At the same time, however, Umberto Boccioni's *Still Life* (plate 137) shows that a basic understanding of Cubist principles was essential to their program. More typically, the Futurists sought to represent movement

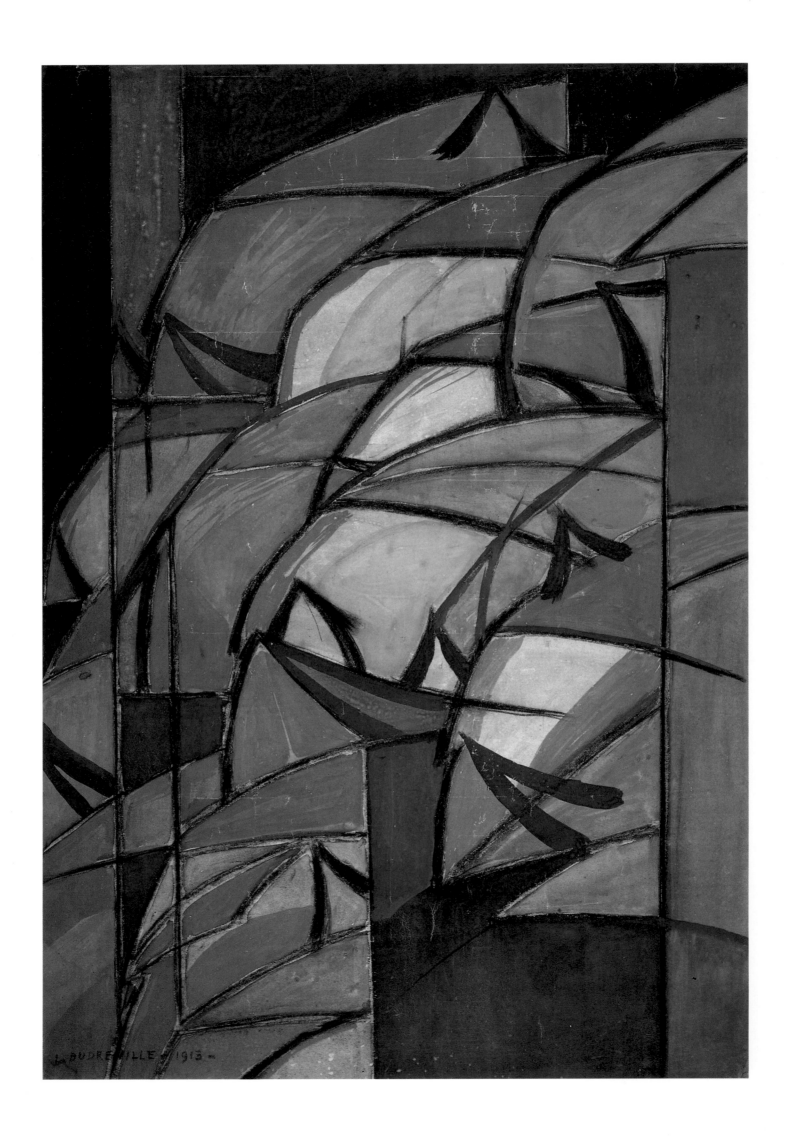

by adapting Cubist devices to record the passage of beings or objects through space. Of the major Futurists, it was Boccioni who made the most effective use of watercolor, but some secondary figures employed the medium to good effect as well. Leonardo Dudreville, for example, was a Milan-based writer, musician, and artist who produced a few beautiful watercolors, such as *Rhythm from Antonio Sant'Elia* (plate 138), named for the great Futurist visionary architect.

Like the Futurists, and like his brother Marcel Duchamp (notorious for his cubistic *Nude Descending a Staircase*), the French artist Jacques Villon sometimes used the fragmentation of form as a way to convey a sense of movement, as in *Jockey Series, No. 4* (plate 139), which demonstrates how, by the 1920s, the Cubist revolution had been undermined by artists whose approach had become overly decorative or analytical.

Analysis had always been a part of Cubism, of course, but in the greatest works analysis was combined with a sensual pleasure in the act of fabrication. That pleasure was continued in the works of Picasso and Braque, but among peripheral figures it was kept alive most effectively by the sculptors who were influenced by Cubism. The Paris-based Ukrainian Alexander Archipenko made some fine gouaches (plates 140, 141) that relate back to the early inventions of Cubism and forward to the "sculpto-paintings"— assemblages of various materials combined with two-dimensional backgrounds—that Archipenko made in the 1920s. As late as the 1940s Picasso's friend Julio González was producing enigmatic and inventive drawings and watercolors imbued with what might best be described as a post-Cubist spirit. In a sense these can be seen as studies for unmade sculptures, but many of them—for example, *Standing Woman* (plate 142)— provide the imaginary sculpture with a fully realized setting that turns the study into a full-fledged painting.

Picasso aside, the Cubists did not contribute much to the evolution of water-color, except—and from an art historical point of view this is by no means negligible— to the extent that they directed attention to Cézanne's watercolors. Watercolor's transparency had served Cézanne well, especially in his exploration of the geometrical

OPPOSITE

138. Leonardo Dudreville (1885–1975)
 Rhythm from Antonio Sant'Elia, 1913
 Gouache and mixed media on paper,
 25⅜ × 17¾ in.
 Mr. and Mrs. N. Richard Miller

139. Jacques Villon (1875–1963)
 Jockey Series, No. 4, 1921
 Watercolor, pencil, and black and red
 ink on tissue paper, 15½ × 21¾ in.
 Yale University Art Gallery,
 New Haven, Connecticut; Gift of
 Miss Katherine S. Dreier for the
 Collection Société Anonyme

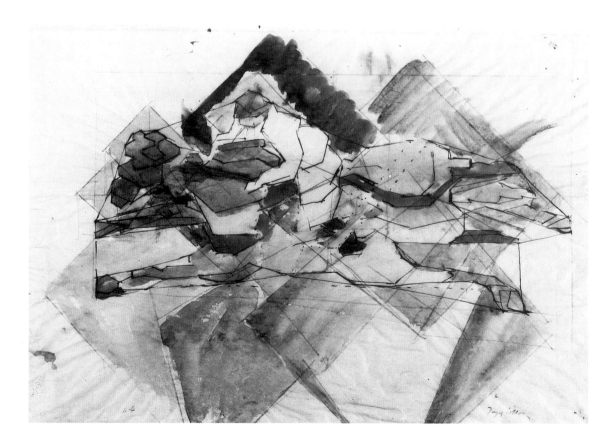

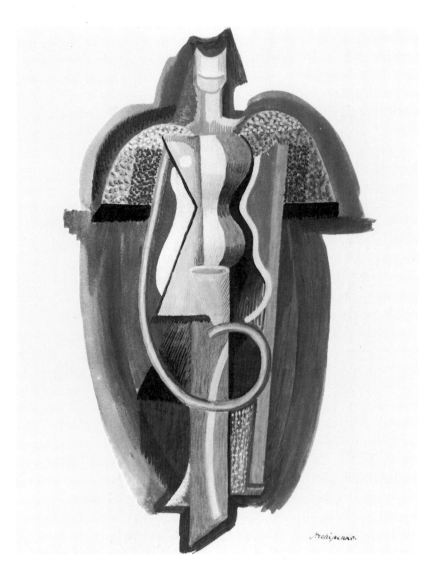

140. Alexander Archipenko (1887–1964)
Figure, c. 1918–19
Gouache on paper, 11⅛ × 8⅜ in.
Yale University Art Gallery,
New Haven, Connecticut; Gift of
Miss Katherine S. Dreier for the
Collection Société Anonyme

141. Alexander Archipenko (1887–1964)
Composition, 1920
Gouache, watercolor, and pencil on
paper, 12½ × 9½ in.
Hirshhorn Museum and Sculpture
Garden, Smithsonian Institution,
Washington, D.C.; Gift of
Joseph H. Hirshhorn, 1972

OPPOSITE
142. Julio González (1876–1942)
Standing Woman, c. 1941
Watercolor, brush, and pen and ink
on paper, 12½ × 9⅝ in.
Collection, The Museum of Modern
Art, New York; Gift of the James S.
and Marvelle W. Adams Foundation

structure underlying natural forms. By looking at his watercolors the Cubists learned much about the ways reality could be deconstructed. Theirs, however, was an art of reconstruction, and for the most part they seem to have felt that their restructured vision of reality would be more convincing if it appeared solid rather than translucent. Braque is perhaps the quintessential Cubist painter, and it was no accident that he sometimes mixed his oil paint with sand or gravel, producing a texture that is the exact opposite of a limpid watercolor wash. And if Braque is the quintessential Cubist painter, then collage is the classic Cubist medium, and it derives its special strength from the introduction of palpably "real" elements—wood veneer, newspaper clippings, bus tickets—that give authority and solidity to unexpected juxtapositions and dislocations.

Cézanne might well have been horrified by Cubism in general and by collage in particular. Gluing an empty Gauloise pack to the support is certainly at odds with the subtle explorations of his watercolor still lifes. This is not to suggest that one approach is right and the other wrong, merely that they are different. That difference in part explains why the Cubists—much as they admired Cézanne's watercolors and learned from them—did not, for the most part, become important watercolorists themselves. But it should be added that Cubism as a whole would be felt as a major influence by many significant watercolorists—including Macke, Klee, and George Grosz—who did not participate in the movement itself but carried forward aspects of its program.

CHAPTER FIVE

ABSTRACTION

Given the benefit of almost a century of hindsight, it is easy to see that there was no single route to abstract art and that many artists heralded its coming. Certainly the Fauves, and Matisse in particular, set the stage by establishing the integrity of the picture plane and by implicitly questioning the validity of conventional forms of representation. It can be argued, in fact, that Matisse's achievements were so advanced that they were not fully absorbed until half a century later, when American color-field painters such as Ellsworth Kelly and Morris Louis carried them to a logical conclusion (not necessarily the only one). The Symbolist-Expressionist tradition also had a profound influence on the evolution of nonfigurative art, as did Cubism. Symbolists and Expressionists had emphasized such notions as the use of color, line, and form to express emotional states, independent of any descriptive functions they might also fulfill. The next step was to strip descriptive function away entirely and leave the raw plastic elements. The problem then became what forms should be conjured up to populate these nonreferential sheets and canvases. For many artists it was Cubism that supplied the clue, since its fragmentation of form had evolved into a nonpictorial geometry that was, in part at least, self-sufficient. Cubism, like Fauvism, respected the integrity of the picture plane, though Cubist paintings tended to exploit a shallow, boxlike space rather than the absolute flatness found in Matisse's most extreme work.

With one notable exception, the artists who first crossed the frontier into the field of pure abstraction were restless figures who did not feel entirely at home in any of the established modernist groups but who tended to find sustenance in some or all of them. (It stands to reason that a successful and contented Cubist, for example, would have been likely to continue exploring the possibilities of Cubism rather than pushing on to entirely fresh challenges.)

A restless figure of this type was Francis Picabia, who must be counted among the fathers of abstraction on the strength of the watercolor *Rubber* (plate 144), which if not the first abstraction painted by a major artist was certainly close to it. Picabia was working in the context of the School of Paris, remaining open to its divergent currents of influence without ever aligning himself with any particular movement. He was also intrigued by the idea, fashionable in the early part of the century, that painting could be made analogous to music, with color harmonies and such substituting for combinations of musical tones. Most artists bandied about such theories without actually making the leap past figuration. Picabia was a little braver, but even he was cautious enough to make his first experiments in this direction on a small scale, on paper, and in the inexpensive medium of watercolor. Picabia pursued abstraction for some time, but his

instincts carried him in directions best discussed in another context, and so his case will be picked up again in the next chapter.

More central to the evolution of nonfigurative art was Wassily Kandinsky, whose paintings and theories were to have a major impact on the course of modernism. Kandinsky did not turn to art full time until he was thirty years old. The year was 1896 and, abandoning a promising legal career, he left Russia for Munich, where he began his studies with Anton Azbé and Franz von Stuck. From the beginning he felt himself to be above the academic infighting of the day, finding inspiration instead in Russian folk art, medieval legends, the music of Wagner, and Impressionist painting. A born organizer, he put together various groups of artists that opposed conservative tendencies and sponsored important exhibitions of modernist art, making younger German artists aware of recent tendencies in Paris and elsewhere. (Kandinsky himself spent time in France and exhibited with progressives there from 1905 onward.)

From the first, then, Kandinsky was deeply involved in the evolution of German Expressionism, yet he brought to the movement a very personal temperament that can perhaps be traced to his Russian origins. Early in the century he painted pictures that had an almost tapestrylike quality, the figurative elements—often borrowed from history or legend—being set down in flat patches of nondescriptive color that obviously

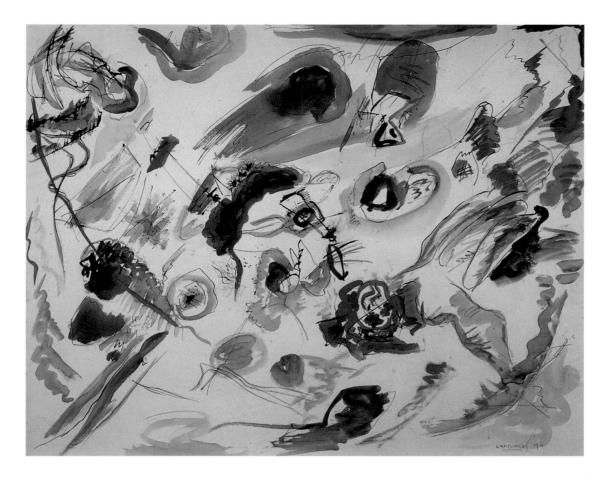

linked his work to that of the Fauves, with whom he sometimes exhibited. Gradually his forms became more organic, and his color, sometimes broken up into Post-Impressionist dabs, took on a more independent and symbolic role. Like Picabia, he was fascinated by possible parallels between the art of painting and the art of music, and by c. 1910, when Kandinsky painted *Horsemen on the Shore* (plate 147), he was on the verge of breaking through to pure abstraction. In this painting it is easy enough to make out two riders on horseback and a steamboat on the horizon, but the forms have become almost independent of context and are ready to be set free from all referential duties. The looseness with which the artist used the watercolor medium—blotted dabs of wash floating free against the off-white ground—tends to emphasize his movement away from representation for its own sake.

The exact moment at which Kandinsky broke through to full-fledged abstraction is open to speculation, but it seems that a smallish untitled watercolor presented to the French government by his widow was his first nonfigurative work (plate 145). Kandinsky had rediscovered this painting among his belongings during the mid-1920s, at which time he declared it to be his first abstract watercolor and dated it from memory as having been painted in 1910. On other occasions, however, he declared that his breakthrough to abstraction occurred in 1911, and some experts have assigned this watercolor a date as late as 1913. In all probability the matter will never be settled to everyone's satisfaction, but the fact is that Kandinsky was undoubtedly one of the pioneers of abstraction, and he arrived at that point by way of a very personal course that made considerable use of watercolor.

By 1909 Kandinsky had begun to describe many of his paintings as "improvisations," and it seems that watercolor proved to be the ideal medium for achieving the extemporaneous quality he sought. No medium is more responsive. The watercolor brush moves easily across the paper support, and the least inflection of the wrist will produce variations in thrust and texture that on a small scale can carry great compositional weight. Kandinsky was entering territory that no one had ever explored before.

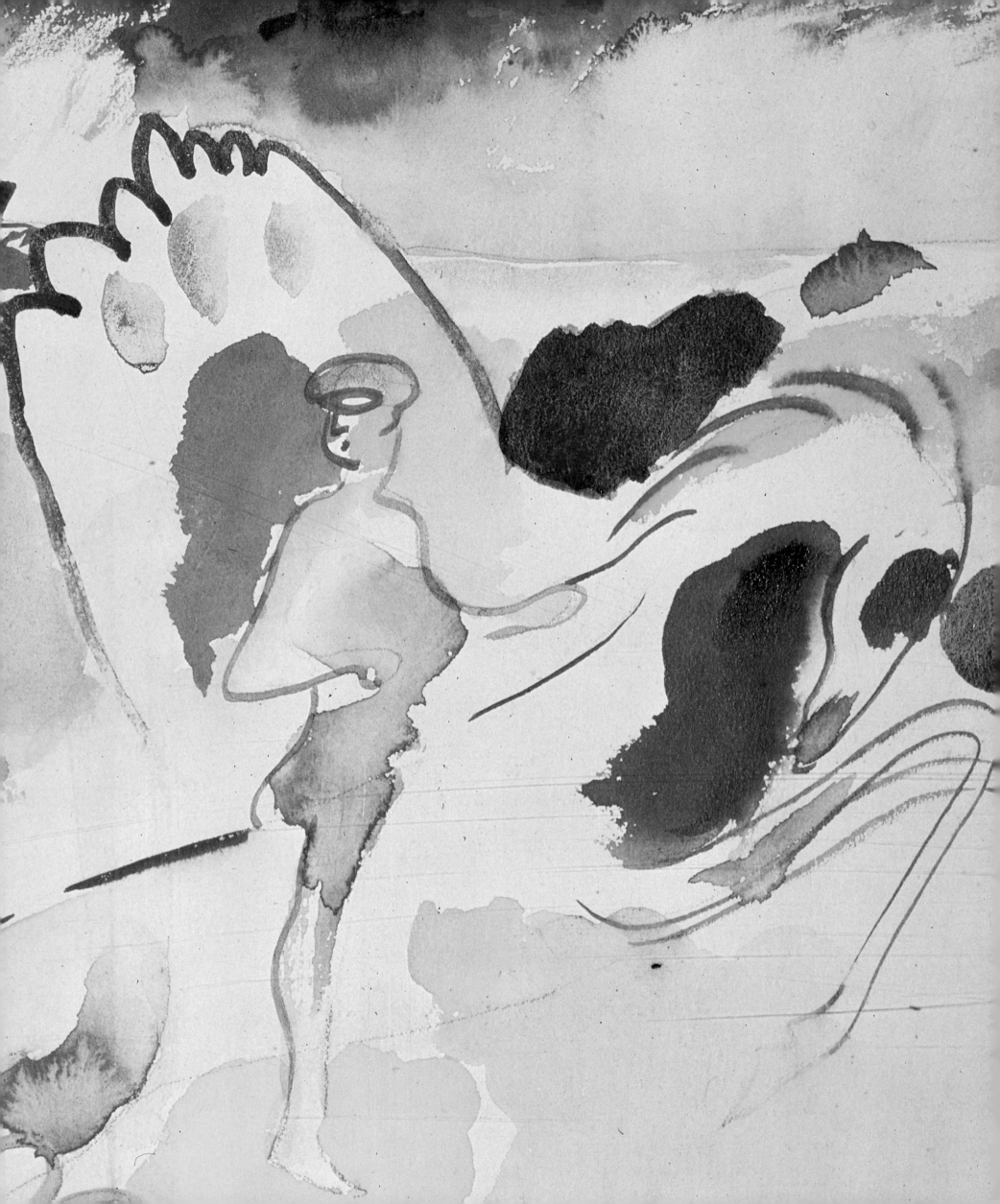

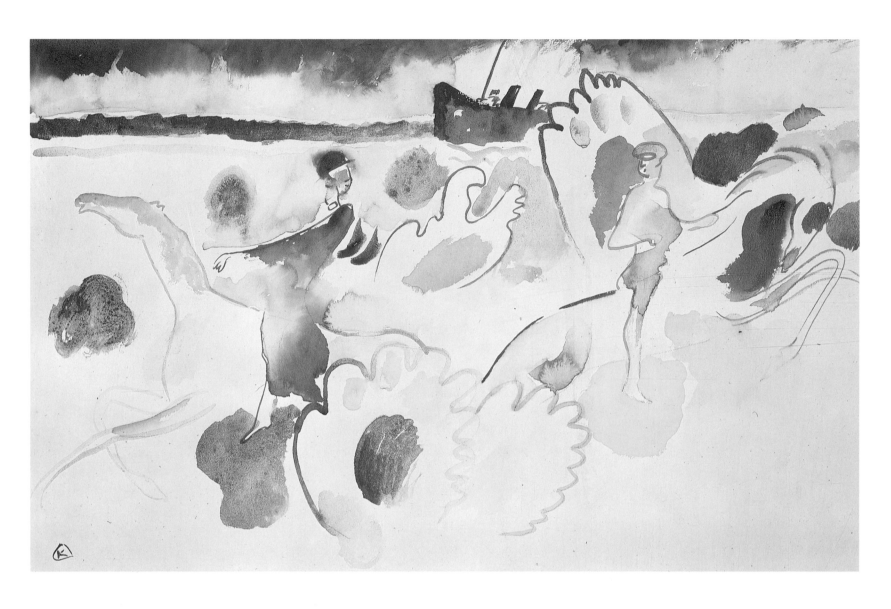

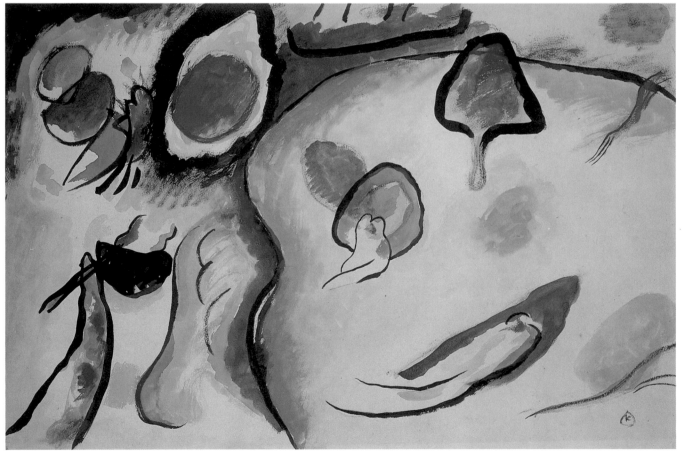

149. Wassily Kandinsky (1866–1944)
Study for "Painting with White Border,"
1913
Watercolor, wash, india ink, and
pencil on paper, 5 × 13¼ in.
The Hilla von Rebay Foundation;
Solomon R. Guggenheim Museum,
New York

Watercolor provided him with the means to cross the border into that new realm and helped give him the confidence to push on. (Since a mistake made on a sheet of paper can be cast aside without qualms, watercolor encourages the taking of risks.) Along the way, Kandinsky discovered the intrinsic qualities of watercolor, and he continued to use the medium prolifically throughout his career, long after experiment had ceased to be the issue. Often he would use watercolor to initiate ideas that would be resolved as oil paintings, but just as frequently he employed the medium for its own sake.

Kandinsky's evolution from figurative expressionism was so gradual that inevitably many forms—or habitual ways of describing forms—carried over into his abstract art, so that sometimes the viewer perceives references to the real world that may or may not have been intended. *Study for "Improvisation 25 (Garden of Love I)"* (plate 148), for example, is at first glance a very free organization of organic shapes that have no basis in the physical world, yet after a little study it is difficult not to find the large shape that dominates the right side of the canvas metamorphosing into an artist's palette, complete with thumb hole. Similarly, *Study for "Painting with White Border"* (plate 149) contains elements that suggest landscape, yet at the same time it is essentially nonfigurative. It may, in fact, be an improvised variation on another drawing since it seems to have been Kandinsky's practice to make many watercolor studies for individual works, often moving further and further from the figurative source until the composition was emptied of reference.

By about 1917 Kandinsky seems to have reached a point where forms emerged spontaneously from his subconscious, products of a kind of automatic drawing. No longer reliant upon the habits acquired during his figurative period, he had achieved an extraordinary independence from the art of the past. Kandinsky played a key role in the evolution of modernism, and the watercolors he painted in the teens have a special place in the pantheon of twentieth-century art.

Watercolor was also much favored by a group of proto-abstractionists based in England, of all places. Despite having produced forebears of modernism such as Turner, Constable, and Blake, England had figured hardly at all in the revolutions that followed Impressionism, although the Pre-Raphaelites had had an impact on Symbolism, and illustrators such as Aubrey Beardsley were widely admired. The fact that Roger Fry had introduced Post-Impressionism to Bloomsbury society at the Grafton Galleries in 1910 hardly placed London in the vanguard. Yet just three years later a group of British artists and intellectuals, headed by Wyndham Lewis—a brilliant satirist and polemicist as well

CLOCKWISE FROM TOP LEFT

150. Frederick Etchells (1886–1973)
Composition: Stilts, 1914–15
Gouache and pencil on paper,
12⅜ × 9 in.
The British Council, London

151. Helen Saunders (1885–1963)
*Abstract Composition in Blue and
Yellow,* c. 1915
Chalk, wash, pencil, and collage on
paper, 10⅞ × 6¾ in.
Tate Gallery, London

152. Edward Wadsworth (1889–1949)
Abstract Composition, 1915
Ink and gouache on paper,
16½ × 13½ in.
Tate Gallery, London

as a painter—was challenging the most advanced positions held on the Continent. Aided by Americans such as Ezra Pound and T. S. Eliot, Lewis launched the Vorticist movement, which proclaimed its aims in the two issues of the formidable publication *Blast: Review of the Great English Vortex.* Lewis perceived Cubism and Futurism as insufficiently radical, and while his own nonfigurative works, such as *Composition* (plate 143), derived their geometry from Cubism and their energy from Futurism, he pursued a vision that was remarkably original, anticipating by a year or more similar innovations by some of the Russian avant-garde. Followers of Lewis—including Frederick Etchells, Helen Saunders, Edward Wadsworth, and Cuthbert Hamilton—also produced handsome abstractions in the same geometric idiom (plates 150–53), but the advent of World War I destroyed the momentum of the group and English provincialism soon reasserted itself.

English provincialism may actually have contributed to the preponderance of small-scale works, including watercolors, produced under the auspices of Vorticism. Some members of the Vorticist circle, such as David Bomberg and William Roberts, did prove themselves to be capable of working in oils and on a relatively large scale. But London—compared with Paris or Munich or Vienna—provided very few outlets for the exhibition of avant-garde work. A Vorticist exhibition was staged in 1915, but *Blast* was the most effective means the Vorticists had of spreading their message, and much of their work has the look of having been made for black and white reproduction. Indeed, for half a century many of these works were known to the general public only as black and white reproductions, and when recent exhibitions and publications revealed

OPPOSITE

153. Cuthbert Hamilton (1884–1959)
 Reconstruction, c. 1919–20
 Gouache and drawing on paper,
 22 × 16½ in.
 Tate Gallery, London

154. Enrico Prampolini (1894–1956)
 Abstract Still Life, 1919
 Watercolor, ink, and pencil on paper,
 6⅛ × 5⅞ in.
 Yale University Art Gallery,
 New Haven, Connecticut; Gift of
 Miss Katherine S. Dreier for the
 Collection Société Anonyme

that many of the Vorticist watercolors were chromatically as well as stylistically lively, it came as a pleasant surprise. Almost always, however, it is structure rather than any other element that carries the image, and so watercolor tends to play a supplementary rather than dominant role in these remarkable pioneering works.

The vigor of the Vorticists at their best can be judged by comparing their work with that of a second-generation Futurist such as Enrico Prampolini (plate 154). By the end of World War I (during which he had contact with the Zurich Dada group), Prampolini was beginning to forge an elegant form of abstraction derived in large part from Cubist geometrics. His paintings have an air of classical coolness that seems at odds with his political stance: Prampolini was a polemicist whose pamphlets flaunted titles such as *Bomb the Academies.*

A more genuinely revolutionary art was taking shape in Russia, where young artists responded to developments in the West by wedding the new iconography to the euphoric idealism that accompanied the October Revolution. Alexander Rodchen-

158. El Lissitzky (1890–1941)
Proun 1A, Bridge 1, 1919
Gouache on paper,
3⅜ × 5⅞ in. (sight)
Mr. and Mrs. Eric Estorick, London

159. El Lissitzky (1890–1941)
Proun, 1920
Gouache and watercolor on paper,
15⅜ × 15⅞ in.
Indiana University Art Museum,
Bloomington; Jane and Roger
Wolcott Memorial

160. El Lissitzky (1890–1941)
Proun, before 1924
Pen and ink, watercolor, and various
types of applied paper,
25½ × 19½ in.
Museum of Art, Rhode Island School
of Design, Providence; Museum
Appropriation

ko's early *Cubo-Futurist Composition* (plate 156) shows that this Russian art had its roots in Parisian experiments, but jumping ahead to his 1918 abstract *Composition* (plate 155) makes it clear that Rodchenko and his compatriots quickly turned the language of modernism to new ends. Rodchenko is among those artists who have been called Constructivists, and for once this art historical label seems to be a satisfactory description. Matisse, Picasso, Braque, and the other School of Paris innovators had employed a largely analytical approach to arrive at a new visual vocabulary and syntax. Artists such as Rodchenko felt they could take that vocabulary and syntax for granted. They were inclined to use the new language as an opportunity for constructing radically novel forms and images rather than as an occasion for further analysis. So it is that in Rodchenko's

Composition geometry was set free from all descriptive chores, becoming a sublime Tinkertoy which the artist could use freely to invent nonobjective icons.

Often the results of such invention were architectural in nature, as in Liubov Popova's gouache *Abstractions* (plate 157). This composition (which is surprisingly painterly by Constructivist standards) illustrates another quality frequently found in Russian work of this period: the tendency to reintroduce an illusion of depth, so that even though the work remains nonreferential, its forms seem to exist in relatively deep space as opposed to lying flat on the picture plane. In this work planes overlap and intersect in provocative ways.

The architectural aspect of Constructivism is prominent in the gouaches and watercolors—sometimes combined with collage—by one of the movement's premier practitioners, El Lissitzky. Indeed, Lissitzky had studied engineering, and from 1919 he was professor of architecture and graphic art at the Institute for New Art in Vitebsk. It was during this period that Lissitzky began his series of Prouns. (The word *Proun* seems to have been a kind of acronym signifying "for the new art.") In *Proun IA, Bridge I* (plate 158), the bridge image is very specific, yet it would be equally possible to read this as a space station in orbit with the curved edge of a planet in the background. In this, as in other works, Lissitzky played abstract games with perspective. "A Proun," he once

161. El Lissitzky (1890–1941)
Study for Page from "A Suprematist Story—About Two Squares in Six Constructions," 1920
Watercolor and pencil on cardboard, 10⅛ × 8 in.
The Sidney and Harriet Janis Collection; Gift to The Museum of Modern Art, New York

162. Maria Vladimorovna Ender
(1897–1942)
Untitled, n.d.
Watercolor and pencil on paper
mounted on paper, 10⅛ × 14¾ in.
George Costakis

wrote, "is a station for changing trains from architecture to painting."[10] A Proun now in the collection of the Indiana University Art Museum (plate 159) certainly suggests some kind of physical interchange, with interlocking forms organized around diagonal axes. The similarity here to the work of Vorticists such as Lewis and Etchells is fully apparent, while some later Prouns (plate 160) have a less painterly feel and seem to belong more to the world of the graphic artist. Lissitzky is well known for such work, and he is justly celebrated for his witty *Tale of Two Squares,* a Suprematist story about extraterrestrial squares that arrive in a world of geometric chaos. The lithographs that make up this fable were preceded by pencil and watercolor studies (plate 161).

By now a good deal is known about the careers of major Russian artists such as Lissitzky, Kasimir Malevich, and Vladimir Tatlin, but experimental art activity in the years following the Soviet Revolution was widespread, and much of it remains relatively undocumented. For example, very little has been published about the Ender family of Leningrad, a remarkable clan of artists and musicians, several members of which explored the possibilities of nonobjective art, often working in watercolor. Maria Vladimorovna Ender taught art in Leningrad, specializing in form-color perception and in the uses of color as applied to architecture. Her work is wonderfully delicate and evocative, as can be judged from the example reproduced here (plate 162), which consists of just

a few loose stripes of transparent color floating against a pale wash ground. She was perhaps the most gifted member of the family, though her brother Yuri also painted quite strikingly original free-form abstractions (plate 163), full of subtle color gradations and flickering brushstrokes. Seldom has nonfigurative art arisen so completely out of the properties of the watercolor medium.[11]

In this regard the watercolors of Maria and Yuri Ender are somewhat reminiscent of work made a few years earlier by Georgia O'Keeffe, within the context of the New York avant-garde. O'Keeffe had been attracted to the orbit of Alfred Stieglitz, whose Photo-Secession Gallery at 291 Fifth Avenue provided a focus for new art, both homegrown and imported from Europe. Early in her career O'Keeffe worked extensively in watercolor, and almost all the sheets she produced at the time seem to have grown naturally out of properties inherent in the medium. Indeed, she sometimes reduced watercolor to its most elemental state, as is the case with *Blue No. 3* (plate 164), in which the way the paint has wrinkled the unconventional tissue-paper support becomes a significant constituent of the final image. *Evening Star* (plate 165) is perhaps less radical, in that it does contain references to the observed world, but it is nonetheless a remarkable painting that owes nothing to Cubist geometry and very little to Kandinsky's experiments, although the lyrical mood and expressive use of color are perhaps related to the spirit of Kandinsky's work.

O'Keeffe's way with watercolor is in many ways the opposite of her way with

163. Yuri Vladimirovich Ender (n.d.)
 Untitled, 1921
 Watercolor on paper, 6 × 8¾ in.
 George Costakis

164. Georgia O'Keeffe (1887–1986)
Blue No. 3, 1916
Watercolor on tissue paper,
15⅞ × 11 in.
The Brooklyn Museum;
Dick S. Ramsay Fund

oil. Her oils are typically hard-edged and seem to be approximations of images that existed within the artist's mind before she ever made a mark on canvas. Her watercolors, on the other hand, are uninhibited improvisations. In making these paintings, she simply loaded the brush with wash and created an image with a few quick strokes. They are perhaps the most radical works she ever produced.

Other American abstractionists of the period, such as Andrew Dasburg (plate 239) and Max Weber, stayed closer to European models. Weber was one of the first Americans to grasp the lessons of Cubism and, briefly at least, he pushed forward to an almost purely nonobjective art (plate 166). Abraham Walkowitz was also touched by Cubism but worked in a variety of idioms, sometimes approaching abstraction, sometimes veering toward figuration. *New York* (plate 167) is a curious example of American proto-abstraction. Its spindly squiggles are surprisingly Klee-like, and also anticipate the

165. Georgia O'Keeffe (1887–1986)
Evening Star, 1916
Watercolor on paper,
13⅜ × 17¾ in.
Yale University Art Gallery, New
Haven, Connecticut; The John Hill
Morgan Fund, the Leonard C. Hanna,
Jr. Fund, and Gifts of Friends in honor
of Theodore E. Stebbins, Jr.,
B.A. 1960

166. Max Weber (1881–1961)
Abstraction, 1917
Gouache on paper, 18⅞ × 11½ in.
Private collection

167. Abraham Walkowitz (1880–1965)
New York, 1917
Ink, pencil, and watercolor on paper,
30⅝ × 21¾ in.
Whitney Museum of American Art;
Gift of the artist in memory of
Juliana Force

calligraphic art of later Americans such as Mark Tobey (plate 313).

For the most part, however, the story of early modernism in America is only marginally concerned with the evolution of abstraction. Back in Europe, Kandinsky's influence was felt by artists such as Rudolf Bauer, whose *Untitled (Abstract Forms)* (plate 168) captures some of the energy of the Russian master's style without matching its coherence. A more important artist, whose course to some extent paralleled that of Kandinsky, was the Czech František Kupka, who had begun his career as a Symbolist working in a style that might be described, anachronistically, as "magic realism" (plate 41). In Paris from the mid-1890s, Kupka had worked both as an illustrator and as a spiritualist medium. Later he came into contact with Jacques Villon, Marcel Duchamp, and Raymond Duchamp-Villon, who were his neighbors in Puteaux, near Paris. The Puteaux group was involved in analytical discussions of Cubism, and this inspired Kupka, around 1911, to begin experimenting with nonreferential forms and colors that raised the spiritual concerns of his earlier art to a new and far more sophisticated plane. Like Picabia (whom he must also have met through the Puteaux group) and Kandinsky, he was intrigued by parallels between music and abstract art, and some of his earliest

nonfigurative images are curiously like those that Walt Disney's artists devised for segments of the animated film *Fantasia*.

Many of Kupka's watercolors and gouaches relate to the series entitled *Around a Point* (plate 169), all of which were studies for a large oil on canvas dated 1925–30 but possibly reworked in 1934. This series of paintings dates back to 1915 at least, and it is fascinating to see an artist struggling with a single basic idea over a period of two decades. Kupka's work provides a classic example of a pioneer abstractionist attempting to find new principles of organization, principles that do not rely at all upon the practices of figurative art, even as modified by the avant-garde of his generation. His handling of gouache and watercolor is often painterly and gives his most theoretical works an almost tactile sensuality.

To a large extent, all of Kupka's mature works can be seen as variations on a handful of themes. Watercolor played an important role in his oeuvre because it functioned for him—to employ a parallel he might have approved of—rather as chamber music might function within the total oeuvre of a composer. Sometimes he used watercolor as a study medium, but often he employed it for fully realized works that just happened to be on a relatively small scale. In running through the variations on a given theme he might make one painting in gouache, the next in oil, a third in watercolor. There is no indication that he considered his works on canvas to be more important than his works on paper, any more than Beethoven considered his symphonies to be greater than his quartets.

168. Rudolf Bauer (1889–1953)
Untitled (Abstract Forms), c. 1917–18
Watercolor on paper, 8½ × 12½ in.
Yale University Art Gallery,
New Haven, Connecticut; Gift of
Miss Katherine S. Dreier for the
Collection Société Anonyme

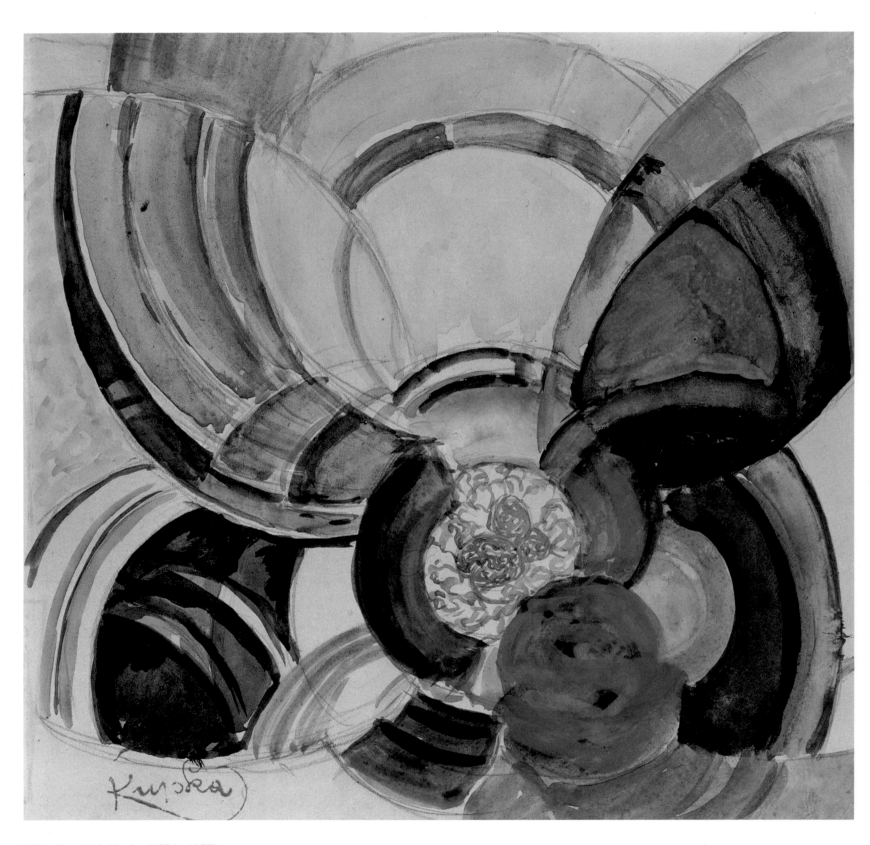

169.	František Kupka (1871–1957)
Around a Point, c. 1920–25
Watercolor, gouache, and graphite
on paper, 8 × 9⅜ in.
Peggy Guggenheim Collection,
Venice (The Solomon R. Guggenheim
Foundation)

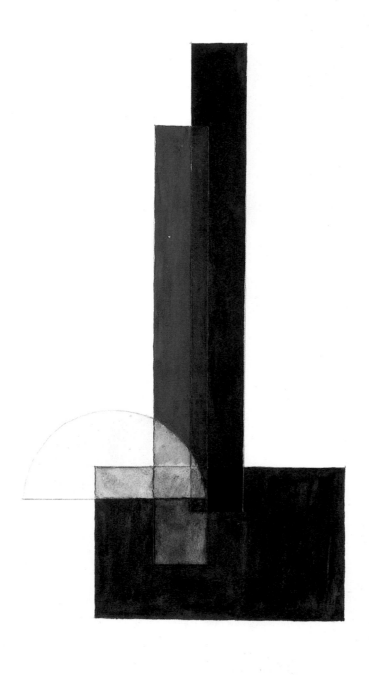

14/II/1923

L. Moholy = Nagy

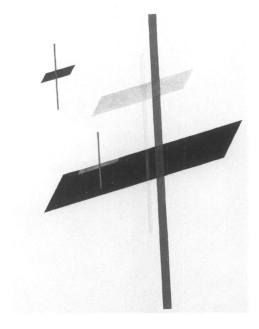

A more conventional Constructivist approach to nonfiguration was taken by László Moholy-Nagy, who had been in contact with Lissitzky and other Russians before going to the Bauhaus in 1923. At the Bauhaus and later in America, Moholy-Nagy made a point of using industrial materials and allying himself with those who sought a marriage between art and technology. At the same time, however, he made many studies using more traditional materials, such as watercolor, some of which are marked by great simplicity and graphic strength (plates 170–71).

Simplicity and graphic strength are the hallmarks, too, of paintings by Piet Mondrian, who must be counted, with Kandinsky, as the greatest of the first-generation abstractionists. Unfortunately, he never worked in watercolor during his mature period. Early in his career, however, he used the medium occasionally, and the fundamental dignity of his art is already apparent in early representational works such as *Red Amaryllis*

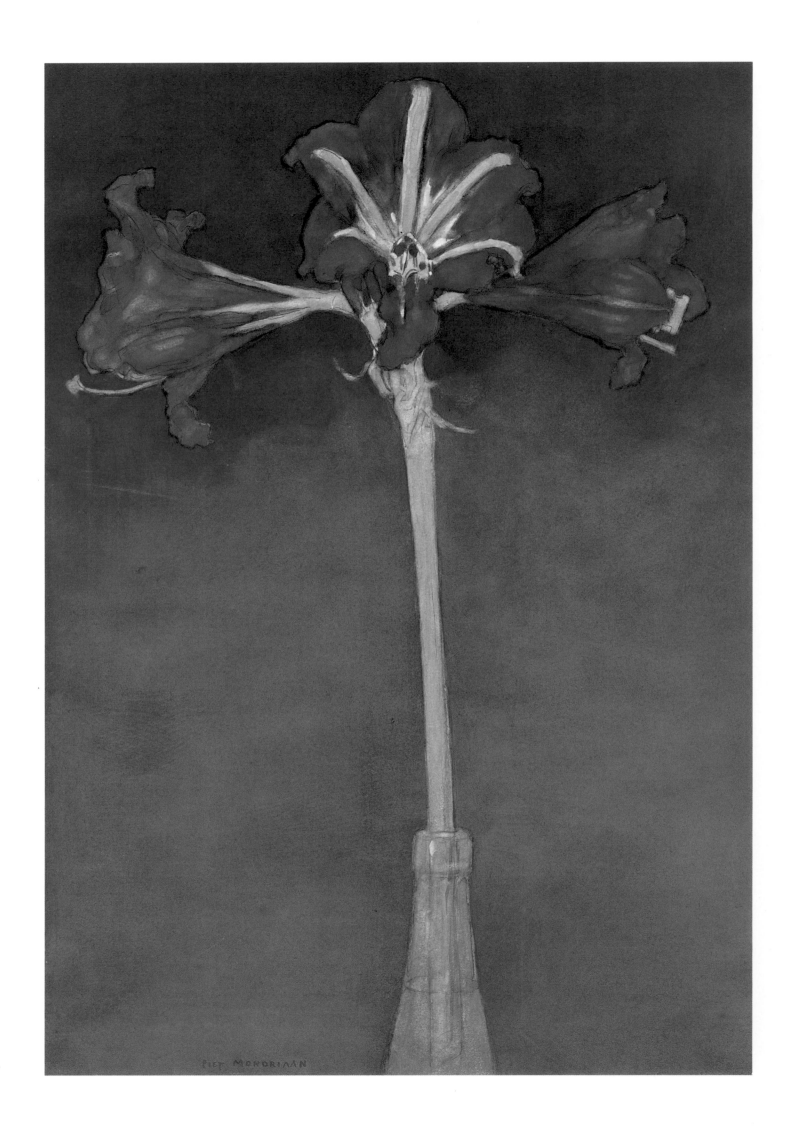

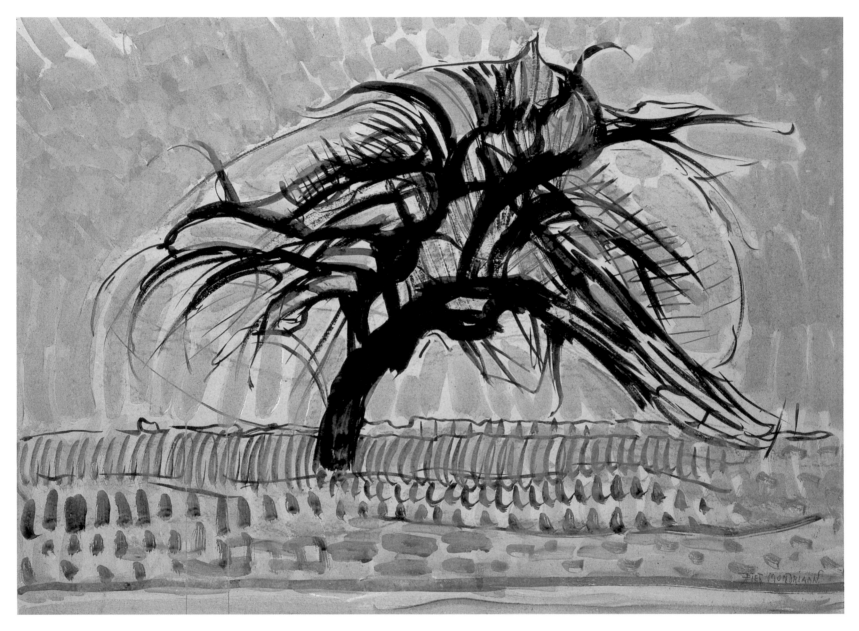

OPPOSITE

172. Piet Mondrian (1872–1944)
Red Amaryllis with Blue Background,
c. 1907
Watercolor on paper, 18⅜ × 13 in.
The Sidney and Harriet Janis
Collection; Gift to The Museum of
Modern Art, New York

173. Piet Mondrian (1872–1944)
The Blue Tree, 1909–10
Ink and watercolor on cardboard,
29½ × 39⅜ in.
Haags Gemeentemuseum,
The Hague, The Netherlands

174. Piet Mondrian (1872–1944)
Pier and Ocean, 1914
Charcoal and white watercolor on
white buff paper, 34⅝ × 44 in.
Collection, The Museum of Modern
Art, New York; Gift of Mr. and Mrs.
Daniel Saidenberg

OPPOSITE

175. Theo van Doesburg (1883–1931)
Contracomposition, 1924
Gouache on paper, 22⅛ × 22 in.
Stedelijk Museum, Amsterdam

with Blue Background (plate 172). That Mondrian was a master of the medium is fully evident in the dense saturation of the background wash. *The Blue Tree* (plate 173) shows how Mondrian—like other Dutch painters, such as Leo Gestel—was touched by the influence of the Fauves, but it is characteristic of Mondrian's voyage toward nonfiguration that he placed special emphasis on the structure of the tree itself, so that its branches come close to forming a quasiabstract grid. By the time he set down *Pier and Ocean* (plate 174), the grid was fully established, derived from Cubism certainly but transformed by Mondrian's unique reading of Cubist principles. The white pigment in this work has the odd effect of introducing a naturalistic touch of reflected light into a composition that is otherwise reduced to a cluster of signs.

Mondrian never used watercolor or gouache during his Neo-Plasticist period, but his colleague Theo van Doesburg—the movement's theoretician—did so quite often, as in *Contracomposition* (plate 175).

By 1924, when the painting was made, the first battle for abstraction was over, and painters were beginning to consolidate their positions. As they did so, they tended to abandon watercolor, so useful at the experimental stage, for more "substantial" media. As will be seen, however, watercolor always had a place, often emerging at the most unlikely moments in the history of art.

149

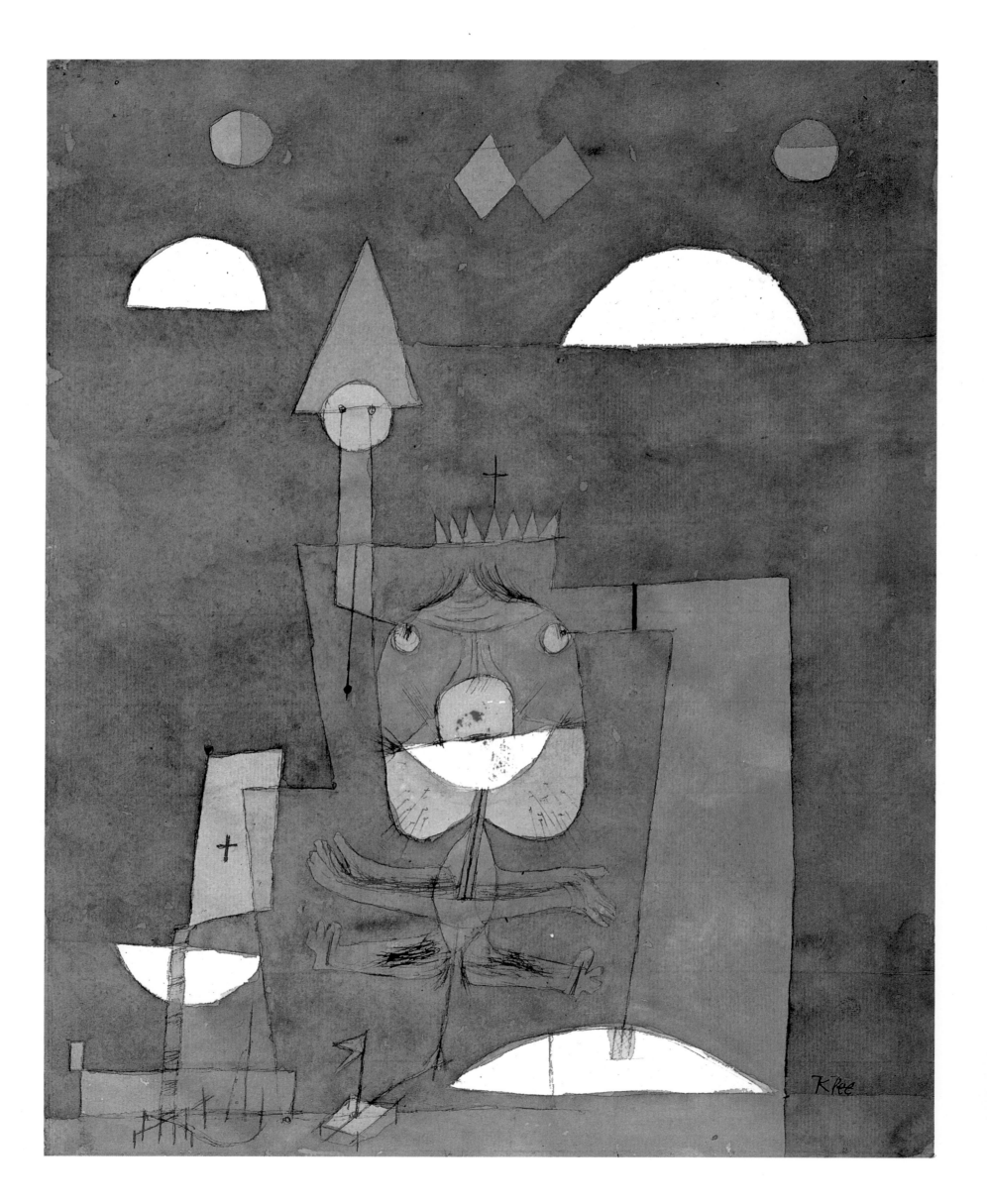

To consider the art of the twentieth century is to confront a panorama made up of elements so startlingly varied that it is sometimes difficult to see how everything fits together. At first glance, there seems to be no logic to it except that of reaction: the logic of one artist reacting against a predecessor, of one movement reacting against a rival movement, setting up a kinetic pattern of mutual opposition that has propelled twentieth-century art from one new frontier to another. The art of the past hundred years has thrived on novelty but artists, no matter how dissimilar their innovations, share certain basic disciplines and lore. Therefore, it often turns out that even artists who appear to belong to opposite camps have roots that bind them together at a level much deeper than that of style. Critics and historians tend to define Matisse and Picasso, for example, by their stylistic differences, yet both were clearly products of a similar cultural milieu and share debts to certain predecessors (Cézanne, for example). Similarly, the work of the two great pioneers of abstraction, Kandinsky and Mondrian, seems utterly different, yet both were deeply dependent upon spiritual ideas associated with fin-de-siècle Symbolism.

Indeed, as we study the art of the first half of the twentieth century, the role of the Symbolist movement seems more and more important. If it has been discounted by some art historians it is probably because its stylistic influence is seen to be relatively slight (though even this seems a misreading, given that artists as dissimilar as Bonnard and Kupka were able to develop aspects of Symbolist style). The fact is that Symbolism's intellectual principles provided support for many young artists who emerged in the years preceding World War I, and the artists often continued to lean on those principles long after most of them had abandoned the outward mannerisms of Symbolist style. Symbolist thought was antirealist and antirational. It looked on modern Western civilization as crass and materialistic. When Gauguin fled to Tahiti, when Picasso drew inspiration from African masks, this was the Symbolist ethos at work. (Symbolism's reputation may have been belittled by a name inadequate to describe its devotees' ambitions.)

The artists and poets we now call Dadaists were the first to make fun of Symbolism, yet in a sense they were also its heirs, since they carried the opposition to realism and rationality—and the hatred of materialism—to extremes no one else had approached. The Dadaists, and their successors the Surrealists, carried this attitude so far, in fact, that they sometimes seem at odds with almost everything else that was happening around them. Yet they actually had much in common with other modernists. It was simply that their responses to events—and especially to the carnage of World

War I—pushed them to extremes. The trend toward glorifying the absurd had begun before the horror of the war, however, and those beginnings were inextricably bound up with the attitudes and experiments of Marcel Duchamp and Francis Picabia.

Duchamp was a member of an unusually gifted family that included not only Jacques Villon and Raymond Duchamp-Villon but also their sister, Suzanne (later Suzanne Crotti), who would be active in Dadaist circles. Around 1909 Jacques and Raymond, the older brothers, inaugurated a series of weekly Sunday meetings at their studio in Puteaux, meetings that attracted Cubists such as Gleizes and Roger de La Fresnaye, free spirits such as Picabia, and poets such as Guillaume Apollinaire. Discussions were on an elevated intellectual level, sometimes leavened with humor, and the young Marcel seems to have been one of the liveliest participants almost from the beginning. As a painter he passed quickly through Cézannesque and Fauvist phases, then began, in 1911, to experiment with Cubist ideas, to which he brought his own quirky and highly original sensibility. Along with art he was obsessed with chess, and in the fall of 1911 he began

making studies for a neo-Cubist painting of chess players. One of these, in watercolor and ink (plate 177), demonstrates clearly how he was already combining the spatial analysis of Cubism with an attempt to give the image an intellectual dimension, though the effort is crude and even illustrational by Duchamp's later standards. Here chess pieces seem to take on a life of their own, independent of the players—a device that was dropped from the final painting.

Soon after this, Duchamp painted his *Nude Descending a Staircase,* which was to make his reputation, especially in America, where it was the sensation of the 1913 Armory Show. That celebrated painting tracks the movement of a figure walking down stairs, using a system of overlapping images related to the French physiologist Etienne-Jules Marey's photographic studies of figures in motion and also to roughly contemporaneous Futurist experiments (though Duchamp was not familiar with Futurist work when he painted this image). By subjecting the figure to Cubist-inspired fragmentation, Duchamp arrived at a mechanistic image, an approach he continued to develop in works such as *King and Queen Surrounded by Swift Nudes, at High Speed* (plate 178). The king and queen of the title are chess pieces but, like the speeding nudes, they have been transformed into icons replete with references to the mechanical world, so that they

seem to be propelled by drive shafts and flywheels. Later that year Duchamp painted *Virgin No. 2* (plate 179), one in a sequence of works that inaugurated an ironic investigation of sexuality. What precisely is represented here is a matter for speculation. It is possible to read the image as a fragmented human figure (there is a suggestion of a head at the top, of legs at the bottom). Then again, it can be read as a diagram of reproductive organs made by an engineer with a sense of humor.

By this early point in his career Duchamp was already well on his way to becoming the patron saint of irrationality in the arts, but it is possible that he did not suspect, in 1912, where this trajectory would take him. For the time being, one foot was still firmly planted in the more orderly and rational world of his older brothers, but his success in America would have a profound effect on his evolution, as would his friendship with Francis Picabia.

Picabia was, if anything, even more an iconoclast than Duchamp, but when they first met he was still engaged with the kind of serious ideas about relationships between music and poetry, color and feelings that had led to his early experiments with abstraction. Duchamp, the younger man, was further along the road toward confronting the absurd, but there was a chemistry between them that would catalyze both their careers. For the next several years, their great individual achievements notwithstanding, theirs was an almost symbiotic relationship, comparable to that between Picasso and Braque during the pioneering years of Cubism.

Duchamp was not in New York to enjoy his first great success at the Armory Show, but Picabia was on hand as his surrogate. Being the only European modernist available for dinner parties and press interviews, he enjoyed great celebrity. Picabia was entranced with New York, seeing its electric signs, its emancipated women, its skyscrapers, and its automobiles equipped with self-starters as the world of the future.

While in New York he made a series of beautiful abstracted watercolor tributes to the city, such as *Negro Song* (plate 180), which were shown at Stieglitz's gallery, 291. Completely orthodox in terms of watercolor technique, these paintings were original insofar as they represented a response to the sights and sounds of New York as filtered through the aesthetic and intellectual advances of the School of Paris at its most sophisticated. Little of Picabia's habitual irony is in evidence. Rather, these watercolors are the record of a wholly unambiguous love affair between the artist and the city. It seems that Picabia would visit a nightclub in Harlem, drive through Times Square on his way back to his hotel, and then—in his suite at the Brevoort—he would take out his box of watercolors and set down his impressions. The forms that found their way onto paper might suggest skyscrapers or advertising signs, but essentially the image was abstract.

On his return to France, Picabia memorialized his trip with huge canvases such as *Edtaonisl* and *Udnie,* which must be counted among the masterpieces of early nonfigurative art. And yet they were not entirely nonfigurative because they built upon the New York watercolors and, like Duchamp's *Virgin,* they seemed to make references to the mechanical world, as well as to characters Picabia had encountered during his transatlantic crossing. It was the mechanistic aspect of his imagery that he developed next, a tendency that found expression in watercolors such as *Comic Force* (plate 181). Meanwhile, he and Duchamp continued to fire one another's imaginations, and Duchamp began to prepare notes and studies for what was to be his most ambitious work, *The Bride Stripped Bare by Her Bachelors, Even,* an absurdist presentation of human behavior enigmatically couched in terms of pistons and capillary tubes. This huge work on glass was not started until Duchamp arrived in America in 1915, but well before he left on this first trip to the New World he had already begun making detailed preparations for it, such as *Cemetery of Uniforms and Liveries, No. 2* (plate 182), in which a major element

183. Man Ray (1890–1976)
Admiration of the Orchestrelle for the Cinematograph, 1919
Gouache, wash, and ink, airbrushed on paper, 26 × 21½ in.
Collection, The Museum of Modern Art, New York; Gift of A. Conger Goodyear

of the final work is delineated full scale, the image reversed because it would have to be transferred to the back of the glass.

Duchamp was joined in New York by Picabia, and together they pursued their iconoclastic path, with Duchamp going so far as to offer a urinal—retitled *Fountain*—for exhibition as a work of art. Needless to say, this phase of their careers did little to further the art of watercolor. Duchamp's American protégé Man Ray, soon to become a major photographer, did use airbrushed gouache, wash, and ink in such works as *Admiration of the Orchestrelle for the Cinematograph* (plate 183). Here the mechanistic imagery clearly derives from that of Duchamp and Picabia, and the use of the airbrush, till then the tool of commercial artists only, undermined fine-art conventions. Picabia, his absurdist philosophy now fully evolved, soon returned to Europe, where he wielded enormous influence over the development of Dada in Zurich, Paris, and elsewhere. He was experimenting with commercial materials—metallic paint, for example—at this period, and later he would employ such unlikely materials as macaroni and feathers. He did return to watercolor occasionally, as in *Conversation I* (plate 184), a powerful work that despite its Dada antecedents has an almost classical feel. (Perhaps it was intended,

in part, as a comment on Picasso's neoclassical stance of the postwar years.)

Dada was in large part a disgusted response to World War I, and thus it is hardly surprising that it should have been baptized at Zurich's Cabaret Voltaire, a refuge for bohemian exiles in the heart of neutral Switzerland. After the war the energy from Zurich flowed to Paris and to Germany, where Dada found a fertile breeding ground, particularly in Berlin. That city had been a hotbed of radical activity before the war—encompassing psychoanalysis and political activism as well as Expressionism—and had a long tradition of verbal and visual satire. The defeat of Germany had reduced the city to a state of chaos, with inflation rampant and food scarce at any price. When the painter and propagandist Richard Hülsenbeck brought the gospel of Dada from Zurich, he quickly found willing disciples. Among them was Raoul Hausmann who, in 1918, discovered or devised the photomontage, a variant on collage in which photographic material—with all its weight of associative imagery—became the chief component. Some of these montages were made entirely from found photographic materials, or a

184. Francis Picabia (1879–1953)
Conversation I, 1922
Watercolor on board,
23⅜ × 28½ in.
Tate Gallery, London

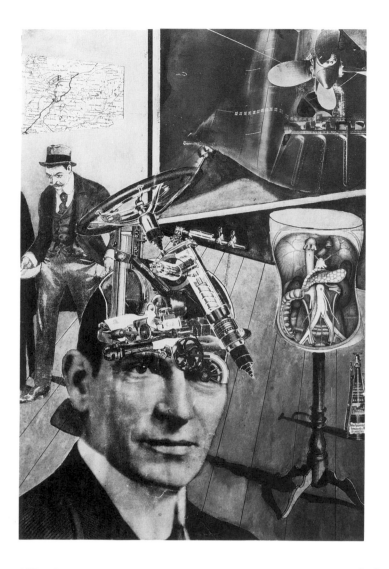

185. Raoul Hausmann (1886–1971)
Tatlin at Home, 1920
Collage and gouache on paper,
16⅛ × 11 in.
Moderna Museet, Stockholm

186. Hannah Hoch (1889–1978)
Man and Machine, 1921
Watercolor and trace of pencil,
11⅜ × 9½ in.
Collection, The Museum of Modern
Art, New York; The Joan and Lester
Avnet Collection

OPPOSITE
187. Hannah Hoch (1889–1978)
Souvenir, 1923
Watercolor on paper, 9⅜ × 7⅝ in.
Private collection

mixture of photographic and typographic elements, but quite often they also included hand-painted passages, most frequently done in watercolor or gouache.

In Hausmann's *Tatlin at Home* (plate 185), for example, gouache is used to tie the collage elements together, creating sloping floorboards and cast shadows that provide both context and a sense of receding space. In Hannah Hoch's satirical *Man and Machine* (plate 186), she dispensed with collage entirely, using watercolor to conjure up a production line in which machine and operator have become one. By the time she produced her charming *Souvenir* (plate 187), in 1923, Dada was becoming more memory than movement. Among the artists most successful in combining montage with watercolor was George Grosz, whose *The Engineer Heartfield* (plate 188) is probably the best-known example of the genre. Here the collage elements play an important note—the postcard at top right introduces an unexpected touch of realism—but the overall success of the picture depends on Grosz's skill as a draftsman, a skill that would determine the course of his career, as will be seen later in this chapter. Another interesting exponent of Berlin Dada was Rudolf Schlichter, who made what might be described as "painted montages," in which he reproduced the character of a montage without using actual montage elements. Such a work is *DA-DA-Dachatelier* (plate 189), an elaborate composition incorporating mannequin figures that suggest Schlichter was familiar with the work of Giorgio de Chirico.

Two of German Dada's most important figures operated away from the cultural turmoil of Berlin: Kurt Schwitters in Hanover and Max Ernst in Cologne. It might be argued, indeed, that these artists never entirely belonged to Dada since both were moving toward constructing new language systems that were essentially at odds with the antiart attitudes initiated by Duchamp and Picabia and espoused by the Zurich and

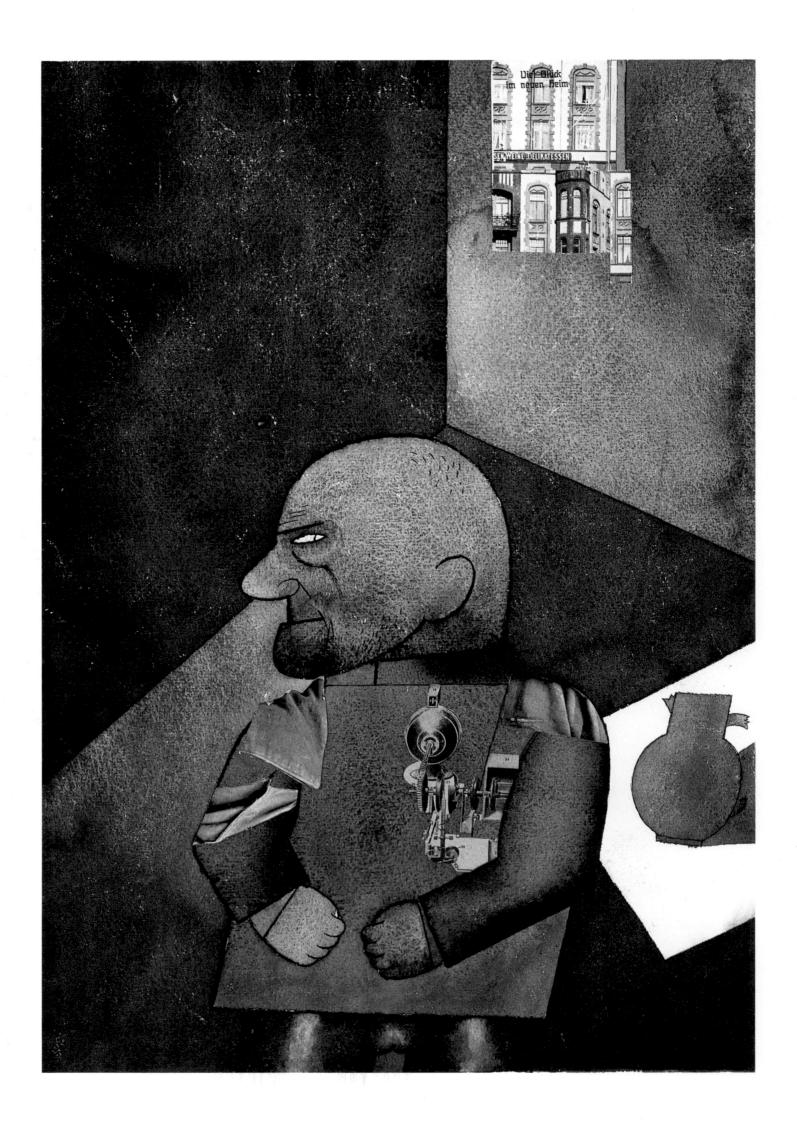

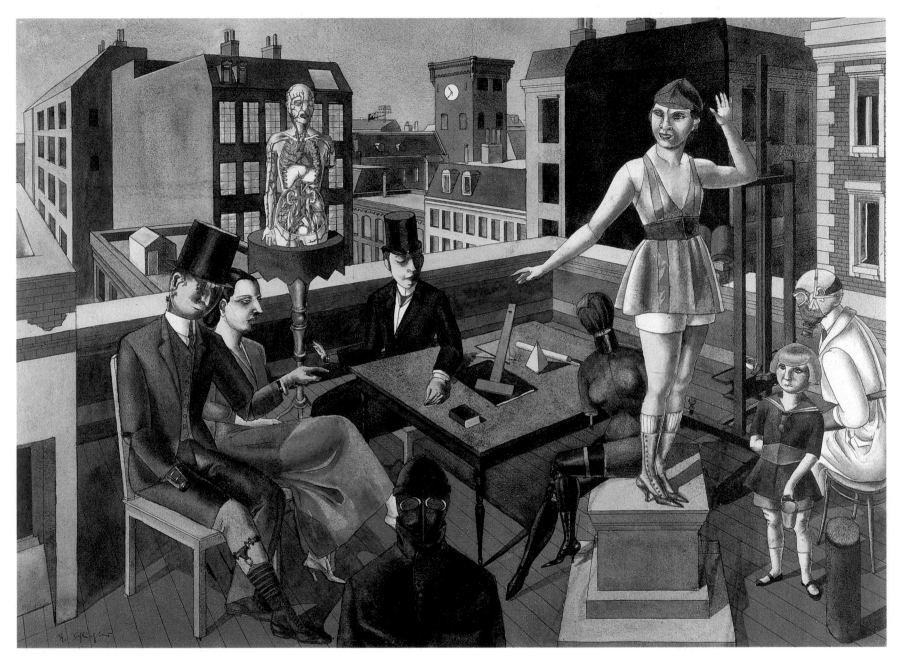

OPPOSITE

188. George Grosz (1893–1959)
The Engineer Heartfield, 1920
Watercolor and collage of pasted
postcard and halftone on paper,
16½ × 12 in.
Collection, The Museum of
Modern Art, New York; Gift of
A. Conger Goodyear

189. Rudolf Schlichter (1890–1955)
DA-DA-Dachatelier, c. 1920
Pen and ink and watercolor on paper,
18 × 25⅛ in.
Galerie Nierendorf, West Berlin

Berlin groups. Schwitters called his personal and highly lyrical version of Dada *Merz,* and its most typical expression is to be found in the collages and constructions he made from found objects and scraps of paper—bottle tops, bus tickets, and so forth. As has often been pointed out, what Schwitters achieved was an effective synthesis of Dada—especially the use of nonart material—and Cubism.[12] Before becoming totally committed to collage, however, Schwitters had produced witty tinted drawings such as *The Heart Goes from Sugar to Coffee* (plate 190). Even after turning to collage, he still occasionally modified his compositions with paint, as is the case with *Merz Drawing 75* (plate 191), a delicate miniature with a softness about it—typical of Schwitters's poetic approach—that makes it seem almost out of focus.

Working in Cologne, Ernst (calling himself Dadamax Ernst) had discovered photomontage for himself and had also developed a distinctive form of collage based on scientific illustrations, reproductions from advertising catalogs, and engravings from old books. Occasionally he used watercolor to alter or organize the found elements, as in *The Hat Makes the Man* (plate 192). Like Schwitters, Ernst was creating—perhaps almost by accident at first—a new language. The montages of Hausmann and his coconspirators functioned as critiques of existing systems, both aesthetic and ethical. Almost from the beginning, Ernst's montages evoked new worlds. Unexpected juxtapositions of objects created playful and sometimes magical images that seemed to open onto the future rather than simply reject the past in the manner of Berlin Dada. By 1922 Ernst had made the inevitable move to Paris, and there he became a pioneer of Surrealism, the movement that logically succeeded Dada. Over the next two decades he would

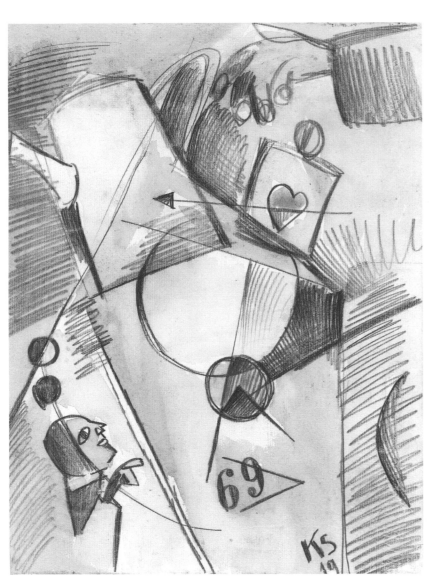

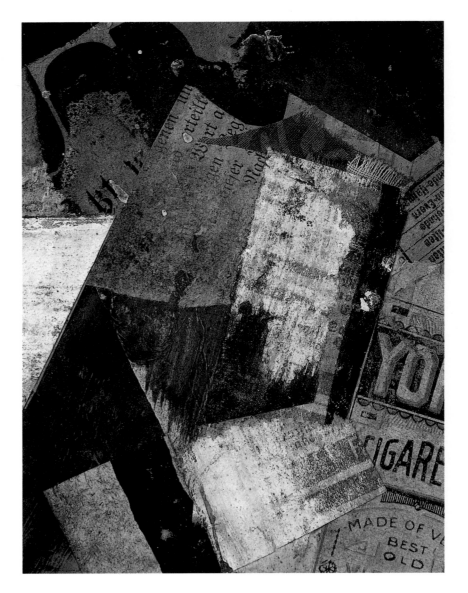

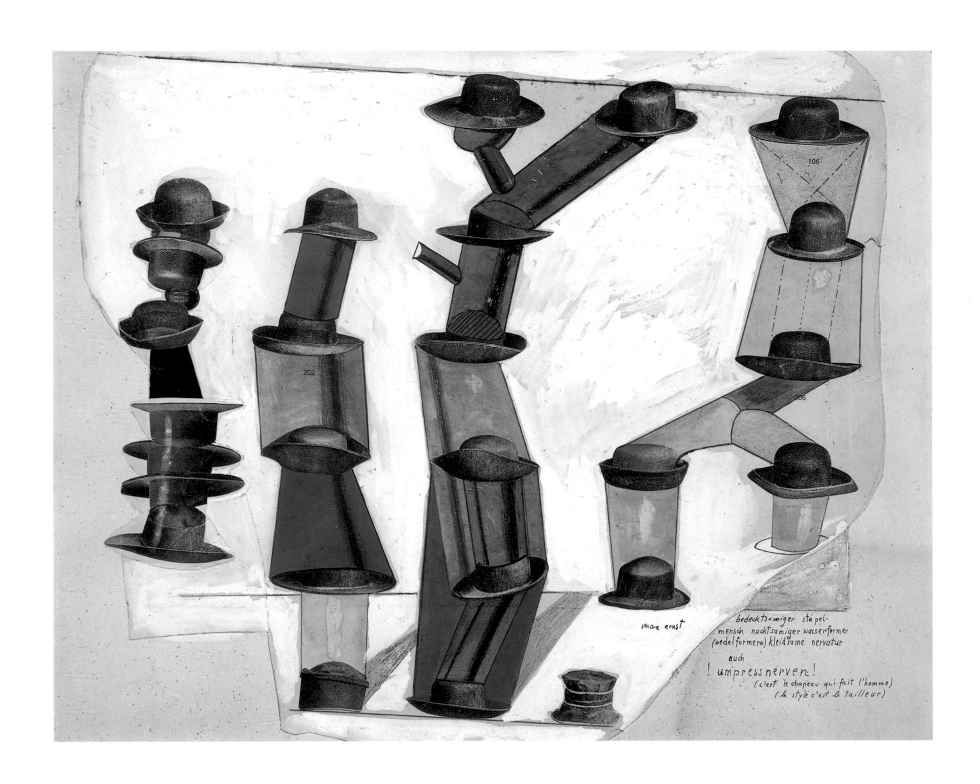

192. Max Ernst (1891–1976)
The Hat Makes the Man, 1920
Collage, pencil, ink, and watercolor
on paper, 14 × 18 in.
Collection, The Museum of Modern
Art, New York; Purchase

193. Giorgio de Chirico (1888–1978)
Two Horses, n.d.
Watercolor on paper, 9¼ × 13¼ in.
Private collection

194. Salvador Dalí (b. 1904)
Frontispiece for "The Second Surrealist Manifesto," 1930
Pen and ink and watercolor on paper,
12 × 10⅝ in.
The Sidney and Harriet Janis
Collection; Gift to The Museum of
Modern Art, New York

make many contributions to this movement, few of which involved the use of watercolor.

Along with the Dadaists, Surrealism's most significant immediate precursor was Giorgio de Chirico, who used watercolor strikingly if infrequently (plate 193). Among members of the Surrealist movement, Salvador Dalí used watercolor occasionally, usually as an adjunct to pencil or pen and ink, as is the case with his *Frontispiece for "The Second Surrealist Manifesto"* (plate 194). René Magritte had little use for watercolor, but his Belgian confrère Paul Delvaux did employ the medium with relative frequency. In *The Siesta* (plate 196), three of Delvaux's trademark nudes languish in the shadow of a building embellished with Corinthian columns. Trains often feature in Delvaux's work, as is the case with the late *In the Local Train* (plate 195) which, with its insertion of nudes into a closely observed naturalistic setting, creates an authentically dreamlike atmosphere. These are basically tinted drawings; more interesting from a technical point of view is Yves Tanguy's untitled gouache (plate 197). Despite its diminutive size, this is a fully realized example of his mature style, complete with beachlike or desertlike setting, perspective lines, and sculptural forms scattered about, as if a shipload of Henry Moore's work had washed ashore. Tanguy did not think of watercolor and gouache as media only for studies, being quite explicit about his belief that each was a distinct medium with special problems and rewards of its own.[13]

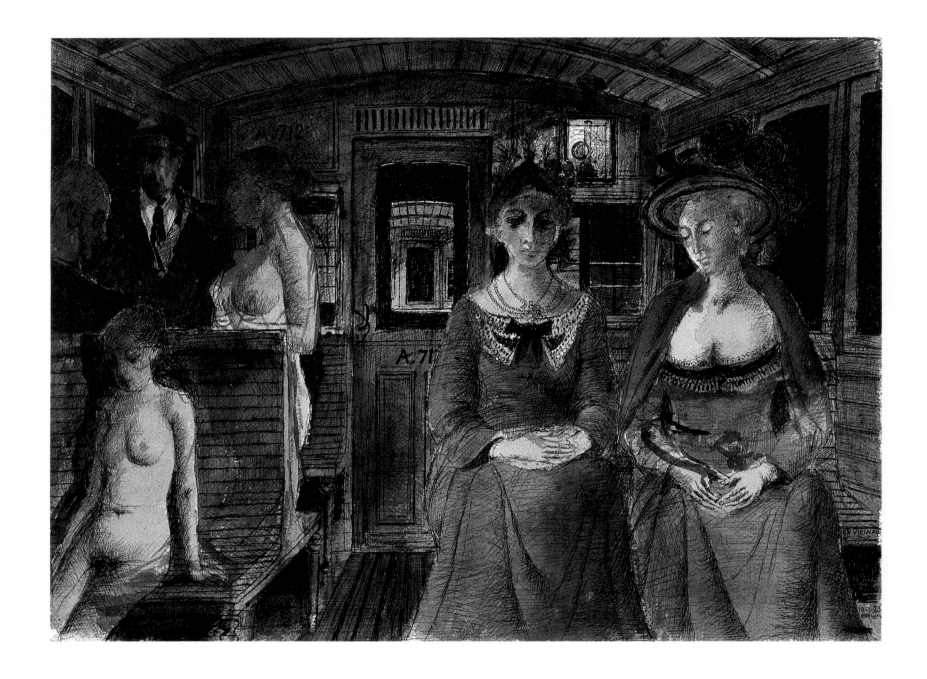

195. Paul Delvaux (b. 1897)
 In the Local Train, 1973
 India ink and watercolor on paper,
 22½ × 30¾ in.
 Paul Delvaux Foundation,
 Saint Idesbald, Belgium

 OPPOSITE, TOP
196. Paul Delvaux (b. 1897)
 The Siesta, 1947
 Watercolor and pen and ink on
 paper, 23½ × 30⅞ in.
 Collection, The Museum of Modern
 Art, New York; Kay Sage Tanguy
 Bequest

 OPPOSITE, BOTTOM
197. Yves Tanguy (1900–1955)
 Untitled, 1938
 Gouache on paper, 3¾ × 9¼ in.
 Peggy Guggenheim Collection,
 Venice (The Solomon R. Guggenheim
 Foundation)

198. Joan Miró (1893–1983)
Gouache Drawing, 1934
Gouache and pencil on paper,
42 × 27½ in.
Private collection

199. Joan Miró (1893–1983)
Head of a Man, 1937
Gouache and ink on black paper,
25½ × 19½ in.
Richard S. Zeisler Collection,
New York

OPPOSITE
200. Joan Miró (1893–1983)
Acrobatic Dancers, 1940
Gouache and oil wash on paper,
18⅛ × 15 in.
Wadsworth Atheneum, Hartford;
The Philip L. Goodwin Collection

The only major Surrealist to use watercolor or gouache extensively was Joan Miró. Since his approach frequently depended on linear invention, he often worked on paper in pencil or ink; since his vision was also highly coloristic, he often introduced body color into these compositions. The 1934 *Gouache Drawing* (plate 198) shows this approach at its most basic, with pencil lines doing most of the work and gouache being employed in a very limited way. *Head of a Man* (plate 199) is a far more integrated image, with the head drawn in a way that accepts the conventions of primitive art and the art of children. It even suggests graffiti, and thus anticipates the kind of thing that Jean Dubuffet would be doing a decade later, though Miró's vision is much gentler than Dubuffet's.

When the Germans invaded France in 1940, Miró returned to Spain, where he completed a series of small-scale gouaches, dubbed "Constellations," that are among his masterpieces. Describing how they were made, Miró has said, "I would set out with no preconceived idea. A few forms suggested here would call for other forms elsewhere to balance them. These in turn demanded others. . . . I would take it up day after day to paint in other tiny spots, stains, washes, infinitesimal dots of color in order to achieve a full and complex equilibrium."[14]

All of the Constellations are striking. Some, like *Acrobatic Dancers* (plate 200), are relatively conventional in organization, with certain key forms dominating the ensemble. Others, such as *The Beautiful Bird Revealing the Unknown to a Pair of Lovers* (plate 201), reveal a new kind of compositional principle at work, a uniformity of distribution that looks forward to the kind of "allover" composition that would come

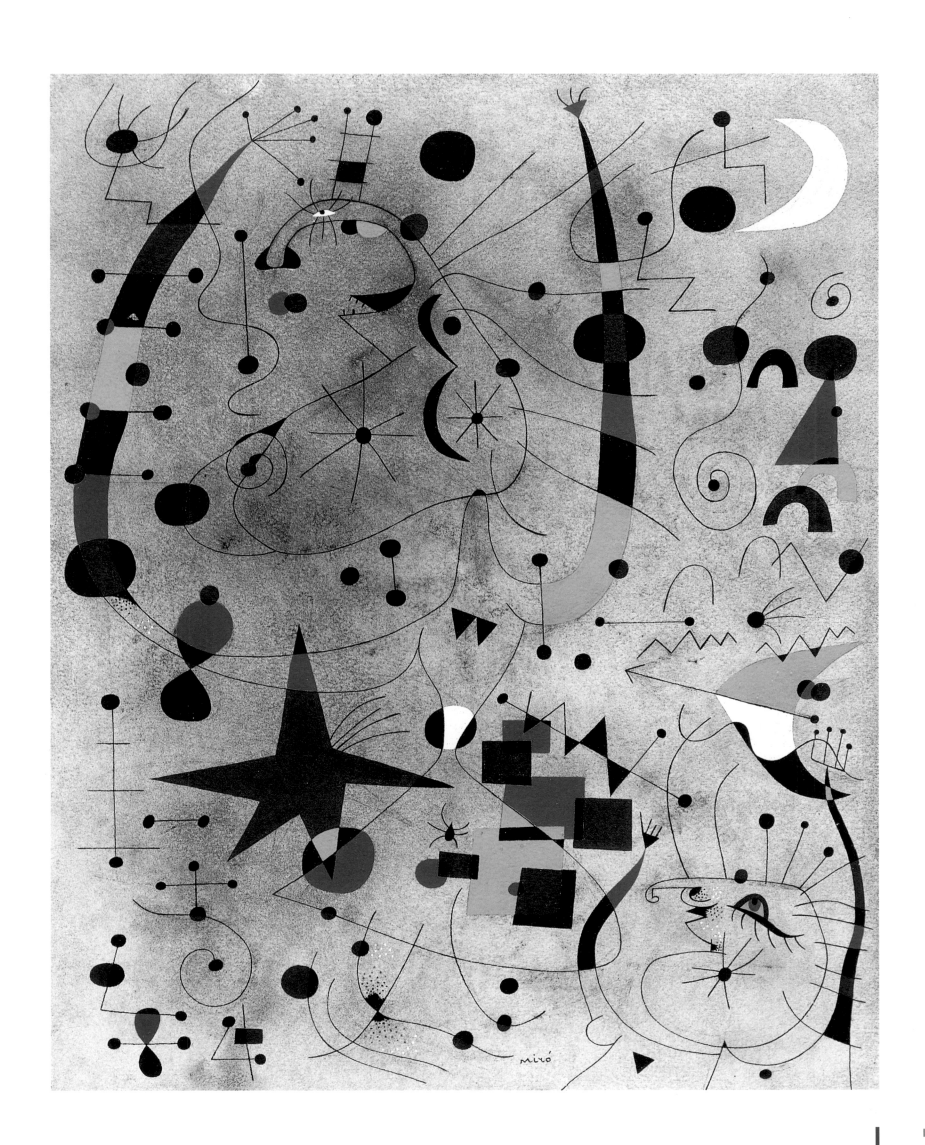

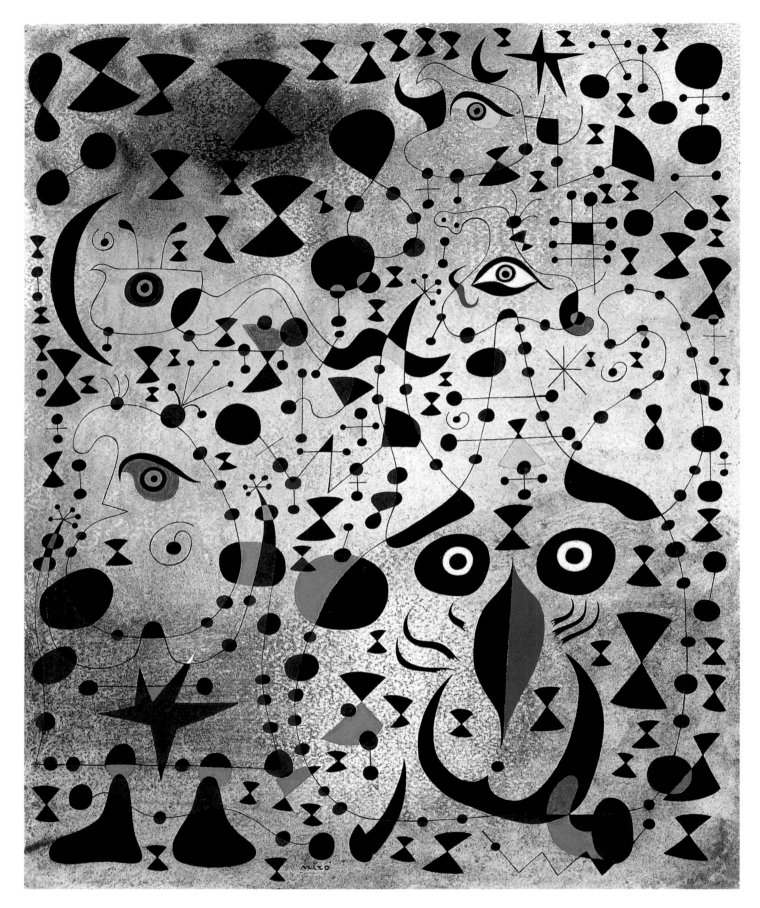

201. Joan Miró (1893–1983)
The Beautiful Bird Revealing the
Unknown to a Pair of Lovers, 1941
Gouache and oil wash on paper,
18 × 15 in.
Collection, The Museum of Modern
Art, New York; Acquired through
the Lillie P. Bliss Bequest

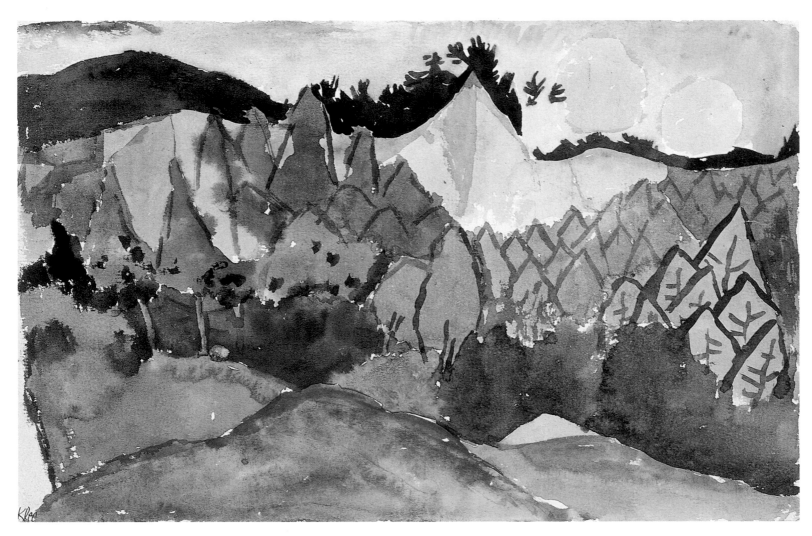

to prominence in America later in the decade. At the same time, the imagery and symbolism of these Constellations express the irrrational in art with a wit and gaiety that are matched only by the work of Miró's Swiss contemporary, Paul Klee.

Advanced artists in the first half of this century saw themselves as being pitted against a monolithic academic establishment. For this reason they frequently found themselves banding together—basically in order to get their work seen—and inevitably, these groups quickly splintered into factions with differing ideologies and aesthetics. It was, to a large extent, from this factionalism that the principal art movements of the period arose. Always, however, there have been artists who never seemed quite at home within the patchwork of factions, even though they may have temporarily associated with one group or another. They are artists with visions too personal ever to align themselves with a defined way of thinking. Such an artist was Paul Klee.

Born in Switzerland to German and Swiss parents with a passion for music, Klee studied art in Munich and traveled in Italy. From early in his career he combined an idiosyncratic draftsmanship with a determination to respond to the world in a way unfettered by convention. *Portrait of a Pregnant Woman* (plate 203), made when the artist was in his twenties, displays a debt to Kubin and to the art of German satirical magazines such as *Simplicissimus,* but Klee's line is already notable for its own sureness and economy.

Inevitably Klee felt the wind of Expressionism that swept through the German-speaking world, yet he bent with that wind without being shaped by it. He remained open to other influences, especially Cubism and its offshoots, but instead of imitating he absorbed and transformed. From 1912 he was associated with the Blue Rider group, but even though he was very much in tune with the other members—Marc, Macke, Kandinsky—and learned from them, here too he retained his distinct identity. *In the*

202. Paul Klee (1879–1940)
In the Quarry, 1913
Watercolor on paper mounted on cardboard, 8¾ × 13⅞ in.
Paul Klee Foundation, Museum of Fine Arts, Bern

203. Paul Klee (1879–1940)
Portrait of a Pregnant Woman, 1907
Pastel, watercolor, wash, and brown ink on laid paper, 9⅝ × 13½ in.
The Brooklyn Museum; Museum Collection Fund

Quarry (plate 202) is a fairly typical Klee work (if there is such a thing) of the Blue Rider period. The influence of Cézanne is apparent, heightened by Expressionism and by Klee's study of the Cubists. Conceptually it is not especially advanced for the date, but the handling of the medium is deliciously free, and the viewer need study this image only a few seconds to understand why watercolor was one of Klee's favorite media.

Soon after he made this painting, Klee traveled to Tunisia with August Macke, and it was during this trip that Klee (according to his own delighted admission) "discovered" color. Simultaneously, he absorbed the lessons of Cubism, especially the Orphic Cubism of Robert Delaunay, whom Klee had visited in Paris in 1912. The results, once again, exemplify how Klee could process many influences without compromising the individuality of his vision. A painting such as *Zoo* (plate 204) contains echoes of many sources, yet it is inimitably a Klee. The slightly comical animals alone would give away its identity, but just as much a mark of his art is the way in which, while breaking down form in a post-Cubist way, he simultaneously invented signs that became part of a new vocabulary employed to make highly evocative poetic statements. The technique also is very much Klee's own: as he did from time to time, he prepared the paper by spreading a thin layer of plaster of Paris upon it, so that the paint created distinctive textures.

In *Red-Green Steps* (plate 205), Klee used watercolor more conventionally, tak-

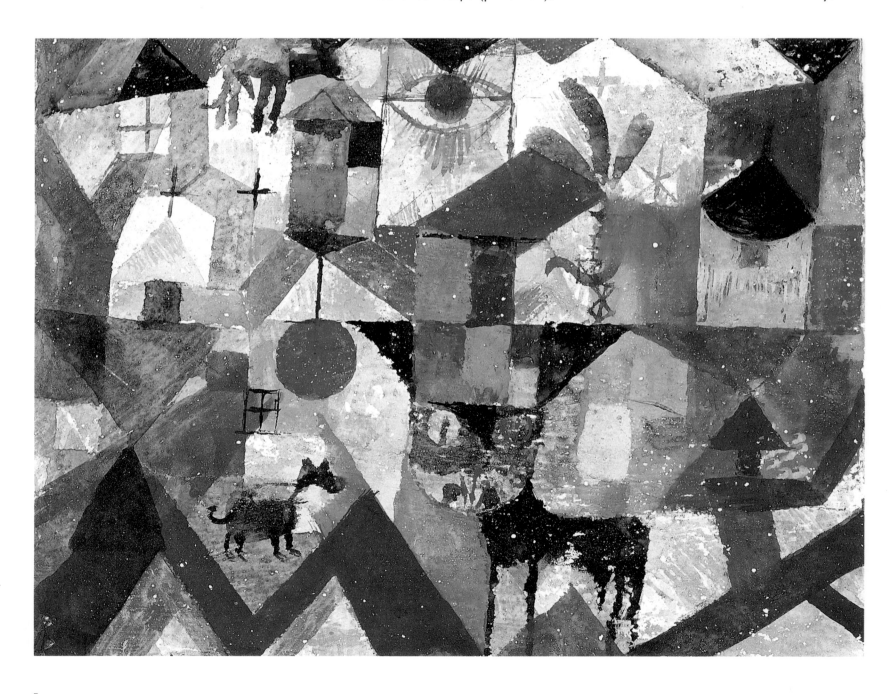

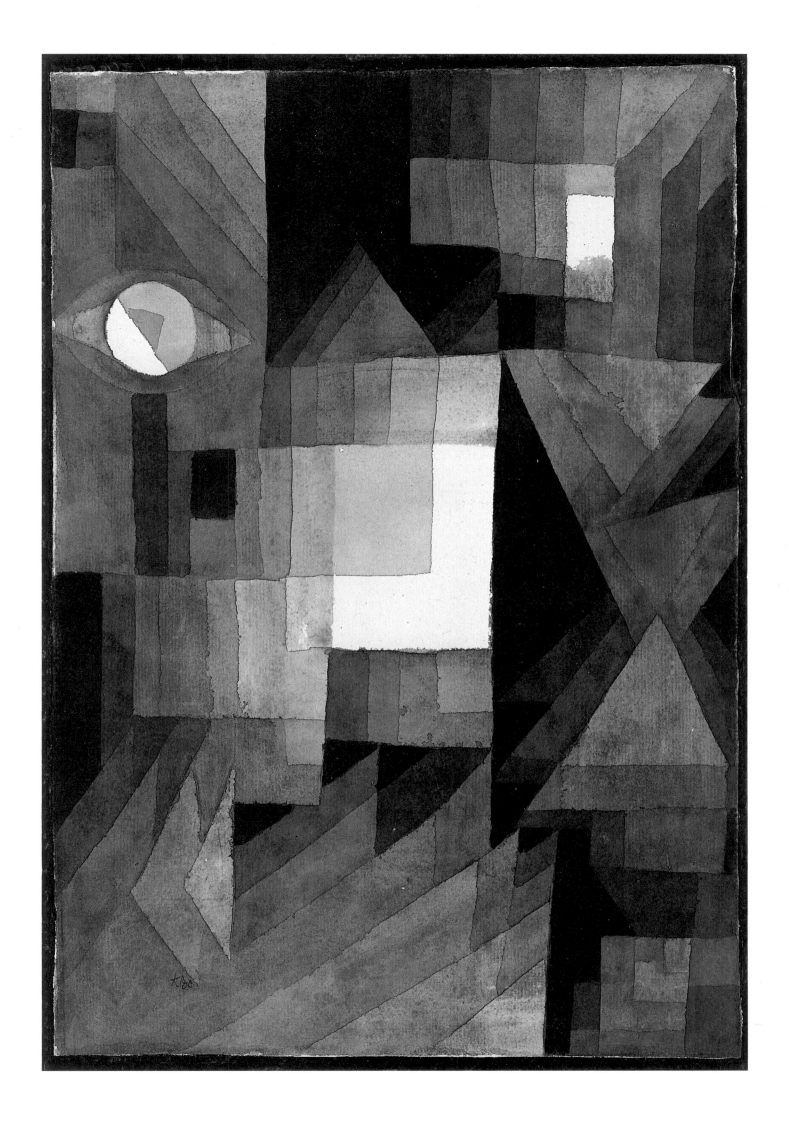

206. Paul Klee (1879–1940)
A Young Lady's Adventure, 1922
Watercolor on paper,
17¼ × 12⅝ in.
Tate Gallery, London

207. Paul Klee (1879–1940)
The North Sea, 1923
Watercolor on paper mounted on
cardboard, 12 × 18½ in.
Paul Klee Foundation, Museum of
Fine Arts, Bern

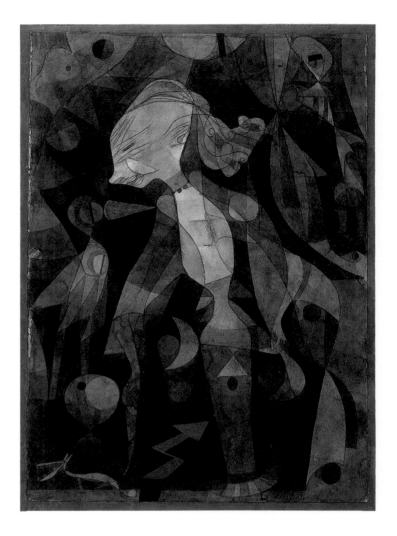

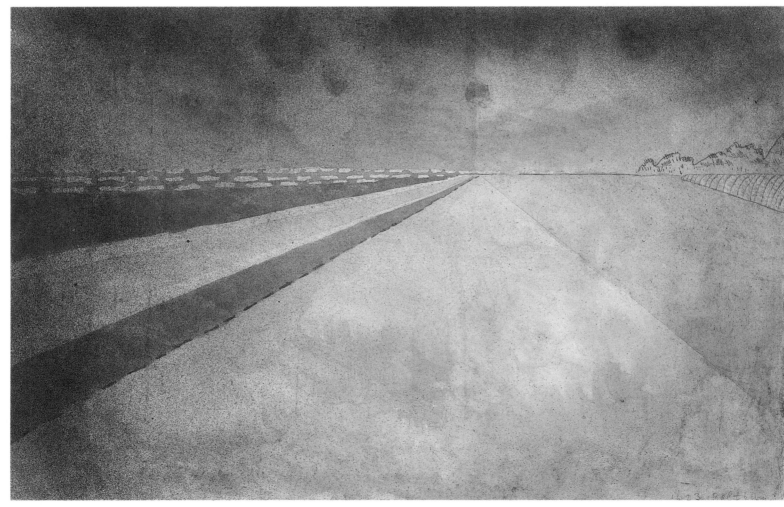

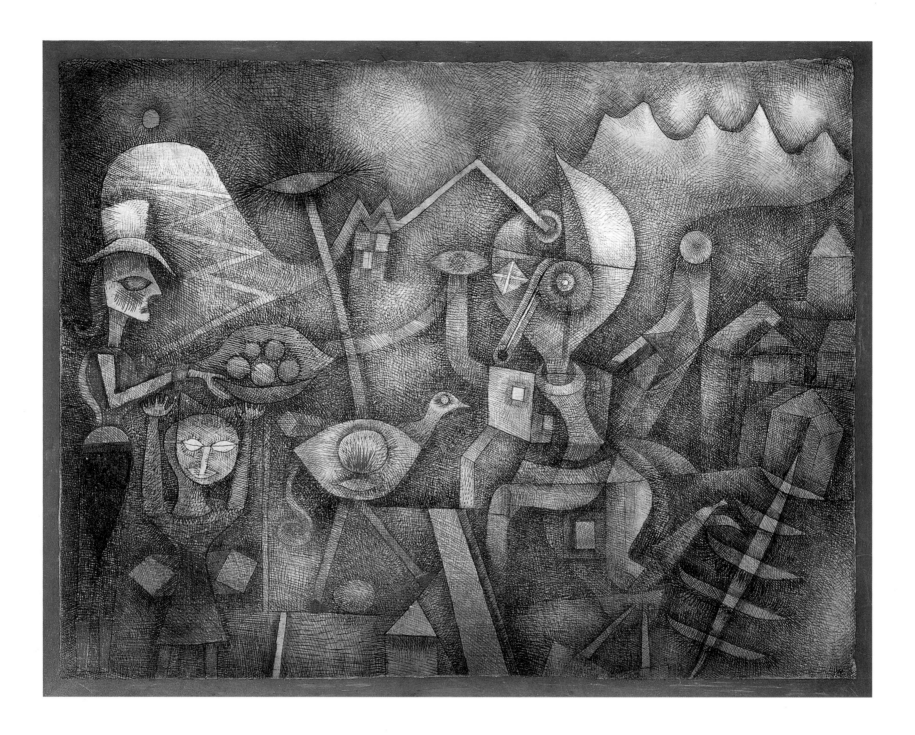

ing advantage of the medium's transparency to build the image from a series of overlapping forms that derive from Cubist practice, while still displaying an eccentricity wholly his own. By now Klee was teaching at the Bauhaus, and this work, like others of the period, has the air of being an inspired gloss upon a schoolroom exercise. In his teaching —and in writings such as *Pedagogical Sketchbook*—Klee was evolving a remarkably articulate approach to describing the aims and methods of modernism, at least according to his own tenets. It was a tribute to his genius that he was able to do so without ever becoming pedantic, either verbally or visually.

One of Klee's qualities that protected him from pedantry was his sense of humor, which was always bubbling to the surface. *The King of All Insects* (plate 176) is comical in much the way that a child's drawing is comical, except that it is under the precise control of a master—especially the beautifully modulated color scheme of pinks and purplish blues. The allusions to children's art are even more specific in *A Young Lady's Adventure* (plate 206), but here again the innocent vision is articulated with an all-pervasive sophistication. Comparing the tonality of this work with that of *The King of All Insects* makes clear how much Klee had learned about establishing mood purely by

208. Paul Klee (1879–1940)
Carnival in the Mountains, 1924
Watercolor on paper, 10½ × 13 in.
Paul Klee Foundation, Museum of
Fine Arts, Bern

209. Paul Klee (1879–1940)
Near Taormina, 1924
Pen and ink and watercolor on paper,
5⅞ × 9¼ in.
Paul Klee Foundation, Museum of
Fine Arts, Bern

210. Paul Klee (1879–1940)
Monument in Fertile Land, 1929
Watercolor on paper mounted on
cardboard, 18⅛ × 12⅛ in.
Paul Klee Foundation, Museum of
Fine Arts, Bern

the use of color. Once again he made skillful use of watercolor's transparency by layering washes to create a pattern of densities.

The North Sea (plate 207) is an unusually straightforward treatment of a landscape subject, which seems cool and analytical compared to the emotionally charged North Sea subjects of Emil Nolde (an artist Klee very much admired). With its use of white dashes to represent waves and its almost geometrically precise perspective, this is more reminiscent in mood of Piet Mondrian's North Sea subjects, painted a decade earlier, though Klee's atmospheric color sense is very different from that of his Dutch contemporary.

Carnival in the Mountains (plate 208) shows Klee at his most personal, creating fantastic images from post-Cubist fragmentations of form. Here the transparent washes are underlaid with delicate crosshatching that enlivens the entire surface while creating a sense of shallow, bas-relief–like depth by emphasizing the edges of forms as if they were darkened by shadow. This image also demonstrates that Klee could capitalize upon the irrational as capably as any Surrealist. Indeed, his imagery sometimes recalls Miró, sometimes Ernst; both artists expressed admiration for his work, and in *The First Surrealist Manifesto,* published the year *Carnival in the Mountains* was painted, André Breton included Klee among a group of artists deemed "of interest to Surrealism."

Near Taormina (plate 209) was the result of a visit to Sicily (just as *The North Sea* had been a response to a stay on the island of Baltrum). Typically, this diminutive work functions on two levels. On the one hand, it records a specific landscape, making

it recognizable not only by reproducing its basic contours but also by signifying, in shorthand, the distinctive domestic architecture, the variety of local flora, and so forth. At the same time, it is a free linear invention, enlivened by Klee's splendid feeling for color. To some extent the distribution of color seems arbitrary, yet in some sections— the sky, for instance—it is descriptive in a completely conventional way. The application of paint—flat here, blotchy and evocative there—demonstrates Klee's mastery of the medium. The image considered as an entity demonstrates how Klee, perhaps more fluently than anyone except Picasso and Matisse, was capable of fusing modernism with traditional ways of seeing.

In *Monument in Fertile Land* (plate 210), Klee seems to have been less concerned with such fusion than with pushing some of the more radical implications of modernism as far as they would go, at least within the parameters of his own vision. Klee was never as vigorous in his pursuit of abstract form as, say, Mondrian, but his virtually nonfigurative

211. Paul Klee (1879–1940)
Poison, 1932
Watercolor on paper mounted on cardboard, 24⅛ × 19⅛ in.
Paul Klee Foundation, Museum of Fine Arts, Bern

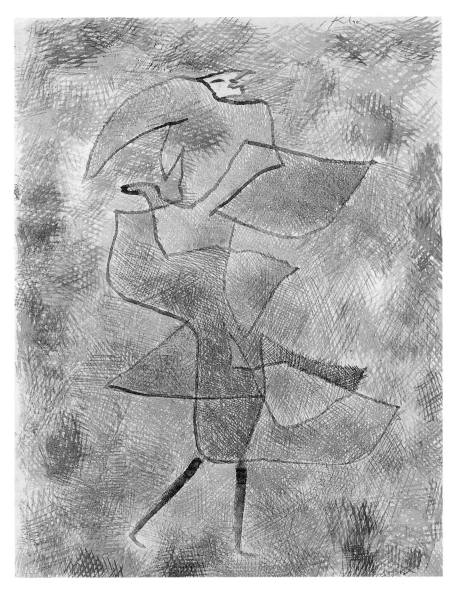

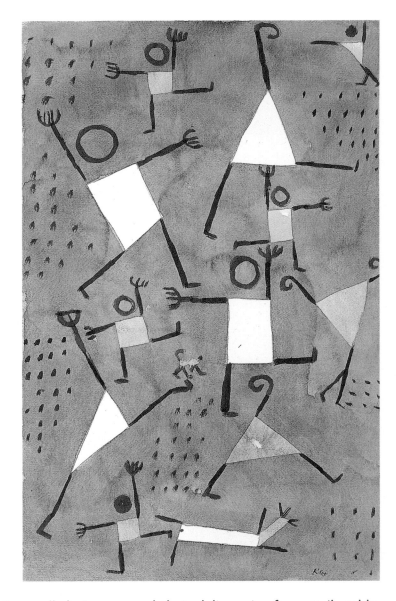

212.	Paul Klee (1879–1940)
	Diana in the Autumn Wind, 1934
	Watercolor on paper mounted on
	cardboard, 24⅝ × 18¾ in.
	Paul Klee Foundation, Museum of
	Fine Arts, Bern

213.	Paul Klee (1879–1940)
	Dance for Fear, 1938
	Watercolor on paper mounted on
	cardboard, 18⅞ × 12⅜ in.
	Paul Klee Foundation, Museum of
	Fine Arts, Bern

images have a charm and delicacy all their own, and their delicacy is often attributable to his use of watercolor.

Poison (plate 211) is also close to being nonreferential in the ordinary sense, though a dot conjures up an eye and a blunt line, a mouth. These forms are decidedly sinister, a note often present in Klee's later work, when the rise of the Nazis forced him to leave Germany and illness clouded his life. Occasionally he still produced paintings as carefree as those of the 1910s and 1920s, but his technical approach gradually shifted and he evolved a way of building pictures from powerfully simplified elements.

Diana in the Autumn Wind (plate 212) employs the delicate crosshatching of *Carnival in the Mountains,* but the mood is very different. Once more the shapes are sinister, and the title seems to hint at a change of emotional climate (months earlier Klee had been violently attacked by Nazi officials and forced to quit his teaching post at the Düsseldorf Academy). Soon after this he began to employ thick black lines in place of the delicate, weblike tracery that had characterized so much of his work till then. The late work is well exemplified by *Dance for Fear* (plate 213), a painting that retains the wit of Klee's early manhood but also displays a structural solidity that is new. As in all of Klee's output, the sense of scale is magnificent. This painting would hardly be more impressive if it were ten feet tall.

Paul Klee was in the true sense *un petit maître*—a master of small formats—but he never lost sight of the grand aims of the art of his time, and his influence continues to make itself felt almost half a century after his death. His career is a classic example of modernism's propensity for taking unexpected twists and turns in the German-speaking

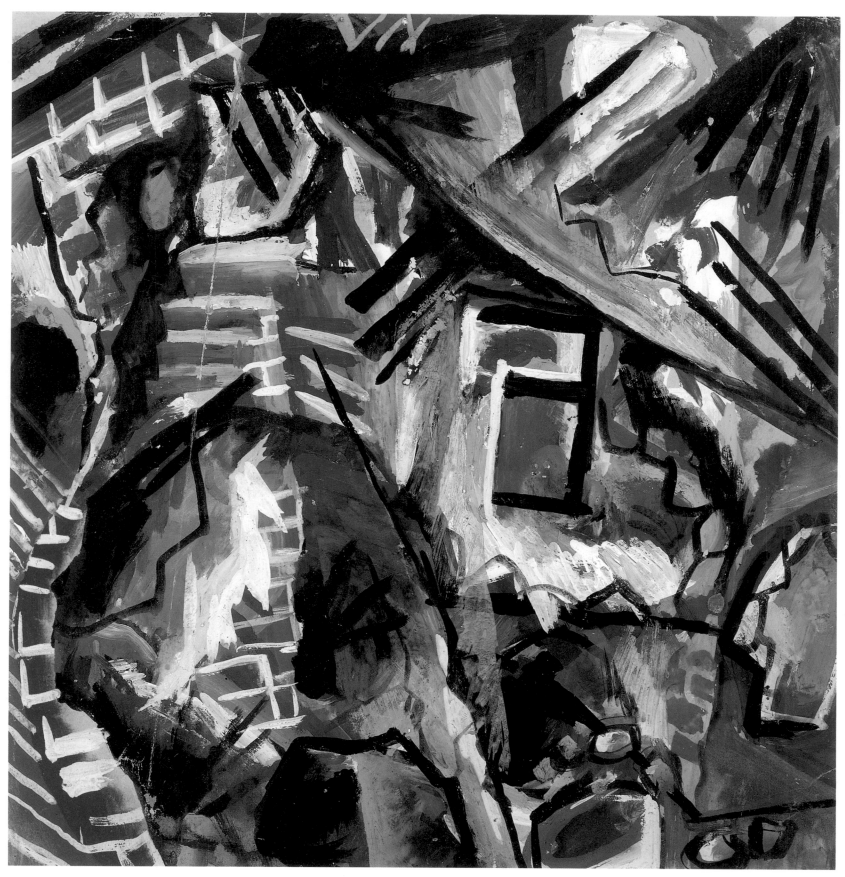

214. Otto Dix (1891–1969)
House at Angres, 1917
Gouache on paper, 11⅜ × 11¼ in.
Moderne Galerie des Saarland-
Museums in der Stiftung
Saarländischer Kulturbesitz,
Saarbrücken, West Germany

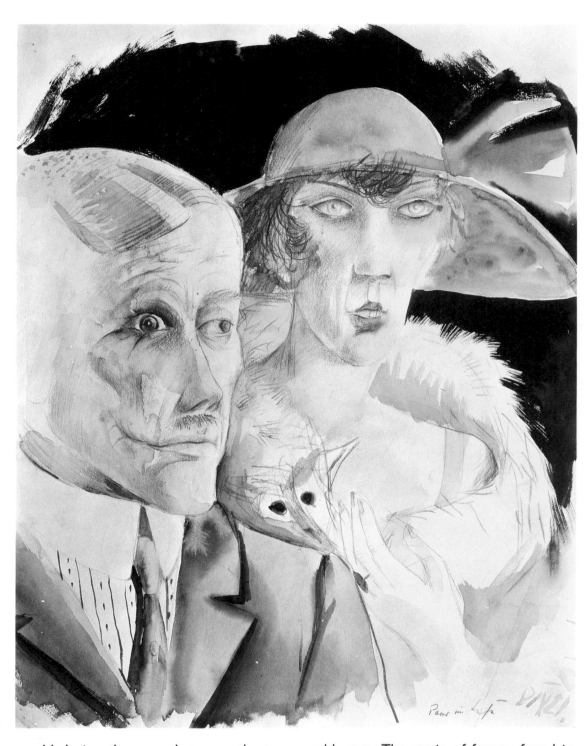

215. Otto Dix (1891–1969)
Café Couple, 1921
Watercolor and pencil on paper,
20 × 16⅛ in.
Collection, The Museum of Modern
Art, New York; Purchase

world during the years between the two world wars. The strain of fantasy found in Klee's work is more innocent than the kind of fantasy—often verging on violence—that was the province of Surrealism (though, as already noted, Klee and Miró had a good deal in common). At the opposite pole, it was German artists who took social realism and satire to greater lengths than anyone else during this period. Not that these satirists ignored fantasy entirely; but when they did employ it they turned it to ends entirely different from those espoused by Klee.

The anarchic ferocity of Berlin Dada had given notice of the fact that some German artists did not see any division between aesthetic revolution and social state- ment. Otto Dix and George Grosz, for example, were artists who received early exposure to Expressionism and Cubism—and certainly benefited from that exposure —but who never entirely abandoned realism because of the opportunities it offered for social commentary. Without betraying their modernist sympathies, both these artists also drew upon other sources, from Matthias Grünewald to *Simplicissimus.* The results were tangential to the mainstream but nonetheless relevant to the concerns of all who

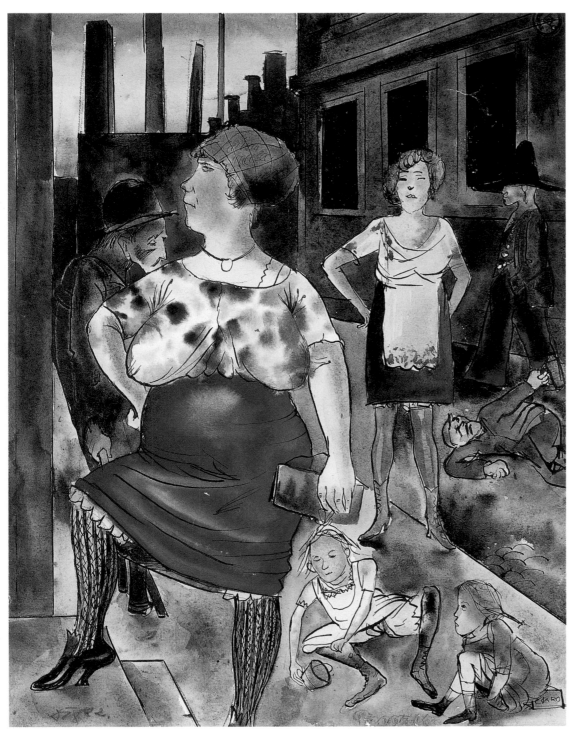

216. Otto Dix (1891–1969)
Suburban Scene, 1922
Pen and watercolor on paper,
19⅜ × 15⅝ in.
Museum Ludwig, Cologne,
West Germany

lived through that period.

Dix came from a working-class background—his father was an ironworker—and his earliest mature work was in the German realist tradition, harking back to Lucas Cranach and Albrecht Dürer, as well as to more recent models. During World War I he responded to Expressionism and Cubism, as is apparent from *House at Angres* (plate 214), but the war itself had far greater impact on him. Later he would translate his revulsion into a series of prints and canvases in which he captured the horror of war as effectively as anyone since Francisco Goya. The war shaped his view of life in general, and it was a jaundiced eye that he turned on the postwar world, as is evident even in so straightforward a study as *Café Couple* (plate 215).

Dix's work of the interwar period is rife with social criticism, but this criticism lacked an overt political program and was usually tempered by a degree of sympathy for the actors in his little dramas. These dramas were, in fact, drawn rather directly from the world he found himself in, a world that we recognize from Bertolt Brecht's plays and movies such as *The Blue Angel. Suburban Scene* (plate 216) is hardly the kind of

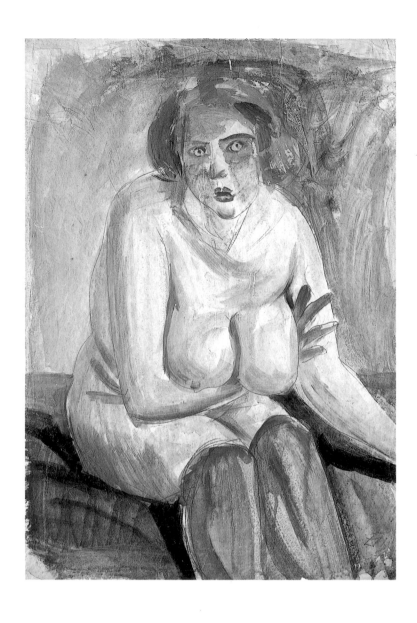

217. Otto Dix (1891–1969)
Harbor Scene, 1927
Pencil, watercolor, and gouache on
paper, 23 × 18⅞ in.
Private collection

218. Otto Dix (1891–1969)
Nude with Red Stockings, 1922
Pencil and watercolor on paper,
20¾ × 29⅛ in.
Private collection

219. Otto Dix (1891–1969)
Girl in a Pink Blouse, 1923
Watercolor, gouache, and pencil on
paper, 21¼ × 20⅛ in.
Museum Ludwig, Cologne,
West Germany

benign image that the title initially conjures up. This is a drab industrial suburb hemmed in by factories, and this is the Germany of the Weimar Republic, where inflation meant that a dozen eggs might cost two million marks. Dix presents the scene with a directness that does not balk at the unsavory: there are derelicts on the street, ragged children playing on the sidewalk. And if the title *Suburban Scene* is perhaps tongue in cheek, *Harbor Scene* (plate 217) is also employed with ironic intent, for this records not a charming view of fishing boats at their moorings but a passing encounter between a sailor and a prostitute. Here the handling is loose and casual, but Dix's line, as always, is incisive. There is nothing particularly advanced about the treatment, though Dix's watercolors and drawings—as opposed to his precisely rendered paintings—do owe a debt to Fauvist and Expressionist practices.

This is evident in *Nude with Red Stockings* (plate 218), which is set down in a deliberately crude style that relates to work by Die Brücke artists such as Heckel and Kirchner. Some of the same effect carries over into *Girl in a Pink Blouse* (plate 219), a powerful portrait of a broad-faced peasant girl smoking a cigarette. Dix had the ability to exaggerate features without stooping to caricature, and while this could hardly be described as a flattering likeness, there is basic humanity in Dix's vision that keeps cruelty at bay. *Mutzli* (plate 220) is a far gentler portrait but, again, it demonstrates Dix's ability to establish a strong image with just a few sure brushstrokes.

Fine as these watercolors are, however, Dix was most at home working on canvas, and it is his large-scale works of social commentary, such as the 1927 triptych

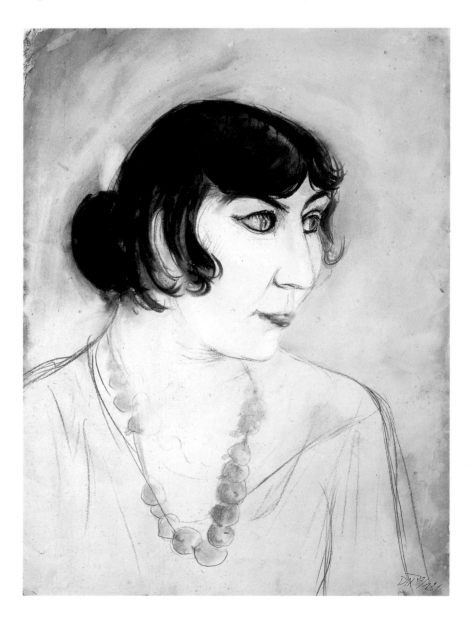

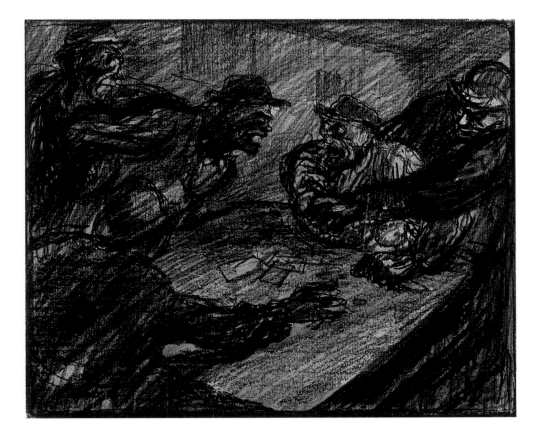

221. George Grosz (1893–1959)
Bar Fight, 1912
Crayon and watercolor on paper,
8¾ × 10⅞ in.
Private collection

The Big City, and his many incisive portraits for which he will be best remembered. His contemporary George Grosz, on the other hand, occasionally worked successfully on canvas but was most in his element when working either in pen or pencil alone or else when combining line and watercolor. He must be counted as one of the major watercolorists of the century.

We have already encountered Grosz, in passing, as a member of the Berlin Dada group, but his commitment to satire and social comment went back to the prewar period. Indicative of his future achievements is a teenage work, *Bar Fight* (plate 221), in which a fierce dynamism enlivens the scene of feuding card players. A year later Grosz was capable of a work as devastating as *End of the Road* (plate 222). Here we have a domestic tragedy right out of the newspapers, and the young artist delineated it with journalistic zeal, not forgetting to instill pathos by contrasting the gruesomeness of the corpses with the shabby gentility of the setting. Note, for example, the fan tucked behind the mirror, a touch of playful coquettishness that circumstances have rendered hideously incongruous. Grosz had not found his idiom at this early stage, but clearly he already possessed the basic tools of his calling.

That these tools included superb draftsmanship can be seen in *Nude Torso* (plate 223), in which sinuous line is allied to expressive use of washes. This somewhat resembles an academic study, but that resemblance should not conceal how busily Grosz was absorbing the lessons of modernism. Like all young German artists he was exposed to Expressionism, and he soon learned to turn its exaggerations to his own ends, arriving at a new kind of caricature that no longer leaned on nineteenth-century predecessors such as Honoré Daumier. In 1913 Grosz spent six months in Paris, where his exposure to Cubism and Futurism provided him with devices for transcending the journalistic approach of *End of the Road,* replacing it with a more fragmented and cinematic approach. Service in World War I further soured his already acidic view of the world, and after returning to Berlin, Grosz was inevitably drawn to the Dada group. He changed the spelling of his given name from Georg to George as a deliberately antipatriotic gesture and paraded through the streets of Berlin wearing a death's-head mask and a

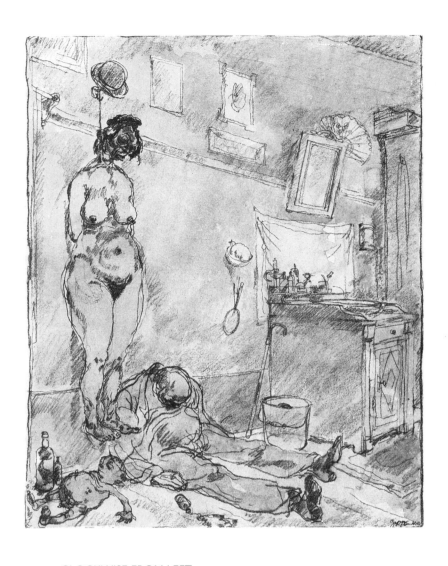

CLOCKWISE FROM LEFT

222. George Grosz (1893–1959)
End of the Road, 1913
Watercolor and pencil on paper,
11½ × 9 in.
Collection, The Museum of Modern
Art, New York; Purchase

223. George Grosz (1893–1959)
Nude Torso, 1916
Pencil and watercolor on paper,
12¾ × 10½ in.
Estate of George Grosz, Princeton

224. George Grosz (1893–1959)
*Daum Marries Her Pedantic
Automaton George in May 1920, John
Heartfield Is Very Glad of It*, 1920
Watercolor and collage on paper,
16½ × 11⅞ in.
Galerie Nierendorf, West Berlin

OPPOSITE

225. George Grosz (1893–1959)
Republican Automatons, 1920
Watercolor on paper,
23⅝ × 18⅝ in.
Collection, The Museum of Modern
Art, New York; Advisory
Committee Fund

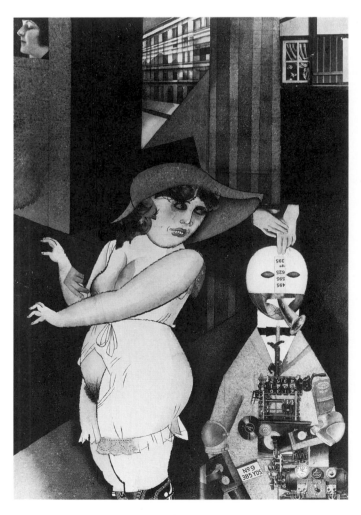

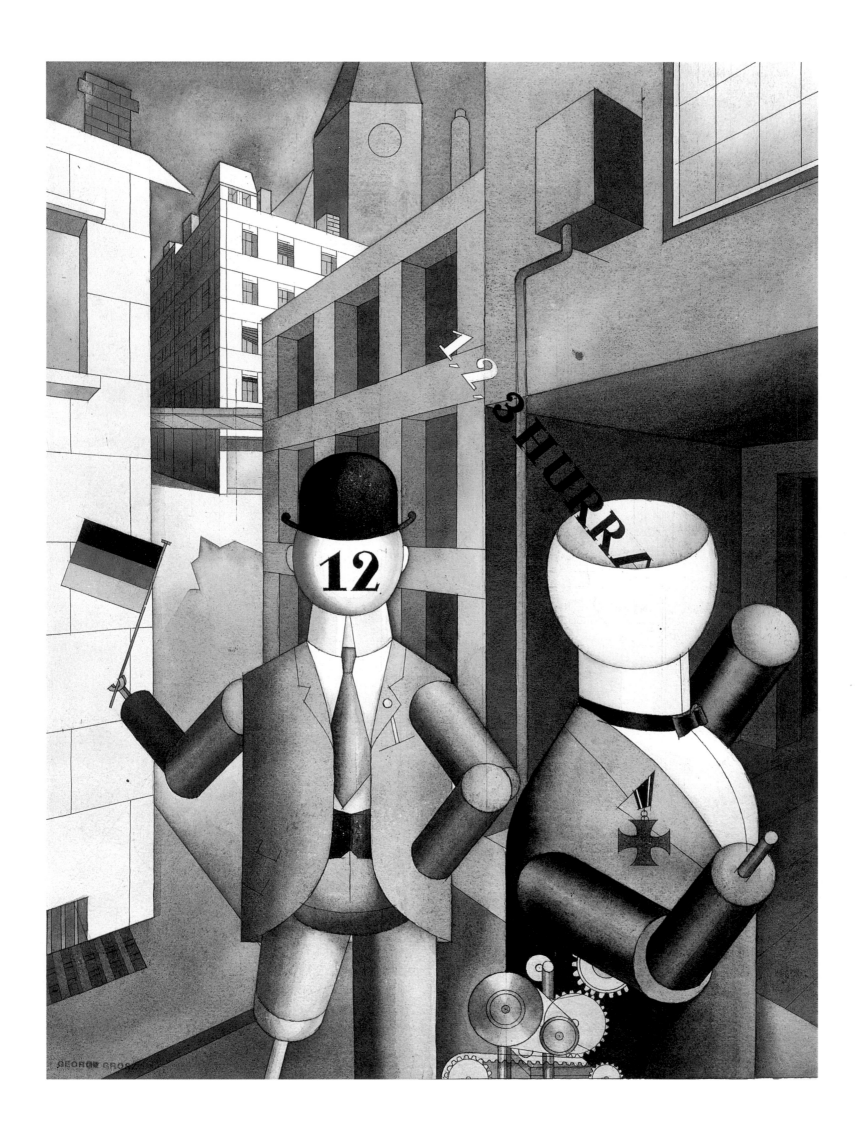

placard inscribed "Dada über Alles."

Grosz thrived under the auspices of Dada, producing works such as *The Engineer Heartfield* and *Daum Marries . . .* (plates 188, 224), which combined photomontage and watercolor, caricature and mechanistic imagery. In a similar mode he also made purely watercolor paintings such as *Republican Automatons* (plate 225), in which the use of mannequinlike figures evokes the work of de Chirico. Alongside this Dada humor, however, Grosz was pursuing a more personal form of satire—related to Dada, certainly, but significantly different in both spirit and method from that of artists such as

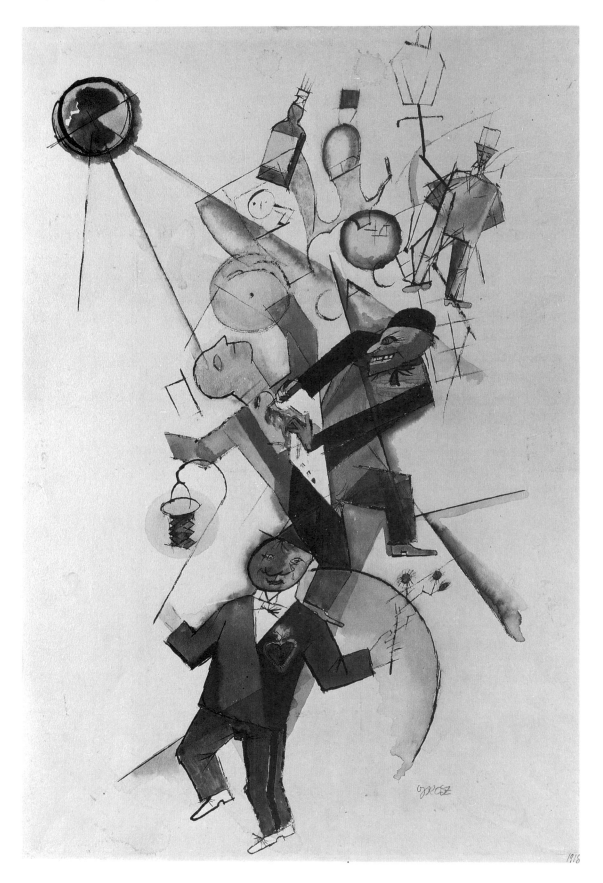

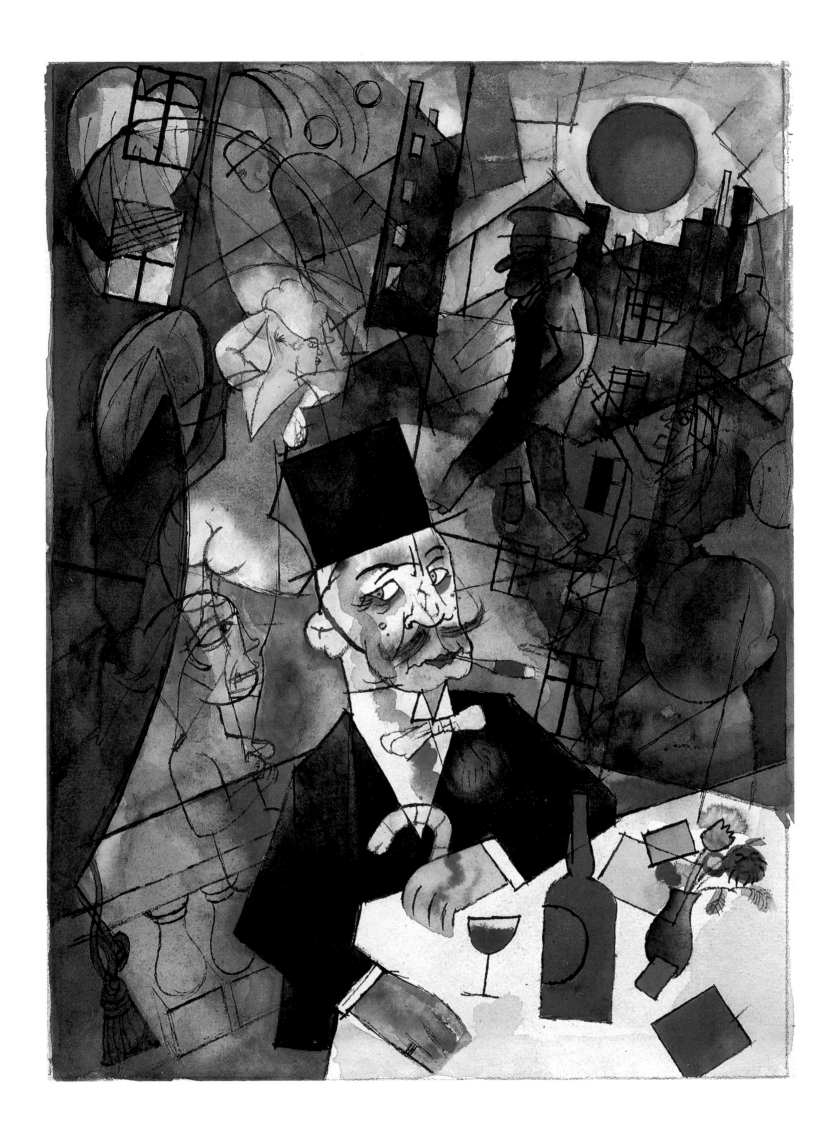

228. George Grosz (1893–1959)
Castors Panoptikum, c. 1918
Brush and ink and watercolor on
paper, 12½ × 9½ in.
Bauhaus-Archiv, Museum für
Gestaltung, West Berlin

Raoul Hausmann and Johannes Baader.

Grosz's compositions such as *The Case "G"* and *White Slaver* (plates 226, 227) tell stories from the streets and the tabloids, using a skillful mixture of modernist technical devices and *faux-naïf* draftsmanship. This mixture recalls Bertolt Brecht's method of stage presentation, which Brecht, incidentally, did not perfect until the mid-1920s; Grosz's style also predates such visually related cinematic experiments as *The Cabinet of Dr. Caligari* and Fritz Lang's *M.* Original and daring, these drawings are filled with the sordid characters and goings-on that had always obsessed Grosz—here a man is stabbed to death, there a war profiteer sits with a naked prostitute—but now these incidents are presented alongside others within the bounds of a single image, the Cubo-Futurist scaffolding of the compositions permitting this simultaneity. Despite the stark difference of subject matter, Grosz's method in many ways resembles Klee's at approximately the same period. Both blended post-Cubist devices with childlike mannerisms to produce a new synthesis.

229. George Grosz (1893–1959)
Circe, c. 1925
Watercolor on paper,
24⅛ × 19⅛ in.
Hirshhorn Museum and Sculpture
Garden, Smithsonian Institution,
Washington, D.C.; Gift of
Joseph H. Hirshhorn, 1966

In some images of the period, such as *Castors Panoptikum* (plate 228), the Cubist substructure is pushed into the background and Grosz's caricatures dominate the picture plane. Nothing deflects the pitiless scrutiny of Grosz's gaze. The players in these little dramas may lack the mechanical heart of Heartfield the Engineer but they are flesh and blood machines, driven by their appetites. No artist has ever reduced human beings to their conditioned reflexes so convincingly as Grosz did in the decade or so after World War I.

In 1920 Grosz broke with the Dada movement and forged his own way, which did nothing to diminish the ferocity of his vision. Gradually the Cubist scaffolding became less important, though it left a permanent imprint on the way he assembled a picture and on the way he knowingly dispensed with the conventions of perspective. *Circe* (plate 229) is a relatively straightforward image, ignoring modernist devices almost entirely. As Grosz moved on to this new phase in his work, he began to rely more and more upon the flexibility and fluency of his watercolor technique, using skillful washes

230. George Grosz (1893–1959)
On the Street, c. 1926
Pen and ink and watercolor on paper,
20 × 27½ in.
Estate of George Grosz, Princeton,
New Jersey

Grosz used free brushstrokes painted wet into wet. Rendered with equal freedom is *New York Harbor* (plate 232), in which the waterfront—piers and ocean liners, tugs and ferries, smoke and bustle—is evoked against a background of skyscrapers painted with a mild disregard for perspective that might be taken as a metaphor for New York's divergent and sometimes contradictory value systems. In other early American-period watercolors Grosz zeroed in on the life of New York's streets and tenements. *Street Fight from the Roof* (plate 233) focuses not on the fight but on the boy who hangs over the cornice of a building to see what is happening down below. Again the handling is very loose, with some use of wet into wet.

Grosz's satiric instincts did not vanish in America, but his means of expression changed. *The Ambassador of Good Will* (plate 234) attacks the Nazis in particular and the military in general. (His hatred of the military dated back to childhood, when his widowed mother had managed an officers' club.) Grosz had lost some of his edge, however, and these later images seem less like original perspectives on the sins of the world and more like skillful cartoons. By the 1950s he was accepting the commission of a department-store owner to depict the streets of Dallas (plate 235). The results were not bad—Grosz remained a skillful technician—but they owed as much to a tradition of illustration as to the adventures of twentieth-century art.

The relative blandness of Grosz's later art should not obscure the fact that he was, for a decade or two, one of the most incisive and original of twentieth-century painters, an artist whose best work is as sharp as the writings of Jonathan Swift. It is this sharpness, allied to scepticism raised to the level of a philosophical principle, that links Grosz—even in his post-Dada phase—to hard-core Dadaists such as Picabia, and to a lesser extent to Surrealists such as Ernst and Dalí. The Surrealists tried to push beyond that scepticism to create a new reality, and when they did so they found relatively little use for watercolor. In its earlier and more anarchic phase, however, the Dada-Surrealist phenomenon relied upon watercolor to a surprising extent—surprising because it is unexpected to find self-proclaimed aesthetic revolutionaries making such effective use of a medium as seemingly innocent as watercolor.

234. George Grosz (1893–1959)
The Ambassador of Good Will, 1936
Ink and watercolor on paper,
18 × 24 in.
The Metropolitan Museum of Art,
New York; Gift of Mrs. Priscilla A. B.
Henderson, 1950

235. George Grosz (1893–1959)
A Dallas Night, 1952
Watercolor on paper, 21 × 13¾ in.
Dallas Museum of Art, Foundation for
the Arts Collection; Anonymous gift
in memory of Leon A. Harris

At the turn of the century the United States possessed no avant-garde to speak of, but it could boast a thriving watercolor tradition, with Winslow Homer and John Singer Sargent the last great masters of traditional watercolor technique. Homer, a semirecluse in his Maine retreat, died three years before the Armory Show brought Duchamp's *Nude Descending a Staircase* to his native Boston. Sargent lived long enough to have read *The First Surrealist Manifesto,* had he so chosen, but he was untouched by the tides of modernism, though some of his watercolors employ compositional devices that anticipate some of the more radical practices of twentieth-century art (see chapter 1). It is Homer, however, who seems remarkably modern from today's perspective. This can be attributed to his being the progenitor of a school of realism that thrived in the United States during the first half of this century despite the eagerness of many artists to come to terms with Matisse and Picasso, Duchamp and Picabia, Kandinsky and Mondrian.

The history of modernism in America through the first half of our century, and even beyond, is distinct from the history of modernism in Europe. American painters visited Paris, and Europeans took up temporary residence in New York, but in the days before transatlantic air travel there was no such thing as the casual relationships that now link artists, dealers, and museums on the two continents. The differences between America and Europe were then far more pronounced. The Old World got older every day, or so it seemed to European artists who wanted to break with the past. America, on the other hand, was brand new, and its cities—New York in particular—were the last word in modernity. Manhattan's skyline, with its towering skyscrapers, was a famous symbol of newness and a powerful inspiration to visiting European artists such as Picabia and Marcoussis.

American artists themselves were impressed by skyscrapers and other symbols of the country's status as the most modern of nations; they were impressed, and yet they could take this brave new world for granted in a way that Europeans could not. The Americans could seek modernity simply by depicting their surroundings—by responding in paint to the soaring architecture and the energy of the industrial landscapes. Such a direct response fueled talents as different as those of Charles Sheeler and John Marin. At the same time, American artists prior to World War II were not entirely secure basking in the glory reflected from what foreigners perceived as a futuristic environment. American artists were disturbed by the crudity of the messages conveyed by those electric signs, made self-conscious by the provincialism of the people who went to work in those skyscrapers. It would be an exaggeration to say that American

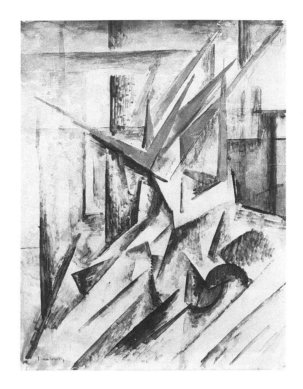

artists suffered from a communal inferiority complex, but those who sought to espouse modernism often thought of themselves as removed from its mainstream, which was perceived to flow through Munich and Vienna and Paris, but not through New York. Because of this, American artists often came at movements like Cubism and abstraction from a somewhat oblique angle. They were not caught up in the main flow of events, and so their work could afford to be more personal, even eccentric. (And it might be noted that personal statements lend themselves well to watercolor as a means of expression.) The result was a complex dialogue between native American tendencies and the modernist mainstream, a dialogue that permitted both highly individualistic approaches to nonfiguration and the exploration of forms of realism that in Europe would have seemed anachronistic.

The 1913 Armory Show—which exhibited nearly 1300 more or less advanced European and American artworks to eager viewers in New York, Chicago, and Boston—intensified this dialogue, which Alfred Stieglitz and his Photo-Secession Gallery had helped to start a few years earlier. It is significant that many of the works Stieglitz showed in those early days—by Cézanne, Rodin, Matisse, Picasso, and others—were watercolors. The fact that he showed so many works in the medium seems to have been mainly a consequence of availability and space limitations, but it may have had some influence on the fledgling American modernists, at least to the extent that it presented watercolor as a legitimate medium for radical experiment. Marsden Hartley—an important member of the Stieglitz group—had presumably seen the Picasso drawings and watercolors shown at the Photo-Secession Gallery in 1911 before he embarked upon *Landscape No. 32* (plate 237), an interesting essay in proto-Cubist style. Hartley was a young man just embarking on his career, but modernism had its impact on older figures too. Henry Fitch Taylor was sixty years old when the Armory Show opened. The fact that he was one of its organizers indicates that he was not a reactionary, but nothing in his career to that time had marked him as a radical. Taylor was so bowled over by the advanced European work in the show, however, that he became an overnight convert to abstract art. *The Parade: Abstracted Figures* (plate 238) demonstrates that it was the more decorative aspects of abstraction that he most easily absorbed, but Taylor's conversion is nonetheless remarkable.

Some Americans did, of course, travel to Europe and experience contemporary

art at firsthand. Andrew Dasburg had spent time in Paris before painting *Sermon on the Mount* (plate 239), in which Cubist procedures are evident, though the image goes beyond mainstream Cubism in its degree of abstraction. As was frequently the case among Americans of his generation, however, Dasburg found it difficult to prolong a wholehearted embrace of such radicalism, and he later turned to a wholly figurative style, though one that was strongly influenced by modernist thinking.

Another American who spent time in Paris—several years, in fact—was John Marin, who returned to New York shortly before the Armory Show to become a key member of the Stieglitz group. Although he liked to pose as a self-made artist—a rough-hewn American original—Marin was clearly influenced by Fauvism during his Paris period. He modified this influence to arrive at a very personal watercolor style, which is seen at its most basic in *Municipal Building, New York* (plate 240), in which the image is presented with a straightforward vigor that seemed very fresh at the time. *Brooklyn Bridge* (plate 241), painted two years before, makes more use of modernist distortion and may even be touched by exposure to Cubism, though the distortion

240. John Marin (1870–1953)
Municipal Building, New York, 1912
Watercolor on paper,
18½ × 15⅝ in.
Philadelphia Museum of Art;
The A. E. Gallatin Collection

241. John Marin (1870–1953)
Brooklyn Bridge, 1910
Watercolor on paper,
18½ × 15½ in.
The Metropolitan Museum of Art,
New York; The Alfred Stieglitz
Collection, 1949

242. John Marin (1870–1953)
Lower Manhattan, 1920
Watercolor on paper,
21⅞ × 26¾ in.
Collection, The Museum of
Modern Art, New York; The
Philip L. Goodwin Collection

243. John Marin (1870–1953)
 Ship, Sea, and Sky Forms (An
 Impression), 1923
 Watercolor on paper, 13½ × 17 in.
 Columbus Museum of Art, Columbus,
 Ohio; Gift of Ferdinand Howald

244. Georgia O'Keeffe (1887–1986)
Canna Lily, 1919
Watercolor on paper, 23 × 12⅞ in.
Columbus Museum of Art, Columbus,
Ohio; Museum Purchase, Derby Fund

245. Charles Demuth (1883–1935)
Circus, 1917
Watercolor and pencil on paper,
8 × 13 in.
Hirshhorn Museum and Sculpture
Garden, Smithsonian Institution,
Washington, D.C.; Gift of Joseph H.
Hirshhorn Foundation, 1966

246. Charles Demuth (1883–1935)
Red Roofed Houses, 1917
Watercolor on paper, 9¾ × 14 in.
Philadelphia Museum of Art; The
Samuel S. White, 3rd, and
Vera White Collection

probably owes more to Expressionist influences. By the time he painted *Lower Manhattan* (plate 242), Marin had absorbed many of the lessons of Cubism, and perhaps Futurism too, yet to a large extent he still relied on the excitement of New York itself—the sweep of the El, the thrust of the Woolworth Building—to produce a sensation of modernity.

Simultaneously, Marin was applying a modernist approach to more traditional landscape subjects, such as *Ship, Sea, and Sky Forms* (plate 243), where he used a framing device—a *G*-shaped figure that circles the image—similar to those sometimes used by Braque in his post-Cubist period. Marin often introduced such geometrics into otherwise fairly naturalistic images in a way that seems on casual inspection to be arbitrary, whereas these geometrics are in fact an integral part of his visual language. In some of his paintings he actually seems to superimpose an abstract painting on top of a figurative one. Marin must be counted a major watercolorist, an artist who knew how to exploit the medium's strengths and delicacies, who had a natural feeling for transparent washes but could also, when the occasion demanded, use raw color direct from the tube to make bold structural statements.

Another member of the Stieglitz group who used watercolor brilliantly, if only for a relatively short while, was Georgia O'Keeffe (see chapter 5). She did not spend an apprenticeship in Europe but came under the influence of Arthur Wesley Dow, who revolutionized art education in America by turning his back on academic methods and advocating that students focus on basic compositional elements such as line, mass, and color. Dow derived many of his ideas from Gauguin and the Symbolists, so in a sense O'Keeffe was exposed to the same notions as her contemporaries in Europe, but she developed those ideas within the context of the very limited avant-garde community

that centered on Stieglitz and his gallery. Not surprisingly, then, O'Keeffe's art evolved in a highly personal way, independent of any movement. *Train at Night in the Desert* (plate 236) quite clearly shows what the title describes; yet it comes close to being an abstract work because the iconography is reduced to something approaching the hieroglyphic, and form and color are allowed to speak for themselves. From a technical point of view this is a skillful performance, with highly effective use of wet-into-wet

247. Charles Demuth (1883–1935)
Fruit and Flowers, c. 1924
Watercolor over graphite on white paper, 18 × 11¾ in.
The Harvard University Art Museums (Fogg Art Museum); Purchase—Louise E. Bettens Fund

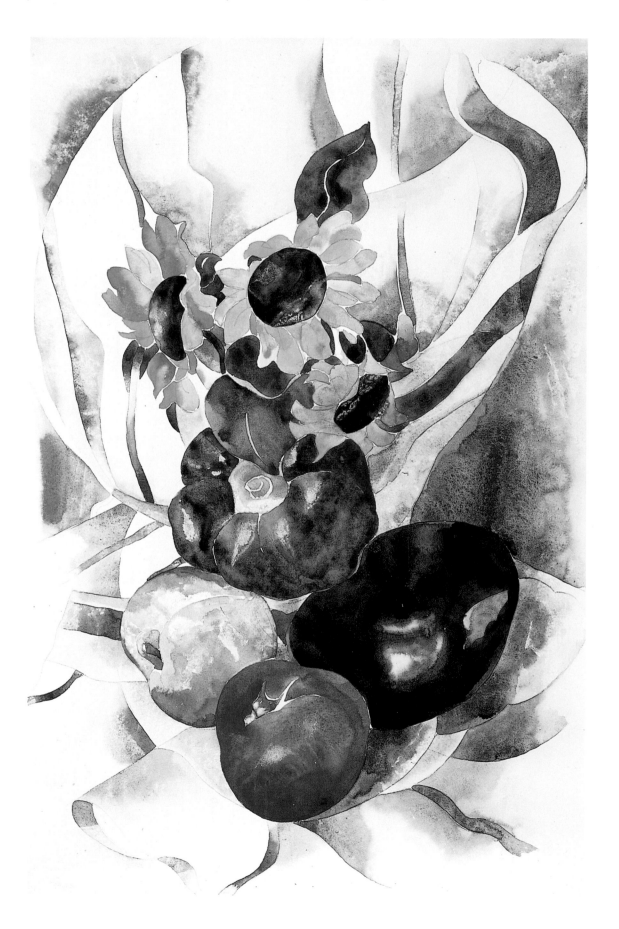

brushwork. *Canna Lily* (plate 244) is a more deliberately controlled piece of work that predicts much about O'Keeffe's later career and also about the coming evolution of American art. Many American artists would look at nature this way, seeking the structure beneath the surface.

Charles Demuth is at least a partial instance of this phenomenon and is certainly an artist who was involved in the American dialogue between realism and the new movements. Lame since childhood, Demuth was in poor health throughout most of his life, which partially explains his predilection for small-scale works and for watercolor in particular. One aspect of his work is typified by *Circus* (plate 245). Demuth loved to record the life of arenas, nightclubs, and cabarets, doing so in a straightforward though subtle realist style that is often reminiscent of Pascin, whom he knew and admired. These genre scenes delicately balance flickering line with skillfully applied washes that sometimes nestle up against the perimeters of objects, sometimes bleed over into surrounding areas.

The same basic skills are to be found in paintings such as *Red Roofed Houses* (plate 246). In it Demuth responded to European modernism, especially Cubism, which he had encountered both through his contacts with the Stieglitz circle and his extended trips to Paris. When reaching for a more geometric form of art, as in the present instance, Demuth habitually looked for subjects that already contained an angular substructure. *Red Roofed Houses* was painted in Bermuda, but he also found such subjects in the Pennsylvania Dutch towns of his childhood.

It can be argued that the greatest achievements of Demuth's rather short career

248. Charles Demuth (1883–1935)
Still Life with Apples and Bananas,
1925
Watercolor and pencil on paper,
11⅞ × 18 in.
The Detroit Institute of Arts;
Bequest of Robert H. Tannahill

249. William Zorach (1887–1966)
Sailing by Moonlight, 1922
Watercolor over charcoal on paper,
21 × 14½ in. (sight)
The Phillips Collection,
Washington, D.C.

were the watercolor still lifes painted during the last decade of his life, including *Fruit and Flowers* and *Still Life with Apples and Bananas* (plates 247, 248). These are not innovative works—they frankly hark back to Cézanne's watercolors of two decades earlier—but they benefit from Demuth's knowledge of Cubism and other modernist trends, and from that ongoing dialogue in American art, and so they have a decidedly modern feel that keeps them as fresh today as when they were painted. Another artist who displayed similar qualities in his occasional watercolors was the sculptor William Zorach (plate 249).

Demuth is sometimes associated with the Precisionists, an informal group of artists whose most prominent member was Charles Sheeler. Born, like Demuth, in Pennsylvania, Sheeler studied art at the Pennsylvania Academy of the Fine Arts and toured Europe before establishing himself as a photographer in Philadelphia. During the period immediately before and after the Armory Show—at which he exhibited six paintings—he traveled frequently to New York, making contact with various advanced groups, especially the circle around Walter and Louise Arensberg, which included Marcel Duchamp. In 1919 Sheeler moved to New York, where his mature style began to crystallize. He had absorbed the lessons of Cubism and considered the possibilities of abstraction, but his experience as a photographer had helped convince him that he could find, in nature and in man-made objects, forms more significant than any he could invent. It was his belief that "a picture could have incorporated in it the structural design implied in abstraction, and be presented in a wholly realistic manner. . . ."[15]

In *Chrysanthemums* (plate 250), Cubism's influence is apparent in the slightly distorted treatment of the wine glass and in the way the elements relate to the

boundaries of the picture plane. In particular, the angle of the table in relation to the edge of the picture recalls Cubist practice, although this relationship could also be explained by the artist's angle of vision. This is basically a naturalistic picture, but it speaks to the viewer with a slight Cubist accent. That accent is also discernible in *Still Life and Shadows* (plate 251), in which the highly structured arrangement of objects echoes some aspects of work by Juan Gris, a resemblance heightened by Sheeler's use of strongly defined patterns of shadow to create a geometry that removes this picture from the realms of conventional realism. Some of Sheeler's most successful paintings were of industrial plants, a subject that he tackled only occasionally in watercolor. *River Rouge Industrial Plant* (plate 252) is not as abstracted as many of his comparable works on canvas, but it demonstrates how Sheeler could coax a curious poetry from prosaic scenes of factories and railroads.

250. Charles Sheeler (1883–1965)
Chrysanthemums (formerly *Dahlias and White Pitcher*), 1923
Gouache, conté crayon, and graphite on paper, 25½ × 19 in.
Columbus Museum of Art, Columbus, Ohio; Gift of Ferdinand Howald

251. Charles Sheeler (1883–1965)
Still Life and Shadows, 1924
Conté crayon, watercolor, and
tempera on paper, 31 × 21 in.
Columbus Museum of Art, Columbus,
Ohio; Gift of Ferdinand Howald

252. Charles Sheeler (1883–1965)
River Rouge Industrial Plant, 1928
Graphite and watercolor on paper
mounted on paper, 8⅜ × 11¼ in.
The Carnegie Museum of Art,
Pittsburgh; Gift of
G. David Thompson

253. Edward Hopper (1882–1967)
Skyline near Washington Square, 1925
Watercolor on paper, 15 × 21⅝ in.
Munson-Williams-Proctor Institute,
Utica, New York

Another realist with a powerful sense of structure was Edward Hopper, though Hopper made no particular claims to have learned from Cubist or nonobjective models. Indeed, he often expressed himself as being at odds with experimental art, but his paintings have a nonetheless modern feel to them, and some of his works on canvas create an almost surreal atmosphere, though one that owes more to the dislocations of everyday existence than to orthodox Surrealist theory.

As a watercolorist, Hopper was perhaps Winslow Homer's true successor, though Hopper's emotional level is more subdued, his technical approach more constrained. Homer's brushwork is gestural and overtly expressive, while Hopper's is flatter and more purely descriptive. Homer's color schemes are often keyed to warm colors, whereas Hopper's tend to be cool (many of his watercolors are dominated by crisp northern skies). Homer's personality seems to be encoded into every square inch of each of his watercolors. Hopper seems to have been courting anonymity; it is almost as if he painted from a textbook. Yet both artists built their paintings with care and precision, creating form by juxtaposing areas of transparent wash, modifying colors by the addition of more washes, working logically from the sparkle of white paper to the deep richness of shadows that remain as luminous as shadows are in real life. Both, in short, borrowed their method from the British watercolor tradition at its purest, and both wed this technical heritage to an unblinking directness of vision. Both of these artists knew how to look at something honestly, and how to set down what they saw without mannerism or affectation. It might be said of Hopper, in fact, that lack of affectation is what defined his personality.

Hopper had a fondness for roofscapes, and his *Skyline near Washington Square* (plate 253) captures an aspect of New York very remote from the bustle of the metropolis that had attracted Picabia and Marin. Hopper's urban views tend to emphasize the state of solitude in the city, the condition of alienation that is as much a part of twentieth-century art as abstraction. And although he denied any allegiance to modernism, like Sheeler he used careful composition and patterns of shadows to build a powerful abstract structure. In *Cars and Rocks* (plate 254), Hopper found structural strength

254. Edward Hopper (1882–1967)
Cars and Rocks, c. 1927
Watercolor on paper, 13⅞ × 20 in.
Whitney Museum of American Art,
New York; Josephine N. Hopper
Bequest

in the rock formations themselves, combined with the silhouettes of automobiles. This image also demonstrates that Hopper's color sense, though low keyed, was highly developed. See, for example, how the blue and reddish-brown washes work together as complements.

No other major twentieth-century artist employed traditional watercolor technique with greater purity than Hopper. He applied his washes with great clarity and was such a stickler that he spurned the use of body color even for highlights. *House of the Fog Horn, No. 3* (plate 255) reveals his art at its simplest and most direct. There is nothing clever or self-conscious about this painting; it is a plain statement of pictorial fact painted with great economy and an utter lack of sentimentality. The same is true of *Highland Light (North Truro)* (plate 256), which seems more complex only because the architectural subject is more complex. Hopper's style makes it clear that there was more than one way to be modern. Most artists demonstrate their modernity by espousing new idioms—though all but those who pioneer those idioms tend to look a little old-fashioned. Hopper demonstrated that it was possible to be modern simply by avoiding clichés. His kind of modernity can also be found in the work of certain photographers who rely primarily on sureness of eye.

Hopper's reputation rests in part upon his watercolors; that of his friend Charles Burchfield rests entirely upon watercolor. Indeed, Burchfield rarely worked on canvas —he considered his few oils to be failures—and instead evolved a highly unorthodox watercolor technique that permitted him to work on a relatively large scale and with

an intensity that rivals anything that can be achieved with oil paint. Fiercely individualistic, Burchfield was one of the most interesting painters of his generation.

Burchfield was unusual in that he developed outside the New York art scene and even outside major provincial centers such as Boston and Philadelphia; born and raised in small Ohio towns, he studied at the Cleveland School of Art. Although he arrived at an original style early in his career, Burchfield was forced to work for years in industrial jobs—first as an accountant, then as a wallpaper designer—before he was finally able to support himself from his painting in his late thirties. Even after achieving a degree of success he avoided the Manhattan art world, preferring to remain in Buffalo, New York. Indeed, much of his inspiration came from the industrial towns and cities of

255. Edward Hopper (1882–1967)
 House of the Fog Horn, No. 3, 1929
 Watercolor over preliminary sketch in pencil on paper, 14 × 20 in.
 Yale University Art Gallery, New Haven, Connecticut; Gift of George Hopper Fitch, B.A. 1932

256. Edward Hopper (1882–1967)
 Highland Light (North Truro), 1930
 Watercolor over graphite on paper, 16⅝ × 25¾ in.
 The Harvard University Art Museums (Fogg Art Museum); Purchase—Louise E. Bettens Fund

CLOCKWISE FROM LEFT

257. Charles Burchfield (1893–1967)
Ravine in Summer Rain, 1917
Watercolor on paper, 21½ × 18 in.
Greenville County Museum of Art,
Greenville, South Carolina; Gift of
Mr. and Mrs. Arthur F. Magill, 1974

258. Charles Burchfield (1893–1967)
Moon through Young Sunflowers, 1916
Gouache, graphite, and watercolor
on paper, 19⅞ × 14 in.
The Carnegie Museum of Art,
Pittsburgh; Gift of Mr. and Mrs. James
H. Beal, 1967

259. Charles Burchfield (1893–1967)
The East Wind, 1918
Watercolor on paper,
17½ × 21⅝ in.
Albright-Knox Art Gallery,
Buffalo, New York; Bequest of
A. Conger Goodyear, 1966

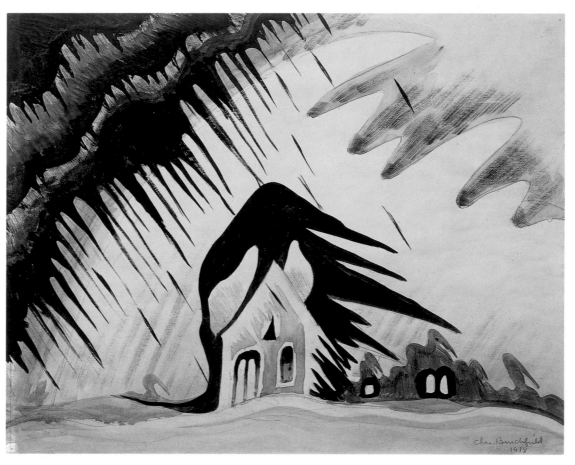

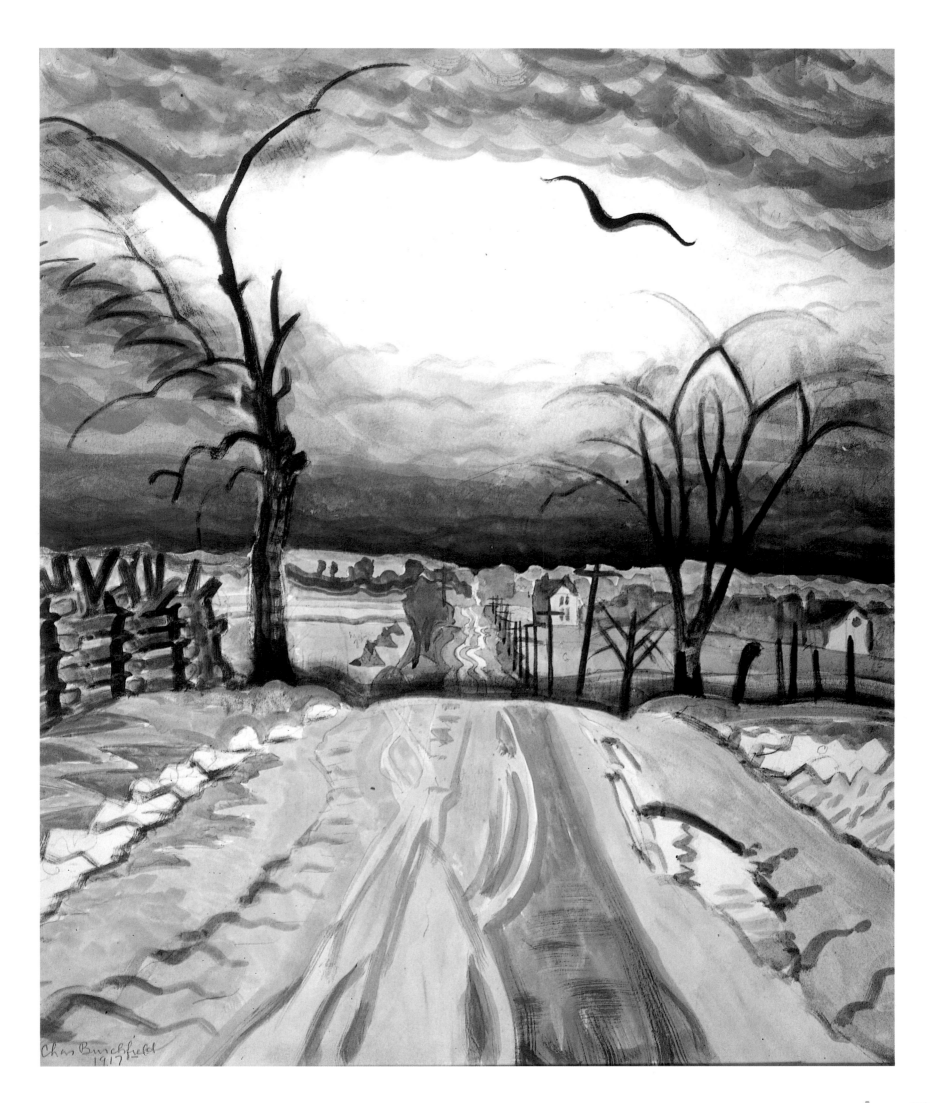

the Northeast and from the surrounding countryside, icy in winter, sultry in summer.

Burchfield had little early contact with European modernism but discovered Japanese art for himself; like so many of his contemporaries, he also became fascinated by the parallels between painting and music. Presumably aware of van Gogh and perhaps of Munch, but certainly unaware of the German Expressionists, by 1916 Burchfield was developing an expressionistic idiom that had much in common with some art by the Brücke and Blue Rider groups. Paintings such as *Moon through Young Sunflowers* of 1916 (plate 258) display his ability to reduce pictorial elements to significant form and express the exuberant pantheism of his art. This particular example also announces Burchfield's very personal sense of color, too seldom remarked on even by his admirers.

During the next year or two Burchfield had an extraordinary burst of creative activity, producing the eloquent *Ravine in Summer Rain* (plate 257) and the startling *The East Wind* (plate 259). Although expressionistic, the former is also relatively naturalistic, and essentially lyrical in mood. *The East Wind,* on the other hand, utilizes an almost cartoonlike simplification of form. Buildings, trees, and the weather itself are anthropomorphized. Form becomes emotion and emotion, form, almost to the extent found in Kandinsky's work when he was on the verge of abstraction. But Burchfield never edged over into nonfigurative art, and even during this first experimental phase of his career the strength of his work often derived from fairly straightforward portrayals of the everyday world. *The Mysterious Bird* (plate 260), for example, is a highly charged picture that derives much of its energy from expressionistic devices, but at the same time it is plainly a view of a rural highway, unpaved and rutted, such as Burchfield would have found in the vicinity of Salem, Ohio, where he lived and worked at the time.

In the middle period of his career, in the 1920s and '30s, Burchfield deliberately

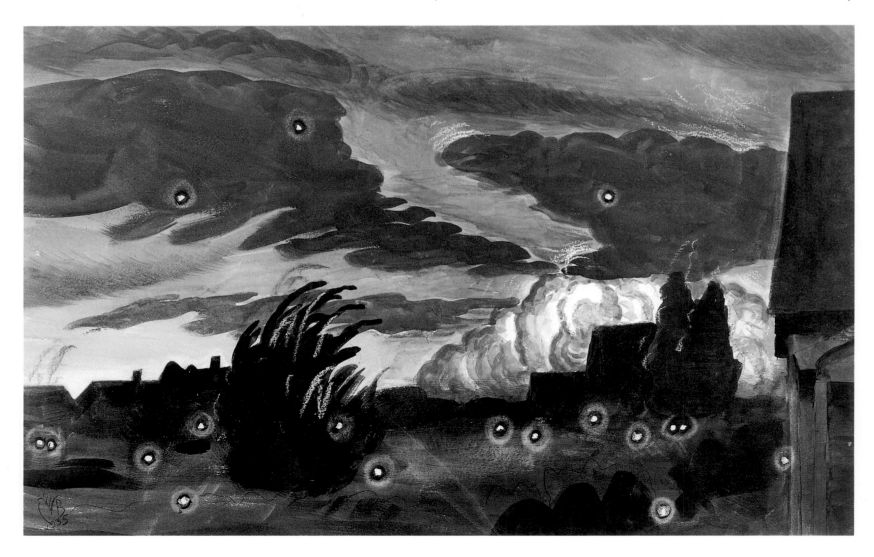

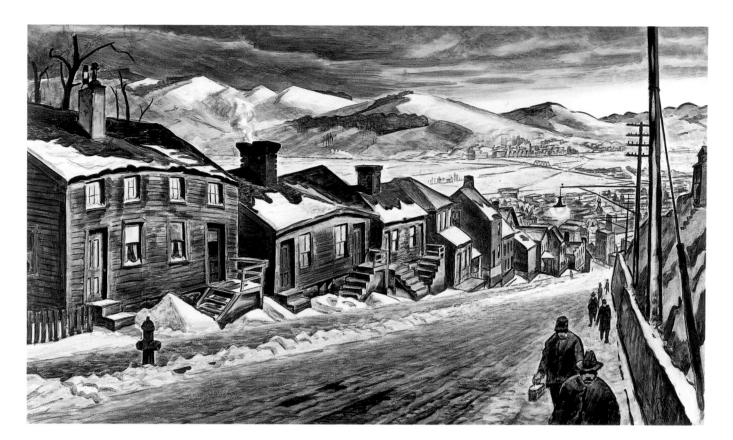

emphasized the realistic aspect of his art, apparently hoping it would make his work more accessible to the public. Occasionally, as in *Night Scene* (plate 261), some of the energy of his earlier work would be apparent. More often in this period he depended on direct observation, with only a minimal use of expressionistic distortion. In paintings such as *End of the Day* (plate 262), with its steep, snow-covered street lined with drab workers' houses, he was as successful as Hopper in eliciting poetry from a banal scene.

During this realist period Burchfield perfected his remarkable watercolor technique, in which washes are overlaid with stippling and little flickers of calligraphy. Early in the 1940s he returned to a more expressionistic approach, and the first thing he did following this shift was to rework some of his paintings from the 1916–18 period, giving them the benefit of his increased technical expertise and often enlarging them by adding fresh sheets of paper to the perimeters of the old image. The result was a new approach that combined the emotional energy of his early style with the large scale and technical assurance of his realist period. One example is *The Sphinx and the Milky Way* (plate 263), a remarkably rich work that evokes the sounds as well as the sights of the night world—and counterpoints that teeming world with a sky seeded with stars. No twentieth-century artist has been more adept at evoking the mood of a certain place at a certain time—Bonnard is one of Burchfield's few equals in this respect—and increasingly in his late work Burchfield exploited this gift to great effect. In *Overhanging Cloud in July* (plate 264) the hills are edged with a halo of light, a frequent sight in Burchfield's art. The sun streams down through the thunderclouds, and the viewer can almost feel the humidity. But this is not just a mood piece: it is also a powerful plastic statement marked by great directness of expression. In subject matter, *North Otto—Thunderhead* (plate 265) is almost a companion piece. Painted just three years before his death, it demonstrates Burchfield's ability to make the air in his watercolors vibrate with energy. There is no such thing as empty space in his paintings. Everything is alive, and this is one of the qualities that made Burchfield not only a major figure in the development of American art but also one of the greatest watercolorists of this century.

Another American artist who developed a highly individualistic watercolor technique—sometimes branching off to work in tempera, sometimes in pen and wash—was

262. Charles Burchfield (1893–1967)
End of the Day, 1936–38
Watercolor on paper, 28 × 48 in.
The Pennsylvania Academy of the Fine Arts, Philadelphia; Temple Purchase Fund

OPPOSITE

263. Charles Burchfield (1893–1967)
The Sphinx and the Milky Way, 1946
Watercolor on paper,
52⅝ × 44¾ in.
Munson-Williams-Proctor Institute,
Utica, New York

264. Charles Burchfield (1893–1967)
Overhanging Cloud in July, 1947–59
Watercolor on paper, 39½ × 35 in.
Whitney Museum of American Art,
New York; Purchase with funds from
the Friends of the Whitney Museum
of American Art

265. Charles Burchfield (1893–1967)
North Otto—Thunderhead, 1964
Watercolor on paper, 44 × 26¾ in.
Kennedy Galleries, Inc., New York

266. Reginald Marsh (1898–1954)
Hudson Bay Fur Company, 1932
Egg tempera on muslin mounted to
particle board, 30 × 40 in.
Columbus Museum of Art, Columbus,
Ohio; Museum Purchase, Howald
Fund

Reginald Marsh. An unabashed realist, Marsh took for his subject the streets of New York, the life of its burlesque theaters and of the beaches and sideshows of Coney Island, always focusing on the crowds that enliven these places. *Hudson Bay Fur Company* (plate 266) depicts live mannequins showing off furs in the second-floor display window of a garment-district showroom. This provides Marsh with the opportunity to portray from an unusual angle the pretty working girls who feature so prominently in his work. As is so often the case with Marsh, lettering plays an important role in the composition, but the principal interest comes from the liveliness with which he captured the characters of the young women—their poses more vividly revealing than their features. In *New Dodgem* (plate 267), the young women's styles are perfectly caught. As always Marsh proved himself a master of social observation, reminiscent at times of George Grosz, who by this time was a presence in New York. Marsh's ability to zero in, like a journalist, on the telling minutiae of life is illustrated by *Sideshow* (plate 268), a World War II subject in which an alleged victim of torture has been turned into a freak-show attraction alongside the Tattooed Man and the Bearded Lady.

Marsh steered clear of modernist influence, but his colleague Milton Avery welcomed it—especially as embodied by Matisse—and forged a style in which landscapes and figures were simplified into pattern without ever losing their identity. *Dune and Bushes* (plate 269) is a strong example of Avery's mature idiom and presents one of his favorite subjects, the beach. The forms are delineated with great confidence, and this graphic sureness combines with Avery's well-developed color sense to make a monumental statement that belies the painting's modest scale.

Avery's mastery of the dialogue between modernism and realism rivaled that achieved by many European artists. More typically American was Arthur Dove's ambiv-

alence; throughout his entire career he seems to have been drawn in both directions. Having started his career within the Stieglitz circle, he demonstrated himself early in the century to be one of America's most adventurous and gifted avant-garde artists. He embraced abstraction at a very early date, incorporated real objects into his work, and generally demonstrated his alertness to all the possibilities of the new art. Remaining open to all possibilities has its perils, however, and the public seems to have lost track of Dove's career after World War I. Left to his own devices, he explored many different

267. Reginald Marsh (1898–1954)
New Dodgem, 1940
Watercolor on paper,
40¼ × 26¾ in.
Whitney Museum of American Art, New York; Gift of the artist, and gift of Gertrude Vanderbilt Whitney by exchange

268. Reginald Marsh (1898–1954)
Sideshow, 1944
Graphite and watercolor on paper mounted on board, 31½ × 22½ in.
The Carnegie Museum of Art, Pittsburgh: Gift of Marty Cornelius (Martha C. Fitzpatrick), 1974

269. Milton Avery (1893–1965)
Dune and Bushes, 1958
Watercolor and gouache on paper,
22⅜ × 30¼ in.
Collection, The Museum of Modern
Art, New York; Purchase

paths, sometimes working in a very free idiom that anticipated Abstract Expressionism, as is the case with *Dawn III* (plate 270), at other times pursuing a loose kind of realism, as exemplified by *Phelps, New York* (plate 271).

Little appreciated for many years, Dove is now acknowledged to be one of the great pioneers of American modernism. We do not find in his work the sustained achievement of a Mondrian or a Kandinsky, but what he did provide—along with a handful of masterpieces—is a brilliant gloss on the ideological dialogue that fueled American art during the years from the Armory Show to World War II.

That dialogue is to be found in a particularly clear form in the art of Stuart Davis. Davis was the son of a Philadelphia publisher who frequently employed artist-illustrators such as William Glackens and George Luks, well-known members of the so-called Ashcan School. The influence of these artists—masters of the American vernacular—is evident in his early work, and it was reinforced by Davis's studies with Robert Henri. Soon, however, he came into contact with the first generation of American modernists, and then at the Armory Show and in Europe he absorbed the lessons of European modernism and was strongly, if a little belatedly, attracted to Cubism.

In works such as *Havana Landscape* (plate 272), many influences can be seen at work, though it is Marin and Dove rather than any Europeans who are called most urgently to mind. By the time he painted *Study for "Flying Carpet"* (plate 273), the Cubist influence had become dominant, but Davis's version of Cubism had a decidedly American

270. Arthur Dove (1880–1946)
Dawn III, 1932
Watercolor on paper, 9½ × 9½ in.
The Brooklyn Museum;
Dick S. Ramsay Fund

271. Arthur Dove (1880–1946)
Phelps, New York, 1937
Watercolor on paper, 5⅛ × 7⅛ in.
The Phillips Collection,
Washington, D.C.

272. Stuart Davis (1892–1964)
Havana Landscape, 1920
Watercolor on paper,
17¾ × 23¾ in.
Earl Davis

cast. It was the Synthetic phase of Cubism that he built upon—the phase in which the rules of the game had been so well established that they could be taken for granted. Sometimes Davis would incorporate Gallic imagery into his paintings, as if to acknowledge his source, but far more often he introduced imagery drawn from specifically American sources—jazz, highway culture, advertising signs. *Study for "Flying Carpet"* emphasizes pattern rather than symbol, but even this pattern seems to encapsulate his involvement with American popular culture. The arrow might be the arrow on a street sign, the squiggles that help tie the geometry together are reminiscent of bent neon tubes.

Davis gave one of his paintings the tongue-in-cheek title *Colonial Cubism,* and that rather accurately describes both his own work and that of some other early American modernists. But the Americans of Davis's generation cannot easily be dismissed as mere "colonials," for they were working in the context of a society and a culture that were on the rise. At the time it was made their work was peripheral to the mainstream, but by virtue of their influence on later artists—such as Arshile Gorky, Willem de Kooning, and Jasper Johns—they have come to constitute an important tributary of that mainstream.

273. Stuart Davis (1892–1964)
Study for "Flying Carpet," 1942
Gouache on paper, 10 × 14 in.
Earl Davis

The 1920s and 1930s were marked by continuing ferment in the art world. Surrealism was at its height, and nonfigurative art claimed more and more converts. Alongside all this there arose the phenomenon of the modern master. The revolutionaries of Fauvism and Cubism were now wealthy and famous. Matisse was living in comfort in the south of France, while Picasso shuttled between Paris and a succession of chateaux. Collectors waited patiently to buy their work, and new museums were built to house their masterpieces. It was a far cry from the days of the Salon des Refusés and the Bateau-Lavoir. Not the least of the changes was the fact that this first vanguard generation was becoming middle-aged. Not that this meant that they had ceased to experiment. It has been said that the mark of the greatest masters is that they reinvent themselves many times during a career, and certainly that was true of Matisse and Picasso. Their colleagues may have been less indefatigably creative but nonetheless they, too, continued to evolve long after leaving the radical phase.

Just as Picasso had led the way into Cubism so was he the first to emerge from it. His approach to Cubism had been influenced by his exposure to Iberian and African primitive sculpture, and his neoclassical phase was similarly ushered in by his interest in classical sculpture, especially the Roman marbles he encountered on a 1917 visit to Italy. Having thoroughly confused the public with his Cubist work, Picasso now confused them all over again by seeming to turn his back on Cubism. What only a few perceptive observers realized at the time was that the neoclassical compositions were in fact built on the structural knowledge acquired while Picasso was mastering the challenge of Cubism.

This is certainly true of *Sleeping Peasants* (plate 275), a charming work in which the neoclassical theme is given a new twist by the somewhat contemporary setting (the clothing and barn suggest Spain). This is a study in interlocking volumes that—despite its skillfully rendered naturalistic trappings—is essentially Cubist in structure. A slightly later notebook drawing deals with the mother and child theme that recurred throughout Picasso's oeuvre (plate 276). Here the volumes so solidly modeled in the neoclassical works have been flattened out once more. The figures are outlined in a naturalistic rather than a Cubist style, but the flatness and the accompanying manipulation of the picture plane derive from Cubism. During the 1930s Picasso often dealt with mythological scenes, and one of his favorite subjects was the Minotaur (plate 277), here boldly presented in a combination of ink calligraphy and loosely brushed color.

What is discovered, if Picasso's career is studied as a whole, is that his apparently contradictory idioms flow into one another in many unexpected ways. A basically

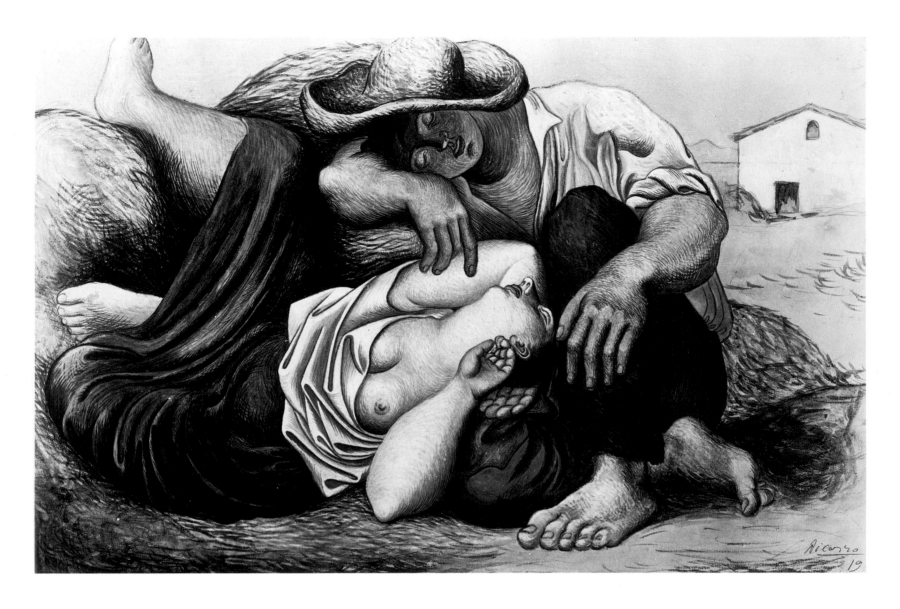

realistic subject, for example, is informed by a Cubist sense of structure, or a Cubist image may be enlivened by the introduction of neoclassical elements. Picasso used many different iconographies, but they were permitted to overlap. Similarly, he used many technical approaches and a wide variety of media; the lessons he learned from collage, for instance, might be applied to the way he worked in oils. Not surprisingly, in view of this, he used any given medium in different ways on different occasions. This is certainly the case where watercolor and gouache are concerned. Sometimes he would use watercolor for the sake of its transparency, building with it in layers; at other times he would employ it simply as a convenient means of indicating local color. As for gouache, he sometimes called upon it as a fluid yet chromatically rich improvisational medium, but on other occasions he used it for highly finished compositions.

The other great Cubist pioneer, Georges Braque, built more systematically upon the discoveries that he and Picasso had made, gradually translating the language they had evolved together into a more personal dialect that he continued to enrich throughout his career. Still life remained Braque's greatest preoccupation, but like Picasso, he turned for a while to neoclassical renditions of the figure.

For Braque the primary inspiration seems to have been the monumental nudes of Renoir's last years, which were exhibited for the first time at the Paris Salon d'Automne in 1920, the year after Renoir's death. *"Les Fâcheux": Act Curtain (The Naiad)* (plate 278) was made for a Diaghilev ballet production but never used. In style it relates to the majestic series of Canéphores—paintings of women holding baskets of fruit—that Braque completed between 1922 and 1926.

An artist who was deeply indebted to Cubism but who managed to retain an essentially personal vision was Marc Chagall. Born into a Hasidic family in western Russia in 1887, Chagall absorbed during his childhood the folklore of the shtetl—half-magical tales of rabbis and peasants, peddlers and fiddlers, lovers and angels—which would pervade his art for the rest of his life. In 1910 he went to Paris and first encountered modernism—especially Cubism. He began to fragment images and to juxtapose objects and figures in unexpected ways and in unexpected scales. The results, although in some respects reminiscent of some of Delaunay's work, were essentially unique.

At the outbreak of World War I, Chagall was on a visit to Russia and found himself trapped there. The October Revolution resulted in his reorganizing the art school in his home town, Vitebsk, along his own quirky principles. This proved confusing for the local Bolsheviks, and even for his superior at the school, Kasimir Malevich, and he was dismissed. After spending some time in Moscow, designing for the State Jewish Theater, Chagall returned to the West in 1922.

It was during his Russian period that Chagall made some of his most striking images, such as *Homage to Gogol* (plate 279), in which the influence of other members of the Russian avant-garde is felt quite strongly. Back in the West he continued to make

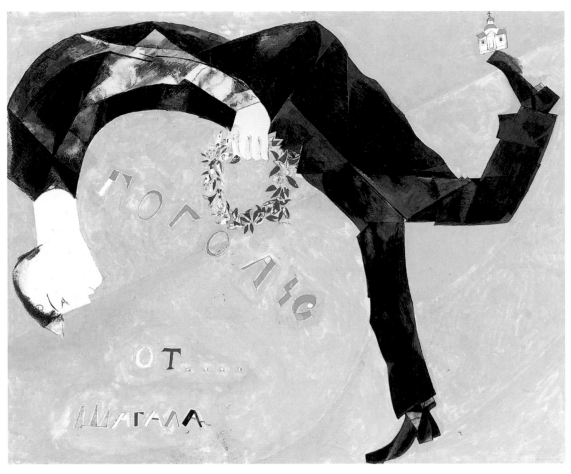

OPPOSITE

278. Georges Braque (1882–1963)
 "Les Fâcheux": Act Curtain (The Naiad), 1924
 Pencil, watercolor, and gouache on paper, 12 × 12 in.
 Wadsworth Atheneum, Hartford, Connecticut; From the Serge Lifar Collection and The Ella Gallup Sumner and Mary Catlin Sumner Collection

279. Marc Chagall (1887–1985)
 Homage to Gogol, design for curtain (not executed) for Gogol Festival, Hermitage Theater, Petrograd (Leningrad), 1917
 Watercolor on paper, 15½ × 19¾ in.
 Collection, The Museum of Modern Art, New York; Acquired through the Lillie P. Bliss Bequest

280. Marc Chagall (1887–1985)
 The Soldier, c. 1923–24
 Gouache on paper, 25 × 19 in.
 Solomon R. Guggenheim Museum, New York

À Hilla Rebay

Marc Chagall

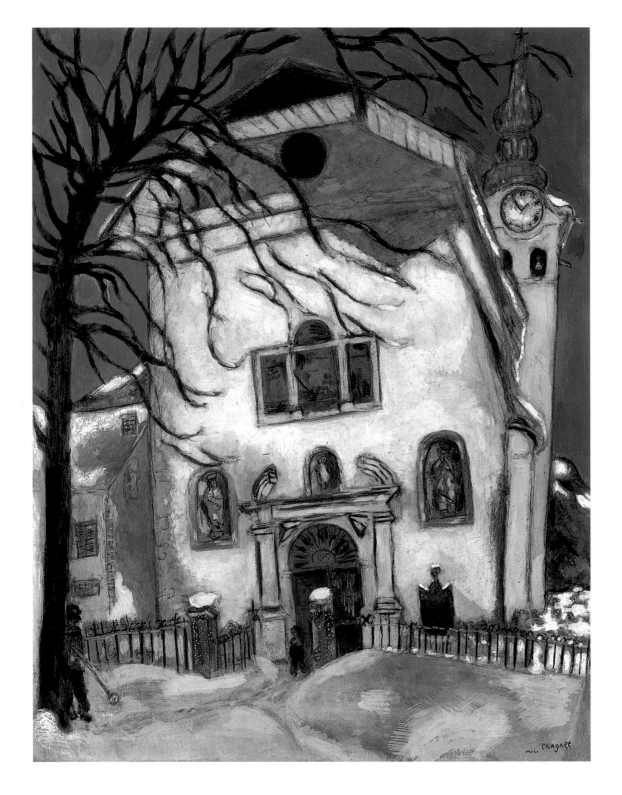

OPPOSITE

281. Marc Chagall (1887–1985)
 I and the Village, c. 1925
 Gouache and watercolor on paper,
 15¼ × 11¾ in.
 Solomon R. Guggenheim Museum,
 New York

282. Marc Chagall (1887–1985)
 Snow-Covered Church, 1927–28
 Gouache on paper, 26½ × 20¼ in.
 The Detroit Institute of Arts;
 Founders Society Purchase, Friends
 of Modern Art Fund

images that evoked Russia, such as *The Soldier* (plate 280). In particular he continued to evoke the world of the Jewish shtetls in works such as *I and the Village* (plate 281), which is almost a catalog of Chagall's distinctive devices: freely floating objects, dramatic shifts in scale, reconstruction of pictorial space along post-Cubist lines. Not that Chagall was incapable of making straightforward images, as is clear from *Snow-Covered Church* (plate 282), which might almost be by Maurice Utrillo. Snow always seems to have a poetic connotation in Chagall's work, and it crops up again and again, as in *Snowing* (plate 1), with its gigantic clownlike violinist strolling down a wintry street.

Chagall was a friend of the poets Guillaume Apollinaire and Blaise Cendrars, and certainly it is understandable that his lyric imagery would appeal to them. Apollinaire described Chagall's work as *surnaturel*—just as André Breton later claimed it for Surrealism—but if we need a simple description of Chagall's world then *dreamlike,* surely,

283. Marc Chagall (1887–1985)
The Dream, 1939
Gouache on paper, 20½ × 26⅞ in.
The Phillips Collection,
Washington, D.C.

is as accurate as we can get. More than any Surrealist, Chagall successfully created the atmosphere of dreams, as is specifically acknowledged by the title *The Dream* (plate 283), a magical composition in which a couple embraces on a bed that seems to float above the village streets while an angel watches over the entire scene.

Like Chagall, Kandinsky found himself in Russia during World War I and did not relocate to the West until 1921, the year before he began teaching at the Bauhaus in Weimar. At that point Kandinsky was in transition from painting in a relatively free-form Expressionist style to a more purely geometrical one. Often, in the work of that period, loosely hand-drawn shapes are found alongside harder-edged shapes made with the aid of a compass or triangle. By 1925, when he painted *Inner Simmering* (plate 284), geometry had become dominant. Kandinsky began to draw all his forms in india ink, using compass and ruler; then he would apply color in a variety of ways. Sometimes he employed conventional washes, but on other occasions he sprayed color or spattered it onto the paper (possibly with the aid of a toothbrush). He used sponges and blotting paper on his washes to modify their textures, and sometimes he would add alcohol or soap to a wash to obtain a mottled effect.

In *Aglow* (plate 285), the cluster of geometrical forms on the left side of the

284. Wassily Kandinsky (1866–1944)
Inner Simmering, 1925
Watercolor, wash, india ink, and
pencil on paper, 19⅛ × 12⅝ in.
The Hilla von Rebay Foundation;
Solomon R. Guggenheim Museum,
New York

285. Wassily Kandinsky (1866–1944)
Aglow, 1928
Watercolor and ink on paper,
18 × 19⅜ in.
Solomon R. Guggenheim Museum,
New York

286. Wassily Kandinsky (1866–1944)
Abstract Construction, 1930
Gouache over black ink, red ink
over preliminary pencil drawing,
8⅜ × 6⅛ in.
Yale University Art Gallery,
New Haven, Connecticut; Gift of
Miss Katherine S. Dreier for the
Collection Société Anonyme

image suggests a medieval town clinging to a hilltop, but what is most remarkable is the luminous use of color, which clearly led to the work's title. This color has been applied using a combination of conventional wash and spatter techniques, with the different densities built up by layering the transparent pigments. The edges of these layers—visible along the right side of the composition—suggest that Kandinsky employed some kind of masking device.

In the 1930 *Abstract Construction* (plate 286), the geometry is precise and non-referential, but the blotchy color is loosely applied so that it overruns its outlines, which makes this angular image seem less severe. This watercolor is highly typical of Kandinsky's Bauhaus period; but *Round Poetry* (plate 287), painted three years later—the year the Nazis closed the Bauhaus and Kandinsky moved to Paris—pushes beyond these geometrical explorations to a startling simplicity. Indeed, it is hard to think of any

painting in the entire history of twentieth-century art more reductive than this.

In Paris, Kandinsky's imagery became more complex again, almost baroque, and he developed a fondness for working in gouache on black paper. He still employed compass and ruler from time to time, but sheets such as *Untitled (No. 653)* (plate 288) are drawn mostly freehand. What they demonstrate above all is that Kandinsky—an inveterate theorist—had gone beyond theory and was able once more, as in his Blue Rider years, to invent forms with exuberant freedom.

Raoul Dufy was a much-traveled cosmopolitan who would turn his brushes to recording anything from sailboats flecking the Mediterranean to the pomp and circumstance of a coronation. By the 1930s he had developed a personal calligraphy that was not only immediately recognizable but also much imitated. It lent itself especially well to crowd scenes such as *Epsom* (plate 289), since this calligraphy—similar whether describing jockey's silks or trees—serves as a unifying factor in busy, complex works.

His method also lent itself well to architectural subjects, as can be seen from *Versailles* (plate 290), an image dominated by the equestrian statue of Louis XIV that stands in the great court of the palace. It might be argued that by now Dufy had reduced Fauvism to a formula, but he was still capable of little flourishes of plastic invention, as

OPPOSITE, BOTTOM LEFT
287. Wassily Kandinsky (1866–1944)
Round Poetry, 1933
Watercolor and gouache on paper,
17⅜ × 17⅜ in.
Collection, The Museum cf
Modern Art, New York;
John S. Newberry Fund

OPPOSITE, RIGHT
288. Wassily Kandinsky (1866–1944)
Untitled (No. 653), 1940
Gouache on black paper, 19⅜ × 12⅝ in.
The Hilla von Rebay Foundation;
Solomon R. Guggenheim Museum,
New York

289. Raoul Dufy (1877–1953)
Epsom, 1935
Watercolor on paper, 19⅞ × 26⅛ in.
The Phillips Collection,
Washington, D.C.

290. Raoul Dufy (1877–1953)
Versailles, c. 1936
Watercolor on paper,
19¾ × 25¾ in.
The Phillips Collection,
Washington, D.C.

291. Pierre Bonnard (1867–1947)
Still Life: Preparation of Lunch, c. 1925
Gouache on paper, 19⅝ × 25⅝ in.
The Art Institute of Chicago; Olivia
Shaler Swan Memorial Fund

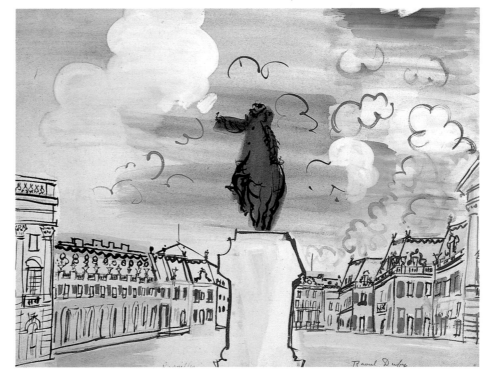

when he set the drawing of the statue against an area of color that is arbitrary from a descriptive point of view but that lifts the composition out of the ordinary.

Dufy might best be described as a superior entertainer. Pierre Bonnard operated on a higher level and, although his reputation was often eclipsed during his lifetime by those who espoused more radical trends, he can now be seen as one of the great masters of twentieth-century art. He had used gouache occasionally during the early part of his career, but it was not until the last decade of his life that he created his key works in the medium. *Still Life: Preparation of Lunch* (plate 291) is a marvelous painting that captures the full opulence of his mature style. The painting is actually very economical in execution, but the density of the pigment is remarkable, as is the shimmering interplay of colors. Anyone who has ever worked in gouache will realize how difficult this was to achieve, for gouache pigments change in shade and tint as they dry—change rather slowly—so that the relationships between colors shift. What the artist sees as he paints is not what will be there the following day.

This should be kept in mind when looking at *The Mediterranean* (plate 292), arguably one of the greatest gouaches ever painted. Having saturated the support with intense blues and greens, Bonnard punctuated the color scheme with notes of black and white and touches of reddish earth color. The results are stunning. The artist even managed to create the illusion of blur, as if the landscape is seen through a summer heat haze. Studying these two paintings, one can only regret that Bonnard did not work in this medium more often.

A most unusual use of gouache was made by Henri Matisse, who employed

292. Pierre Bonnard (1867–1947)
The Mediterranean, 1941–44
Gouache on paper, 19½ × 24⅝ in.
Musée National d'Art Moderne,
Centre Georges Pompidou, Paris

les bêtes de la mer...
H. Matisse 50

293. Henri Matisse (1869–1954)
Beasts of the Sea, 1950
Paper on canvas (collage),
116⅜ × 60⅝ in.
National Gallery of Art, Washington,
D.C.; Ailsa Mellon Bruce Fund

294. Henri Matisse (1869–1954)
Venus, 1952
Paper on canvas (collage),
39⅞ × 30⅛ in.
National Gallery of Art, Washington,
D.C.; Ailsa Mellon Bruce Fund

295. Henri Matisse (1869–1954)
The Negress, 1952
Paper on canvas (collage),
178¾ × 245½ in.
National Gallery of Art, Washington,
D.C.; Ailsa Mellon Bruce Fund

sheets of paper painted with body color as the raw materials of the large cutouts that were his last masterpieces. From the late 1920s on, his work had become increasingly reductive in concept and spacious in scale. In his eighties, Matisse was confined to a wheelchair but was determined to carry through his vision to one final series of statements. And so, during the last few years of his life, he embarked on an aesthetic adventure that would have daunted most artists half his age. Unable to paint with a brush, he used scissors to cut up the gouache-covered sheets of paper and then had assistants help him move these shapes around, pinning them to a background and making further adjustments until the configuration was exactly what he wanted. At that point the colored shapes were glued permanently into place to create giant *papiers collés.*

These are among the most extraordinary works ever made using water-based paint on paper, and it should be noted that the quality of hand-brushed gouache brings to them a distinctive character that is part of their appeal. Had they been made from commercially printed papers their impact would have been quite different. For one thing, Matisse would not have been able to control the color so precisely, and for another they would have lacked the warmth contributed by the track of the brush-strokes. Some cutouts, such as *Beasts of the Sea* (plate 293), are relatively complex; others, such as *Venus* (plate 294), are amazingly simple. Some, including *The Negress* (plate 295), are clearly figurative, while others, including *Ivy in Flower* (plate 274), approach total abstraction. All of them demonstrate Matisse's matchless gift for setting up a dialogue between form and color. Never has an artist's career been more satisfyingly concluded.

Works like these remind the viewer that the term "modern masters" should not be used disparagingly. Too often the phrase is employed to suggest that an artist has passed his creative prime and is now to be regarded as an elder statesman. Never satisfied with that role, artists such as Picasso, Bonnard, and Matisse were capable of springing surprises until the very end.

A somewhat different case is presented by Wyndham Lewis, whose early contributions to abstraction have already been noted (see chapter 5). Lewis, too, was capable of reinventing himself throughout his career, but unlike his great Parisian con-

296. Wyndham Lewis (1882–1957)
A Battery Position in a Wood, 1918
Pen and watercolor on paper,
12½ × 18½ in.
The Trustees of the Imperial War Museum, London

297. Wyndham Lewis (1882–1957)
Red Nude, 1919
Pencil and watercolor on paper,
22¼ × 16⅛ in.
The British Council, London

temporaries he did not always do so as a painter. Indeed, it can be argued that he was far more gifted as a writer. That should not diminish the fact that his achievements as a visual artist were substantial, nor should the interplay between his writings and his paintings be ignored.

Lewis was both a brilliant polemicist—the author of such tracts as *The Art of Being Ruled*—and a major novelist. During World War I he completed his first novel, *Tarr,* a Dostoyevskian study of the Parisian art world, and it convinced him that humanity —and the portrayal of humanity—should be at the center of all artistic endeavor. The logic behind this, as applied to painting, is easily challenged, but in any case it meant that Lewis forbade himself any further experiments with abstraction. During the course of the war he was appointed an official war artist, and this provided him with the opportunity to explore the possibilities of portraying the human body in action, as is the case with *A Battery Position in a Wood* (plate 296). In the late 1910s and early 1920s Lewis demonstrated that he was an exceptionally fine draftsman, as can be seen from *Red Nude* (plate 297) and from many portrait drawings of the period. Later he made imaginative drawings in a neo-Cubist figurative style, but they never quite recaptured the energy of his Vorticist years. Indeed, as his career progressed his literary output so eclipsed his plastic work that it is easy to overlook how important an artist Lewis was, if only for a brief time.

If Lewis was the dominant avant-garde "master" in Britain during the period from the beginning of World War I to the onset of the Great Depression, then it was

298. Henry Moore (1898–1986)
Reclining Nude, 1924
Pencil, wash, and gouache on paper,
8½ × 15 in.
The British Museum, London

299. Henry Moore (1898–1986)
Four Forms: Drawing for Sculpture,
1938
Ink, chalk, and gouache on paper,
11 × 15 in.
Tate Gallery, London

Henry Moore who took over that role from about 1930 until at least the end of World War II. Primarily a sculptor, Moore was perhaps more successful than anyone else in blending British sensibility with the lessons of European modernism. Moore's work conveys a feeling for British landscape that is evident even when he was dealing, as he generally was, with the human figure. Not only do his sculptures fit naturally into landscape settings—like prehistoric monoliths—but their forms frequently echo the contours of the hills of his native Yorkshire. In this sense Moore's art is essentially pantheistic, but from the beginning he was able to modify his pantheism with lessons learned from Picasso, Brancusi, Jean Arp, and others.

Besides being a sculptor, Moore was a considerable draftsman, and the early *Reclining Nude* (plate 298) shows off his draftsmanship to excellent effect, as well as suggesting his feeling for sculptural form. *Four Forms: Drawing for Sculpture* (plate 299) is a study that recalls the forms found in the dreamscapes of Yves Tanguy (plate 197) and reflects the influence of Surrealism as well as that of Picasso in his near-Surrealist mood. As in many of his other studies from this period, Moore mixed media, combining gouache with ink and chalk. He took a similar technical approach in his great series of drawings made during World War II of Londoners sheltered from bombing raids in the stations of the underground railway (plate 300). Intensely personal in style and handling, these drawings nonetheless succeed in addressing the great public issues of the day, much as Picasso had done with *Guernica*. Full of humanity and enhanced by Moore's great sculptural feeling for form, they are among the finest art works to come out of the war.

With the exception of a handful of individuals such as Lewis and Moore, British art in the first half of the century can claim few artists of international stature (Francis Bacon did not burst upon the scene until the late 1940s). The parochialism that afflicted

British art did not, however, prevent a vigorous school of watercolor painting from thriving there. The best of the British watercolorists built upon the solid foundations provided by the great British masters of the nineteenth century, but some of them also managed to stay open to the currents of modernism, and their ranks include a number of minor masters who deserve to be better known outside the United Kingdom.

One singular painter was Gwen John, the reclusive older sister of Augustus John. Born in Wales, Gwen John studied with Whistler, was befriended by Rodin, and spent the last forty years of her life living quietly in France, doing little to promote her career, which has yet to receive the attention it deserves. Despite her long stay in France, John's work retained a very British sense of intimacy, quite different in mood from the *intimism* of Vuillard, for example. It is tempting to call her the Jane Austen of painting, though John's sparsely populated world is more solemn, less sociable and sprightly. A skillful exponent of transparent watercolor—cats were one of her favorite subjects— she also had a particularly deft touch with gouache, using it with a fluency that gives all of her work in the medium a distinctive signature. *Green Leaves in a White Jug* (plate 301) is a fine example of her gouache style. The overall statement preserves an almost monumental simplicity, but the leaves in the pot are evoked with a splashy brilliance that brings the image to vivid life.

Almost a full generation younger than Gwen John, Paul Nash was a young man when World War I broke out and it proved to be the key event in the career of an artist who had just begun to make a modest mark as a somewhat old-fashioned inter-

300. Henry Moore (1898–1986)
Shelterers in the Tube, 1941
Watercolor, gouache, pen and ink, and wax crayon on paper, 15 × 22 in.
Tate Gallery, London

preter of landscape. Service with an infantry regiment preceded his appointment as an official war artist, and the stricken landscapes of the Western front brought an unexpected ferocity to his vision. "I have seen the most frightful nightmare of a country," he wrote, "more conceived by Dante or Poe than by nature, unspeakable, utterly indescribable."[16] In *The Landscape—Hill 60* (plate 302), he committed a portion of this "indescribable" landscape to paper—a barren waste pocked with shell holes, crisscrossed with barbed wire. Instead of focusing on human activity at the front, as did artists as varied as Lewis and Léger, Nash concentrated on the raw setting, denuded of the activities that might give it meaning. His is a desolate vision of war, but one not without a certain malevolent poetry.

After the war Nash had difficulty finding imagery as powerful as that he had encountered at the front. He looked first to Cubism, then to Surrealism for inspiration, yet he never seemed entirely comfortable when he moved away from the British landscape tradition. During World War II he was once more appointed an official war artist. Ill health prevented him from seeking the direct contact with military action that could have provided him with imagery as powerful as that he had painted in 1917–18, but still he found the distorted poetry of combat in such subjects as crashed German

301. Gwen John (1876–1939)
 Green Leaves in a White Jug, 1922
 Gouache and pencil on paper,
 6½ × 5 in.
 National Museum of Wales, Cardiff

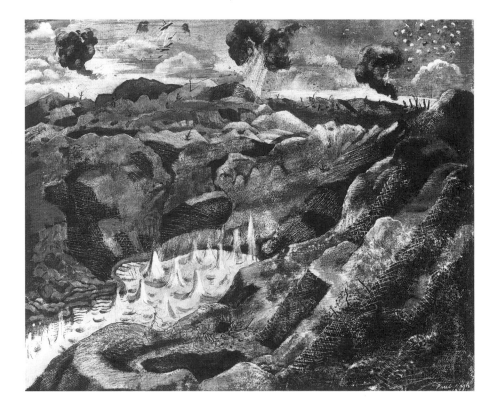

302. Paul Nash (1889–1946)
The Landscape—Hill 60, 1918
Pencil, pen, and watercolor on paper,
15½ × 19½ in.
The Trustees of the Imperial War
Museum, London

303. Paul Nash (1889–1946)
Bomber in the Wood, 1940
Watercolor and chalk on paper,
15½ × 22⅜ in.
Leeds City Art Galleries,
Leeds, England

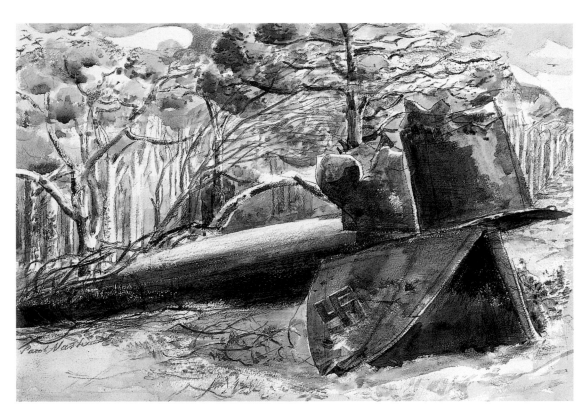

bombers (plate 303) and the intertwined vapor trails left above the English countryside by dogfighting Spitfires and Messerschmidts.

At the end of his life Nash produced visionary landscapes that recall the arcadian world painted by Samuel Palmer, and the influence of Palmer is even more evident in the early career of Nash's younger contemporary, Graham Sutherland. After abandoning a career as an engineer Sutherland became an etcher, and it was as a printmaker that he was first inspired by the work of Palmer and Edward Calvert (who, like Palmer, was a disciple of William Blake). Palmer's highly charged imagery—ripe with swollen hillocks, bursting blossoms, and looming harvest moons—continued to hold sway over the watercolors that Sutherland made in the 1930s and 1940s (plate 304). Sutherland's

304. Graham Sutherland (1903–1980)
 The Wanderer I, 1940
 Watercolor on paper, 8½ × 14¼ in.
 Victoria and Albert Museum, London

vision was also touched by Surrealism and by the onset of war, so that his most striking watercolors, such as *The Dark Hill* (plate 305), have a sinister cast that removes them from the innocent afterglow of Palmer's pastoral world.

After the war Sutherland went on to become an internationally known figure, celebrated for his less-than-flattering portraits, as well as for large-scale religious commissions. In retrospect, however, it seems likely that he will be best remembered for the watercolor landscapes that he made in the 1930s and during the war years. Through these he ranks with Paul Nash as one of the most striking exponents in his generation of the Romantic landscape tradition.

A more conventional, yet still interesting, watercolorist with a strong feeling for British landscape was Eric Ravilious. At times his work has an almost illustrational look to it, but his best sheets display an intensity of vision that lifts them out of the ordinary. Primarily he was a realist concerned with recording the singularities of the world that surrounded him, and he combined his feel for landscape with an interest in the man-made world that gives many of his watercolors a somewhat documentary aura. *Train Landscape* (plate 306) provides a glimpse of England's South Downs, but much of the artist's attention has been lavished on the textures that make up the woodwork and upholstery of a third-class railway carriage. During World War II, Ravilious did some fine work as an official war artist before being lost in action off the coast of Iceland.

Little known outside the British Isles, David Jones was a painter of some distinction and a watercolorist of real merit. Influenced by Matisse and Dufy, Jones subdued

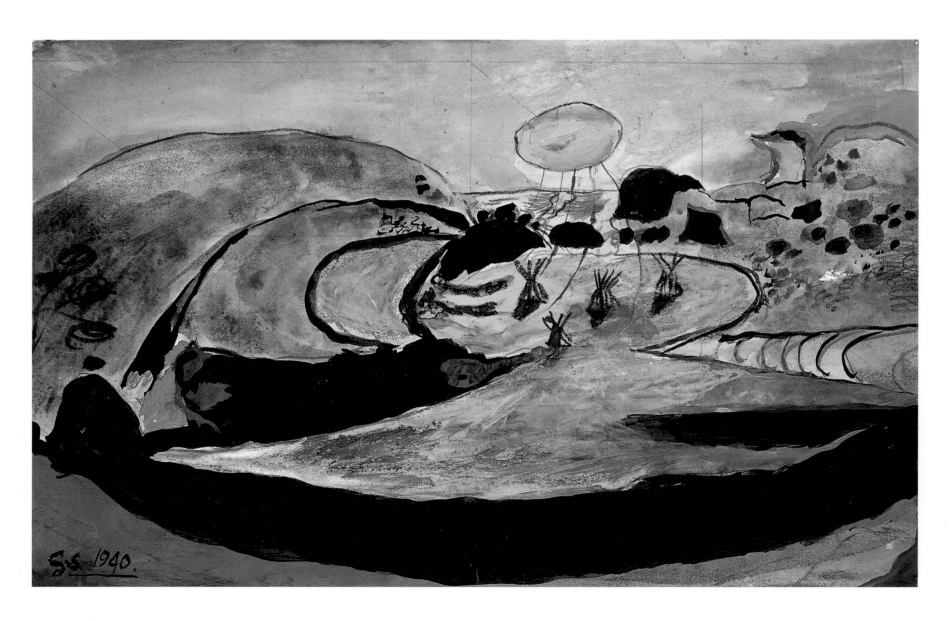

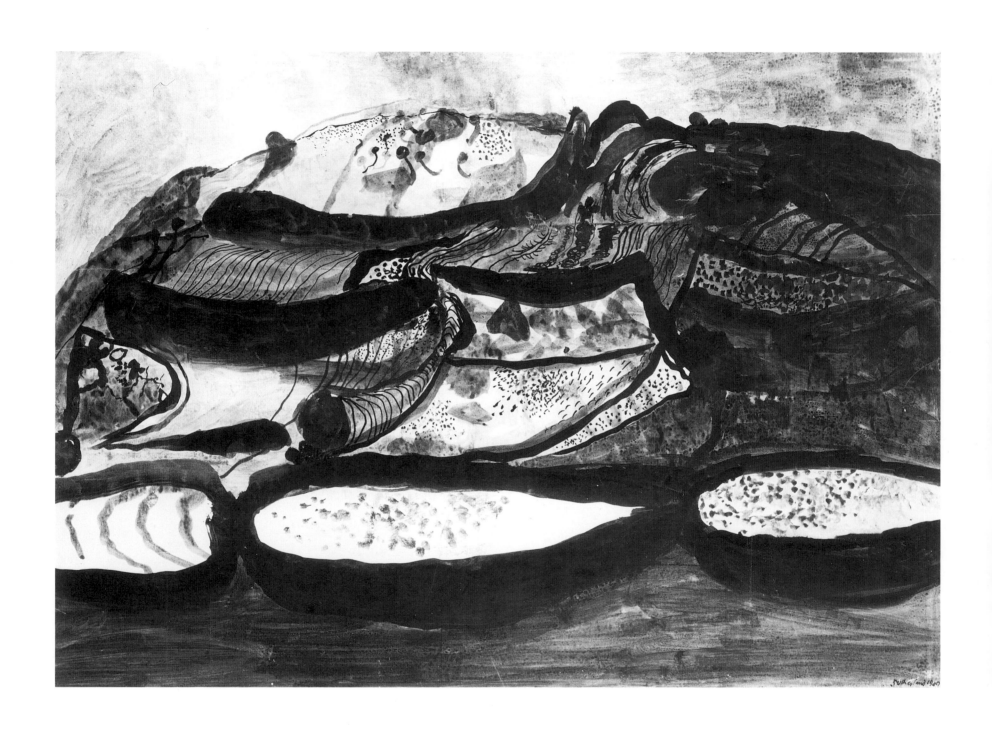

305. Graham Sutherland (1903–1980)
The Dark Hill, 1940
Watercolor on paper,
19¼ × 27½ in.
Swindon Museum and Art Gallery,
Swindon, England

306. Eric Ravilious (1903–1942)
Train Landscape, 1940
Watercolor on paper,
17½ × 21½ in.
Aberdeen Art Gallery and Museums,
Aberdeen, Scotland

307. David Jones (1895–1974)
The Terrace, 1929
Watercolor on paper,
25½ × 19¾ in.
Tate Gallery, London

the Fauve palette but took advantage of the freedom of linear invention that was opened up by their innovations. *The Terrace* (plate 307) is a variation on the window theme that was a favorite of Matisse's, especially during that artist's early years in Nice. Yet Jones's view is decidedly not of Nice—rather the color scheme locates this scene at a British seaside resort. Nor did he adopt Matisse's method: instead of using color to build pattern Jones washed delicate tints over spindly pencil lines. Even though it lacks the power of Matisse's work, this is a fine watercolor, gently evocative and full of pale light that is the product of the way Jones laid in the transparent color. Jones was an ardent Catholic, and it seems that in some of his most striking work he tried to express a kind of neo-Platonism combined wtih Celtic mysticism, attempting to give shape to the spiritual essence of objects, people, and places. Watercolor, by virtue of its delicacy, was well suited to this task, and Jones must be counted among the finest watercolor

technicians of his generation, always in control of the medium yet able to use it with great flexibility and fluidity. His best watercolors offer the illusion of having been painted almost without a thought, yet close consideration shows them to have been constructed with great care and skill.

Perhaps the most interesting British watercolorist of his generation was Edward Burra, underappreciated during his lifetime but recently the subject of serious reevaluation. Like Charles Demuth he turned to watercolor because of a physical disability, and like Charles Burchfield he sought to give the medium the weight and impact of oil paint, generally working on a relatively large scale. His early works, such as *Storm in the Jungle* (plate 308), are full of fantastic invention, and it is easy to see how, for a time at least, he was drawn to Surrealism. In the mid-1930s Burra traveled to New York and spent much of his time there painting the black community in Harlem, often with striking results (plate 309). Later he turned increasingly to landscape but, while his achievements in this area were considerable, it is the work of the 1930s that is most memorable and upon which his reputation will depend.

An extremely dexterous manipulator of the watercolor medium, Burra employed a generally traditional technical approach but devised new uses of standard procedures to build larger and more complex images. *Complex* is perhaps the key word, since his most impressive sheets overflow with humanity and rich detail. Burra's compositional method has something in common with the jigsaw puzzle. Each picture seems

308. Edward Burra (1905–1976)
Storm in the Jungle, c. 1931
Gouache on paper, 22½ × 27½ in.
Nottingham Castle Museum and Art
Gallery, Nottingham, England

to be made up of dozens of disparate elements, which have somehow been miraculously fit together to make a whole. Although he undoubtedly used broad washes in his underpainting, there is clear visual evidence that each element of the "jigsaw" was given close individual attention so that a remarkable intensity is spread rather evenly throughout each composition.

Burra exemplifies the kind of minor master whose reputation depends almost entirely upon watercolor. For this reason he tends to be overlooked by most conventional art histories of the period. It might even be said that his involvement with watercolor for its own sake directed him away from the mainstreams of modernism (the same might be said about Burchfield) and that this has harmed his reputation. Happily, the current perspective on modernism, with the advantage of hindsight, now permits a new look at the recent past that gives eccentrics such as Burra their due. Indeed, the opportunity is now presented to reconsider many of the peripheral aspects of twentieth-century art—such as the survival of a strong if provincial watercolor school in the British Isles—and to acknowledge the fact that such regional activity has yielded many minor masters and added greatly to the richness of twentieth-century art.

309. Edward Burra (1905–1976)
Harlem, 1934
Gouache on paper, 31¼ × 22½ in.
Tate Gallery, London

CHAPTER NINE
THE THIRD WAVE

In the art of the twentieth century there is a distinct demarcation—easy to sense though difficult to define—between those major artists who matured before World War II and those who reached maturity after it. Art from the turn of the century to 1939 was dominated by Europeans and by a limited number of fairly clear-cut movements. The first wave—Fauvism, Expressionism, Cubism—struck before World War I, as did the initial stirrings of abstraction. The war spawned Dada and in its wake came Surrealism, along with various programmatic explorations of nonfiguration, such as Neo-Plasticism and Constructivism.

There was a definite falling off during this interwar period in the arrival of new talent. Literally dozens of important careers were launched in the years 1900–18, far fewer in the two decades after the 1918 Armistice. Except for the Surrealists—Ernst, Magritte, Miró, Masson, Dalí, and the rest—most avant-garde activity was in the hands of people such as Mondrian and Kandinsky, who had been well on their way to their ultimate goals by 1914.

Young artists feeling their way toward their own language in the late 1930s and early 1940s were still subject to the dominant influence of artists such as Matisse and Picasso, who had been active for three decades. Their appeal was offset—notably in America—by that of Surrealism, which was undoubtedly the most magnetic ideology of the interwar period. Above all, the continued fertility of Picasso's imagination—especially as it bordered on the surreal—made his oeuvre the yardstick by which young artists continued to judge their own creativity. Measuring up to Picasso was both challenging and frustrating. He turned fifty in 1931, but still he seemed to anticipate every new idea spawned by the younger artists. The explanation is simple enough. Everyone was drawing upon the fund of inventions that Picasso had pioneered, starting with *Les Demoiselles d'Avignon,* and no one understood the implications of those inventions better than Picasso himself.

The tenets of modernism told young artists that they must continually move ahead, remaining loyal only to the principle of eternal revolution and leaving behind the achievements of their spiritual ancestors—however much admired. Yet somehow Picasso was always out in front, refusing to make way for the next generation. Willem de Kooning is one of the American artists who would, in time, escape Picasso, but not in the 1930s, as can be seen in the untitled gouache reproduced here (plate 311). It looks as though it might be a study for a relief or a mural, but in any case it is an attempt to extend Cubist geometry toward abstraction in a way that recalls the efforts of Ben Nicholson in England.

The debt to Picasso is even more evident in Mark Tobey's *Interior of the Studio* (plate 312), painted during the artist's residence in England, which lasted from 1931 to 1938. Spatially this owes as much to Matisse as to Picasso, but the objects that crowd the picture plane derive almost totally from Picasso's iconography. Profiles and volumetric representations, elevations and deliberately distorted perspectives are juxtaposed in a typical post-Cubist manner. The viewer needs only to look at the drawing of the various vessels in this image—pitchers, vases, bowls, drinking glasses—to be aware of Picasso's ghostly presence.

Yet Tobey was one of those who was able to emerge from Picasso's thrall, and a clue as to how he managed this is to be found in the calligraphy that knits this composition together. As early as 1934 Tobey visited the Far East, and while there he gained a profound respect for Chinese and Japanese art. Previous generations had been influenced by the iconography of Oriental art, by its use of pattern and its cavalier ways

with perspective, but what most affected Tobey was the way the images were made—specifically how the art of calligraphy was performed with the Chinese brush. He was impressed by the fact that calligraphy existed in the Orient as an independent art form, and he was apparently struck by the relationship between this and the ambitions of Western abstract art. Soon after his return from the Orient, Tobey began to experiment with calligraphy, beginning a series of paintings that came to be described generically as "white writing." In time he evolved an approach to picture making that owed nothing to Western ideas of composition and everything to the act of covering the surface of the paper with an intricate network of brush writing (plate 313). The modest scale of Tobey's work and the fact that he worked in Seattle, at a distance from the New York art world, have caused some historians to dismiss his distinctive art as peripheral. Undoubtedly, however, he was one of the pioneers who saw a way to surpass the achievements of the first- and second-generation modernists.

313. Mark Tobey (1890–1976)
Advance of History, 1964
Gouache and watercolor on paper,
25⅜ × 19¾ in.
Peggy Guggenheim Collection,
Venice (The Solomon R. Guggenheim
Foundation)

314. Jackson Pollock (1912–1956)
Over the Hill, c. 1934–38
Watercolor on paper,
12¼ × 20¼ in.
The Nelson-Atkins Museum of Art,
Kansas City, Missouri; Gift of
Rita P. Benton

OPPOSITE
315. Hans Hofmann (1880–1966)
Cataclysm, 1945
Watercolor on gesso, 51¾ × 48 in.
Private collection

The most flamboyantly original of these pioneers was Jackson Pollock. His first major influence was the equally flamboyant Thomas Hart Benton, whose style of exaggerated realism Pollock built upon in watercolors such as *Over the Hill* (plate 314). If this sheet is compared with Benton's work of the same period, one sees that Pollock's effort has a wilder kind of energy. The brushwork is loose and fluid; clouds and landscape swirl together, anticipating the vertiginous movement of Pollock's later works.

Coming to New York during the later stages of the Depression, Pollock was impressed by the Mexican muralists José Orozco and David Siqueiros and by the Surrealists—notably Matta and Miró. Inevitably, he also fell under the spell of Picasso. It may be argued that Pollock was Picasso's most gifted spiritual son, but if so the relationship was Oedipal. Symbolically, Pollock had to kill the father figure, an act he performed through the intensely physical ritual of his drip paintings. There is no exact equivalent of these on paper, but the Hirshhorn Museum's watercolor (plate 310), which probably predates the drip paintings, shows how Pollock reduced the art of composing a picture to the perpetration of an "all-over" automatist swirl of pigment.

Another major innovator, Hans Hofmann was a product of the Munich art world that had hosted the Blue Rider and witnessed the leap from Expressionism to abstraction. Emigrating to the United States in the early 1930s, when he was already in his fifties, Hofmann became influential as a teacher, preaching a gospel that Kandinsky would have endorsed: that creative expression for the painter required transforming inner states of being into pure form and color. But Hofmann was not just a teacher. He put his own theories into practice in a long series of adventurous paintings that gradually moved away from the conventions of European modernism and toward a new concept of nonfigurative art that was to play a crucial role in forming a distinctively American tradition. By 1945, when he painted *Cataclysm* (plate 315), his work was often as "American" as Pollock's. In this large-scale watercolor Hofmann splashed and spattered paint with an abandon that reminds the viewer that action painting was not exclusively a young man's invention.

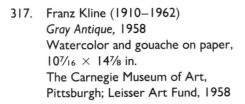

Because the American artists of Pollock's generation tended to favor large-scale works once they could afford to paint them, their use of watercolor tends to be concentrated in the early and more experimental phases of their work. A good example of this is Mark Rothko's *Sacrifice* (plate 316), a handsome watercolor that exemplifies the Abstract Expressionists' debt to the biomorphic wing of Surrealism and demonstrates that Rothko—with his command of liquid brushstrokes and dragged washes—had a sound grasp of the medium. The soft-edged rectangles of his mature work did not lend themselves to watercolor, though toward the end of his career he made some exquisite large-scale paintings using thinned acrylic on paper as if it were gouache.

The Abstract Expressionists favored large formats because they were painting with broadly physical gestures made using the entire body rather than just the wrist. There are, however, occasional examples of small-scale works by members of this group that can stand up to the larger paintings. Franz Kline's *Gray Antique* (plate 317), for example, duplicates the thrust and energy of the artist's works on canvas. It is, incidentally, a reminder that Kline—generally associated with black and white—could be a subtle and effective colorist.

The major American sculptor of this generation was David Smith. He began his career as a painter—following the typical course toward Abstract Expressionism from early admiration of Cubism and Surrealism—but to support himself he found employment as a sheet-metal worker and welder. Almost inevitably, the two worlds came together for him and he began, in the late 1940s, to make welded-metal sculptures of great originality, the three-dimensional equivalent of action painting. Later Smith created assemblages of stainless-steel boxes that anticipated some aspects of the Minimalist art that came to the fore in the late 1960s. Not surprisingly, his works on paper often suggest sculptural concerns, as is the case with *August 12, 1961* (plate 318).

Younger than this first generation of Abstract Expressionists, Sam Francis was one of Clyfford Still's most gifted students—during Still's West Coast sojourn—and brought a decidedly lyrical feel to the sometimes harsh world of painterly abstraction. His delicate touch with both gesture and color is especially well suited to watercolor (plate 319), and indeed he has been the most consistent exponent of the medium among the better-known Abstract Expressionists. Francis's technique is deceptive: Although he learned much from Pollock's drip paintings and appears to thrive on accident, his paintings are, in fact, rather tightly controlled. He permits paint to dribble across the support, but these dribbles are not the product of frenzied activity (as is the case with the loops of pigment in a work by Pollock) but rather well-planned events within the painting. The fact that the dribbles are made without a brush produces a feeling of spontaneity, but this spontaneity is partially illusory. Francis's dribbles are signs that say "accident" just as, in Chinese and Japanese painting, certain brushstrokes—although endlessly rehearsed—signify an improvisational approach. (It is not surprising to discover that Francis is an admirer of Oriental art.) The crucial problem that Francis faces in creating his illusion is that he must work with great economy so that the feeling of spontaneity is preserved. This means that there can be no subterfuge in the way the watercolor is applied. He must get things right the first time, and this ensures that the washes stay clear and fresh and the paper sparkles through, just as it does in a Cézanne. Like Cézanne, Francis is a master in leaving areas of white paper to speak for themselves.

If Francis has remained faithful to a brand of abstraction that was very much a product of its time, Philip Guston is an example of an artist who moved on from Abstract Expressionism to a form of realism that proved to have great influence upon younger artists. Guston and Pollock had been friends since high school but, like Francis, he should properly be counted among the most gifted of the second wave of Abstract Expressionists. It is, however, the work Guston did toward the end of his life that is most likely to perpetuate his reputation. Cartoonlike yet painterly, these paintings spoke to a younger generation contemplating a return to figuration. Guston seems to have shared with artists a fraction of his age a healthy scepticism about the immutability of art history, abandoning the clichés of modernism in order to discover his own quirky, hybrid imagery (plate 320). In sheets such as this he used acrylic in much the same way that an artist would use gouache. (Being water-based, acrylic can easily be thinned to a gouachelike consistency or even to the consistency of a watercolor wash.)

Another painter who has explored the potentials of the acrylic sketch is Richard Diebenkorn. Having settled in California, Diebenkorn became one of the West Coast's

leading painterly abstractionists before abruptly changing styles to begin portraying figures, landscapes, and still lifes. In the best of these realist works he achieved an unlikely synthesis between the existential objectivity of Edward Hopper and the energy of Willem de Kooning. Later, in his Ocean Park series, Diebenkorn returned to a form of nonfiguration rooted in his strong sense of place, if not actually in landscape. The untitled example reproduced here (plate 321) relates closely to the Ocean Park canvases; it is also, in its scaffolding, quite reminiscent of Mondrian's experiments from about 1912.

American artists were not alone, of course, in struggling to reach a new territory beyond the one mapped out by the first modernists. As early as his teenage years, the German artist Hans Hartung was painting very free watercolors that owed little to either Fauvism or Cubism. By the time he painted *Composition* (plate 322), he was juxtaposing organic forms in much the same way as Rothko and his colleagues, though Hartung's work antedates most American efforts in this direction. A few years later Hartung arrived at a strikingly stark form of calligraphic art that many critics saw as the European equivalent of Abstract Expressionism.

Like that of almost all European artists, Hartung's evolution was interrupted by World War II. During the period when American artists were starting to make their most dramatic advances—spurred by the presence of Duchamp, Mondrian, Ernst, Tanguy, Matta, and other exiles—the European art world came to a virtual halt. Once the war was over, Paris reestablished itself as the center of European culture, but now Surrealism was in decline and the dominant ethos was that of Existentialism, with Jean-Paul Sartre as its chief spokesman. Existentialism did not spawn a school of painting as such, yet much that was original in the European art of the late 1940s and 1950s was infused with the Existentialist viewpoint. Certainly this was true of the kind of painting that became known as *l'art autre* or Tachisme—a form of abstraction in which the mark

OPPOSITE

319. Sam Francis (b. 1923)
 Untitled, 1959
 Watercolor on paper,
 25⅝ × 18⅜ in.
 Philip Samuels, Saint Louis

320. Philip Guston (1913–1980)
 Untitled, 1984
 Acrylic on paper, 23 × 29 in.
 David McKee Gallery, New York

261

321. Richard Diebenkorn (b. 1922)
Untitled, 1974
Acrylic on paper, 24 × 18⅝ in.
The Harvard University Art Museums
(Fogg Art Museum); Purchase—with
funds from the NEA and Deknatel
Purchase Fund

on canvas was held to have an autonomous value, independent of anything it might be thought to describe. In other words, "the mark" had the same importance for these Europeans as "the gesture" did for their contemporaries across the Atlantic.

Among the most gifted of the artists who have been claimed as Tachistes—though he might more accurately be labeled proto-Tachiste—was the German painter Wols (Alfred Otto Wolfgang Schülze). Wols made occasional large paintings, but his most characteristic works are small-sized drawings and watercolors. Although these works on paper do place paramount importance on building an image from clusters of marks or strokes, they are often somewhat representational, as in *Root* (plate 323), which looks like a swollen parsnip enmeshed in a spider's web. Other of his works recall Klee. *Adversity of the Winds* (plate 324) is Klee-like even in its choice of title, but this is a variant on Klee by someone whose view of the world was also colored by Kafka.

322. Hans Hartung (b. 1904)
Composition, 1936
Conté crayon and ink wash on paper,
37⅞ × 30⅛ in.
Hirshhorn Museum and Sculpture
Garden, Smithsonian Institution,
Washington, D.C.; Gift of Joseph H.
Hirshhorn Foundation, 1966

Possibly the greatest European artist of the period was Jean Dubuffet, whose work paralleled many of the principles of Tachisme. Turning to primitive art as a source for fine art was not new, of course, but Dubuffet's originality lay in discovering it all around him, in his own mundane environment, rather than seeking it out in galleries and museums. *Facade* (plate 325)—made on specially prepared paper—is an example of how Dubuffet could transform an everyday subject, in this case a street scene, by drawing it as a graffiti artist might, with a cleverly concealed sophistication.

Dubuffet called his art *art brut,* and certainly he often affected to use materials in a coarse and brutal way (though paintings that once shocked now seem almost exquisite in their handling). The term *art brut* can hardly be said to apply to *The Garden of Bibi Trompette* (plate 326), in which gouache is used along with dozens of iridescent butterfly wings. Dubuffet seemed to love every material—coarse or fine—for its own

323. Wols (1913–1951)
Root, 1949
Pen and ink and watercolor on paper,
7¾ × 4¾ in.
Hirshhorn Museum and Sculpture
Garden, Smithsonian Institution,
Washington, D.C.; Gift of
Joseph H. Hirshhorn, 1966

324. Wols (1913–1951)
Adversity of the Winds, 1950
Pen and ink, watercolor, and
watercolor wash on paper,
7⅝ × 6⅛ in.
Hirshhorn Museum and Sculpture
Garden, Smithsonian Institution,
Washington, D.C.; Gift of
Joseph H. Hirshhorn, 1966

325. Jean Dubuffet (1901–1985)
Facade, 1951
Watercolor on gesso on paper,
9⅞ × 13 in.
The Sidney and Harriet Janis
Collection; Gift to The Museum of
Modern Art, New York

326. Jean Dubuffet (1901–1985)
The Garden of Bibi Trompette, 1955
Butterfly-wing collage with gouache
on paper, 9 × 12½ in.
Stephen Hahn, New York

327. Georges Mathieu (b. 1921)
Abstraction, 1954
Gouache on paper, 19¾ × 25⅝ in.
Hirshhorn Museum and Sculpture
Garden, Smithsonian Institution,
Washington, D.C.; Gift of Joseph H.
Hirshhorn, 1966

sake. The need to deal with materials—whether watercolor or plaster of Paris—seems to have been at the root of his creative instinct.

A younger contemporary of Dubuffet, who came to prominence in the 1950s, is Georges Mathieu, whose paintings are characterized by energetic and elegant swirls of calligraphy (plate 327). For a while Mathieu was looked upon as France's answer to Jackson Pollock, but any resemblances between the two artists are essentially superficial. Certainly Mathieu made use of gesture, but his gestures were always contained within a concept that was essentially decorative. (It should be acknowledged that on occasion he could be a superb colorist.) Far from being a European Pollock, Mathieu might best be described as the Dufy of *l'art autre.*

The tendencies evident in Abstract Expressionism and *art brut* were not, of course, confined to New York or Paris. A vigorous offshoot of these movements developed in Britain, an offshoot to which two Scottish-born artists—Eduardo Paolozzi and William Scott—made significant contributions. Best known as a sculptor and print-maker, Paolozzi is a cosmopolitan artist who has, at various times, been close to the wellsprings of both French and American postwar modernism. *Drawing for a Saint Sebastian* (plate 328) shows an affinity with Dubuffet that was most evident in Paolozzi's work during the late 1950s and early 1960s.

Paolozzi is perhaps the most protean of recent British artists, and his work has gone through many phases. Scott, on the other hand, has quietly mined a narrow but rich vein of aesthetic ore. His painting is grounded in Fauvism, and especially in the lessons of Matisse, but it owes much to the feeling for scale that is found in Abstract Expressionism. His imagery is not especially original, but his feeling for color combinations is both personal and highly assured (plate 329). Scott's art demonstrates that by about 1960 the advances of Abstract Expressionism had been thoroughly absorbed into the international mainstream.

The emphasis on large formats that came along with this influence made this something of a fallow period for watercolor. For the most part, artists who used

328. Eduardo Paolozzi (b. 1924)
Drawing for a Saint Sebastian, 1957
Ink, gouache, and collage on paper,
13½ × 9¼ in.
Solomon R. Guggenheim Museum,
New York

329. William Scott (b. 1913)
Composition: Brown, Grey, and Red,
1961
Gouache on paper, 19⅜ × 24¼ in.
Victoria and Albert Museum, London

watercolor at this time did so because of its convenience rather than because of its inherent qualities. Already, however, a reaction was setting in. The trend toward giganticism did not go away, but as alternatives to Abstract Expressionism—from Pop art to Conceptualism—began to appear, new opportunities began to arise for the effective use of watercolor. In particular, a renewed interest in realism of various kinds created a veritable renaissance of interest in watercolor techniques and saw some artists using the medium in ways that had been largely overlooked since the earliest years of the twentieth century.

CHAPTER TEN

BEYOND MODERNISM

The art world has undergone such an expansion during the past two decades or so that it would take an entire book to give an adequate account of the changes. There are more galleries than ever before, more patrons, more museum shows, more art magazines, more theories, more working artists. The avant-garde had become institutionalized to the point that the term has almost lost its meaning. Once an underground phenomenon, it is now everybody's property—part of the information explosion that has transformed our culture. Once thought dangerous, avant-garde art has become the occasion for Saturday outings when the weather is too chilly for the beach or a picnic. There is more art than ever before but the resulting saturation of the art market has been accompanied by a loss of focus. Even the most adventurous art has lost some of the urgency that experimental work once had.

Balancing this loss of urgency, however, is the fact that avenues of exploration which had been cut off for decades have suddenly opened up once more. No longer are only a few rather narrowly defined courses available to the artist who wants to be taken seriously by critics and the art establishment. The first sign of this, in the 1970s, was a fresh interest in forms of realism that had long been dismissed as archaic. More recently, there has been a reevaluation of varied approaches to abstraction that had been passed over in the headlong flight toward novelty that has been so characteristic of twentieth-century art until recently. For the first time, perhaps, artists have been pausing long enough to look back over the whole panorama of modernism, from the advent of Fauvism and Expressionism on, and to study with renewed interest ideas that previously had been touched on in passing but never fully exploited.

One consequence of this is that artists have felt free to pursue paths that are personal rather than those dictated by art-world politics. Among other routes, artists are choosing to explore—to a greater extent than at any time in the past century—the virtues of various media for their own sakes. Not surprisingly, watercolor has been a beneficiary of this situation. As always, there are artists who use it in combination with other media, but increasing numbers of watercolor specialists are appearing on the scene once more.

Another consequence of the changes that have taken place is a decentralization of the art world. While New York remains a commercial nexus it can no longer claim dominion over innovation, which is just as likely to manifest itself in California or Europe, Japan or Australia. That said, however—and despite the fact that this chapter indicates important exceptions to this general rule—it is in America that most of the vital watercolor activity has occurred during the past twenty years. The reasons for this are

twofold. In the first place, America has maintained throughout the century a strong watercolor tradition, especially where realist work is concerned. Younger American artists have grown up admiring the watercolors of Hopper, Burchfield, Demuth, and others, and this has helped them appreciate the medium's potential. A second factor is that American artists, in the second half of the twentieth century, have shown particular interest in pushing past the limits of traditional media. Although some Europeans have done the same thing, it is in particular the American artists who arrived in the wake of Abstract Expressionism who have insisted (to paraphrase Marshall McLuhan) that the medium is a large part of the message. This has led, on the one hand, to artists' exploring the possibility of working in such unlikely media as molten lead and industrial felt. On the other hand, it has also led to a renaissance of printmaking and to the reevaluation of the potential of all traditional media, including watercolor.

Of the artists whose influence has been partly due to the thoughtful exploration of media, Jasper Johns is among the most important. Each of his works seems to gain

significance from the way in which he has considered the character of the materials used. The fact that his early paintings, for example, are made of wax encaustic rather than oil paint gives them a special presence. Often he has taken a single motif and reworked it many times, using different media on different occasions. The variations between one version and another are largely due to variations in the character of the materials.

Johns's art is complex, however, and it would be a mistake to think that manipulation of materials is at the base of everything he does. The way he uses media is crucial to his work, but he is also a masterful exploiter of imagery, and it was he more than anyone who was responsible for the reemergence of powerful imagery in American art in the late 1950s and the 1960s. Without in any way denying or challenging the achievements of artists such as Pollock, de Kooning, and Rothko—in many ways he was building upon those achievements—Johns found a way to reintroduce representation into his art. His work became, in large part, a laboratory for the investigation of reality and

332. Jasper Johns (b. 1930)
Flags, 1972
Watercolor and pencil on paper,
25⅛ × 30 in.
Collection of the artist

333. Jasper Johns (b. 1930)
Untitled, 1977
Ink, watercolor, and crayon on
plastic, 21 × 14 in.
Margo H. Leavin, Los Angeles

334. Robert Rauschenberg (b. 1925)
Illustration for Dante's "Inferno, Canto
XXXI: The Central Pit of Malebolge,
The Giants," 1959–60
Red and graphite pencil, gouache, and
transfer on paper, 14½ × 11½ in.
Collection, The Museum of Modern
Art, New York; Given anonymously

illusion in the plastic arts.

In his earliest mature works Johns announced his field of research by utilizing as primary motifs flags and targets—motifs that were already flat to begin with and thus could be represented without the use of perspective, foreshortening, chiaroscuro, or other illusionistic devices. So powerful were these motifs that Johns has returned to them often in his career, as can be seen from the two flag paintings reproduced here (plates 331, 332), each painted several years after this motif first appeared in his oeuvre. The result is something closely related to nonfigurative art, except that it is assembled from immediately recognizable and emotionally charged icons. Given that this particular configuration of stars and stripes is so highly charged, the very act of changing the color scheme becomes a powerful statement. In a sense these paintings point out that the flag was an early and very successful example of abstraction. In another sense these paintings pose subtle questions about the nature of figuration and its role in picture-making.

It is not only the flag that has been put to repeated use in Johns's work (one of his special abilities is to find powerful motifs). An untitled drawing from 1977 (plate 333) alludes to a small sculpture of 1960 titled *Painted Bronze.* That sculpture is indeed a painted bronze which represents artists' brushes standing in a coffee can, the whole painted so as to reproduce the appearance of the original—printed paper label, wooden handles, and so forth. It presents the viewer with several puzzles. For example, was this bronze cast from an original modeled in clay, or was it cast from real brush handles in an actual coffee can? Such conundrums are not mere teasing since they reflect philo-

sophically on the notion of the artist's efforts to represent reality. In the context of Johns's oeuvre the watercolor thus becomes a representation of an already ambiguous representation. Johns further complicated the interplay between representation and reality by introducing his own handprints into the drawing, announcing his involvement in a peculiarly direct way and thus introducing another reminder of the "real."

These intellectual concerns aside, Johns continues to display great sensitivity to materials, as is evident in the use here of ink and watercolor on a synthetic surface that in theory is totally unsuitable. That he is just as much at home working with watercolor more conventionally is evident from the exquisite *Between the Clock and the Bed* (plate 2), which is distinguished by confident brushwork and subtle color gradations.

Closely associated with Johns are two other artists of major importance: Robert Rauschenberg and Cy Twombly. Rauschenberg, in the 1950s, announced that he wanted to work in what he described as "the gap between art and life." Like Kurt Schwitters, he introduced the detritus of the everyday world into his work, combining Abstract Expressionist brushwork with photographs found in magazines and with abandoned objects found in the streets of New York. His best work has often depended on expansiveness, but he has also made some handsome small-scale drawings (plate 334) in which the ghost images of newspaper photographs are combined with gouache and other media.

Twombly's art is rooted in gesture and graffiti. Unlike Dubuffet, however, he does not use graffiti as a way of generating figurative images. Rather, he tends to use it

335. Cy Twombly (b. 1928)
Epithalamion III, 1976
Collage, watercolor, and pencil on paper, left panel: 60½ × 43 in.; right panel: 30 × 22 in.
Private collection

336. Oyvind Fahlström
Notes for "Sitting . . . Six Months Later," 1962
Ink and watercolor on paper,
8⅝ × 11⅝ in.
Jasper Johns

as an extension of the concepts of action painting. But whereas the primary element of action painting is the gestural brushstroke, in Twombly's work it is the mark scribbled or scratched onto canvas or paper. Sometimes his work contains actual words, at other times suggestions of writing that have no literal meaning. *Epithalamion III* (plate 335) is a work made on two separate sheets of different size. It shows how, even when working in watercolor, the artist has been able to achieve a scuffed, graffitilike effect.

Influenced by Johns, Rauschenberg, and Twombly, the Swedish artist Oyvind Fahlström created drawings, paintings, and variable constructions (with magnetic elements that could be rearranged) in which the world of the comic strip met the most sophisticated theories of the postwar generation, with amusing and sometimes surprising results. Sometimes Fahlström used actual cartoon characters, such as Krazy Kat; in *Notes for "Sitting . . . Six Months Later"* (plate 336) he surrounded an abstracted comic strip with a border of graffiti.

Fahlström's art might be said to be on the threshold of Pop art. Andy Warhol crossed that threshold with *Campbell's Soup Can and Dollar Bills* (plate 337)—a relatively early work lacking the impact of the mass-produced imagery that typifies Warhol's full-blown Pop idiom. Rather, this drawing is made in the style of the commercial illustrations with which Warhol had earned his living prior to achieving success with his early silkscreened paintings.

Of the major Pop artists, the one who has used watercolor most extensively is Claes Oldenburg. *The Bathroom Group in a Garden Setting* (plate 338) transforms common bathroom fixtures into garden ornaments. The irony and unexpectedness of the idea permitted Oldenburg to use watercolor in a rather traditional way, almost as a

nineteenth-century artist would, and this is certainly true of many of the proposals for colossal monuments that have emerged from his studio. Some of these are positively pastoral—his *Frankfurter for Ellis Island,* for example—but *Proposed Chapel in the Form of a Swedish Extension Plug* (plate 339) is, appropriately, more in the style of an architectural rendering. Oldenburg is, in fact, a skillful appropriator of idioms, though his work always bears the mark of his personal handwriting.

The pigments used in watercolors are derived from a variety of sources, including cuttlefish, insects, and certain kinds of vegetable matter. In the nineteenth century, American primitive artists unable to obtain or afford commercial colors sometimes turned to their garden or kitchen for substances they could use to paint. In recent years Ed Ruscha (though neither a primitive nor a pauper) has revived this tradition. *A Boulevard Called Sunset* (plate 340), for example, is painted in blackberry juice on moiré. This is only one example of Ruscha's use of unusual media—they vary from gunpowder to soy sauce—which are employed in a form that can reasonably be described as watercolor, though their impurities certainly yield a distinctive appearance. This use of unusual substances is not the only thing that makes Ruscha's work of interest, for he is one of the subtlest practitioners of post-Johnsian art. Playing sophisticated games with

337. Andy Warhol (1930–1987)
Campbell's Soup Can and Dollar Bills,
1962
Pencil and watercolor on paper,
24 × 18 in.
Roy and Dorothy Lichtenstein

338. Claes Oldenburg (b. 1929)
 *The Bathroom Group in a Garden
 Setting,* 1965
 Crayon, pencil, and watercolor on
 paper, 26 × 40 in.
 Moderna Museet, Stockholm

339. Claes Oldenburg (b. 1929)
*Proposed Chapel in the Form of a
Swedish Extension Plug,* 1967
Crayon and watercolor on paper,
22 × 30 in.
Krannert Art Museum, University of
Illinois, Champaign

340. Ed Ruscha (b. 1937)
A Boulevard Called Sunset, 1975
Blackberry juice on moiré,
28 × 40 in.
Leo Castelli Gallery, New York

341. Ray Johnson (b. 1927)
A Water Cooler, 1985
Watercolor and pencil on paper,
11 × 8½ in.
Ray Johnson

reality and illusion, this artist manipulates words or phrases so that they take on a new resonance.

Sometimes Ruscha's paintings are visual puns, and that is also the case with Ray Johnson's *A Water Cooler* (plate 341). Like Schwitters, Johnson is a master of collage and a miniaturist by choice. He first came to attention in the 1960s as the originator of the New York Correspondence School, which promoted the exchange of small-scale art works through the mail. Later he made wood reliefs, silhouettes, and photomontages featuring pop-culture personalities, as well as drawings and watercolors. A consistently inventive artist, he has been unjustly neglected in recent years, his modestly scaled work overlooked in the rush to monumentality.

Red Grooms is best known for his three-dimensional environmental cartoons, but he is a prolific artist in many media and makes varied use of both gouache and

342. Red Grooms (b. 1937)
Bombs over Beirut, 1983
Gouache, ink, and crayon on paper,
60½ × 100½ in.
Private collection

343. Red Grooms (b. 1937)
Franz Kline, 1983
Gouache on *Yellow Pages*,
11¼ × 10¼ × 4½ in.
Collection of the artist

344. Robert Stackhouse (b. 1942)
 *Inside Shiphall—A Passage Structure
 Borrowing Some Lines from the Osberg
 Burial Ship,* 1977
 Watercolor and charcoal on paper,
 40½ × 59½ in.
 Collection of the artist

watercolor. *Bombs over Beirut* (plate 342) is a powerful statement about international politics and the monstrosity of war. Technically it is something of a tour de force, since few other artists would presume to use gouache with such inventive freedom on so large a scale. Grooms's portrait of Franz Kline (plate 343) is one of many he has made of artists he admires. The unusual support is explained by the fact that Kline used the New York telephone directory as a sketchbook.

An interesting and unusual use of watercolor is made by Robert Stackhouse, a sculptor whose room-filling wooden structures relate to bridges and marine architecture. (One piece, for example, evokes the skeleton of a Viking ship.) Many of his three-dimensional works are temporary structures, and the artist makes watercolor studies of them as records for himself and for posterity. But the value of his watercolors goes well beyond the purely archival. The special character of the sculptures—the patterns of light and shade created by the wooden slats—lends itself particularly well to being recorded in this way, and Stackhouse has a sure touch with the medium that is its own justification (plate 344).

Chuck Close has often been misleadingly described as a Photo-realist. Though it is true that photographs are the sources of his images, his interests are far from those of artists who are interested primarily in reproducing the camera's version of reality. Concerned with ways of setting down visual information, Close works with the portrait image precisely because it is so familiar and yet so complex and varied. (In theory, fingerprints might serve his purpose just as well.) He uses the camera as an intermediary between himself and the subject so that the subject is already translated into two-dimensional information before he begins.

Much of this information relates to the color of the subject. At first Close sidestepped this problem by working in black and white. When he did turn to color he

avoided the conventional solution of mixing colors on a palette, preferring to superimpose layers of transparent primary color to build up the full chromatic range. Watercolor, because of its transparency, proved ideal for this purpose, and he employed it on several occasions, as in *Leslie/Watercolor I* (plate 345). Close has experimented with other ways of setting down color information, as in *Leslie/Watercolor II,* a different treatment of the same subject (plate 346). Here he placed colors side by side, recalling the method of the Impressionists and especially of Georges Seurat and his Pointillist disciples. Close's approach, however, differs from theirs in that he begins with an almost arbitrary distribution of color—the underpainting looks positively Fauvist—and then modifies this by the addition of dots and dabs of contrasting and complementary colors, several to the square inch, adjusting until the combination satisfies his eye.

Like many other Americans of his generation, Close has made the most of process as a compositional device. Each of his pictures looks the way it does because he decided in advance to create it according to a specific process. Such an involvement with process implies that the artist must take materials seriously for their own sake, since process is inevitably tied to the medium being used. American artists often take a special pride in mastering technical problems, almost as if this validates their involvement with something as frivolous as art. Doubtless this attitude is changing as art becomes more sociably acceptable and economically viable, but it was certainly reflected in the work of many artists who emerged in the 1960s and 1970s. Even Andy Warhol's production-line methods tended to make art respectable by linking it with the efficiencies of, say, automobile production.

Although some Europeans, such as Joseph Beuys, have been very involved with process, Europeans in general have been less obsessed with technique for its own sake. (By technique I mean not virtuosity but the rigorous use of a specific methodology as a

345. Chuck Close (b. 1940)
Leslie/Watercolor I, 1986
Watercolor on paper,
30¼ × 22¼ in.
Mr. and Mrs. George Perutz

346. Chuck Close (b. 1940)
Leslie/Watercolor II, 1986
Watercolor on paper,
30¼ × 22¼ in.
James and Barbara Palmer

347. Georg Baselitz (b. 1938)
Dog-Split, 1968
Pencil and watercolor on paper,
19⅝ × 12¼ in.
Collection, The Museum of Modern
Art, New York; Gift of the
Cosmopolitan Arts Foundation

OPPOSITE

348. Georg Baselitz (b. 1938)
Untitled, 1981
Watercolor and chalk-pastel on white
paper, 23¾ × 16¾ in.
Courtesy of The Harvard University
Art Museums (Fogg Art Museum);
Acquired through the Deknatel
Purchase Fund

way of generating a specific kind of imagery.) In the last decade or two the leaders of European art have tended to rely upon a more improvisational and intuitive approach. In some ways, indeed, they are as much the descendants of the Abstract Expressionists as are the younger Americans.

Georg Baselitz belongs to the generation of Europeans that has been able to absorb the lessons of recent American art while retaining a strong sense of identity that has permitted him and others to redefine ties to European tradition, especially German Expressionism. Not that Baselitz should be seen as a throwback. On the contrary, he is one of the artists who has succeeded in taking the Expressionist tradition forward and giving it new relevance. Often he does so by utilizing Expressionist brushwork while at the same time submitting his subject to some transformation that alters the viewer's conception of it.

In *Dog-Split* (plate 347), for example, the image of the dog has been split between two sheets of paper that do not quite match, so that, although there is a complete dog here, the viewer is aware not of completeness but of dislocation. That dislocation forces the viewer to consider the painterly attributes of the work, since only these attributes prevent the image from falling apart. Baselitz's most celebrated device is simply to turn an image upside down, as in *Untitled* (plate 348). In this case the image is that of a man who may be singing into a microphone or perhaps eating a chicken leg. By inverting the image Baselitz warns the viewer that definitions of subject are secondary to plastic concerns.

Several years younger than Baselitz, Anselm Kiefer is another of the German artists who has helped revitalize European art. He often introduces unconventional materials such as straw into his large-scale works on canvas or he paints over woodcut images. It is not surprising, then, to find him using gouache to alter a photograph—the artist himself is represented on a painted tree stump—in a work that has a very specific political message (plate 349). The title suggests that Germany has been transformed into "a little anti-tank device," a pertinent comment on NATO policy and a reminder that Kiefer, like a number of other artists in his generation, feels comfortable with a degree of political commitment that would have seemed alien to many in the art world just a couple of decades ago.

Although Baselitz and Kiefer are major artists, it could not be said that either uses watercolor with anything resembling virtuosity. Francesco Clemente, on the other hand—while fluent in many media and an exponent, like most of his contemporaries, of huge formats—is a watercolorist of great skill and inventiveness. In *Ritz* (plate 350), a rather complex image is evoked with liquid strokes confidently applied into wet washes. The image is surrealistic, but what gives the startling conjunction of heads such authenticity is the sureness of Clemente's technique. There is not an artist working today who has a more highly developed feel for the range and richness of watercolor. Nor does anyone have a more spontaneous touch with the medium, as is evident from his Brooklyn Academy of Music poster (plate 351). The poster is a form of expression that often

OPPOSITE
349. Anselm Kiefer (b. 1945)
For Chlebnikow: A Small German Bazooka, 1980
Gouache on photograph, 32 × 23 in.
Courtesy of The Harvard University Art Museums (Fogg Art Museum); Acquired through the Deknatel Purchase Fund

350. Francesco Clemente (b. 1952)
Ritz, 1983
Watercolor on paper, 14⅛ × 20 in.
Bruno Bischofberger, Zurich

285

351. Francesco Clemente (b. 1952)
Poster for the Next Wave Festival
BAM, 1984
Watercolor on paper, 28½ × 20 in.
Angela Westwater, New York

tempts artists into simplifying their aims and hardening their forms into something that reads as design rather than art. Clemente avoided these dangers, coming up with a typically ambiguous and evocative image that he brought to life with characteristic informality underscored by confident draftsmanship.

Clemente's fellow Italians Sandro Chia and Mimmo Paladino do not have his virtuosic command of the medium but they have nevertheless made effective watercolors. Although Chia's untitled study (plate 330) does not pretend to be more than it is—a colored sketch for a work to be completed in another medium—it encapsulates some of his prime qualities, including his willingness to mix modernist devices with neoclassical imagery. If Chia's work sometimes calls to mind the world of Italian opera, Paladino makes images that evoke the Middle Ages, as in his untitled watercolor that seems to represent a monk in his cell (plate 352). Paladino's technique appears crude, but this is perhaps deceptive since the washes are kept very clean and the overall handling appears rather studied. His approach to watercolor technique might best be described as *faux naïf*.

The work of the American artist David Salle resembles that of Clemente in that his touch with watercolor verges on virtuosity. Salle's method is to superimpose images in transparent layers—an approach well served by watercolor. Improbably juxtaposed images can have a special power, which Salle's system of layering intensifies by freeing

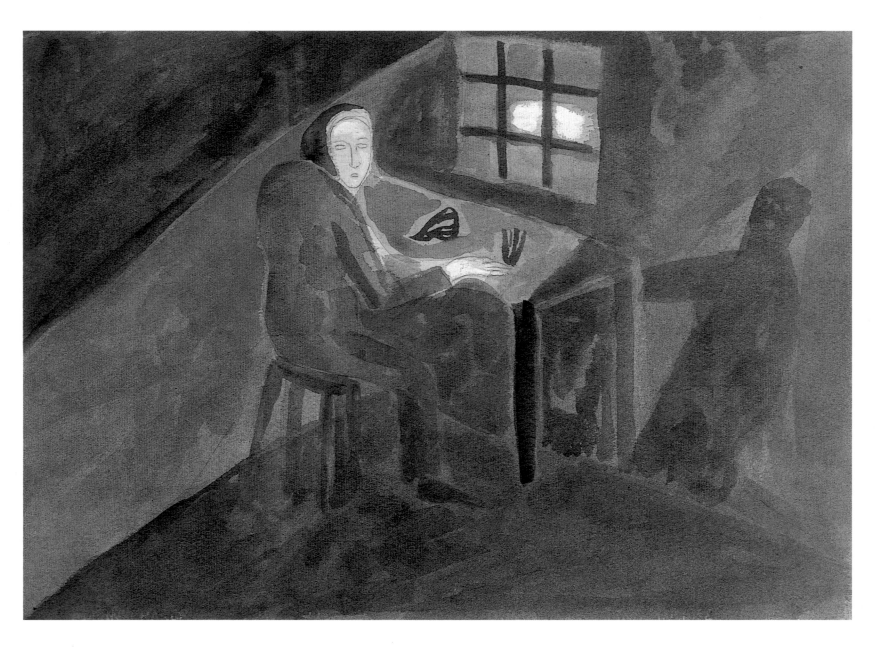

352. Mimmo Paladino (b. 1948)
Untitled, 1984
Watercolor and pencil on paper,
11¼ × 16 in.
Sperone Westwater Gallery,
New York

353. David Salle (b. 1952)
Untitled, 1984
Watercolor on paper, 25 × 31 in.
Mary Boone Gallery, New York

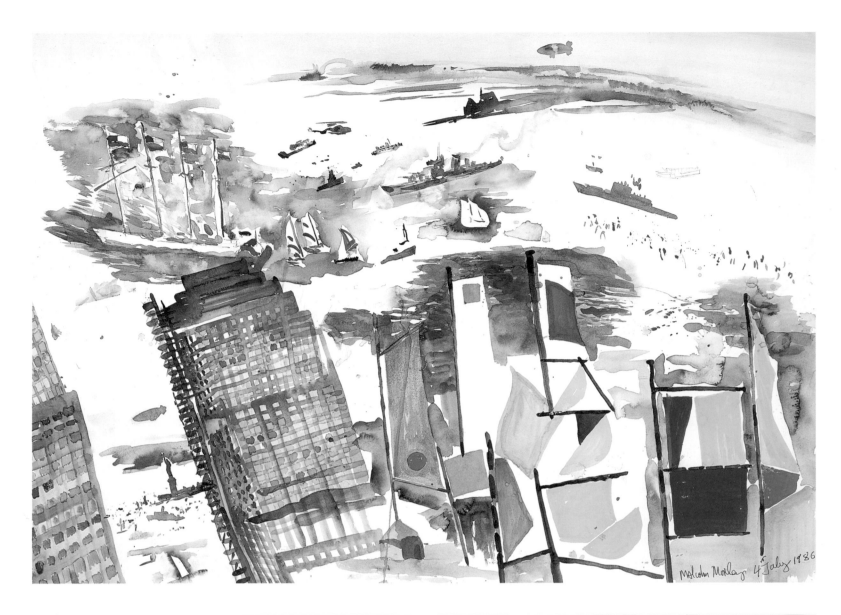

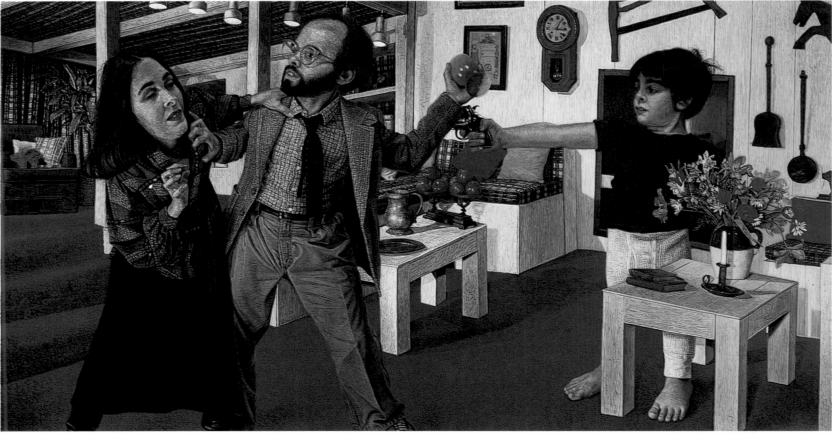

the components from any fixed context and thus permitting meanings to shift as the viewer studies the painting (plate 353).

Malcolm Morley, born in England but long resident in New York, first came to prominence with meticulously rendered paintings of postcard scenes such as cruise liners arriving in port. Like Chuck Close, he was sometimes misleadingly described as a Photo-realist, but over the years he has changed his style dramatically to a more expressionistic approach, often laced with black humor and informed by witty art historical references. In the 1980s he has been especially successful with his watercolors, which have a delightful, eccentric freshness (plate 354). At times the freedom of his brushwork recalls Marin, at times Kokoschka, but the decidedly offbeat vision is distinctly his own.

If Morley is something of an eccentric, the American Mark Greenwold is so far from the mainstream that he almost defies definition. It could be argued that his highly charged psychosexual dramas have something in common with the paintings of Eric Fischl (which Greenwold's predate), though their claustrophobic atmosphere is unique. Originally Greenwold painted large canvases that sometimes took years to complete. Lately he has put his efforts into exquisitely detailed gouaches that concentrate the already intense energy of his singular vision, making it even more powerful (plate 355).

The subject of Greenwold's work is generally autobiography, though distorted by the visual equivalent of poetic license. Beth Shadur's earlier watercolors were also autobiographical, though in a somewhat different sense—her subject being carefully organized conjunctions of mementos and memorabilia that amounted to metaphors for personal experience. In more recent watercolors, such as *Don't Burn Your Bridges behind You* (plate 356)—one of a series of works with a bridge motif—she combines real and imaginary objects and figures with architectural forms that function like stage sets.

British artist Elizabeth Butterworth has employed watercolor in the tradition of John James Audubon and scores of other painter-naturalists to make a series of magnificent studies of members of the parrot family (plate 357). There is little to be said about her stylistic approach—it could not be more straightforward—but her work brings home how marvelously well watercolor, in the right hands, is suited to rendering something like feathers, where it is necessary for the artist to capture both sheen and local color in a convincing way.

The healthiest branch of the realist tradition, so far as watercolor is concerned, is to be found in the United States, and its most famous representative (though not necessarily its most typical) is Andrew Wyeth, who has been mining a narrow vein of emotionally charged Americana since the late 1930s. *Alvaro and Christina* (plate 358) is a good example of his watercolor style, which has roots in the nineteenth-century realism of Eakins and Homer, but which manages to remain modern by virtue of its fidelity to the subject at hand—which, inevitably, reflects the moment. Like Edward Hopper, he possesses an eye that a photographer might envy.

OPPOSITE
357. Elizabeth Butterworth (b. 1949)
 Scarlet Macaw, 1979
 Watercolor on paper,
 27⅞ × 20¼ in.
 Private collection

358. Andrew Wyeth (b. 1917)
 Alvaro and Christina, n.d.
 Watercolor on paper, 22 × 29 in.
 William A. Farnsworth Library and
 Art Museum, Rockland, Maine

359. Fairfield Porter (1907–1975)
Sketch for Lizzie and the Christmas Tree, c. 1972
Watercolor on paper, 20 × 16 in.
Glenn C. Janss

360. Nell Blaine (b. 1922)
Green Table by Night Window, 1986
Watercolor on paper, 10 × 14 in.
Mr. and Mrs. John D. Gottwald

More typical of postwar American realists—an influential figure in a quiet way —was Fairfield Porter, a painter of insightful portraits, light-filled landscapes, and intimate interiors that reveal his profound debt to Vuillard. Porter's primary gift was not for watercolor, yet on occasion (plate 359) he could use the medium to good effect, capturing the feel of a scene with the economy that is characteristic of all his best work.

Another American who has learned much from the French tradition is Nell Blaine, who displays great ability as a watercolorist, conjuring up a scene effortlessly with strokes of color applied with a precision disguised by a seeming informality of execution. Like Porter, she is at her best with landscapes and intimate interiors (plate 360). Her way with these subjects is quite profound, and she has a knack of injecting them with vitality that derives from the sprightliness of her eye, the liveliness of her brushwork, and the almost Fauvist intensity of her palette.

A lower-keyed landscapist is Jane Freilicher, best known for her paintings of Long Island, though some of her more evocative watercolors have been of Caribbean subjects (plate 361). Freilicher's watercolors tend to be small in size. Susan Shatter, on the other hand, is one of a number of recent American watercolorists who have made watercolors on a grand scale. As in *Aqua Rhythms* (plate 362), she deals primarily with conventional landscape subjects and employs a largely traditional technical approach, but the size of the sheets she works on—allied to breadth of handling—make for a new sensibility that had not been part of the watercolor legacy until the very recent past.

The remaining artists in this chapter all share this sensibility to a greater or lesser extent, using traditional watercolor technique—building realistic images from layers of

361. Jane Freilicher (b. 1924)
St. Maartin, 1983
Watercolor on paper, 7½ × 8¾ in.
Fischbach Gallery, New York

362. Susan Shatter (b. 1943)
Aqua Rhythms, 1984
Watercolor on paper,
46½ × 83¾ in,
Fischbach Gallery, New York

363. Leigh Behnke (b. 1946)
Still Life with Telephone, 1983
Watercolor on paper,
40½ × 52¼ in.
Mrs. William C. Janss

OPPOSITE, TOP

364. Joseph Raffael (b. 1933)
Rose Garden, 1987
Watercolor on paper, 22½ × 30 in.
Private collection

OPPOSITE, BOTTOM

365. Carolyn Brady (b. 1937)
Carnations and Classic Roses, 1987
Watercolor on paper, 52 × 72 in.
Private collection

transparent wash—but on a scale that was seldom attempted by their predecessors, even in the heyday of the Victorian "exhibition watercolor," designed to catch the eye at the Salon or the Royal Academy. Leigh Behnke, for example, uses multiple images and multiple viewpoints to make statements about the sense of place (plate 363). The others deal in straightforward presentations of single images painted on a scale not generally expected from watercolorists.

Joseph Raffael is the most painterly of the group and the one who has most successfully preserved, on this large scale, the fluidity of the medium. Retaining the ability to improvise, even on these oversize sheets, Raffael takes advantage of chance in much the way that Homer or Sargent did when creating watercolors on a much smaller scale (plate 364).

Even so, Raffael builds his paintings with care. That is a prerequisite of watercolor on this scale, and the craftsmanship involved is very apparent in the still lifes and flower studies of Carolyn Brady (plate 365). Brady uses a classical watercolor technique —one that John Sell Cotman would have appreciated—creating the image carefully from layers of transparent color, working the whole tonal range from the virgin white

366. John Stuart Ingle (b. 1933)
Still Life with Brass Candlestick, 1982
Watercolor on paper, 29½ × 42 in.
The Metropolitan Museum of Art,
New York; Gift of Dr. and Mrs.
Robert E. Carroll, 1984

of the paper to the darkest shades that can be achieved by stacking up dense color. She does not leave as much room for extemporization as does Raffael, but the edges of her washes, though precise for the most part, sometimes have a hint of calculated casualness about them that reminds the viewer of the fluidity inherent in the medium.

Perhaps the most technically controlled of these realists is John Stuart Ingle, who has the ability to lay down a velvety wash that is unmatched among his contemporaries, especially given the large area that must be evenly covered in a work on this scale (plate 366). Scale aside, Ingle's work is almost Victorian in concept and execution. Yet there is something inexplicable that happens when an artist sets about honestly recording a subject, however traditional, without affectation and without mannerism: the atmosphere of the artist's own era inevitably creeps in, making the painting a contemporary vision. (A relevant sidelight on this is that Van Meegeren's forgeries of Vermeer, painted in the second quarter of this century, were convincing when they first came to light but now look like period pieces. The aura of the age insinuated itself into these recreations of a past style.)

Rounding out this group of realists is Julio Larraz, born in Cuba but long resident in the United States. Larraz is not exclusively a watercolorist—his large-scale works on canvas conjure up an ambience that is distinctly Latin American and often recalls the worlds created by novelists such as Carlos Fuentes and Gabriel García Márquez—but

367. Julio Larraz (b. 1944)
Study for Labor Day, 1986
Watercolor on paper,
45⅜ × 75¼ in.
Carolyn Wente,
Livermore, California

he uses the medium with great fluency. His watercolors include quick studies of aerial landscapes made from airplane windows, as well as atmospheric evocations of such subjects as airplanes and trains hemmed in by lush tropical vegetation. He is not, then, committed to the large-scale watercolor still life in quite the same way as Brady or Ingle, but when he chooses to tackle it, as in *Study for Labor Day* (plate 367), he proves himself capable of performing as skillfully as anybody. Indeed, he displays a breadth of handling and achieves a richness of tonality—related perhaps to the traditions of Spanish still-life painting—that is seldom encountered in watercolor.

The revival of interest in realist watercolor and traditional watercolor techniques is a significant aspect of the present-day art scene. This does not mean that realism is necessarily the wave of the future so far as watercolor is concerned, but it does suggest that traditional watercolor methods will continue to regain currency. It would be an exaggeration to say that the situation in the watercolor world is as fluid now as it was at the turn of the century; but it is nonetheless true that the medium is enjoying its greatest popularity in decades and that the increased visibility of the large-scale watercolor in galleries indicates that many artists are approaching the medium with high seriousness.

Beyond that, watercolor's adaptability has been proven over and over again. On the one hand it lends itself to the studied experiments of Chuck Close, and on the other, to the loose improvisations of Francesco Clemente and Malcolm Morley. Claes Oldenburg uses the delicacy of the medium as a cloak for the expression of fantastic and sometimes preposterous ideas, while Robert Stackhouse employs it to provide a literal record of work made in another medium.

In the nineteenth century the term *watercolor* could be used to describe not just a medium but also a special way of painting—a method of building a figurative image from overlays of transparent color. There were many ways of varying this method but all of them related to one basic approach that was first perfected by artists such as Cozens, Thomas Girtin, and Turner. In the twentieth century it is possible to trace the vestiges of that tradition, but to focus on that alone is to see only a small part of the story. Painters from Picasso to Dubuffet and from Klee to Johns have opened up new avenues of exploration for the watercolorist with an adventurous bent. The future of watercolor promises to be as rich as its past and far more varied.

NOTES

1. George Heard Hamilton, *The Pelican History of Art: Painting and Sculpture in Europe, 1880–1940* (New York: Penguin Books, 1967), p. 60.

2. Lawrence Gowing et al., *Cézanne, the Late Work* (New York: Museum of Modern Art; Boston: New York Graphic Society, 1977), p. 65.

3. John Rewald, *Paul Cézanne, the Watercolors: A Catalogue Raisonné* (Boston: Little Brown, 1983), pp. 191–94. In 1934, before the vegetation there was destroyed by a forest fire, Rewald took photographs near the Château Noir which demonstrate that Cézanne had been extremely faithful to his subject matter in compositions such as *Pine and Rocks at the Château Noir*. Some of these photographs are reproduced in Rewald's catalogue raisonné; others were used in "The Camera Verifies Cézanne's Watercolors," *Artnews*, September 1944, pp. 16–18.

4. Edvard Munch, in Reinhold Heller, *Munch* (Chicago: University of Chicago Press, 1984), p. 165.

5. Peter Selz, *Emil Nolde* (New York: Museum of Modern Art; Doubleday, 1963), p. 67.

6. Ibid., p. 70.

7. Roland Penrose, *Picasso: His Life and Work* (London: Gollancz, 1958), p. 275.

8. Pablo Picasso, in *Picasso on Art: A Selection of Views*, ed. Dore Ashton (New York: Viking Press, 1972), p. 153.

9. See Juan Gris's statement, quoted by Amédée Ozenfant in *L'Esprit nouveau*, no. 5, 1921, pp. 533–34. The statement occurs in a piece entitled "Juan Gris by Vauvrecy," Vauvrecy being a *nom de plume* employed by Ozenfant. The piece was based on material supplied to Ozenfant by Gris himself.

10. El Lissitzky and Hans Arp, "Proun ist die Umsteigestation von Malerei nach Architektur," in *Die Künstismen*, Zurich, 1925, n.p.

11. For an introduction to the work of the Ender family, see Angelica Zander Rudenstine, ed., *Russian Avant-Garde Art: The George Costakis Collection* (New York: Harry N. Abrams, 1981).

12. For a full discussion of this, see William S. Rubin, *Dada and Surrealist Art* (New York: Harry N. Abrams, 1968), pp. 99–111.

13. Angelica Zander Rudenstine, *The Peggy Guggenheim Collection, Venice* (New York: Harry N. Abrams, 1985), p. 719.

14. Joan Miró, in James Johnson Sweeney, "Joan Miró: Comment and Interview," *Partisan Review*, February 1948, p. 211.

15. Charles Sheeler, in Daniel M. Mendelowitz, *A History of American Art* (New York: Holt, Rinehart, Winston, 1970), p. 405.

16. Paul Nash, in Margot Eates, ed., *Paul Nash: Paintings, Drawings and Illustrations* (London, 1948), p. 18.

SELECTED BIBLIOGRAPHY

GENERAL

Brett, Bernard. *A History of Watercolor*. New York: Excalibur, 1984.

Cohn, Marjorie B. *Wash and Gouache: A Study of the Development of the Materials of Watercolor*. Cambridge, Mass.: Fogg Art Museum, 1977.

Daulte, François. *French Watercolors of the Twentieth Century*. New York: Viking Press, 1968.

Gardner, Albert Ten Eyck. *History of Watercolor Painting in America*. New York: Reinhold Publishing Co., 1966.

Hofmann, Werner. *Expressionist Watercolors, 1905–1920*. New York: Harry N. Abrams, 1967.

Hoopes, Donelson F. *American Watercolor Painting*. New York: Watson-Guptill, 1977.

Koschatzky, Walter. *Watercolor: History and Techniques*. New York: McGraw-Hill, 1970.

Reynolds, Graham. *A Concise History of Watercolor*. New York: Harry N. Abrams, 1971.

INDIVIDUAL ARTISTS

Charles Burchfield
Baur, John I. H. *The Inlander*. Newark, Del.: University of Delaware Press, 1984.

Paul Cézanne
Rewald, John. *Paul Cézanne, the Watercolors: A Catalogue Raisonné*. Boston: Little, Brown, 1983.

Chuck Close
Lyons, Lisa, and Robert Storr. *Chuck Close*. New York: Rizzoli, 1987.

Charles Demuth
Haskell, Barbara. *Charles Demuth*. New York: Whitney Museum of American Art; Harry N. Abrams, 1987.

George Grosz
Sabarsky, Serge. *George Grosz, the Berlin Years*. New York: Rizzoli, 1985.

Winslow Homer
Hoopes, Donelson F. *Winslow Homer Watercolors*. New York: Watson-Guptill, 1969.

Edward Hopper
Goodrich, Lloyd. *Edward Hopper*. New York: Harry N. Abrams, 1971.

Wassily Kandinsky
Svendsen, Louise Averill. *Kandinsky Watercolors: A Selection from the Solomon R. Guggenheim Museum and the Hilla von Rebay Foundation*. New York: Solomon R. Guggenheim Foundation, 1980.

Paul Klee
Klee, Paul. *The Inward Vision: Watercolors, Drawings, Writings by Paul Klee*. New York: Harry N. Abrams, 1959.

František Kupka
Cassou, Jean, and Denise Fedit. *Kupka: Gouaches and Pastels.* New York: Harry N. Abrams, 1965.

Franz Marc
Lankheit, Klaus. *Franz Marc: Watercolors, Drawings, Writings.* New York: Harry N. Abrams, 1965.

John Marin
Reich, Sheldon. *John Marin: A Stylistic Analysis and Catalogue Raisonné.* Tucson: University of Arizona Press, 1970.

Reginald Marsh
Goodrich, Lloyd. *Reginald Marsh.* New York: Harry N. Abrams, 1972.

Henry Moore
Clark, Kenneth. *Henry Moore Drawings.* New York: Harper and Row, 1974.

Emil Nolde
Selz, Peter. *Emil Nolde.* New York: Museum of Modern Art; Doubleday, 1963.

Georgia O'Keeffe
Turner, David, and Barbara Haskell. *Georgia O'Keeffe: Works on Paper.* Santa Fe: Museum of New Mexico, 1985.

Auguste Rodin
Elsen, Albert, and J. Kirk Varnedoe. *The Drawings of Rodin.* New York: Praeger, 1971.

Wols
Haftman, Werner, ed. *Wols: Watercolors, Drawings, Writings.* New York: Harry N. Abrams, 1965.